Latin American Icons

# LATIN AMERICAN ICONS

Fame Across Borders

EDITED BY

Dianna C. Niebylski
Patrick O'Connor

VANDERBILT UNIVERSITY PRESS

*Nashville*

This book is printed on acid-free paper.
Manufactured in the United States of America
Book design and composition by Cheryl Carrington

Library of Congress Cataloging-in-Publication Data on file
LC control number 2012038980
LC classification F1408.3.L27428 2013
Dewey class number 305.5'209228—dc23

ISBN 978-0-8265-1929-0 (cloth)
ISBN 978-0-8265-1930-6 (paperback)
ISBN 978-0-8265-1931-3 (ebook)

**Permissions to Reprint**
We gratefully acknowledge permission given by the following publishers and authors for
the following article and book chapters:
Excerpts, translated by the editors from the original, of *La pasión y la excepción*, by
    Beatriz Sarlo, pp. 9–13; 82–85; 88–94; 104–6; 108–14. Copyright © 2003 by Siglo XXI
    Editores.
"From Hollywood and Back: Dolores del Río, a (Trans)National Star," by Ana López, from
    *Studies in Latin American Popular Culture* Volume 17, pp. 5–32. Copyright © 1998 by
    the University of Texas Press.
Excerpt from "Bananas is My Business," with minor changes by author David William
    Foster, from the chapter "Constructions of Feminine and Feminist Identities," in
    *Gender and Society in Contemporary Brazilian Cinema* by David William Foster.
    Copyright © 1999 by the University of Texas Press.
Excerpt from "Fetishizing Frida," with minor changes by author Margaret Lindauer,
    from the chapter "Fetishizing Frida," pp. 150–63 and pp.178–79 in *Devouring Frida*.
    Copyright © 1999 by Wesleyan University Press.

Permission to reprint images from the following sources is gratefully acknowledged:

| | |
|---|---|
| Agrasánchez Film Archive | Juan Pablo Spicer-Escalante |
| Associated Press | Sara Facio |
| Brown Brothers | Tamara Falicov |
| Daniel Alberto Rugna | Texas University Press |
| El Paso Public Library | UNAM Film Archives |
| Fondo Casasola | Wesleyan University Press |

# CONTENTS

## PART III

## Contemporary Latin American Icons: National
## Stars and Global Superstars

## PART IV

## The Afterlife of Fame: Consuming Iconicity

# ACKNOWLEDGMENTS

The editors wish to thank Eli Bortz for his enthusiastic support of this volume, for his generous advice, and for seeing the project to the end. We are also grateful to the anonymous readers at Vanderbilt University Press for their informed and thoughtful suggestions, and to managing editor Joell Smith-Borne for her invaluable technical support and advice. Our gratitude goes also to Alejandra Marín Pineda for extensive assistance in preparing the manuscript, and to Jacqueline Niebylski for providing a concept for the present book cover.

Latin American Icons

# INTRODUCTION
## Reflections on Iconicity, Celebrity, and Cultural Crossings

*Patrick O'Connor and Dianna C. Niebylski*

You know one when you see one, of course, and you'll see it often, or else it isn't an icon at all. Whether we date our interest in icons to the 2008 US presidential election and the transformation of the photograph of a junior senator into a red-and-blue icon of Hope, or whether we trace the term back to ancient Greece or to Byzantine and Russian Christianity, the traits that define an icon remain more or less constant. These are, in short order, a figure's appeal to the visual; a certain fixity and reduction of detail in the image that invites constant reproduction; its capacity to convey some relatively fixed meaning or value; and, implicitly, the presence of a community that knows how to read the image as iconic in situations which often include some kind of veneration, admiration, or a host of other more complex emotional responses, sometimes against our better judgment.

Derived from the Greek *eikon*—image, thing seen—the icon draws its power from three related fields of meaning. The first is religious. The first known icons date to the fourth century CE but gain ample recognition and become truly "iconic" with the spread of the Greek Orthodox and Russian Byzantine churches, where Russian portraits of saints became the earliest known use of religious icons in the history of art. By the eighth and ninth centuries, the popularity of these first religious icons infuriated believers who saw the growing interest in divine duplicates as a form of idolatry. Our term *iconoclast*, from the Greek *eikonoklastes*, or image-breaker, comes from this period.[1]

The Latin American religious icon best known in the United States (and perhaps elsewhere) is the Virgin of Guadalupe, named "la diosa de las Américas" in a loving anthology written by mostly Chicana authors and edited by Ana Castillo (1997). Academics and authors of cultural studies are far more often idolaters than iconoclasts, with the result that—like the Virgin—some of the icons studied in this volume already have anthologies of their own.[2] The most famous image of the Virgin of Guadalupe was found, according to legend, on the cloak of a recently catechized Nahuatl-speaking indigenous serf in 1531. Since then it has evolved over the hundreds of years of colonial and independent Mexican history to bear shifting meanings of cultural nationalism as well as Catholic values of womanhood and maternity; women in Mexican and emigrant cultures, even those who consider

themselves rebellious, all claim to know what the image of the Virgin means.[3] In her recent book on Chicana art, Laura Pérez (2007) has demonstrated that the enormous range of citations and allusions to Guadalupe almost never involve outright blasphemy; instead, they display a variety of complex negotiations between Christian piety and the varieties of womanhood that can be extracted from a strong yet nonaggressive, dark-skinned, maternal goddess figure. When a reader of icons finds herself closer to that territory, she will often discover that secular icons borrow the emotions and the sociological organizations of religious icons: the church of Diego Maradona in Argentina; the direct imitation of the style of *retablos* and *ofrendas* employed by Frida Kahlo.

On another side of the conceptual field, the icon is bordered by the images massively reproduced in the world of commerce. Although prefigured by the much earlier woodcuts and lithographs, as Walter Benjamin pointed out, modern iconic images are characteristic of the age of mechanical reproduction and technical reproducibility, and have been for some time now. A commercial icon like the Michelin Man or the Pillsbury Doughboy, insofar as it is an image which refers reliably to the product it represents, has some of the elements of a logo, like the Nike swoosh or the McDonald's golden arches (which have been so fully disseminated that they are frequently reproduced without the names of the companies they represent). If they are repeated often enough, these signs can certainly become independent of their original motivation: it matters only trivially that one insurance company's name sounds like a gecko lizard, or another one's name sounds like the quack of a duck. Insofar as our anthology has decided quite consciously to focus on people as icons, instead of including essays on, say, the ruins of Machu Picchu or the Chilean *arpilleras*, the iconic people in our anthology in some ways seem like the advertising spokespersons for the abstract concepts or ideals that they represent.

This association between a person and the product he advocates maps most fully on the use of cultural icons for nationalist purposes, often partisan ones. In the Argentina of the 1940s Eva Perón was sold to the Argentine people by a team of image-makers (dressmakers, speechmakers, ghostwriters, paparazzi), and she then disseminated a clearly partisan image of Argentina to the world. The iconic photograph of Che Guevara *means* Cuba, or the Cuba of a certain era, just as the icon of Gardel *means* Argentina of a certain era, even though Guevara was not born in Cuba nor Gardel in Argentina.

Like heraldry or the symbolism of a flag's designs and colors, an icon that has become streamlined to a sort of logo must be explained to children and to those outside of the community. In his book about Sandinista Nicaragua, *The Jaguar Smile* (1986), Salman Rushdie writes of the omnipresence on walls and flags of an almost abstract drawing of a Stetson hat, which symbolized the Sandinista movement because of its association with Sandino, the *guerrillero* from the 1930s who was the movement's inspiration. After working for years in the United States, Sandino returned to his home country to help with the revolts against the US occupiers, and photographs of him invariably show him wearing this American headgear. In the 1980s the Stetson hat became a sort of logo of Sandinismo. (Another such icon-logo-political symbol: the white scarf of the Madres de la Plaza de Mayo.)

The religious and commercial-national uses of the icon come into play with a third border: the Freudian fetish. It is difficult to disentangle the notion of the

Freudian fetish from either the religious or the commercial icon. Indeed, in many ways the Freudian fetish concept is merely the privatization and overt eroticization of the larger space we have already described. In their important anthology *Fetishism as Cultural Discourse* (1993), Emily Apter and William Pietz recontextualized Freud's language of the fetish to describe a range of cultural behaviors. In his intellectual history of the term, Pietz highlights its Enlightenment history: comparative religion of the eighteenth century elaborated the notion of the fetish as a false god of "savage" tribes who foolishly think that their little wooden statues actually embody divinity; from his reading of those early anthropological texts, Marx proposed the famous notion of the commodity fetish. Apter and Pietz's anthology demonstrates that many of these earlier propositions need rethinking—we now understand the imperialist force behind the Enlightenment's condemnation of non-Western cultures as "premodern" and "savage"—yet there is little doubt that nineteenth-century bourgeois fetishistic behaviors and accounts of fetishist personality traits described by the sexologists of that era (Freud, Krafft-Ebing, or Havelock Ellis) still inform our views on the behavior of icon lovers.[4] Certainly the ambiguous affects that course through us when we think about "our" star or "our" politician overlap with those of the classic fetishist. When these behaviors and affects become public and if they lose their sense of overvaluation or disproportionateness—when they become the new normal—a fetish figure and a cultural icon become indistinguishable.

## Making Faces: The Technology of Latin America's Celebrity

> To make sense of a celebrity, then, is not simply a study of the primary text—what perhaps a simple film studies analysis of John Wayne and his roles in films produces is an overcoded star text—but rather the magazine profiles, the television interviews, the presentation of premieres, the many unplanned photos and stories about the celebrity's personal lives that populate the mediascape along with the fans' work on the celebrity and how they have re-presented the famed.
>
> P. David Marshall, *The Celebrity Culture Reader* (2006, 9–10)

> We didn't need dialogue. We had faces!
>
> *Sunset Boulevard* (1950)

Although some of the icons in our anthology are *guerrilleros*, painters, playboys, politicians, and bandits, many are entertainers (in sports, music, and films), and in the twentieth and twenty-first centuries these figures become "iconized" following the rules and the machinery of the entertainment industry. When we present an anthology of Latin American icons, many readers will see an anthology of Latin American celebrities. And they will be generally correct in doing so. If the history of art has a tradition of dealing with the visual icon, cultural studies has a broader and a more recent but quite deep history of examining celebrities, the machinery that makes (and breaks) them, and the masses of fans who participate in the sometimes voracious consumption of them.

The story of cultural studies cannot be summarized here, but we hope that most of our readers know of its two principal faces: the first one, generally hostile to mass culture, we associate with the Frankfurt School of the 1930s and The New York Intellectuals of the 1950s; the second one, which rethinks the way mass culture is consumed, we associate with the British Cultural Studies school of Raymond Williams, Stuart Hall, and Dick Hebdige of the 1970s and 1980s.[5] Most of the writers in our anthology prefer the latter approach, which after all squares better with the populism (at times, national-populism) typical of Latin American studies as a field.[6] Indeed, as one moves from Latin American icons to collections studying Latino/a icons, in this anthology's essays and in other volumes that deal with Latin Americans or Latino/as in Hollywood, there is a distinct tone of rooting for the underdog. Performers who submit themselves to the machinery of Hollywood almost always find their meaning twisted to suit the needs of the larger audience.[7] The machinery allows access, wealth, and fame, but at a cost.

What may come as a surprise to readers of this anthology is how similar the machinery is in other dream factories during the twentieth century. The paratexts that fuel the star-making machinery of Hollywood described by Marshall in the epigraph above had equivalents in Mexico City and Buenos Aires, the largest cinematic industries of the Spanish-speaking world, and although at times Hollywood made attempts to hold on to its Spanish-language market after the invention of sound cinema (see Navitski in this anthology), the mass culture industry around the globe mostly replicated each other's best and worst ideas (think of the way the premise behind the first generation of reality television shows jumped from one nation to another in a frenzy of imitation), tweaking basic formulas but for the most part creating a similar moviegoing and radio-consuming population in all of North and South America.

Some of our icons began to impress themselves on local Latin American audiences through their voices rather than their image, particularly in the era that ushered in sound technology: Carlos Gardel and Lupe Vélez began as singers, or as singer-dancers, although each quickly expanded his or her fame. Gardel went on to become a megastar in the Argentine film industry, then on to greater international fame. Vélez expanded her celebrity status not just as a favorite entertainer in the *revista* spectacles of 1920s flapper-era Mexico City but also as a favorite poster girl for postrevolutionary Mexico (see Rawson in this collection). From there she would eventually make a successful if ambiguous leap to Hollywood.

And in all these nations, in all these markets, there entered into everyday life the possibility of mass repetition of images. Sound recording and radio could, and did, make singers stars beyond the circuits of their physical performances; eventually entire musical genres could travel from their place of origin to global audiences, with individual singers becoming iconic representations of their music and their country.[8] Before the explosion of cultural product distribution and the ease in wider distribution, which has forced theorists to talk more of niche markets than they did for previous cultural moments, film was consumed throughout Latin America intensely as well as massively. Some of the authors in our anthology will use the careers of our icons to tell the story of a nation or a subculture; others will use them to tell the story of the changing modes of technical reproduction.

For better or for worse, we are well past the critical era when Walter Benjamin aggressively and anxiously tried to distinguish between the "true" aura of the work of art and of the human actor, and the "false" auras generated by technical reproductions and the Hollywood celebrity machinery. We're both too smart and too stupid for the distinction between a true and a false aura. We certainly still value our real-time, face-to-face encounters with people and places and art, but we are now far more skeptical about attributing to these relationships *immediacy*, non-mediated-ness. And, conversely, when something matters too much to us, we forget its constructedness all over again. What Derrida termed "the myth of presence" in reference to a tradition from Plato to Hegel and beyond continues to rule unchallenged in middlebrow culture. We recognize and are moved by the breathtaking image brought to us by television cameras of a Chinese protester walking toward a tank in Tiananmen Square; we are *there* in the moment; but therefore we do not stop to ask why and how there were cameras running to capture it all, or whether this historical episode might have ended differently, or not happened at all, if there had been no cameras present. We also have at times a naïve belief in the power of images to bring about political change: publicizing the iconic images of torture in Abu Ghraib did not bring down the Bush Administration in 2004. Meanwhile, as technology changes, our pact with how new media circulates its images also changes: the chaos of the Arab Spring and the slow-motion anger of the nationwide Occupy Wall Street protests have generated viral videos of military and police brutality, which in turn have been repackaged to stoke further fury and manipulated for the purpose of black humor.

Other mediations between the Latin American icons we present here and you, the readers, are the authors themselves and the academic institution in which we are positioned. In at least one case in recent history, the Latin American academy took a leading role in distributing and disseminating an icon in the genre of the *testimonio*, 1992 Nobel Peace Prize winner Rigoberta Menchú, who became a face and voice for indigenous rights through the oral history she told anthropologist Elizabeth Burgos-Debray. Menchú's denunciations of the US-funded Guatemalan ethnocide were circulated not just through the press but also through Latin American Studies conferences and syllabi.[9] (A decade later, the next icon of pan-Mayan indigenous protest, the masked Subcomandante Marcos of the Zapatistas, manipulated the new mediascape perfectly well without a need to appeal to the Latin Americanist academy.)[10] While occasionally pressed to advocate a contemporary face, the academy generally serves an archival and interpretive function.

The authors of the essays that follow often presume you don't necessarily know the icon about whom they write or that, if you do, you don't know what they meant to the Latin Americans who first found them so fascinating. Insofar as we have an audience in mind, it is composed of people who have not already lived the story of Maradona or Carmen Miranda, at least not with the same passionate veneration of those "original" communities that made these figures iconic in the first place. This is especially true of our essays on figures from longer ago: in telling you why a playboy from the Dominican Republic in the 1950s or a Mexican American bandit from the 1850s attracted the attention of a nation or a region, our goal is to give you insights into the cultural epics and melodramas of those nations or regions.

Insofar as we academics are working upon the cultural materials we have found in contemporary or previous Latin American (and at times Latino) history, then we too are part of the circulation of these icons. Some of the Latin American icons chosen for this book circulate internationally, some just within Latin America, and some just within certain regions of Latin America. As a peripheral region of the world, Latin America is somewhat at a disadvantage at circulating its icons. That we as Latin American academics should join the cultural forces that do so marks the continued importance we attribute to a meaningful face.

Whatever faces could have meant before the invention of the cinema, now they mean something else, something more: they mean *everything*. Film studies theory was the first space in which psychoanalysis informed our thinking about the face. These accounts stressed stages of the human psyche before the Oedipus complex. In Lacan's mirror stage the pre-Oedipal infant gains a (premature) sense of self by looking at itself in the mirror. Kleinian and other theorists of the pre-Oedipal describe the mother's gaze upon the infant as nurturing, giving emotions and affect not yet structured by the symbolic order. In Christian Metz's and others' film theories, the face on the screen is both mirror and mother: the cinematic encounter allows a return of the gaze much like the gaze of the mother upon the infant, returning something to us that our adulthood may have robbed from us. *Mutatis mutandis*, the larger-than-life faces of our icons do that too. As we see them, they seem to be seeing us, to be bringing us into their often quite public world. When the dyadic relationship between that face and our gaze is structured in this way, the premature sense of identity between us and the face on the screen or in the photograph can also generate a demand: you, too, must be like Che, outwit the gringos the way Pancho Villa did, love Perón as Evita loved him.[11]

But of course, icons often circulate beyond their original communities, and we use them not just to help identify with a communal self but to identify a communal, possibly exotic other: now we know what Brazil is, because we've seen Carmen Miranda perform; now we know what the new cosmopolitan Mexican is, because we follow Salma or Gael. The fan magazines in Mexico or Perú emphasize that although the star has gone Hollywood, she is still just like you; the fan magazines in Minnesota or Pittsburgh emphasize that although the star lives in New York, she is still authentically other. In the latter case, the otherness of the face is guaranteed, authenticated, by paratexts, often nowadays DVD featurettes or interviews with the directors or actors. As is the case with fashion, where the supposedly secondary discourse of the captions and the articles accompanying the photos actually create the system it is supposedly commenting upon, the authors of our anthology often locate the ideology in the texts *about* the faces that the system brings us, not in the faces themselves.

The author of *The Fashion System* was Roland Barthes. The most committed Barthesian of our authors, Beatriz Sarlo, is a full generation older than the others we have anthologized, and she shares with the recently deceased Mexican cultural critic Carlos Monsiváis the status of founders of two uniquely national critical discourses on national iconology. Their tones differ, to be sure, but both can trace part of their lineage to the early Barthes. Especially in her recent collections of criticism on postmodernism, Sarlo often speaks of neoliberal culture with the scorn of the Barthes who, in his 1957 introduction to *Mythologies*, could say, "What I claim is to

live the full contradiction of the time, which could well make sarcasm the condition of truth" (1972, 12). In her reading of Eva Perón, Sarlo herself interrogates her own feelings toward Evita, insofar as she herself is a representative member of her generation. Likewise, when examining the tension in photographs of Evita's face between the merely beautiful (Eva the actress) and the sublime (Eva the passionate politician fighting death), Sarlo chooses to compare Eva's face to the faces of two of the twentieth century's most celebrated actresses, Audrey Hepburn and Greta Garbo, precisely the two actresses cited by Barthes in his *Mythologies* essay "The Face of Garbo."

Yet sarcasm does not prevent Barthes from at times adopting the tone of a fan or enthusiast, a tone that informs the exuberant scenes of semiosis in his essay on wrestling that opens the collection *Mythologies*. Carlos Monsiváis is himself no stranger to sarcasm, but his many essays on popular culture find a similar delicate balance between idolatry and rigorous sociocultural critique. Closer to Monsivías in approaching their respective icon(s), most of the essays in this volume adopt an attitude that teeters between respect or admiration for the accomplishments of the celebrity and the knowing suspicion of the natural-born iconoclast present in every critic. Perhaps fittingly, the essay which best plays with the extremes of sarcastic criticism and abject idolatry is Mexican Juan Villoro's treatment of Argentina's soccer god, Maradona.

Sarlo is not alone in this anthology in trying to place the icon she studies in relation to other famous faces (chapters of her book not excerpted here include detailed comparisons between Eva's style of beauty and that of more successful Argentine movie stars, such as Libertad Lamarque). The face as sign works like other signs. Many of our iconologues have decided that the figure they have chosen to study is most legible when read in comparison with other figures, establishing the sort of minimal pairs and binary oppositions from the structuralism of Barthes's era. Not just astronomy but astrology: the star takes its meaning not in itself alone but in its position in a field of stars.

Identifying the face with the self is the first possibility; identifying the face as a desirable exotic other (or a demonizable exotic other) is the second. Many of the cultural historians included in this volume are especially interested in the latter. But these two positions do not exclusively exhaust the possibilities for icon-gazing. If one needed still another reason to privilege Frida Kahlo as an icon—an icon of iconicity, so to speak—it would be that the ferocious, pained face that stares out of so many of her canvases (not necessarily all of them to the same degree) prevents us from remaining comfortably in either of these positions. The viewer feels uncomfortable identifying with Frida, but cannot look comfortably upon Frida as a (desirable or stereotyped) Other, because her own gaze interferes with ours. Many of Frida's self-portraits are without flirtatiousness or self-pity because they enact a gaze that looks at itself in a dyad that seems to exclude the spectator altogether.

Still, some people do strongly identify with the face of Frida—but they have more material to work with than just her constantly reproduced face. As Margaret Lindauer points out in the essay excerpted in this collection, some acolytes of Frida identify not just with the defiance of her gaze (to the point of dressing like her for look-alike contests), but also with the tortured life story, the constant pain, the awkward mix of extravagant marital fidelity and bisexual romance. Even in the era of the image, sometimes a face is insufficient without a story.

## My Brilliant Career: Iconic Narrations

A fetish is a story in the form of an object.

Marjorie Garber, *Vested Interests*

Since most—although not all—of our contributors are cultural critics trained predominantly in literary studies, and since we have included a playful literary exposé on Maradona from the novelist Juan Villoro, it is perhaps not surprising that the faces and images in this collection come with narratives attached to them. But we venture to say that this phenomenon is actually relatively common in the transactions between icons and their venerators.

The ambiguity of visual images needs to be managed. In Latin America, where the mendicant friars tried to preach the gospel to indigenous peoples who did not yet speak Spanish, the awareness that a master discourse is necessary in order to prevent misunderstandings, even heresy, produced many hybrid texts in the colonial era, with pictures addressed to the Indians and with accompanying suggestions of how to use these images addressed to the friars doing the preaching.[12] (Conversely and, perhaps, more naively, Guaman Poma de Ayala in colonial Perú supplemented his six-hundred-page letter to the King of Spain with four hundred pages of illustrations, fearing that his imperfect Spanish would not convey his ideas fully; many of those illustrations today seem more enigmatic and multivalent than the denunciations of bad government and praise of Incan kings that they were supposed to illustrate.)[13] Indeed, without proper doctrinal management, the statues of the saints in the temples of the Caribbean baroque churches became associated with the various divinities of santería and other Afro-Caribbean cults. The freest of the icons presented in this book, that of Che Guevara's photograph, is not only liberated from ownership and copyright because Cuba's government did not sign the requisite treaties, but is also free to circulate in the imagination because the tragic ending of the story—with its own accompanying photograph of the cadaver on a table in a Bolivian army barracks—fits so badly with the look of the iconic *guerrillero* that it is hard to unite them in a single story. With all his different cults preferring to identify as rebels or nonconformists or Cubans or idealists rather than as martyrs, various parts of Che's own life are detached from the image in circulation.

But for many of the other authors of this anthology, the image evokes a story, a history. The story of Joaquín Murrieta or of Lola Casanova supersedes any single image of them; indeed, there is no authentic image of Murrieta, for instance. Vélez, Dolores Del Río, Carmen Miranda, and the cinematic representative of the Argentine middle classes, Norma Aleandro, all had careers long enough for their own biographies to be a story worth telling: to know who these women are and have been is to know the history of some segment of Latin American history and culture and to know some significant detail about the awkward relationship between Latin America and Hollywood, or the resignification of diva worship in gay camp, or the vulnerability of the middle classes to the periodic shocks of Argentine political and economic history.

An icon in a particularly conflictive moment of history (or, as McKee Irwin argues here, from a region with a perpetually conflictive history) generates multiple and contradictory histories. All anti-Peronists knew what to think of Eva, just as

all Peronists of a certain age knew what they thought of her, and younger Peronists thought something quite different about her altogether. A careful analysis of the history of the treatment of these images and their reception can help explain the history of the nation: quoting texts such as J. J. Sebreli's, which served for the basis of such treatments as Julie Taylor's *Eva Perón: The Myths of a Woman*, Beatriz Sarlo narrates how what older Peronists thought of Evita (*la santa peronista*) modulated into what a post-Cuban-Revolution generation of Peronists saw in her (*Evita revolucionaria*).

The most reliable unit of narrative in a cinematic age is the biopic (the theory of the novel in its Hegelian mode, whether Lukács, Bakhtin, or Benjamin, frequently reduces all the possible plots of a novel into the life of a single male protagonist: Odysseus/Apuleius/Dante/Don Quixote/Tom Jones/Pip/Julien Sorel). The biopic is transportable across local and even national cultures; Evita, Frida, and Che (the latter first by Walter Salles and then by Steven Soderbergh) have all recently been given this deluxe treatment. In these works we can see at play one of the distinctive characteristics of Latin American narratives in a global theater, one that also applies to our icons: Latin American icons engage with a tradition of melodrama that thrives at home but is also crucial to the success of Latin American cultural products abroad. If the streamlining of an image to allow its mass reproduction is characteristic of the icon, and if the icon is supposed to be used to channel strong emotions in large groups of people, then there is a natural linkage between the icon and melodrama.[14] And if there is a propensity to expect all Latin culture to tell its own story in melodramatic terms, then a Latin American icon and the story it accompanies will circulate faster and more grandly than anything associated with other cultures, if the global cultural distribution systems choose to take it up. One breaks this presumption of Latin American melodrama and iconicity at one's own peril: while Latin American Nature (the pampas, mountains, Machu Picchu, the Amazon) and high idealism satisfyingly frame Gael García Bernal's face as the young Che in *The Motorcycle Diaries*, Steven Soderbergh received acclaim but little box office revenue for producing *Che*, the anti-Romantic, anti-melodramatic double-biopic of Che Guevara's guerrilla success and failure.

As long as Latin America is associated in the global atmosphere with a culture of extremes, especially the extremes of gender (including the extreme androgyny of a bisexual like Frida and a boyish Lupe Vélez), then the global circulation of identifications, exoticisms, and melodrama can always be induced to tilt in favor of Latin America. If there are indications that certain behaviors from the South are beginning to replicate themselves in the North—spontaneous funeral tributes to Princess Diana; electing to state and national office figures better known for being actors, or bodybuilders—, then it becomes all the more imperative for Latin American scholars to present to each other and to a general public some of the ways that the Latin American melodramatic imagination has used faces and bodies to anchor stories that stoke passionate attachments, both positive and negative.

## Case Studies in Latin American Iconicity: Local Icons, National Histories, Transnational Narratives of Fame

From various degrees of critical distance, the twelve essays included in this volume examine some of these faces and the stories of passionate attachments they elicit

at different times and from different audiences. As should be clear from our table of contents, our volume does not claim to be an exhaustive or encyclopedic review of famous Latin Americans; neither are we interested in distilling an "essential" Latin American iconic quality from the studies that follow.[15] The case studies examined in these essays analyze a variety of national, transnational and global icons from various parts of Latin America while reflecting on the diverse, often contradictory, cultural meanings that these figures accrued during their lifetime and, in many cases, continue to accrue long after their death. As we indicated when first approaching possible collaborators to this volume, what motivated us in the first place was realizing that despite the biopics, biographies, and fictionalized histories inspired by some of Latin America's best known famous political and military figures or celebrities from the entertainment and sports worlds, there was a real need for a volume that integrated the study of Latin American icons with the historical and cultural circumstances that made their rise to iconic fame possible. Additionally, we were particularly interested in compiling a selection of essays that made use of contemporary cultural studies theory to examine the phenomenon of iconicity in the context of rising cultural, popular, and political trends, both regional and transnational. Icons require an interpretive community, and some of the essays in this volume discuss at length the conflicts that arise among different interpretive communities with relation to the icon in question. As noted above, often the disagreements play out across national borders (as in the case of Mexican vs. US films on Pancho Villa, or Mexican vs. US popular novels depicting Joaquín Murrieta and Lola Casanova). But just as often the conflict is local and no less explosive for being so contained (as in the case of Argentine's love-hate relationship with Evita or Brazilians' divided reactions toward the caricaturesque Hollywood version of their Carmen Miranda). At other times it is the same fans who turn against their soccer icon only to embrace him in his next resurrection or makeover.

The essays that follow could have been ordered in any number of ways, and readers are welcome to experiment with different combinations. We are confident that the present organization invites useful comparisons and provocative contrasts: Part I of the volume, titled "Rebels, Revolutionaries and Border Bandits," focuses on figures whose iconic stature is inseparable from the political events in which they participated, unleashed, or help to shape. In "Pancho Villa: Icon of Insurgency," Brian Gollnick reminds us that Pancho Villa is, indisputably, the world's most famous Mexican, but also one of the most controversial of political Latin American icons. Everyone seems to know the identity of the mustachioed, unkempt figure on horseback, but few gathered in any one place are likely to agree on what he stands for or what his legacy means. As a revolutionary without a clearly stated political agenda, explains Gollnick, Villa can be demonized as a reactionary and a blood-hungry brute or celebrated as a rebel driven to extremes for the sake of his peasant soldiers. Unlike Zapata, who was and continues to be immediately identified with land redistribution, Villa's apparent unwillingness or inability to articulate an ideology in the form of a slogan has left his instantly recognizable image open to widely diverse interpretations. Focusing on three of Villa's most iconic images as a starting point for examining the extreme but mixed reception Pancho Villa elicits throughout the twentieth century, Gollnick reflects on Villa's place in Mexican politics, Mexican literature, and Mexican and US film. As Gollnick amply

demonstrates, Mexican writers and filmmakers on both sides of the border have taken up this challenge with gusto. Drawing on Max Parra's and Friedrich Katz's histories of Villa and influenced by Carlos Monsiváis's theorization of historical icons, Gollnick first traces many of Villa's best known reincarnations on the pages of Mexican literature, then reviews Pancho Villa's characterization in well-known Mexican and US films centered on the figure of Villa as a soldier, a rebel, a villain, or a hero, depending on the director's or the producers' politics. Gollnick ends his essay with a brief discussion of the importance of Pancho Villa in US-Latino culture by focusing on the mediating role of Villa's figure—or of his talking, severed head, at any rate—in an important early play of the *Teatro Campesino* movement in the Southwestern United States.

In "Eva Perón: Excerpts from *The Passion and the Exception*," Beatriz Sarlo, Latin America's best known living cultural critic and public intellectual, examines the construction and self-remodeling of Eva Duarte de Perón as a political figure after her limited success as a popular celebrity in the Argentine film industry of the 1930s and 1940s. In the selections translated exclusively for this volume and previously unavailable in English, Sarlo complicates Kantorowicz's theory of "the King's two bodies" from medieval and Renaissance theology in order to reflect on Evita's body as the incarnation of the Peronist state. Sarlo argues that, despite his populist appeal, Perón himself lacked the abstract legal or theological status to legitimize his regime's radical reforms. What it had instead was the body of Eva and her passionate mediation between the leader and his "shirtless" masses. When Eva's body began to show signs of cancer, its pallor and thinness rendered it temporarily sublime. Only when Eva's body succumbed altogether to the disease could the legitimacy of the Perón regime be called into question, as indeed it was. The excerpt ends with Sarlo's reading of "The Simulacrum," Borges's ambivalent thoughts about the hollowness at the center of Perón and Eva's exceptionality, a hollowness that does not prevent political passions; indeed, Sarlo suggests, it inflames them still more.

J. P. Spicer-Escalante's "From Korda's *Guerrillero Heroico* to Global Brand: Ernesto 'Che' Guevara" traces the transformation of the Argentine physician turned revolutionary into a transnational, multimedia cultural icon. This transformation, argues the author, is due almost entirely to the influence of a single photograph by Alberto Korda. Widely considered to be the world's most recognizable photograph, the image of a youthful, bearded, bereted Che has become the most iconic representation of Guevara. It has circled the globe many times over, immortalizing the Argentine-born, Cuban-national and revolutionary *comandante* as an ever-young, virile, unkempt rebel. Yet, as Spicer-Escalante carefully documents the story, the photo's fame also has had the effect of progressively distancing the historical figure from his original political cause. The more widely Che's iconic image became distributed, the more uprooted the image became from the revolutionary ideology that set the subject of the photograph on his path to fame in the first place. Anchoring parts of his reading of this iconic image on Robert Hariman's and John Lucaites's theories of iconic images as discussed in *No Caption Needed: Iconic Photographs, Popular Culture and Liberal Democracy*, Spicer-Escalante reflects on the Cuban state's strategic resurrection of the Argentine hero-rebel in the economically-distressed Cuba of the 1990s, speculating that this was a calculated move on the part of Castro's political machine to draw attention away from Cuba's economic

troubles. After tracing the history of the famous Korda photo to the present day, Spicer-Escalante concludes that Che's continued and present global appeal can be attributed to the way in which his iconic image has been made into a protean signifier whose relevance is culturally determined yet dynamic enough to serve multiple causes in diverse historical and cultural scenarios.

One of the recurrent themes in this volume's analyses of iconicity revolves around the role of the Mexico-US border in defining and complicating the reception of the icon as hero or anti-hero, savior or villain. Robert McKee Irwin theorizes the importance of the US-Mexico border in geographic, historical, and ethnic terms as he argues for an iconicity of the "contact zone." In "Joaquín Murrieta and Lola Casanova: Icons of the Contact Zone," McKee Irwin insists that the Murrieta known to Anglo-Americans as a savage Mexican invader has little in common with the Murrieta known to Mexican Americans as the heroic defender of Mexicans in the face of Yankee racism. In the case of Joaquín Murrieta and Lola Casanova, says Irwin, their fame is inseparable from the slippery, border-zone gender ambiguity of cross-cultural perceptions. Furthermore, argues Irwin, both images differ from the Murrieta circulating in northern Mexico (an embarrassing case of a Mexican criminal) or the Murrieta re-territorialized in Chile by Pablo Neruda (a Latin American hero struggling against Yankee imperialism). Likewise, the Lola Casanova of Seri Indian legend—a Creole woman who fell in love with and preferred to live among Indians—is not the same Lola Casanova known among non-indigenous Sonorans as a Creole beauty tragically kidnapped by savage Indians, nor is the latter the Lola Casanova who briefly became a national symbol in Mexico as a catalyst for indigenous assimilation to Mexican national culture. In the conflictual "multicultural" context of the contact zone that is the US-Mexico borderlands, Irwin argues, iconic figures such as the controversial bandit Joaquín Murrieta and the contested Creole Lola Casanova assume palimpsestic qualities. Just as their legends were constructed according to the necessities mandated by differing cultural contexts but marked by the contact points of those bordering zones, the figures themselves often assumed distinct characteristics that were often at odds with traits assigned to them in other cultural contexts within the same region.

The next and most extensive section of this volume, "Golden Era Icons at Home and in Hollywood," examines some of the biggest names in Latin American cinema and entertainment as well as one of Latin America's most famous real-life playboys from the 1920s to the early 1960s. Many of the essays in this section theorize the complicated ways in which new technologies, growing national film industries in Argentina and Mexico, and new conceptions of cosmopolitanism influenced, changed, and amplified the potential for the minting of national icons and their transformation into international celebrities. In "Tango International: Carlos Gardel and the Breaking of Sound Barriers," Rielle Navitski argues that Carlos Gardel's pioneering performances of the emotionally charged tango in the early part of the twentieth century and the almost overnight fame that followed are inextricably tied to the development of new sound and film technologies as well as to the mass-market distribution of cultural commodities. According to Navitski, the availability of affordable phonographs and records, the rise of radio broadcasting, and the transition to sound film or "talking pictures" would give tango culture

a pivotal place in the development of the Argentine film industry, which took advantage of sound film's capacity to record the performances of popular musical artists. As tango's most authentic and identifiable voice, Gardel and his growing popularity drew the attention of Hollywood, and the singer would soon be seduced by US-owned Paramount Pictures for English-language musicals, as part of Hollywood's efforts to minimize the language barrier newly erected by talking pictures. In turn, Argentine producers and national film audiences would re-appropriate the Hollywood musical into the very popular genre of the tango film. The multinational contracts and the immense popularity of film musicals would all contribute to Gardel's superstar status and his lasting myth.

Kristy Rawson's "Lupe Vélez Before Hollywood: Mexico's First Iconic 'Modern Girl'" examines the early career of singer-actress Lupe Vélez, who began her professional career as a popular entertainer in Mexico before making a name for herself in Hollywood in the Roaring Twenties. Referencing weekly supplements from Mexico's major newspaper *El Universal Ilustrado* in order to rescue a history that has been mostly forgotten, Rawson's essay tells the story of Vélez's beginnings as a self-taught singer, dancer, and impersonator in Mexico's popular *revista*, or "revue" theater. Vélez's early stardom and the first iconic images that were circulated of her build on the popularity of imported French burlesque cabaret (known as the "Ba-ta-clán") and her successful comic-parodic performances of the genre. In fact, contends Rawson, the success of the Mexican variants of Ba-ta-clán was for a time credited to Vélez's success on stage. An important part of Rawson's essay resides in arguing that Vélez's wiry, "boyish" body, her capacity for irreverent parody, and her modern flapper persona served to challenge normative gender roles in postrevolutionary Mexico both on and off the stage.

In her essay "From Hollywood and Back: Dolores Del Rio: A Trans(National) Star," Ana López chronicles Dolores Del Río's long career from her days as a siren and sex symbol of silent films to her own limitations as an actress and her difficulties in early Hollywood sound films. According to the author, Del Río's unashamed, overt sexuality and her reluctance to become Latin kitsch (à la Carmen Miranda) in the Hollywood of the 1930s and early 1940s accounts for her fall from grace with the big Hollywood studios. In the second part of her essay, López follows Del Río back to Mexico and details the star's transformation from hollow sex symbol to the face of authentic Mexico (especially in her collaboration with "El Indio" Fernández in films like *Flor Silvestre* and *María Candelaria*). By the end of Del Río's life and career, writes López, the star had become an object of near-religious adoration, an icon for artists' altars not dissimilar to those Del Río collected throughout her life.

Referencing Langston Hughes's astute study of mixed-race Dominican playboy Porfirio Rubirosa, Lizabeth Paravisini-Gebert and Eva Woods Peiró explore the sources of Rubirosa's fame and sexual exploits by analyzing the potent combination of Rubirosa's mulatto heritage along with his "Latin" sexual prowess and his identification with the new icons of upper-class mobility (jet airplanes, race cars). In "Porfirio Rubirosa: Masculinity, Race, and the Jet-Setting Latin Male," the authors describe Rubirosa as the 1950s Latin lover par excellence, an international symbol of hyper-masculinity whose amorous exploits involving wealthy and famous women made him the stuff of legend. An ambassador for the Trujillo

regime and, for a time, married to one of General Trujillo's daughters, Rubirosa soon made a career of marrying some of the wealthiest socialites of the day (after divorcing Trujillo's daughter, he married first Doris Duke and then Barbara Hutton —or rather, the Duke and Hutton fortunes). In between, he made news and won the admiration of other powerful men of the day by seducing some of Hollywood's most notorious sex symbols; among them Zsa Zsa Gabor, Rita Hayworth, and Kim Novak. As Paravisini-Gebert and Woods Peiró argue, the mystique of the sexual prowess credited to the darker races, or to Latin males of mixed heritage, coupled with Rubirosa's cosmopolitan and debonair demeanor may explain what made him seemingly irresistible, ensuring his iconic popularity not only with the women he seduced but with the powerful men who wished they could be him, or at least possess his legendary sexual organ.

David William Foster's "Carmen Miranda as Cultural Icon" takes up the iconic figure of Carmen Miranda (1909–1955), Brazil's most famous performance personality. Foster notes that although Brazilians today are proud of their midcentury singer-actress, Miranda was harshly criticized during her life for portraying a kitschy and falsified image of Brazilian culture; of particular concern was her enactment, as a woman of European origins, of aspects of Afro-Brazilian women. The essay focuses principally on Helena Solberg's documentary film, *Bananas Is My Business* (1994), and the director's first-person narrative exploration of the contradictory aspects of Miranda's artistic persona. For Solberg, Miranda's US career, in which she played an all-purpose Latin American female sexpot, denied her the opportunity to evolve into a powerful Brazilian icon. The decline of her health and her early death are reflections of the dark side of US commercial interest in Latin American culture. Foster's analysis of the film, alongside his interpretation of Miranda's career, offers a nuanced, complex study of an icon's transcultural experience with fame and the misfortunes that followed.

The essays in the next section, "Contemporary Icons: National Stars, Global Superstars and Aging Soccer Gods," examine present-day Latin American celebrities in relation to changing images of the nation and against the emergence of the transnational and increasingly postnational, or global, Latin America. In "The Face of a Nation: Norma Aleandro as Argentina's Post-Dictatorial, Middle-Class Icon," Janis Breckenridge and Bécquer Medak-Seguín explore the iconography of Norma Aleandro as the face of Argentina's post-dictatorial, bourgeois society. After surveying Aleandro's acclaimed performances as a middle-class woman in numerous box office successes, the authors set out to study the nature of Aleandro's rising stardom through an in-depth analysis of three particularly salient works: *La historia oficial* (*The Official Story*, 1984), *Cama adentro* (*Live-In Maid*, 2004), and *Andrés no quiere dormir la siesta* (*Andrés Doesn't Want to Take a Nap*, 2009). Each of these films remains critical of the dictatorship and its legacy by casting the national crisis within strained and precipitous (if not overtly calamitous) familial frameworks. At the same time, all three films uniquely approach middle-class domestic space in which the claustrophobic, private arena becomes a battleground for maintaining appearances and stability. *La historia oficial* situates issues of national transition in the bourgeois household, as the protagonist struggles to come to terms with her unwitting complicity in the violent legacy of her country. *Cama adentro* uses domestic space as an allegory for national crisis, directing its critical lens at the

2001 economic collapse. Widely considered the direct result of the regime's neo-liberal policies, the economic disaster threatens the very existence of the middle class. Set in 1977, *Andrés* levels a direct critique of the military regime, focusing on a matriarch who struggles to protect family security amidst extreme military repression. Considered together, these three films constitute a diverse yet representative body of Norma Aleandro's work that has established her face as an icon of the post-dictatorial, middle-class Argentine woman.

In "The Neoliberal Stars: Salma Hayek, Gael García Bernal, and the Post-Mexican Film Icon," Ignacio Sánchez Prado begins by noting that for most of the twentieth century, Mexican film operated as a peculiar kind of machine of subjectivization, promoting a constant production of icons and stars that in turn reflected different modes of the cultural self. From the many characters played by Pedro Infante, to the popular identity of Cantinflas, to the middle-class counterculture of Enrique Guzmán and Angélica María, Mexican film targeted national audiences in their attempts to construct social and mediatized identities. The advent of neoliberalism, the essay argues, results in the production of a new kind of Mexican film icon. Best represented by Salma Hayek and Gael García Bernal, this new kind of icon no longer represents a version of the Mexican self. Rather, it constructs an image for the consumption of a multi-tiered global audience, operational in venues such as film festivals and American multiplexes. By reading the transnational circulation of Salma Hayek and Gael García Bernal and their reinventions before different target audiences, the author measures the ideological consequences of their iconic transformations.

Unlike the other essays in this volume, the next essay, "Diego Armando Maradona: Life, Death, and Resurrection (with One Act to Follow)," by Mexican novelist and journalist Juan Villoro, is a ribald journey and a masterpiece of sports coverage rather than a theoretical analysis. Villoro, who won the Herralde Prize for fiction in 2004, uses his novelistic gifts to trace the various lives of Diego Armando Maradona, an icon whose followers are legion. Villoro marvels at Maradona's idiosyncratic charisma and the soccer star's ability to keep remaking himself despite predictions to the contrary (and at least one brush with death by substance abuse). Noting that Maradona has been a magnet for both the light and the dark sides of soccer, the essay outlines Maradona's sports triumphs and public relations failures while discussing Maradona's very public private flaws. Additionally, the essay discusses the wild passions that Maradona elicits in his fans, passions wild enough to have resulted in a "Maradoniana" religious cult in his native Argentina (one that now counts thousands of global faithful through the Internet). Irreverent but as obsessed as all sports fans are, Villoro convinces us that Maradona's ultimately winning combination of huge personal flaws and megawatt-style expressions of regret, and his ability to remake himself, is what has kept soccer's favorite flawed hero in an iconic status for over three decades.

In the final section of this volume, "The Afterlife of Fame: Consuming Iconicity," Margaret Lindauer traces the posthumous iconic career of Mexico's (and perhaps the twentieth century's) most famous woman artist. Her essay "Fetishizing Frida" sets out to show that many of those invested in preserving Frida's posthumous reputation seek to distance her paintings from the politics or history that gave rise to them in order to turn the artist into a sort of secular goddess of pain

and narcissism, incapable of agency as she is trapped in her grand love for her husband and her own wounded body. This dehistoricized, canonized, yet passive image of Frida, which saturates popular—and many scholarly—interpretations of Kahlo and her paintings, is perpetuated in the artist's 1990s popularity in the United States, a phenomenon variously referred to as Fridamania, Fridolatry, Fridaphilia, and Frida fever. Just as some interpretations of Kahlo's paintings inscribe patriarchal prescription while others note the subversive potential of her work, some aspects of "Fridamania" accommodate while others resist masculinist reduction of the individual, Frida Kahlo, to the category "woman." A careful reading of a painting such as *Self-Portrait as a Tehuana* can show us how to dislodge the artist's current "cult" status from patriarchal prescription to, instead, fortify feminist resistance.

As we edited the essays that would eventually comprise the volume, it became clear that one of our volume's most valuable contributions to the study of Latin American icons would be the historical and political contextualization the essays provide in the study of particular figures. Although all of the essays make clear the original location of the star's rise to fame, many of the narratives that follow the iconic journey show the way in which iconic meaning is mediated, appropriated and re-contextualized sometimes by the celebrity's decision to seek fame internationally (generally in Hollywood), sometimes by circumstances entirely beyond the iconic individual's control (as in the runaway fame of Che's Korda photo).[16] Each of the essays stands firmly on its own as a particular study of an iconic Latin American; yet taken together, they provide important intertextual and contextual reflections on the processes of historical, cultural, and aesthetic translation, mediation, and renegotiation that goes into the making, sustaining, and sometimes destroying of icons.

## Notes

1. The main lines of the story of the intertwining of theology and art history in the icon can be found in Cormack (2007), Zibawi (1993), and Evdokimov (1990).
2. In the case of Che Guevara and Frida Kahlo, there are also collections devoted just to photographs of them: see García and Sola for Che, and *Frida Kahlo: Photographs* (Wolf 2010) for Frida. J. J. Sebreli, whose 1966 book on Eva Perón (*Eva Peron: ¿aventurera o militante?*) is of historic importance in creating an image of Eva for younger Peronist leftists, has studied four of our Argentine icons or "mitos" from an iconoclastic perspective: Gardel, Evita, Che, and Maradona (Sebreli 2008).
3. Rodriguez (1994) does, for the Virgin of Guadalupe among Mexican American women, the sort of interviews in the context of popular piety that other cultural anthropologists do for examining the meaning of celebrities and secular icons.
4. Unsurprisingly, perhaps, queer theory has found it useful to examine the private meanings, or cult and clandestine meanings, of cultural icons either currently in fashion or now out of date: see Rawson in this anthology, briefly, for that element in the Mexican career of Lupe Vélez, who figured posthumously as a gay icon for the Warhol crowd. The bibliography on queer fandom, especially camp, is now quite large; it begins with Sontag (1966), Ross (1989), and Sedgwick (1990). One of the pioneers of analyzing Latin American spectatorship and fandom is Carlos Monsiváis (1988a and 1988b; Monsiváis and Bonfil, 1994; as well as many pieces anthologized in English in 1997), who adopted queer theory in the 1990s. For excel-

lent examples of theorizing queer icons and spectatorship in the Latin American context, see Fiol-Matta on Gabriela Mistral (2002) and the Puerto Rican New Wave singer Lucecita (2011), and José Quiroga on Ricky Martin and Olga Guillot (2000).

5.  P. David Marshall's eight-hundred-page tome *The Celebrity Culture Reader* (2006) tries to define and consolidate cultural studies as a field, as did Simon During's five-hundred-page *The Cultural Studies Reader* ([1993] 2007) before it. As for Latin American cultural studies and its tomes, see note 6.

6.  By "national-popular" we refer to the various nationalist projects we associate with the twentieth century (nationalist projects in Latin America of the eighteenth and nineteenth century seldom approached the people as masses), from the Mexican Revolution to the autocratic populisms of Getúlio Vargas in Brazil and the Peróns in Argentina to the various leftist projects in the wake of the Cuban Revolution, although some of the latter were internationalist rather than nationalist in focus. Some of the important books on Latin American popular culture of the last twenty years, such as Rowe and Schelling (1991), still evince a Frankfurt-School-like distrust of mass culture *tout court*, but most follow along the lines of the British Cultural Studies School. It may be impolite to presume that we must use European labels to describe these two approaches: *The Latin American Cultural Studies Reader* (Del Sarto, Ríos, and Trigo 2004) makes an interesting comparison to the previously cited tomes in focusing much more on theoretical interventions from Latin America itself, although it therefore dedicates much less space to case studies. The Mexican Revolution's cultural policy in the 1930s and the success of the Mexican film industry in the 1940s and 1950s (buoyed by FDR's Good Neighbor Policy) makes the study of Mexican popular culture a particularly rich vein for historians who love case studies: see in particular Joseph et al. (2001) and Hershfield (2008). We are grateful to one of our anonymous readers for reminding us of the influence of FDR's Good Neighbor Policy in facilitating the phenomenon of crossover celebrity. As our contributors argue, however, Hollywood entailed a new set of disadvantages for many of these celebrities.

7.  Berg (2002) and Beltrán (2009) both take that tone. Many of the essays in Gaspar de Alba's anthology *Velvet Barrios* (2003) manage to sidestep the need to speak as partisans, in part because they focus not on Latino/as in the "US eyes" of Hollywood (Beltrán) but on the meanings within various Chicano/a subcultural communities.

8.  Although the only examples we have in the anthology are Gardel and Carmen Miranda, both of whom expanded their personas in the movies, the much larger field of Latin musical icons would have room for the connections forged between the Caribbean and Mexico, finally reaching the United States in the 1950s; the singers of the various *canción nueva* movements of the 1960s, often political activists; and the larger-than-life faces of the contemporary music scenes, often based in Miami or Los Angeles rather than in Latin America proper.

9.  Like the political icons anthologized here, Menchú attracted her share of controversy, as has been amply studied and documented in Gugelberger (1996), Stoll (1999), Beverley (2004), and Arias (2001).

10.  The full story of the technology of Latin America's political celebrities naturally includes Marcos's e-mailed communiqués from the Lacandón Forest.

11.  An efficient and not unsympathetic summary of the ambivalent use of a series of psychoanalytic theoretical tools for feminist film theory, including the Lacan, Klein, and Metz summarized above, is in Stacey 255–59 of Marshall (2006).

   Critiquing the coerciveness of the demand made by the face is part of the generally anarchist poetics of Deleuze and Guattari (see the section on "The Face" in *A Thousand Plateaus* [1980] 1987); for a queer Latino rejection of a claim on identity made in response to a failed interpellation, see Muñoz's *Disidentifications* (1999).

12.  The original title in French of Gruzinski (1993), "La colonisation de l'imaginaire," gives a good idea of the importance of this theme to colonial art historians.

13.  For an extensive discussion of this story, see Rolena Adorno's book on Poma de Ayala (2000).

14.  Of course, this term is both crucial and contested in theater and especially film theory. For its potential use in theater and literary studies, see Brooks (1995), especially the first chapter. For a good introduction to the debate within film theory as to the scope of the term, which focuses on the history of treating it as a pejorative term to describe "women's pictures" and "weepies," see Mercer and Shingler (2004). For an anthology focused explicitly on Latin America melodrama, see Sadler (2009).

15.  A more biographically oriented introduction to Latin American icons is Inger Enkvist's *Iconos latinoamericanos* (2008). *Latina Icons: Iconos femeninos Latinos e Hispanoamericanos* (2006), edited by María Claudia André, covers a wide collection of essays on Latin American iconic women—real, religious, and fictional—and examines the sources of their iconic power. As will be noted, while some of the icons studied in these essays are immediately and almost universally recognizable by a reader familiar with popular culture, others (Lola Casanova, Porfirio Rubirosa, Lupe Vélez, Norma Aleandro) either have a more limited iconic radius of influence or surface from time to time in relation to specific cultural or political events. Yet each of the essays provides an important and distinctive window into the study of iconicity, celebrity, and cultural discourses.

16.  In recent years substantial scholarly work has been done on the phenomenon of crossover celebrities and, in particular, on Hollywood's appropriation of Latino and Latina artists. With rare exceptions, these studies focus on US-born or Puerto Rican celebrities in Hollywood-produced films or music. In particular, the excellent studies of Latino/a celebrities in Hollywood by Angharad Valdivia (2000), Isabel Molina-Guzmán (2010), Camila Fojas (2008), Alicia Arrizon (1999), Arlene Dávila, and Priscilla Peña Ovalle (2006) (among others) place special emphasis on the appropriation and transformation of Latino/a bodies by the mainstream media. Much of this research revolves around the relationship between Latino/a celebrities in Hollywood, race, ethnicity, and gender. As some of these scholars note, the phenomenon of crossover celebrity dates back to the 1920s. Several of our essays reflect on Hollywood's and US audiences' relationship to Latin American celebrities at various points during the twentieth and twenty-first centuries.

# Rebels, Revolutionaries, and Border Bandits

# Pancho Villa
## Icon of Insurgency

*Brian Gollnick*

Accord to urban legend, Pancho Villa's skull is among the unholy relics held by the ultra-exclusive Skull and Bones society at Yale University. Their other cranial captives of renown supposedly include US president Martin Van Buren and Native American leader Geronimo. There is almost no chance that any remains of a Mexican Revolutionary general rest in the Bones' storied vault in New Haven, but the tale points to the uniqueness of Pancho Villa's charisma. Even one hundred years after the Mexican Revolution, his name still resonates in the halls of privilege and power that are almost identical to those that Villa fought to destroy.

Pancho Villa is probably the most famous Mexican in history. But celebrity isn't what drives his status as an icon. Villa emerged into the flow of renown at the head of a massive insurgent army, one of the largest in modern Latin American history. In fact, Villa and Augusto Sandino may rank as Spanish America's last genuine warrior-heroes, historical figures whose real military achievements drive their status in contemporary culture. Che Guevara would be the updated version of this iconic type (see J. P. Spicer-Escalante's article in this volume), but Che is a figure of the Cold War and was as famous for being an ideologue as he was for being a military leader. Villa and Sandino are the heroes of an earlier era, and their resonance in the present is thus even more mediated by long traditions of reception and recirculation.

Next to Sandino, Villa has the more enigmatic image. Enigma is, in fact, a commonplace in discussions of Villa as an icon, but the idea of not really knowing what Villa stood for applies most strongly to a specific point of view on his figure. Villa was never assumed openly by a State revolutionary project in the way Sandino was, and so when we say that he is an enigmatic figure, what we really mean is that his relationship to an articulated and institutionalized understanding of what he meant as an historical figure is not so easily codified. The official, State-sanctioned nationalist project in Mexico took up the banner of Villa the revolutionary general only late in its consolidation. Villa's enigma emerges as well from the simple fact that he left no programmatic statement as his political legacy. As no one's official hero and as someone seemingly without a consistent slogan, Villa has

remained available as an emblem of the un-co-opted insurgent spirit. The power his image has gathered from this adaptable (if uncompromising) position has endured far beyond the shelf life of his contemporaries in the revolution. As a result of his marginality to official history and his lack of programmatic self-definition, Villa's status as an icon goes *unquestioned* even as what he stands for has long been *contested*.

## Three Images of Villa

The most iconic image of Villa is best preserved in a photo from Anita Brenner's montage history of the revolution. In the photograph, which dates to around 1914, Villa lurches his mount with almost brutal zeal and turns into the camera. Dust rises behind him like an aura of physical force projected in the way only a horse under an expert rider can. This image is now on the cover of Brenner's book, *The Wind that Swept Mexico* ([1943] 1971). Villa appears from the desert as one with his land, his horse, and his men. He isn't just riding some metaphorical wind. Villa *is* the wind, as surely as the revolution he commanded responded to the geography of northern Mexico and the social system that predominated there at the turn of the century.

There are, however, at least two competing iconic images of the general. The first has Villa sprawled across the ornate presidential chair in Mexico City with an uncomfortable Emiliano Zapata seated next to him. Neither wanted to be president, but Villa is jocular in his unease; Zapata, resentful. Looming at the center of the photo, they incarnate popular sovereignty. Villa's Cheshire-cat smile and

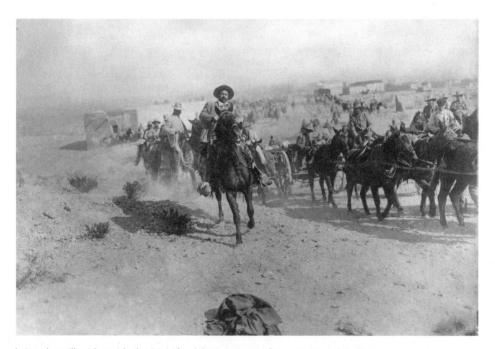

Pancho Villa rides with the División del Norte in northern Mexico, circa 1914. Photographer unknown. © Brown Brothers

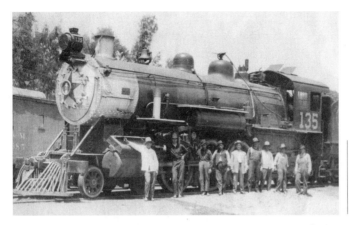

Pancho Villa's personal train. Date unknown. Photo courtesy of the El Paso Public Library, Aultman Collection.

Zapata's sullen scowl do not symbolize the possibility of popular rule. They momentarily occupy the national capital and turn on its head a social system that had always excluded the likes of them and their followers from the exercise of national authority. For both his admirers and detractors, Villa's iconic ability to evoke powerful emotions stems from his achievements as a battle commander and from his ability to displace a ruling elite and, however briefly, place the people in power.

The second iconic image of Villa is a train. There is a photo in the El Paso Public Library of Pancho Villa's train that offers a perfect example. The photo shows a group of men standing alongside a classic steam locomotive. The machine is easily three times the height of the men. Long and black with a star accenting the front end of the boiler, this locomotive is the revolution in all its potential and pride. In Villa's day, a private train was the symbol of access to the best technology, here in the service of a commoner who is commanding an army. Villa's skill with a horse lead to his nickname as the "centaur of the North," a term first meant to stigmatize him as a half-man, half-beast (in the same vein that Zapata was labeled as the "Attila of the South"), although for Villa the insult quickly became a celebration of his skill in the saddle. But it was his command of the rails that took Villa to Mexico City, where he could be photographed next to Zapata.

Able to embody and merge aspects of these three images—the centaur tied to the land, the popular leader and common man sitting uncomfortably in the presidential chair, and the powerful engine pulling a nation toward its future—Villa soon captured the imagination of the poor and the disenfranchised, but his violent, uncompromising, and unsophisticated mannerisms made him suspect to those in power. Today, the name of Pancho Villa resonates as strongly as the ironic gaze of candy skulls, the unnerving self-portraits of Frida Kahlo, the oversized sombreros of mocked-up Mariachis, or the whining polka pulse of *norteña* music, all of it now a commercial, now a genuine condensation of what many consider to be Mexican.

## The Rebel

Villa emerged as a national figure in the chaos that followed the ouster of Porfirio Díaz, the dictator who ruled Mexico from 1876 until 1910.[1] Díaz's regime collapsed

so quickly that the newly elected president, Francisco I. Madero, couldn't develop a military force of his own and was left to govern with Díaz's army largely intact. A coup led by one of Díaz's generals was not long in overthrowing and assassinating Madero. Facing the possibility of a counter-revolution, Villa's troops, the División del Norte or Northern Division, became the indispensable military force that confronted the old regime's remaining military apparatus. Villa and the División del Norte were the hammer that crushed the old military structure in Mexico.

In the process of vanquishing Díaz's army, however, Villa stretched his supply lines and became vulnerable to other revolutionary armies under less radical leaders. Pushed back to his home territory in northern Mexico, Villa's war reverted to a series of brutal guerrilla-style engagements, including the audacious and infamous raid that the general himself led across the border to Columbus, New Mexico, in 1916. The attack on Columbus is usually referred to as the only land attack on the continental United States in the post-Civil War period, which adds an anti-imperialist hue to Villa's iconic legacy. The Columbus raid began as a desperate geopolitical ploy, but it ended up reinvigorating Villa as a folk hero when he humiliated the US army (under John J. Pershing, later US supreme commander in the First World War, namesake to a tank, and a military icon in his own right) in a fruitless, ten-month chase across Villa's home turf. Despite the collapse of the División del Norte, despite retirement, and despite assassination in 1923, Villa's role in the history of the revolution was undeniable, and the importance he had in defeating the ancien régime made Villa's conversion into a cultural icon as inevitable as it was problematic for the postrevolutionary government in Mexico.

The División del Norte's crucial military role made Pancho Villa a difficult figure for the new government to erase from its story of the revolution as a unifying national struggle. The story of the Mexican Revolution cannot be told without Villa, yet his movement left no clear indication of its incorporation into the postrevolutionary regime. The partial and late incorporation of Villa into the dominant histories of the revolution was aided by the long-standing impression that Villa was a military leader without political ideas about how to run the nation.[2] An early and definitive impression of Villa in this regard can be found in the work of Martín Luis Guzmán. The author of a revolution-era memoir entitled *El águila y la serpiente* (*The Eagle and the Serpent*, [1928] 1991), Guzmán was a middle-class intellectual who served briefly as Villa's personal assistant and, as the curator of Villa's archive after the revolution, played a huge role in shaping the general's legacy. Despite personal connections, Guzmán describes Villa as having the soul of a jaguar "whose back we caressed while our hands trembled lest he swipe us with his claw" (50).[3] This is a succinct and representative example of how middle- and upper-class Mexicans saw Villa during and after the revolution: as an animalized figure whose only historical contribution to the new nation was his mastery of physical force; he was a military power who would necessarily have to cede power to properly qualified politicians.[4]

Historian Friedrich Katz's work, especially his detailed biography of Villa, forces us to rethink this impression of Villismo as a purely military force. Katz's influence in Villa studies is hard to overstate, and he has shown that, contrary to the view of Villa as politically unsophisticated, the general implemented significant reforms while he governed the state of Chihuahua. Katz also shows that he did so from the parameters of an ideological project rooted in land reform, municipal autonomy,

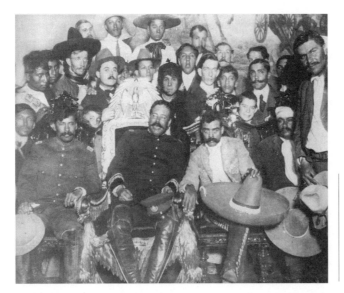

Pancho Villa, at the
National Palace, sitting
in the presidential chair
and accompanied by
Emiliano Zapata and other
revolutionary figures, 1914.
© Fondo Casasola

and education. Yet even an admirer like Katz explains that strategic circumstances limited Villa's political options. The need to operate over a huge territory meant that Villismo remained a military movement with social objectives more than a social revolution achieved through military means. Moreover, perhaps with these strategic considerations in mind, Villa never formulated a succinct program or manifesto comparable to the plans associated with the other major revolutionary figures. Villismo had two newspapers, and both ran numerous pronouncements and laudatory statements about Villa and his revolutionary activities and movement. But none of it acquired great popular traction as a slogan or synthesis of the Villista struggle in the way Zapata's *Plan de Ayala* became a rallying cry for radical agrarian change. Ilene O'Malley notes in this regard that Villa was for several decades not part of the official canon of national heroes from the revolution and argues that he "was in a sense unincorporable because there was no law or reform to promulgate which would allow the government to say, 'Here, we have fulfilled the goals of villismo'" (1986, 111). Without the legacy of a directly expressed political program, Villa has persisted in a position that Jorge Aguilar Mora has powerfully summarized as the perfect emblem for popular anger. "No one," Aguilar Mora argues, "has reflected better the inassimilable separation of the oppressed" (1990, 146). Villa's iconic figure is thus constantly in a field of contestation where, as Aguilar Mora insists, the lines between social classes are inevitably drawn around the problem of how to understand the role of violence and insurrection in history. Literature offers one of the best places to follow the efforts of the middle and upper classes to contain the power of Villa as a figure of popular discontent.

## Villista Fictions

Pancho Villa is the centerpiece of Mexico's revolutionary novel, and his figure remains a touchstone in Mexican fiction.[5] As Carlos Monsiváis notes, in its origins the novel of the Mexican Revolution faced a singular condition of being: how to

understand popular violence. "If violence is the day-to-day fact that explains and defines the position of social classes before reality and before the central fact of private property," Monsiváis writes, "this body of novels cannot be anything other than a prolonged exploration of violence as creation, as midwife to a new concept of society and nationality" (1988b, 1450).[6] No other figure from the revolution allows for a greater exploration of this theme in relationship to popular demands than Villa because all of the other revolutionary leaders bear the burden of *something else* that they have been made to symbolize through their conversion into historical and political icons. The memory of Zapata, in particular, could not be unwound from the theme of subsistence farming, itself co-opted by the new constitution of 1917 and its promise of land redistribution. Unencumbered by a comparable political specificity, Villa often became the face of popular violence *in itself*. He became the center of the most complex stories in the literature of the revolution.

Max Parra's study of Villista narrative traces the historical process of Villa's figure in the dominant narrative of the revolution until the 1940s. Parra establishes how the novel of the Mexican Revolution developed from the Civil War, when a provincial doctor and aspiring writer named Mariano Azuela became trapped in El Paso, Texas, and in 1915 published the first version of *Los de abajo* (*The Underdogs*, 1992) as a desperate ploy for money. Famously, Azuela's novel did not gain public attention until the 1920s. By the 1930s, the novel of the revolution passed into a period of state sponsorship, as seen in the work of a journalist-turned-narrator, Rafael F. Múñoz. The novel of the Mexican Revolution is an important moment in the development of twentieth-century nationalist fiction in Spanish America, and Azuela's *Los de abajo* stands as the foundation of the genre.

Critics often see in *Los de abajo* a condemnation of popular violence as the peasant protagonists degenerate into increasingly brutal acts of apparently senseless abuse against their enemies and even their supporters.[7] But Parra argues that for the deeply impoverished peasant soldiers in the novel, the División del Norte offers a utopian possibility in which "all the endemic needs of the lower classes disappear" and the seemingly wanton destruction of property and even life takes place under the aegis of Villa as a figure who "sanctioned the rancor and hatred accumulated during a lifetime of oppression and privation" (Parra 2005, 42). When read against the grain in this way, *Los de abajo* reveals the desire to overturn an oppressive present combined, explosively, with the realization of an alternate future. These are the telltale social conditions of peasant insurgency. Poverty is endemic and its omnipresence as a social fact does little to explain the dramatic decision of insurgency. The decision to engage in armed resistance to the State implies weighing the possibility of success against the potential destruction of one's community should the insurgency fail. But a rejection of the unacceptable present combined with a powerful vision for an alternate organization of society is the moment in which the peasant rebel can be expected to emerge.[8] That combination is the mystique of Villa and central to his power as an icon: the military successes of the Divisón del Norte gave rise to a sense of the Villista project as a better future which could succeed. It is also one of the central dynamics responsible for the revitalization, in recent years, of Nellie Campobello's 1931 novel, *Cartucho* (heavily revised in 1940), perhaps the most enduring work of literature to have emerged from the Mexican Revolution and one of the most challenging to bourgeois concepts of violence.

In *Cartucho*, Campobello speaks from a fixed location: the space of her child-hood neighborhood in the northern provincial city of Parral, even from the space of the house, of the kitchen. In my classes, I have at times described *Cartucho* as a literary snuff film: someone dies on almost every page in graphic and violent ways. Far from condemning this violence, the novel presents it to the readers as a series of exemplary moments. Where *Los de abajo* presents a coherent depiction of popular violence that must be read critically to get beyond a bourgeois morality, *Cartucho* is a scattering of vignettes that invite readers to go outside usual expectations about what history is and how it can be told. At the same time, the novel's celebration of violence illuminates another aspect of Villa's iconic charisma: his regional identity in north-central Mexico.

Campobello puts every death in *Cartucho* before readers within a strict code of judgment: who is a good member of the regional community, who is a good *hombre del norte* [northerner]. It is a code understandable primarily within the geographic and cultural context of the novel, which is set in a region formed by a long history of isolation from the central government, internal colonization, and violence against indigenous people. In this code, violence and death come not as a *memento mori* in which all are reminded that they are equals (death comes for us all). In *Cartucho*, violence and death rain down instead to create social divisions. They lift up heroes and cast down villains. They bless the brave by confirming or generating their status as local heroes, and they condemn the wicked by establishing or punishing their violations of honor and community. Loyalty to the region and its inhabitants overrides overt political labels; Campobello even redeems or ameliorates the crimes of Villa's enemies when they are otherwise loyal to the community. Villa barely appears in the book, and then only as someone who has to negotiate the power dynamics and mixed loyalties of his local henchmen. Nonetheless, Villa guarantees Campobello's nearly epic code of conduct (the combination of certain fate and violence found in *Cartucho* recalls nothing so much as Homer). Villa stands for or names a breach in the fabric of domination that allowed this regional code to interrupt the bourgeois staging of national history.

The fragmented structure of *Cartucho* is helpful for understanding the nature of Villa's iconic status. Campobello's book is a montage of disconnected short pieces, none of which extends beyond a few pages. Critics have offered several theories about the meaning of this storytelling technique and its relationship to popular forms of expression like folk ballads (called *corridos* in Mexico), allegorical prints (*estampas*), or dance (Campobello was primarily known in Mexico as a choreographer and the director of the national dance company).[9] Regardless of Campobello's inspiration for this collage-like structure, *Cartucho* draws our attention to the fact that the essential unit of Villista narrative is the anecdote—the essential genre of the folk hero tale. We might think of the anecdote as the popular version of celebrity media buzz. Anecdotes circulate and define a mutable, contextualized form of communication and history-making. Within oral societies, the short narrative structure of an anecdote is a rhetoric but also a form of cognition.[10] The brief tale is a specific kind of storytelling. It has genre norms suited to the space of what can reasonably be told in a single sitting, and those norms also generate a way of relating the tale's meaning. Anecdotes establish a narrative unit that can be easily recognized, propagated, and altered to fit circumstances.

To a certain extent we can say that anecdotes belong to that realm of popular agency which historian Ranajit Guha describes as rumor (1999, 250–74). Rumor in this sense forms an alternate public sphere that interacts tangentially with the Liberal concept of the same. Most importantly, this alternate public sphere has no concept of objectivity (one could well argue that objectivity is an illusion in the Liberal public sphere as well, but that is a separate issue). The anecdote in relation to rumor is never neutral. And with a figure like Pancho Villa, the anecdote serves as a core unit in popular ideology. The image of Villa as a popular hero is built through a series of anecdotes that relate his relationship to the politics of the people. The anecdote is simultaneously a kind of narrative easily adapted into higher cultural registers like the short story or the novel. Perhaps no single anecdote is more powerful in crossing these lines of social class than the "fiesta de las balas" (celebration of bullets), an incident that, not atypically, does not even center on Villa but rather on one of his chief lieutenants, Rodolfo Fierro.

Fierro was known as Villa's hatchet man or executioner, with the fitting nickname of "el carnicero" (the butcher). He would have passed into history for many reasons, but without a doubt the most disseminated distillation of his life is the killing of some three hundred enemy prisoners, whom he is supposed to have gunned down one by one in groups of six under the false promise that if they could outrun his trigger finger, they could go free. The primary account is from Martín Luis Guzmán. "La fiesta de las balas" is the most famous chapter in Guzmán's *El águila y la serpiente*, in part due to the rhetorical force with which it condenses a sadistic urge as the central motivation in the popular revolution ([1928] 1991, 199–211). Even the title is in equal measure appalling and appealing. The bullets could be the objects or the subjects of exhortation: is it a celebration of the bullets or a celebration by them? Is there an *agent* of violence at stake here, or is violence depicted as an atavistic force channeled through Fierro? This is Villismo as the incarnation of barbarity, of popular brutality. The problem is that the story as Guzmán tells it doesn't hold up to scrutiny.

According to Guzmán, Fierro dispatched some three hundred prisoners by emptying six rounds from one pistol while an assistant reloaded a second, and he proceeded thusly, alternating between the two weapons. It is a good story, and Guzmán tells it well. But it's not credible. I am no expert on turn-of-the-century firearms, but it is hard to believe that any handgun of that time period could fire that many rounds and not experience a fatal malfunction, much less achieve anything close to the persistent and deadly accuracy attributed to Fierro in this anecdote. We are, *prima facie*, in the presence of a myth, that is, of something which did not happen but which has come down to us with the force of a real event. By portraying Villa as the embodiment of popular violence, the scene depicted in "La fiesta de las balas" assumes such reality that even a fact-obsessed scholar such as Katz relies on Guzmán's account as evidence for what is plainly an ideologically charged fiction (1998, 221, footnote 62). It may be that because this otherwise incredible sequence of events (essentially, a tall tale) has been so effectively told through a genre associated with popular culture (the anecdote), it has become an accepted part of the Villa legend. Anecdotes have played a similar role in other artistic forms of representing Villa, most notably in film.

## Villa on Screen and on Stage

The open-ended nature of the anecdote as a structure which mediates between legend and history has adapted itself to distinct ideological processes and a variety of media, with film being the most pervasive. Villa is, of course, remarkable for having attempted to use film as a tool to create his own public image. The contract he signed with the Mutual Film Corporation is something of a film-history legend, although, as Katz notes, the history of this arrangement is "like everything else related to Villa . . . an inextricable mix of myth and reality" (1998, 325).[11] But Villa's status as a truly larger-than-life figure is closely tied to film. The movie that Mutual Films ended up creating out of its newsreel footage of Villa and his troops, *The Life of General Villa* (Cabanne and Walsh, 1914), is one of the first (if not the first) feature-length biographical films ever made. The survival rate of films from the silent era is exceedingly poor. It is thus lamentable but not surprising that no one has yet found an intact copy of *The Life of General Villa*. However, Mexican director Gregorio Rocha has made a fascinating documentary, *Los rollos perdidos de Pancho Villa* (*The Lost Reels of Pancho Villa*) (2003), about his efforts to locate part or all of the film and about Villa's relationship to the US film industry.

Since the silent era, many films have been made about Villa. Among the best efforts is the film adaptation of Rafael Muñoz's novel, *Vámonos con Pancho Villa* (*Let's Go with Pancho Villa*; the novel dates from 1931; the film from 1936). Múñoz's novel started as a set of short stories built around stylized Villista anecdotes, and the movie brought this semi-official version of Villa as an implacable force to a huge viewing public. A steady string of Villa bio-pictures followed. Most are also built around a series of famous tales meant to capture the multifaceted nature of Villa. In some sequences he is magnanimous, emotive, loyal to a fault, almost innocent; in others, he is violent, ignorant, brutish, lascivious, or absurd. No film better summarizes this tradition of a many-faceted Villa legend than *Así era Pancho Villa* (1957), a big-studio production from Mexico in which Villa's life is recounted non-chronologically after an opening sequence in which Villa (played by the veteran Mexican star Pedro Armendáriz) speaks in voiceover while the camera pans around what is presented as his disembodied head, floating in formaldehyde. Here, we find once again the hero's head held as a relic by Villa's enemies. The sum of the anecdotes in this film falls in line with Guzmán's position that Villa is unfit to hold power, but Villa's brutality in *El águila y la serpiente* has here been transmuted into comedic distraction. *Así era Pancho Villa* is an optimal turning point in the official project of state nationalism about Villa in Mexico: once a danger to be contained, Villa has by the late 1950s moved into the harmless world of local color. Any of the anecdotes related in the film may or may not have a place in the popular imagination of Villa. But by the time they have reached this film, their meanings have been disconnected from popular politics. Instead, the short narrative form operates here as a vehicle through which an urbanized mass public with no lived connection to the revolution could see an ideologically manipulated version of history and think that, since the film includes aspects of stories which might have circulated among extended family or friends, the movie as a whole accurately captures the historical essence of Villa.

Any image of Villa transmitted through anecdotes is thus perilously ductile. You can pile up stories more or less in line with central tenets of the Villa legend as it has been disseminated in many contexts only to end up with incompatible visions of the general: he can become a revolutionary icon, a completely reactionary image of the lower classes, or worst of all, a meaningless pastiche. Such is the nature of a modern icon, and in recent decades Villa has suffered that most corrosive of fates for a social radical: he has become kitsch.

Two examples can be taken to scan the spectrum of Villa's filmic portrayals and his conversion from icon of insurrection to a cartoonish figure of kitsch. Eugenio Martín's Hollywood-produced film *Vendetta* (1972), originally entitled simply *Pancho Villa*, claimed to be a retelling of Villa's infamous cross-border raid on Columbus, New Mexico. The revised title illustrates history's passage into myth. Villa's motives for what might have been one of his more effective geopolitical interventions (a way to catapult himself back into the national spotlight and humiliate the United States at a time when his fortunes had ebbed to their lowest) are reduced in the film to petty revenge. Any chance of seeing in Villa an allegory of collective struggle evaporates into Villa's supposedly volatile personality. But the *coup de grace* comes from casting. In *Vendetta*, Villa is played by Telly Savalas (just before the actor's great success as the television detective Kojak). The casting is so improbable that an escape sequence had to be invented for the film's prelude to explain that while he is a prisoner, Villa's head is shaved to humiliate him so he can parade through the rest of the film as bald as the actor playing him. Best of all, in this film Villa speaks like a New York gangster with a partly peninsular accent that Savalas may have picked up while filming on location in Spain.[12]

On the opposite end of the kitschification of Villa, however, we have Sabina Berman's play, *Entre Villa y una mujer desnuda* (*Between Villa and a Naked Woman*, 1993). The play was adapted and updated by Berman herself two years later as a film (*Entre Pancho Villa y una mujer desnuda*). The play and the film are equally powerful romps into the world of a once-powerful icon whose purchase on the present has become a hollow sounding box: it can return an echo of ourselves but no longer communicates anything about the national past in its own voice. The protagonists are a successful businesswoman (Gina, played by Diana Bracho in the film) and her lover, a crusading journalist named Adrián (played by Arturo Ríos in the film). Gina has a highly successful career in the management of an export-assembly plant (a maquiladora) in Tijuana. The maquiladora is owned by a descendant of one of Villa's archenemies in the revolution. For his part, Adrián has just published a biography in which he hopes to demonstrate that the true and unfulfilled spirit of the revolution was Pancho Villa. From the perspective of the nationalistic Left, a more anathematic figure than Gina is hard to imagine (she is a part of selling out the nation to neoliberalism), and the uneasy affair between her and Adrián offers the exoskeleton of a by-now familiar allegory in which two projects for the nation compete within a framework of romantic give-and-take.[13] When Gina demands more commitment, Adrián receives romantic advice from the incarnate spirit of Villa (played by Jesús Ochoa in the film). However, Villa's outmoded code of masculinity produces increasingly negative results with the independent-minded and successful Gina. Every time Adrián reverts to less *machista* strategies to hold on to her, an invisible gunshot rings out and wounds the

spirit of Villa. Eventually Villa disappears when Adrián admits that he can't talk anymore because he's crying over Gina.

The comic potential of the premise is equally effective in the play and the film, although the film's ending differs significantly from the play's. The film concludes with a sequence in which, goaded once again by Villa's ghost, Adrián imagines killing Gina in a final fit of passion and desperate pride, suggesting a less optimistic perspective about the eclipse of machismo in Mexican society. In both, Berman's parody of Villa measures how far Mexico has moved from the original story of its older, state-centered nationalism rooted in a history of rural insurgency. In Mexico's current position of neoliberal denationalization, Villa is available within urban culture less as an icon of the revolutionary past than as a denatured symbol of negative values without a specific historical weight.

## Conclusion: Across the Border

Some of the more interesting representations of Villa partake more fully of his nature as a figure from the US-Mexican border region. This is especially seen within the Mexican American cultural tradition. Luis Valdez is famous as the founder of *Teatro Campesino*, a major cultural institution in the western United States famous for its outreach efforts to migrants and agricultural workers. Valdez's first full-length drama was *The Shrunken Head of Pancho Villa* ([1963] 2005). The play focuses on the dramatic allegory of a decapitated head, which may or may not be Pancho Villa's, that lives with and is maintained by an impoverished Mexican American family. Valdez's play criticizes assimilation, with one of the family's sons returning from military service to become first a corrupt hiring agent for farm laborers and then a welfare agent who uses the English version (Sunday) of his Spanish name (Domingo) to signify his total incorporation into the dominant culture. But the play is also a condemnation of empty cultural nationalism in which the Mexican Revolution is cut off as a usable history because the legacy of Villa has literally been left without a body. Throughout the play, the head spouts slogans and songs from the Mexican Revolution alongside insults to the other characters, but the idea is that the revolution is a heritage that burdens as much as it inspires (the head demands a prodigious supply of food, leaving the rest of the family to subsist on cockroaches). The decapitated head allegorizes a displaced cultural identity that is unable to integrate as a functional whole in a context of racism and exploitation in the United States and underdevelopment in Mexico. If the myth of a Yale secret society keeping Pancho Villa's skull is an exaggerated example of how the wealthy and privileged collect tokens from their enemies to signify their power, Valdez's play offers an absurdist and sometimes grotesque counter-allegory in which the history of the revolution as a popular insurgency becomes something that cannot be placed into meaningful relationship with the present of a working class, immigrant society in the United States.

The concept of a cultural icon evokes a visual metaphor. Icons are images that are supposed to offer pathways to truth. This visual metaphor is necessarily multiple. An icon can be seen from different angles to mean different things. Despite his trajectory from a symbol of unstoppable insurgency to that of cartoonish violence, Villa persists and even thrives as an icon. When a Mayan insurgency began in

southern Mexico in 1994, its leader, known by his *nom-de-guerre* Subcomandante Marcos, announced his force as the Zapatista National Liberation Army. Marcos thus turned to the agrarian tradition and the other popular force in the Mexican Revolution for the name and iconography of his movement. But when asked by reporters where he had learned the arts of guerilla warfare, Marcos responded that he studied Pancho Villa's tactics. Of course, hidden in the question was a suspicion that Marcos was a plant from Cuba or Central America rather than a figure arisen from the social context of Mexico. Sensing that suspicion, Marcos may have answered with Villa as a means of deflecting an implied criticism of his national legitimacy. Despite the loss of purchase that the revolution holds for a largely urban Mexico in the new millennium, Marcos's deployment of Villa shows that the iconic general can still be invoked as an icon in the struggle over the future of the nation.

## Notes

1. The historiography of the Mexican Revolution is extensive and contested. For an effective and synthetic overview of the armed phase of the revolution, I recommend the entry by John Mason Hart in the *Oxford History of Mexico* (2000).

2. See Ilene O'Malley's 1986 study on hero-cults in postrevolutionary Mexico for a detailed assessment of Villa's incorporation into the State-sanctioned pantheon of historic leaders.

3. "A quien pasábamos la mano acariciadora sobre el lomo, temblando de que nos tirara un zarpazo." The translation is my own as are all others.

4. On this same scene from Guzmán, see O'Malley (1986, 99) and Parra (2005, 90).

5. Villa is as present in contemporary literature as he was in the 1920s. Ignacio Solares's historical novel, *Columbus* (1996), is a first-person retelling of Villa's famous raid on the eponymous New Mexican town in 1916.

6. "Si la violencia es el hecho cotidiano que explica y define la posición de las clases ante la realidad y ante el hecho axial de la propiedad privada, esta novelística no será sino una prolongada exploración en torno a la violencia, gestora, partera del nuevo concepto de la sociedad y la nacionalidad."

7. This reading of *Los de abajo* as a work only about the violence and brutality of the peasantry can be seen prominently in the introductory essay that Marta Portal (1996) wrote for the Cátedra edition of the work, but it dates from Joseph Sommers's highly influential study of the Mexican novel (1968, 14–15) and from the early work of Jean Franco (1970, 80). Franco's assessment of the novel developed considerably over the next decades (see Franco 1973 and 1994).

8. On the historical development of insurgency, see the work of John Tutino, who argues that rural insurrections are most likely the result of "critical meetings of grievances and opportunities" (1986, 22) rather than merely a response to poverty and oppression.

9. See the analyses of Parle (1985), Pratt (2004), and Unruh (2006).

10. Parra also analyzes in greater detail specific narrative qualities of orality in *Cartucho*, as they are part of "the accumulation, preservation, and transmission of notable events [in a culture] not based on the written word" (2005, 54).

11. Among the most enduring legends is Villa's agreement to attack the northern Mexican border town of Ojinaga during the daylight hours so that the event could be captured on camera. But as regional historian and Villa expert Nelson Osorio notes in Gregorio Rocha's film about searching for the lost footage of Villa, the attack actually took place in the dark, and as Katz also notes (1998, 325), the actual contract contains no such language specifying cinematic intrusions on military matters.

12.  The path from here to Antonio Banderas's reprise of the role for Home Box Office's television movie about Villa's relationship to Mutual Films, *And Starring Pancho Villa as Himself* (2003), is both obvious and unfortunate. As Gregorio Rocha notes, *And Starring Pancho Villa as Himself* offers an outdated view of the Mexican Revolution in which Villa plays only a "colorful and clownish secondary role" (2006, 143). Moreover, the HBO film reinforces the stereotype that Villa was "a barbarian leader unscrupulously ready to sacrifice the lives of his men in order to gain publicity" through film (Katz 1998, 325) rather than an agent in at least part of his own making as an icon.

13.  An insightful consideration of changing gender norms related to the theme of allegory, melodrama, and comedy can be found in Dianna C. Niebylski's 2005 analysis of Berman's play.

# Eva Perón
## Excerpts from *The Passion and the Exception*

*Beatriz Sarlo*

## Prologue

There are biographical reasons in the origin of this book, and it is convenient to make them clear at the start. I form part of a generation that was marked in politics by Peronism and in culture by Borges. They are the marks of a conflict which, once again, I will try to explain.

In August of 1970, the journal *Los Libros* published Borges's "El otro duelo" ("The Other Duel"). The publisher's note said, "Of the eleven stories that compose Borges's new collection, *El informe de Brodie* (*Doctor Brodie's Report*), the author of *Ficciones* has selected specially for *Los Libros* the one that is being published in these pages." Borges's story, perhaps the bloodiest one he ever wrote, narrates a race between two beheaded men: two gaucho soldiers, whose rivalry is known to all, now prisoners in one of those unruly encounters of the civil wars of the Río de la Plata, face imminent death. The execution will be macabre and will prolong their rivalry. The captain announces: "I have good news for you: before sunrise you will be able to show which of you is the bravest. I will have you beheaded standing up, and then you will race each other." And that is exactly what happens: the primitive joke, the execution, from which Borges omits none of the truculent details of the work of the knife, the spurts of blood, the few steps that the rivals took, while their executioners held up their newly cut heads. The beheading of the prisoners was not just an act of unconscionable cruelty but also a macabre farce. After many years of silence on political matters, Borges chooses as an anticipation of *El informe de Brodie* this barbarous story, and once again he confronts his readers with the diaphanous narration of a brutal and remote event.

Borges was as legible as he was illegible. Why was this refined old man once again visiting the military campaigns of the nineteenth century and once again writing a story in which a primitive and legendary world is being captured by a disciplined and perfect narration? [ . . . ]

Two months before, on May 29th, the Montoneros had kidnapped Pedro Eugenio Aramburu.[1] The coincidental proximity of these two events is just that, a coincidence from which no further conclusions should be drawn. Or perhaps just one. Borges and the events which occurred in that year, 1970, defined in different ways the following years (as if it were a question of envisioning Argentina

as two different nations momentarily entwined only to split in two afterwards). In August of 1970 I read, half amazed and half irritated, Borges's story. Weeks before, the Montoneros had kidnapped Aramburu. Both events (though I did not know it then) would mark my life indelibly. In this book I seek to understand something of that political configuration and of that cultural presence.

I celebrated the assassination of Aramburu. More than thirty years later, that verb seems evident to me (many people celebrated it), but I have to force my memory to really understand my reaction. I am not even sure that this effort, something I've done many times during these years, has succeeded in wholly capturing the moral sentiment and the political idea that fed my celebration of Aramburu's death. When I recall myself watching television with a group of Peronist friends the day I heard the news of Aramburu's corpse being found, and another day soon after when I watched, also on television and with friends, his burial in the Recoleta cemetery, I see a different woman (someone I no longer am). I want to understand her, because the woman was not very different from other women and men of that time; neither would that woman have seemed out of place in the group that kidnapped, judged, and executed Aramburu. Although my political road would eventually distance me from Peronism, in that year, 1970, I admired and approved what the Montoneros had done.

Eva Perón's corpse was invoked by Aramburu's abductors, as it was during the Montoneros' interrogation of Aramburu and their reasons for his death sentence. [ . . . ] The recovery of Eva Perón's remains was part of a sheaf of Montonero demands that also included the return of Juan Perón to Argentina. These claims stretched across eighteen years, from 1955 to 1973, giving epic dimensions to the struggle of a true and unredeemed Argentina. For someone like me, whose family participated in the "gorilla" opposition to the first Peronist government,[2] both the figure of Eva and the admiration for the manipulative talent, the sly astuteness, the ideas and charisma of Perón were the first chapter of a political formation that implied a rupture with the world of my childhood. To be a Peronist (whatever else it might mean) meant to distance ourselves from our parents and to imagine that we were distancing ourselves from our middle-class origins. Those of us who did not inherit Peronism from our parents but who adopted it had almost no memory of Eva, except for the insults muttered under our parents' breath, the pictures in the papers, and the vindictive reprisals of September 1955.[3] We had to get to know Eva, to receive the myth from those who had preserved it. Although she appeared to be the product of her own will and bravado, Eva too rose out of the political will impelled by the Peronist legend.

Eva died when I was ten years old. My father would not allow me to go to the wake, which felt endless and was held in the halls of the national Congress. A few years later, with the dubious help of a copy of La razón de mi vida [Evita's largely ghostwritten autobiography] bound in red leather, I must have constructed for my own use, as did so many others, the image of a revolutionary Eva, moved by the ungovernable force of the working classes, more militant than adventuress, to quote the classic disjunction of J. J. Sebreli. Yet Eva continued to be a figure foreign to my experience, a condition to embrace, a cultural allegory of Peronism, a character in a tale of the Peronist state which, in the hands of its mythmakers, had something of the feel of a Golden Age. Recovering her corpse—as the Montoneros

demanded—was a symbol of pious justice and reparation for an arrogant crime; but above all, it meant that the Peronists had won the game.

[In *The Passion and the Exception*] I have tried once again to pose the question of why the kidnapping of Aramburu was lived by thousands as an act of justice and reparation. In doing so I have worked on three levels which began intercepting each other the further I advanced: the knowledge contained in Borges's oeuvre; the exceptionality of beauty; the extreme and passionate exceptionality of vengeance. One character, one event, one writing, if I am not mistaken, forms the exceptional trilogy to which I have tried to find some meaning. [ . . . ]

## Beauty and Style

[ . . . ] [The couturier Paco Jamandreu] began a professional relationship with Eva that lasted two or three years, until Eva's dresses began to arrive directly from Paris, from the house of Dior. Jamandreu kept her away from the ostentatious fox stoles and the billowy fabrics, as these conveyed the typical gifts powerful men gave in exchange for sexual favors, or the anxiety of an actress who had languished downstage and in third-rate roles for too long. He gave Eva the ultramodern look, the Garbo look of a competent and decisive Eva: Peronism's Ninotchka.

[ . . . ] Any comparison between Eva Perón and other women who appear in photographs of the era shows that she differentiated herself by a style that eschewed the mannerisms of the fashion of the day, a trend that favored Veronica Lake-style waves, doll-like round faces, heart-shaped lips, folds, lace, and gathers, ornate hats, and a wasp waist. Eva went for timelessness as she became a cross between two figures of the cinema: Garbo from the past, and Audrey Hepburn from the future. Her body, without pronounced curves and thinner with every passing day, contributes to the illusion that she is above or beyond fashion. What was a disadvantage to Evita Duarte the aspiring actress appears now as the unique quality of her beauty, untouched by the more evident marks of the perishability of fashion.

[ . . . ] Jamandreu designed Eva's attire to correspond to the political body of Eva Perón. Of classic inspiration (in the same line of the *tailleur* who also dressed Victoria Ocampo, another fashionable Argentine[4]), Jamandreu created for Eva the Prince of Wales tailored suit with dark velvet collar, the official work look she wore in many snapshots and official reporters' photos. The tailored suit is as much a public attire as the evening wear sent by Dior in which Eva posed for official photographs (the grand portraits), encrusted with jewels, wrapped in silks and stiff satins. When she dresses for galas or affairs of state the dresses are so ornate and the jewels so spectacular that they can almost no longer be judged in relation to fashion, but rather as architectural constructions on an allegorical body: that of the *pueblo peronista*. Dressed for a gala event, Eva is the crowning piece of a set design of power.

But with her Prince of Wales tailored suit and others like it, Eva attended the emblematic acts of the welfare state: she met with the poor, traveled the provinces, debated union leaders, showed up at her office, was an orator on stages and in plazas, received parchments, medals, jewels, accepted and gave out checks, attended events in soccer stadiums, hospital inaugurations or schools, and finally listened to the multitude who offered her the Vice Presidency in Justicialism's Open Cabildo

of August 22, 1951. As such, she worked as both a leading actress and a supporting actress, the providential double of the figure of Perón. As her work attire, the Prince of Wales suit had all the traits identified with her public function. It is, in one sense, a uniform. But in another sense, it is not, since uniforms are imposed on a class of people of the same rank, whereas Eva's suit can only be worn (by tacit agreement) by one very special person.

[ . . . ] The Argentine political situation had an exceptional configuration: the popularity of a swiftly rising actress, the fluidity of the political situation, the impudence of the main actors, the benevolence of fortune. Even the stage costumes had been tried on, and the dresser had given the performers their main cues.

## The Two Bodies of Eva

> During the time I worked with her I always had a strange sensation when facing her. I felt that there were two Eva Peróns: the sweet and well-mannered young woman for whom I sketched dresses to try on, and with whom I joked; and another, totally different one. I've always thought that this second Eva Perón was inhabited by another spirit. More than once I have thought that the spirit of someone else was taking over her body. . . . It seemed to me that when she spoke to the multitudes, when she subdued them, it was because she was possessed by someone, because in her there was incarnated the spirit of some politician of many centuries ago. (Jamandreu 1981, 76)

Jamandreu saw two Evas, a twinned body. He perceived something central in the nature of Peronist power, and tried to express it by its most fantastic side: Eva must have been possessed, a stage in the reincarnation of some politician. Eva herself explained it in terms of her being possessed by the doctrine and teachings of one man. These two Evas have, nevertheless, other symbolic resonances.

E. H. Kantorowicz refers to the twinning of the monarch's body as a "mystic fiction." The king has a political body and a natural body: "Not only is the body politic 'more ample & large' than the body natural, but there dwell in the former certain truly mysterious forces which reduce, or even remove, the imperfections of the fragile human nature." These two bodies, of different natures, compose a single person, in which the political body always prevails. According to Kantorowicz, the fiction of the king's two bodies "gave rise to interpretations and definitions which necessarily tended to configure themselves in the image of those related to the nature of the God-man" (1957, 9).

In his political body, the king cannot be considered a minor nor in any way incapacitated, even if materially he is. In his political body, the king is always in full command of all his royal faculties, even if his physical body endures illness, diminution of capacities, or minority. The political body of the king places his body above the contingencies that affect his material body. The monarchic regime is supported not only on the material body of the king, but rather fundamentally on his political body, which assures continuity because, as opposed to the physical body, it is imperishable.

Eva Perón's body is inscribed in this symbolic line. The Peronist regime was scarcely republican: more plebiscitarian than democratic, and plebeian in its char-

acteristic political institutions; sustained by some corporate groups such as the Peronist unions and by a vast social movement, it was intensely personalist, courtier-like in its acquiescence to and flattery of its leader (to whom there were attributed literally providential qualities), fanatical in its devotion to the cult of the leader's wife, and profoundly hierarchical, according to both partisans and opponents, in their experience of the form in which authority and power were concentrated at the top of the pyramid.

In the originary political scene of this regime, Eva occupied second place. But her second place had some particularities that rendered it unique. Eva's place extended over all the places that Perón himself could not occupy. Expounding on this point in *La razón de mi vida*, she describes herself as Perón's intercessor, representative, bridge, interpreter, and shield. It should not go unnoticed that every one of these functions refers to the millenarian figure of the Virgin Mary. Perón found in Eva not only a collaborator but someone who, along with him, formed in the peak of their power a political society with two heads, hegemonized by the man, but in which the woman had special privileges placed above the republican institutions. The images of this bicephalous society are a tropological mechanism of cultural hegemony implanted by Peronism.

Eva the standard bearer of the humble, Captain Eva, Comrade Eva, Eva the representative of Perón before the people—the list of attributes was as expansive and as exalted as those for Our Lady—occupies a political place quite uncharacteristic of a republic. In her body the virtues of the Peronist regime are condensed and its legality is personalized. Her body is auratic, in the sense that this word has in the writings of Walter Benjamin. It produces authenticity by its presence alone; those who can see it feel that its relationship to Peronism is completely embodied and unique.

Claude Lefort, reading Kantorowicz, indicated that democratic regimes are those in which power is not consubstantiated indissolubly with the body of a person. Democracy institutes an empty place. The Peronist regime filled that vacuum at the heart of democracy with a dual personalization of power. Under Perón's leadership, who was the first principle of this double personalization, Eva was the adequate instrument. As in a monarchy, "the nation—let us say: the kingdom— was seen figured as a body, as an organic totality, as a substantial unity. [ . . . ] In other terms, power, insofar as it is incarnated, insofar as it is embodied in the person of the prince, *gave body* to society" (Lefort 1990, 189). Eva's body *gave body* to the Peronist society (as well as to the other society, that of the opposition, who hated her to death). Before it was an ideology, before it was a system of ideas, Peronism was a mode of identification.

Millions of Argentines recognized themselves in her, because they saw her act and felt the effects, symbolic and real, of her acts. She was a fragile woman; beginning in the 1950s, she began to show the signs of the illness that would consume her. Yet she was also the guarantor of the regime, its representation and its force. Her material body is indissoluble from her political body. Upon the beautiful form of that body rests the cultural dimension of the Peronist regime and its twin principle of identification: Perón and Evita.

Eva's body, then, is the bearer of two indispensable elements to the Peronist regime. Hence the importance of her real body as the visible form of her political

body. As opposed to the king, whose material body is sheltered by his political body and therefore is indissoluble, but who can also suffer all the afflictions of age and illness, the material body of Eva is a reinforcement, a potentiality at the service of her political body. In reality, one could almost say that in her case the twinned body has inverted its function: the material body of Eva produces her political body.

Eva's style, therefore, was not just an additional quality of her public persona but a central fact of her political persona, which was thus invested in unexpected and exceptional values. This style gave body to a new type of state, one that could be called "a homemade welfare state" (*estado de bienestar a la criolla*); and it consolidated a ritual absolutely necessary to that state, one which had the foundational impulse and the institutional weakness of all new regimes.

Peronism did not base its power on the traditional institutions of the liberal republic, from which it sapped both political power and symbolic relevance, but rather in the trade unions and a cultural and propagandistic apparatus of a magnitude hitherto unknown in Argentina (Sigal 1999). One of the pillars of the "welfare state *a la criolla*" was the Eva Perón Foundation (*Fundación Eva Perón*). Led by Eva herself, the *Fundación* replaced all charitable societies, especially the oligarchy's Beneficent Society (*Sociedad de Beneficencia*). Formally the Eva Perón Foundation was a public institution independent of the government; but in practice it was a branch of the state, financed by resources usually obtained under pressure (including blackmail) from private businesses, especially those who belonged to the ranks of the opposition.

The *Fundación* received thousands of letters daily. Many photos of the era show Eva, with her tailored work suit or in simple summer dresses, reading these letters. The requests came from the most remote villages and were answered according to a pattern of distribution that included sewing machines, quilts, false teeth, eyeglasses, soccer balls, pensions for the aged, sheet metal and bricks, and bicycles. Often, Evita attended the parceling out of these objects, radiant amid the mud, next to thankful grandmothers and children who were photographed with her as if she were a movie star, a sister of charity, a fairy godmother. The presence of Eva was the aesthetic extra of the gift, which remained affixed to the person who gave out those goods, and was reinforced by the photos that accompanied them, both a souvenir and a saint's portrait.

Evita personalized the gift, which removed any sense of humiliation for the receiver; there was always an excess, a superfluous expense that was not the dry response to a need. The anti-Peronists bitterly criticized the extremely personal nature of this gift giving, financed ultimately by the state; they also thought of it as a poorly planned *potlatch*. Eva answered them with a cliché that she turned into a slogan: her poor, her "unwashed,"[5] *deserved everything*—the defiant response of an agitator. She herself, in her visits and travels across the country, embodied defiance itself, because her body was the icon of the welfare state *a la criolla* that would provide, miraculously.

Eva Perón was indispensable in the political ritualization of Peronism, and in the distribution of goods and services to the poor, which when deployed in concert produced a strong identification. No wonder, then, that Eva's body was treated and draped with studious care, as the case demanded. Above all, one had to take advantage of that incalculable supplement represented by style.

Evita reading some of the thousands of requests she received for household items and toys at the Sociedad de Beneficencia, the charity she founded, circa 1949. She is wearing her Prince of Wales work suit.

## The Pathetic and the Sublime

The importance of Eva's body grew even as her health ceaselessly declined. Illness, which killed her at the age of thirty-three, invaded her without deteriorating her beauty. On the contrary, Eva's cancer accentuated her unconventional features and gave her a pathos which in some photos is tragic and in others sublime.

Eva became, day by day, more timeless, to the extent to which the cancer affected the features considered "pretty" in the 1940s and 1950s. Her face became more and more angular, her features more precise, her hands thinner, her shoulders more pronounced. Cancer dematerialized Eva's body. That is what the pictures show, especially the ones during public events where Perón supports her from behind, and she, leaning forward slightly, raises her arms as if she were about to throw herself toward the multitude which surrounds the balcony of the Plaza de Mayo; or she hides her face in the leader's white shirt, clinging to his back with a very open left hand, sharpened all the way to the dark finish of her fingernails. As these photographs show, Eva has become Garbo; her beauty cannot be judged by the canons of fashion (she had already gone beyond those of "good taste"). The more she dematerializes, her *achronic* beauty adjusts to future canons, without losing the irradiation (the aura) which makes her magnetic in the present. She is entirely an exception.

The figure of Eva in the mass rally of the Open Meeting of Justicialism on August 25, 1951, brings a history to its culmination. Starting from the renunciation of her plan to accompany Perón on the presidential ticket in the November elections,

Eva Perón, wearing her classic "work suit" in 1951, around the time her supporters nominated her for the vice-presidency of Argentina. *Clarín*, 1951.

which Eva officially announced a few days later, another chapter begins, the story of a conflictive withdrawal, the siege of physical impossibilities provoked by her illness, and the long agony. But that August night in 1951, Eva also achieved a new apotheosis.

The iconography which, beginning in the 1960s, raised her as the banner for the revolutionary conversion of one faction of the Peronist movement, was set in motion on that August night. In the photos of the great event, Eva is a body completely occupied by politics: an axis from which branch out, at cross-purposes, the Peronist forces, the conflicts between the syndicalist and the political factions, the vacillation of the leader, the hatred of the opposition and the desire of a multitude; in her figure one finds, tempestuously, desire and prudence, hope and fear, calculation and the temptation of a greater glory and an increasing power. All political passions hang in the balance in the gestures with which Eva left her decision in suspense. Those gestures were more decisive and warlike than the words that accompanied them. With her body Eva said more than she said in words, and much more than she would say by radio, some days later, on explaining her decision to refuse the demand of the Open Meeting that she run for vice president.

That August night Eva came up against two limits. Tragically, the heroine of Justicialism came up against the conflict that her acceptance of the great opportunity would have produced within and without the movement. She found the place where one political desire contradicted another: to institutionally occupy the position that she already occupied *de facto* in the twinned peak of Peronism would put that same peak into danger. Therefore, the offering of the vice presidency confronted her with a dilemma. Pathetically, her very body placed her before the limit of her forces, because the illness had already captured her without any possible retreat.

The gestures she made that night reflect the tensing, the fury, and the frustration she felt in facing these limits. Against the darkness of the background, against which one can barely make out the tailored dress suit, her blonde hair is aglow, shadowed only in the classic bun above the nape of the neck. Like a blaze, it stands out against her aquiline profile, her thin, determined lips and heavily drawn eyebrows, her hands with their sharp dark fingernails. [ . . . ] Her face is a study in contradictions: the aquiline profile, flat as a drawing, and the mouth drawn back tensely are those of a woman still young, without the marks of time. Yet simultaneously these are signs of a woman whose time is about to close and whose political career will go no higher than it has arrived on this day. The microphones, required stage props for any mass event, trace a shiny metallic fence, they communicate and they separate.

[ . . . ] As death drew near, Eva's body began to show more clearly the features of a pathos that evokes the sublime nature of sacrifice, now not just her sacrifice of the political "renunciation" of the vice presidency, but a physical one. The photograph which shows her exhausted in a hospital bed, after voting in the elections of November 11, 1951, have the lugubrious tone of a Symbolist or decadent painting: the sunken eyes, the prominent cheekbones, the sharp bones marking the oval of her face, the languor of the prone body and the bloodless hands, the shoulders, covered by a loose coat, almost do not sustain the long neck and head which falls diagonally upon the pillow; the hairstyle is almost as voluminous as the face. The bed sheets announce the folds of the shrouded corpse.

This photo traveled the country, announcing, once again, the double body of Eva: her political body, which imposes itself on her illness and pain in order to carry out the public act of the vote, which was the moment of the plebiscitary renovation of Peronist legitimacy; and the material body, which is entering into its stage of final decay. The photo shows what Eva Perón had repeated all those years: she is not her own mistress, she is possessed by an Idea; she is possessed by that which she has received as a gift. Consequently, the extenuated body of the photo is not only her body, sublime in its suffering, but the political body, the more meaningful the more her death approaches. The political body must subsist.

The battle over Evita's corpse has everything to do with this symbolic level. This battle can be analyzed in various dimensions (the rituals of Peronism first, the repugnant revenge of the anti-Peronists later).[6] I will concern myself with only one aspect of this symbolic dimension here.

The preservation of Eva Perón's remains was decided, of course, before her death.[7] The body was exhibited, in national mourning, before a multitude. [ . . . ] The embalmed body was emptied of its organic content, of its viscera and fluids, and converted into a carcass, into the support of what it had been in life. [ . . . ] In the material design of her "entry into immortality," the beauty of the corpse was at the same time exceptional and absolutely necessary. Indeed, death gave Eva a dimension that she had approached during her agony: the dimension of the sublime.

The infinity of the sublime is only achieved through the road of passionate excess. As we know, beauty provokes emotions and feelings that respond to a human measure, however exceptional. The sublime originates in an incalculable overflow beyond that measure. In this sense, what surrounded the death of Eva Perón, and

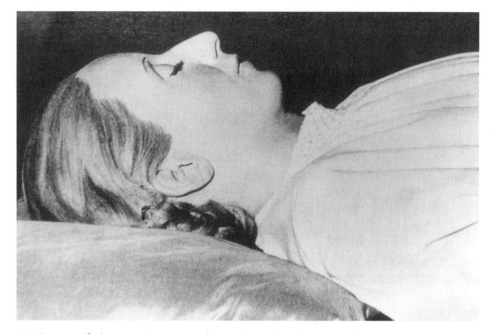

Eva's mummified corpse, circa 1952. Hulton Archive. Photo by Keyston/Getty Images.

above all the treatment of her corpse, has the unlimited and terrible character of the passional sublime.

Eva Perón's corpse was exposed to collective veneration until the military coup of 1955. Afterwards it was sequestered by the conquerors and basely concealed for eighteen years. In this icon of Peronism, both the vanquished and victors saw a symbolic condensation. The destiny of the corpse had been anticipated by the magnitude of its funeral glories. They had converted it into the object of a personalized political cult.

As opposed to the material body of the king, which disappears into that of his successor, the Peronist regime had no hereditary succession, and the coup d'état interrupted its political continuity. But there was, with the indelible perfection of the petrified, the body of Eva, which persisted in its duality: the material remains preserved at the peak of their beauty (which death had made sublime); and the representation of an authority and of a type of regime. Both the political love and the political hatred identified the same thing in that body which both sides wanted to possess forever.

## The Simulacrum

Here is the obverse of the sublime: a solid anti-Peronist, Jorge Luis Borges wrote the story in which he confronts the corpse of Evita with its imperfect replica. "The Simulacrum" is the very short story of a man who, in July of 1952, arrives at a town in the faraway Chaco province to set up there the wake of a blonde doll in a cardboard box. The man receives condolences as if he were the doll's widower. At his side, a tin box receives the two-peso offerings that the visitors leave: "desperate old

ladies, goggle-eyed children, peasants who doffed their cork helmets in respect."
In many villages in Argentina these acts of devotion took place, whose intensity
stoked the scornful distrust of an opposition prepared to find manipulation and
ignorance in all official or spontaneous rituals of the previous regime.

In this macabre fiction ("macabre" is also the adjective Borges uses to describe
the widower), there is nevertheless something moving. The man might be "deliri-
ous," an "impostor" or a "cynic," a "fanatic," or just "sad" (these are also words that
Borges uses). But the doll represents, like the icons of religion, the body which at
the same moment is being mourned in Buenos Aires. The character of the rep-
resentation is grotesque because of the incommensurable distance between the
sumptuous catafalque set up in the Congreso and the hardscrabble misery of the
ranch, with its four candles. Nothing unites the scenography of state that the Con-
greso wake offers, the rows of men and women under the July rains, with this final
village of Argentina in Borges's story. The imitation of the wake could simply be a
joke, an abuse of the gullible. Perhaps it was only that.

Nevertheless, the story needs these desperate old women, these goggle-eyed
children, and these peasants, in order for this deception, or this hallucinatory but
sincere representation, to take place. Before the eyes of these people, the blonde
doll is no longer a poor imitation, a sinister miniature of the woman who entered
into immortality. It is her icon, an object which does not have its same dimen-
sions but which suggests them by a conventional stylization; it makes the cere-
mony of the wake possible because the doll's presence imitates, in a rough and im-
perfect way, the dead woman—as in the manger, where the doll which represents
the Child is not Jesus, but neither is it a parody, not even in the roughest versions.
The blonde doll is *somehow* Eva without being her. It is there for Eva, for those who
have no other form for rendering her homage or making their prayers before her.

In the Buenos Aires of 1952 a multitude marched past Eva's closed coffin, kissing
or touching the glass that let them see the face of the deceased. Others, further away
and more wretched than the ones who waited for their moment in Buenos Aires,
recognized in the doll what one recognizes and venerates in a Virgin of wood or
stucco. Piously, they did not see in the doll a joke, but rather an iconic representation
—an object hitherto inert that has received a breath of sympathetic magic.

Borges's anti-Peronist story speaks this truth. Nevertheless, the doll is also a
grotesque imitation, which will never achieve the sublime appearance of the em-
balmed body of Eva, and it demeans or shrinks the majestic scenario of her wake.
The doll is the Eva of the poor who could not even make it to Buenos Aires to see
her corpse. Evita would not have rejected the indigence of this moment. Of the
people who attended the fictive wake, Borges writes, "many were not satisfied with
coming just once."

*Translated by Patrick O'Connor and Dianna C. Niebylski*

## Notes

*La pasión y la excepción* (Buenos Aires: Siglo XXI, 2004) has not yet been translated. These excerpts
constitute the first published English translation of the book's chapter on Eva Perón.

1.  Aramburu had been the head of the military junta that had deposed Perón in 1955, and that
    had ordered the removal and disappearance of the embalmed corpse of Eva Perón, who had

died of cancer in 1952. The Montoneros, new to the Argentine political scene in 1970, were a radical and yet also heterodox-Catholic leftist guerrilla organization. One of their demands in exchange for the return of Aramburu was that the military return the corpse of Evita to the Argentine people. When the Montoneros realized that their hiding place had been compromised, they killed Aramburu. Evita's body was not returned to Argentina until 1975, after the return to power and subsequent death of Perón, before the next and more repressive military junta ousted Perón's vice president and widow, Isabelita, in 1976.—Trans.

2. The Peróns regularly referred to reactionary elements of the bourgeoisie as "gorillas"; the term was also used by the Peronist youth of the 1960s.—Trans.

3. After much public vituperation by the newspapers and other organs that the Peróns had censored, the Peronist Party, also known as the Justicialist Party, was banned by the military government, and it was forbidden to speak of them in public in any way.—Trans.

4. Victoria Ocampo, the wealthy Argentine intellectual who was friends with Borges and founded the literary magazine *Sur*, was elitist and fiercely anti-Peronist; at the time and in retrospect, Victoria and Evita have often been portrayed as representing opposite visions of Argentine society.—Trans.

5. *Mis grasientos*, "my grimy ones," was an insult that Eva turned into a (far more colloquial) term of affection along the same lines as the better-known *descamisados*, "shirtless ones," used by Perón.—Trans.

6. Rodolfo Walsh condensed these meanings into the 1963 story "Esa Mujer" (That Woman); Tomás Eloy Martínez amplified them into the 1995 gothic *Santa Evita*. On the occasion of the fiftieth anniversary of the death of Eva Perón, *La Nación* published a synthesis of all of the information, clues, and inferences also authored by Eloy Martínez (2002): "La tumba sin sosiego" (The Unquiet Grave).

7. The doctor who embalmed her gives numerous details (Ara 1996).

# From Korda's *Guerrillero Heroico* to Global Brand
## Ernesto "Che" Guevara

*J. P. Spicer-Escalante*

> What makes an iconic photograph? What are the attributes of an image that can convey the *idea* of a political leader, as well as just their physical features?
>
> Andrew Roberts, *Postcards of Political Icons* (2008, 6)

> An icon, activated, becomes a banner, a rallying point.
>
> David Kunzle, *Che Guevara: Icon, Myth, and Message* (1997, 26)

We've all seen it. It's almost impossible to *not* have viewed it somewhere along the way. One of two photographs furtively taken of the subject—he was not the primary photographic objective that particular March day—the original image that you probably *have never seen* is found in frame forty of the roll of Kodak black-and-white Pan-X film that the photographer shot. Its twin-like image—frame number forty-one—was taken from a vertical perspective. Both were captured with a Leica M2 through a fixed focal-length ninety-mm lens. That day the photographer would continue to shoot photos of his two famous subjects for that day: Jean-Paul Sartre, Simone de Beauvoir, and the rebel leader who was not yet famous but would soon be: Fidel Castro. Yet in frame forty—the one you've seen even if you *haven't seen it*—the jutting profile of another young rebel bursts into the image from the left. Faint wisps of palm branches seal the image from the right, framing the subject dead center in the famed horizontal shot. The image's flat gray tonal lines belie the fact that the locus of the capture was, in reality, a Caribbean port city on an early spring day. The cropped version of the photograph in question is the more famous of the two images, and the one that is most readily recalled. The photo I refer to is none other than the endlessly reproduced "Che" Guevara image taken by Cuban photographer Alberto Díaz Gutiérrez (a.k.a. Alberto Korda). You may have seen it in black and white or in Pop Art, Warholian color. Its footprint is simply too deep to be ignored.

The image captures a resolute-looking man in his early thirties, with unkempt hair and an untidy beard, wearing a monotone, metallic-star-adorned black beret.

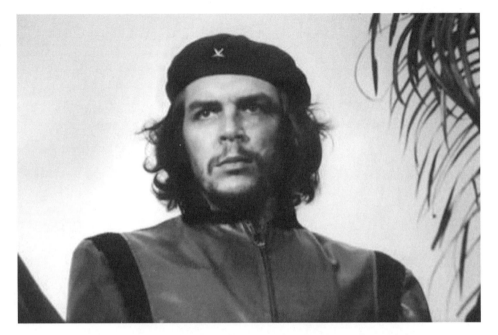

The world's most iconic photo. Che in Havana on March 5, 1960. It was later titled
*Guerrillero Heroico*. Photo by Alberto Díaz Gutiérrez, a.k.a. Alberto Korda.

His penetrating eyes peer out of the image in an unfathomable, almost mystical,
gaze. Striking an *un-posed* pose, his body braces itself in a defiant, angular stance.
While the photographer would later state that the subject was "encabronado y
doliente" (Ziff 2006, 15), you can't really tell if he's *angry and pained*. What is easier
to see is that he appears to be a man on a mission—one that you may already ad-
mire or detest. You are, however, unlikely to be indifferent to it.

    Korda's photograph is indisputably one of the most enduring iconic images
of Latin American history and popular culture. Largely because of it, Che's trans-
national and global cachet has remained current for half a century.[1] Whereas
Guevara's revolutionary actions guaranteed his inclusion in the annals of Latin
American history, Korda's iconic photo made Che a household word on a global
scale, and it remains so to this day. At the same time, the Cuban photographer's
image is a manifest illustration of the intertwined relationship between press pho-
tography and the contemporary popular icon. Although the famous shot eventu-
ally acquired the captive moniker *Guerrillero Heroico*, no caption is needed for it.

    The principal objective of my essay is to trace the origin of Che's iconic fame
and to tease out the various meanings attached to his symbolic image. Accordingly,
my essay does not focus on how historians themselves have dealt with the real-
life doctor-cum-rebel but on the process of signification that transformed Guevara
into the popular transnational and trans-historical icon we know simply as "Che."[2]
Following a brief discussion of the link between photography and iconicity, I begin
my analysis of Che's iconic status by establishing the relevance of 1993 as a water-
shed year for contemporary Cuba and for Che the *revolutionary* icon. That par-
ticular year marks the resurgent ascendancy of Guevara in the context of a Cuba
struggling to regain its bearings after the end of the Cold War. I then trace back

through what could be called the "pre-history" of Guevara's iconic status, start-ing with the *intrahistoria* of the original image that unwittingly immortalized him and now serves as a backdrop for myriad manifestations of Guevara as icon. From there, I map out the process through which the Guevara icon has been later (re) constructed, postmortem, commenting upon the changing "readings" to which it has been subjected between the tumultuous 1960s and the present globalized era. My focus subsequently underscores how the iconic Che has lately become a mere global "brand" to be consumed and exchanged, now devoid of the ideological fer-vor that inspired him and his first followers alike. As I hope to demonstrate, the relevance—and simultaneous *irrelevance*—of Che's lasting iconic presence is due to the fact that Guevara is ultimately a protean signifier whose significance can be culturally transformed and mass-produced to various ends, hence voiding the original *historical* figure's original *ideological* engagement.

## Icon, Photographs, and Mechanical Reproduction

In its remote origins, the term "icon" refers to a revered religious relic. Within the context of an increasingly visually oriented contemporary aesthetic, however, the notion of the iconic carries a broader and looser connotation. With few exceptions, contemporary icons have a more worldly identity than their predecessors, and that identity distances them from the term's original and defining *sacred* aura. Within the context of an increasingly secular understanding of human existence, the image-making capacity of contemporary photography has been fundamental in re-semanticizing the iconic image. Moreover, unlike artisans of the early Christian era who carved wooden icons for Orthodox Church altars but who (supposedly) did not seek to influence the faithful's view of the holy saints or Virgin in the pro-cess, contemporary press photographers like Korda are modern-day photo-smiths intimately involved in the process of icon creation and transformation. Given their capacity to convey potent and often multi-layered responses, photographic images of popular icons aim to provoke powerful and often visceral reactions from view-ers. At least some of the time, the images seem to reach deep to our most profound aspirations, desires, fears or ideals.[3] At times these images can provide us with a sense of community as well as belonging, hence magnifying the hold they have on our more superficial sense of self.

Part of their power resides in their very reproducibility. Unlike Benjamin, who saw in the reproduction of works of art the loss of aura, Roland Barthes observed in *Camera Lucida* that part of the power of famous photographs resides in the fact that they reproduce "to infinity what has occurred only once" (1980, 4). The sheer mass production of iconic photographic images is a testament to the power of these images to speak to multimedia-obsessed contemporary societies much in the same way that ancient religious relics held powerful sway over the faithful. In an impermanent and secular world, iconic photographs anchor our existence much as religious likenesses did in a previous age.

The Pulitzer Prize-winning image of a terrified Vietnamese girl fleeing her vil-lage after a US napalm attack recalls the trauma of the Vietnam War; the photo-graph of the Chinese man who posed a human barrier to government tanks in

Tiananmen Square serves nearly two decades later as a symbol of individual courage and conviction against a powerful political and ideological regime. Iconic photographic images like these, as well as so many others that inhabit our memory, like their chronologically and spiritually more remote analogues, "always seem to stand above the welter of news, debates, decisions, and investigations. They have more than documentary value, for they bear witness to something that exceeds words" (Hariman and Lucaites 2007, 1–2). In *No Caption Needed: Iconic Photographs, Public Culture, and Liberal Democracy*, Hariman and Lucaites note that, once ubiquitous, iconic images can become "[o]bjects of contemplation," evoking or standing for "the aura of history, or humanity, or possibility" (2). By the same token, they also note that the intimate relationship between photography and iconicity derives from the fact that iconic photographs, like religious icons, "work in several registers of ritual and response" (1).

## Revolutionary Turmoil and Resurrected Icons

In my opinion, the retelling of "Che's" iconic story begins, of course, with the resurrection of the Argentine doctor-cum-revolutionary during Cuba's "período especial," a label that refers to Cuba's state of near economic collapse throughout the early 1990s. As a result of the fall of the Berlin Wall and the demise of the Soviet Union, Cuba found itself submerged in the worst economic nightmare it had seen since the early days of the Revolution, when foreign investors fled the island and the United States imposed its quickly felt embargo. Beginning in 1991—after decades of economic and military support from the Soviet Union and other COMECON satellite nations—Cuba was quite suddenly thrust into the brave new world of post-Cold War politics. As *Village Voice* journalist Marc Cooper noted in a July 1991 dispatch from Havana: "The disappearance of Cuba's Eastern European trading partners and the spiraling economic turmoil in the Soviet Union have landed staggering body blows to the island nation's economy. Soviet petroleum deliveries are down . . . and the rickety Cuban productive machine seems to be grinding toward a dead halt. Fidel is calling it a 'special period'" (1994, 82).

Cooper's interviews with ordinary Cubans tell the tale of scarcity and sheer anxiety that characterized the island after the fall of the Soviet Union in December of 1991: "Ordinary Cubans are calling 1991 the roughest economic times since the onset of the American trade embargo. . . . Fuel is scarce. . . . The next three hours are filled with talk of food. How we made do the night before, how we will fix what we have for dinner tonight. There's just this anxiety about food like never before . . ." (1994, 82).[4]

Following a Cuban tradition set in place by Fidel Castro, on the annual anniversary of the Revolution, each new year is feted with a specific title to commemorate the State's achievements for that period. The austere label attached to 1993 was *Año 35 de la Revolución*, a telling sign of the fact that there was little to celebrate other than ideological and bureaucratic continuity. In retrospect, a more appropriate title would have been *Año Punto de Inflexión*—the Year of the Inflexion Point—as it proved to be a crucial swing year in the resurgence of Ernesto "Che" Guevara's iconic cachet in Cuba's foreign tourist-packed beaches, and soon beyond them.

The Argentine-born Cuban rebel *comandante*—assassinated by the Bolivian Army with C.I.A. assistance in the remote Bolivian village of La Higuera in October of 1967—was rehabilitated as an icon of ideological stalwartness in the face of dire hardship, and this was clearly an orchestrated move on the part of the ruling party to focus the nation's attention away from the mundane and back onto the idealistic. In any event, the resurgence of "Che" became an ideological smoke-screen to distract hungry and jobless Cubans from the stark reality of their new economic duress. Another diversionary strategy put in place shortly afterwards was the first "official" publication of Guevara's *Notas de viaje* for a Cuban reader-ship in April of 1993. Later to become the primary source of Walter Salles's 2004 film *The Motorcycle Diaries*, the travelogue unequivocally points to its young au-thor's heightened level of social consciousness in the face of economic, political, and physical hardship.[5] While Guevara's 1952 South American journal notes had been used to garner revolutionary fervor during his own lifetime—he penned nu-merous works during his tenure as a government leader—the message behind the government-sponsored publication of the memoirs in 1993 was neither subtle nor indirect. Within the context of 1993 Cuba, this message was "ideology, über alles."

The 1993 publication of *Notas de viaje* provided a unique opportunity to cash in on Che as a largely unblemished and hence still valid revolutionary icon for long-suffering Cuban and non-Cuban supporters of the Revolution. The renewed at-tachment to his image and the many things it came to mean to so many also served to detract attention away from the public uprising and protests that took place in Havana on August 5, 1994. Commenting on the phenomenon, author Patrick Symmes notes succinctly: "Dead for more than thirty years now, Che has become ever more useful . . . his image has been appropriated for political, economic, and even spiritual purposes" (2000, xvii). Without a doubt, Che's rehabilitation was greatly aided by the appearance of Korda's larger-than-life image of the rebel on the walls of the Ministry of the Interior and gazing confidently over Havana's *Plaza de la Revolución*.

To be sure, Guevara's iconic presence had been a cornerstone of revolutionary ideology since 1967, and his image had been used as a tool of State propaganda well before the 1990s. As Hernández-Reguant notes, "a principal icon of the Cuban revolution and anti-colonial movements worldwide, Che Guevara has been the ob-ject of state worship since his death in 1967" (2002, 254). Yet in the early 1990s, when the Cuban people were struggling to survive largely by finding ways to eke out a living on the black market, through the sex trade, or by risking their lives as *balseros* hoping to reach the coast of Florida on mostly homemade boats, Guevara's revival, with his spectral presence overseeing the Plaza, was meant to loom even larger than during earlier decades. More than ever, Castro and his political ma-chine were reinstating Che as the symbol of the *New Man* in a neoliberal era: one oblivious to his own basic needs in his fervor for promoting economic equality and social justice.

In the 2001 *New Yorker* article titled "The Harsh Angel," well-known chronicler and journalist Alma Guillermoprieto notes the timing of the government's decision to reissue the *Notas de viaje* (86).[6] Similarly, on the well-orchestrated promotion of Che in Cuba during the early 1990s, art historian David Kunzle has observed that "internally, the image of Che challenges social isolation and elitism, embodying an

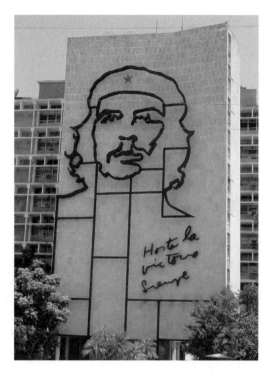

The Korda-inspired image of Guevara peers out over Havana's *Plaza de la Revolución,* from the façade of the Cuban Ministry of the Interior building. © J. P. Spicer-Escalante

egalitarian ideal, and an ever-present reproach to certain trends of the 1990s: dollarization of the economy, 'tourist apartheid,' and other compromises with capitalism. The Cubans see in Che not only the guerrilla hero, the government minister, the revolutionary diplomat, and intellectual, but also the man who systematically engaged in voluntary manual labor—a worker like themselves" (1997, 24).

Whereas both 1968 and 1997 had been linked with Guevara's persona and legacy within the Cuban Revolution's chronological nomenclature—the *Año del Guerrillero Heroico* and the *Año del Treinta Aniversario de la Caída en Combate del Guerrillero Heroico y Sus Compañeros,* respectively—it is conceivable that without the Cuban government's rehabilitation campaign of 1993, his iconic stature might not be as recharged today. But it was and is Korda's image, defiantly staring over the Cuban people from the Ministry of the Interior, that then, as now, held the mystique together.

## Inauspicious Beginnings

Korda's "Che" photograph has been dubbed "the most famous photograph in the world and a symbol of the twentieth century" ("Che Guevara Photographer Dies" 2001). It is, unarguably, "the most reproduced, recycled and ripped off image of the twentieth century" (Holmes 2007). As author Michael Casey relates in *Che's Afterlife: The Legacy of an Image* (2009), the occasion that led to the iconic photograph of Guevara was a state-organized funeral march to commemorate the lives of the victims of the *La Coubre* explosion in Havana.[7] The funeral spectacle had included not only the intellectual elite of the Cuban Revolution but the then arch-famous French existentialist philosopher and public intellectual, Jean-Paul Sartre, and his

equally famous novelist-philosopher companion, Simone de Beauvoir. After capturing both Castro and his foreign guests, Korda's lens found Guevara. His *coup d'oeil* was fortuitous:

> Then someone else appeared in his viewfinder. It was the central bank president, who was standing a little off to the side of Castro. Braced against the cold, the man was dressed in a leather bomber jacket zippered to the collar, and he wore his trademark beret on his head. Before sitting, he paused, an unsettled sky behind him, and looked out intently across the crowd. Little did he know, he was staring straight into the firing line of Korda's trusty Leica camera. . . . The photographer depressed the trigger. . . . Korda then turned his camera on its side and captured a subtly different image. Then the man sat down. The moment passed. (Casey 2009, 27)

The editors of the Cuban daily *Revolución*, to whom Korda submitted his images that evening, printed neither of the two images of Guevara in the next day's edition of the newspaper. Casey speculates that in light of Castro's fiery presidential address and the prominence of his French guests, the image of Che standing on the sidelines seemed hardly noteworthy.[8] He also argues that the image was not immediately recognized for its potential iconicity. The photograph would only be reproduced a year later, and years passed—"it was almost a full decade before most people knew of its existence" (Casey 2009, 28)—until it would become recognizable to Cubans and others.[9]

When the image that would someday become "the most famous image in the world" did appear in print (also in *Revolución*), it was used as promotional material for a public lecture that Guevara was to give on April 16, 1961, at Havana's "Universidad Popular." The conference had to be cancelled, however, since on the scheduled date Cuba was attacked by a group of disaffected Cubans inadequately supported by US funding in what became known as the short-lived Bay of Pigs invasion (Ziff 2006, 41). The image was reproduced in a second advertisement for the rescheduled talk on April 30, 1961, without repercussion. After that, it seems to have languished for years in Korda's studio.[10]

The long delay eventually worked to the photo's, and the icon's, benefit, as the youth who came of age in the intervening years adopted not only Che's tousled look but also his unconventional political philosophy. Once again, Casey is instructive on this point:

> Ironically, [its] also-ran status ultimately worked in the photo's favor, at least in terms of its effect on the world. The delay meant that the image, years later dubbed *Guerrillero Heroico* (Heroic Guerrilla), enjoyed a perfectly timed global launch in late 1967. At that moment, a generation of strong-willed youth was rising up in rebellion across the industrialized West, while their contemporaries in the third world were taking up arms in the hope of replicating Cuba's revolution. With its sudden appearance on the world stage at that time, Korda's image became the defining icon of that generation. (2009, 28)

Ironically, too, the process by which the photograph came to define the late 1960s generation parallels Guevara's actual demise. After the failed attempt to export the Cuban Revolution to Africa, Che returned briefly to Cuba to train Cuban rebels

for a planned insurgency in Bolivia. In Bolivia he was captured near his rebel camp on October 7, 1967, and executed, two days later, in the village of La Higuera. Caught up in the tide of social change that enveloped the late 1960s in Europe, Latin America, and the United States, the social agitators and student protestors who sought radical change were looking for an image through which to identify their anger at the Establishment, if not always with a clear cause. They found it in Korda's "matrix."

## Photo Editing and "Che" as (Re)Constructed Icon

The "matrix photograph" (Kunzle 1997, 58), or "Korda matrix," as it is also known, is the product of photographic editing. Korda cropped out both the wisping palm branches and the silhouette of another man in the image—Jorge Masetti, an Argentine in attendance at the *La Coubre* funeral (Casey 2009, 34–35). This crucial step in an ongoing process of icon-making might be seen as only the beginning of the long history of iconic "denaturing" of the person behind the myth. According to Trisha Ziff, in 1967 Korda gave two prints of the cropped image to Giangiacomo Feltrinelli, a wealthy Italian publisher and supporter of the Cuban Revolution (2006, 17). On returning to Italy, Feltrinelli published a poster of the image and disseminated thousands of copies of it. The image then began to appear with the copyright of Libreria Feltrinelli and no reference to Korda, which would not have been unusual at the time. Shortly before Che's death and Feltrinelli's mass marketing of the image, however, the same cropped photograph appeared in an article on Che published by *Paris Match* in August 1967. According to Ziff, it is the *Paris Match* printing of the photograph that launches the photo's rise to fame.[11] The image was later co-opted from 1968 onward by protestors in Europe, the United States, Mexico, and other locales as a sign of rebellion and counterculture. Footage of Black Panther protestors marching with Che's increasingly famous image in the United States of the late 1960s (as shown in the documentary *Chevolution*) is an illustration of how the Korda matrix simultaneously ushered in the age of the political poster as an aesthetic genre. In the ensuing decades, the political poster became a leading medium of protest (Kunzle 1997, 21–37; Ziff 2006, 41–57; Wallis 2006, 23–31), and the Korda-inspired likeness of Guevara exhibited the medium's potency as a graphic sign of rebellion.

The ensuing popularity of the image is also a prime indicator of how far the original Korda matrix was becoming increasingly removed from its historical reality. This image's passage from protest icon in streets around the world to gallery exhibitions signals yet another step in Che's iconic evolution. Indeed, the frequent appearance of different iterations of the Korda matrix in the Pop Art world begins with the appropriation of the photo by Irish artist Jim Fitzpatrick as part of a London exhibition titled "Viva Che" held at the Arts Laboratory in the spring of 1968 (Ziff 2006, 21). In spite of Fitzpatrick's ideological proclivities in favor of social change, his use of Che imagery for marketing purposes only increased the image's and the icon's cachet. The aesthetic process fomented by Pop Art further removed the Korda photo from the reality of the social conflict from which it sprang. Without a doubt, the later transformation of the matrix into a monothematic, multi-

colored, Warholian bricolage—attributed to Gerard Malanga in 1968—is a testament to the original image's journey from its ideological referent toward the patently bourgeois and materialistic world of Pop Art.[12]

The growing postmodern sense of appropriation and reproduction that Pop Art displays—which also mimics and parodies the capitalist notion of repetitive assembly and economies of scale—signals clearly the eventual transformation of Korda's matrix into a vacuous stereotype.[13] As University of California–Riverside Art Museum director Jonathan Green notes, "Pop's depersonalization and standardization simplified Che's image and helped align him with the masses, at the same time certifying his image as everyman" (quoted in Ziff 2006, 81). The resultant condition is, ultimately, a further degree of abstraction that characterizes Baudrillard's third stage of simulacra. In this stage, argues Baudrillard, the reproduced image "masks the *absence* of a profound reality" (1994, 6). Although the denatured image stakes a claim to represent the original image, no true representation actually occurs—or can occur, for that matter. The distancing from the particular context of conflict and rebellion can be seen in Pop Art's "reduction of the real world [that] provided the perfect vehicle for distancing the image from the complexities and ambiguities of actual life and the reduction of the political into stereotype"; as Green astutely points out, "Che lives in these images as an ideal abstraction" (quoted in Ziff 2006, 81). In other words, Che as icon became predominantly linked to arbitrarily related images—or personal experiences—with which the origin(al) Che has no profound relationship.[14] Brian Wallis similarly notes that "Years after his death, Ernesto 'Che' Guevara is now more famous than ever." Like other Che historians and commentators, Wallis too points to the Korda photograph as the one essential and invariable element in Che's enduring fame: "Che's celebrity lives on because of a single iconic photograph, one that is so ubiquitous that it can be seen almost daily, anywhere in the world, reproduced on everything from baseball caps to computer mouse pads" (2006, 23).

As noted earlier, the generic transition from political poster to art object freed the Korda matrix for future manipulation and abstraction into multiple forms of cultural production, including cinema, theatre, and literary texts. The May 1969 release by Twentieth Century Fox of Richard Fleischer's *Che!*, starring Omar Sharif as Guevara and Jack Palance as Castro, surely assisted in the metamorphosis. The film, deemed a "flop" and quickly removed from theaters after its initial release (Sellin 1997, 99), tried to capitalize on the fame of its big-name actors while attempting a semblance of historical objectivity in its depiction of a polemical and conflictive historical figure during the heated post-Tet Offensive phase of the Vietnam War. As Christine Sellin notes: "in the very failure of this film lies a historical lesson: the story of its making [ . . . ] is a study in how a major studio, a group of notable filmic myth makers harnessing big stars, aimed at what they claimed as 'objectivity': but in giving cinematic life to their vision of Guevara, they found themselves fighting an ideological war on a battlefield of pixels" (1997, 99).

Yet the movie's failure opened the door to numerous later depictions of Che as an iconic but multivalent character on a transnational stage. Vicente Leñero's *Compañero* graced the Mexico City stage in 1970, and subsequent representations of Guevara have appeared in musical and theatrical productions, films, and novels

Korda-inspired "Che" mural in the San Telmo neighborhood of Buenos Aires, Argentina.
The mural parodies Guevara's statement that a "true revolutionary is motivated by love"
by suggesting the use of condoms as a way to practice "safe sex" in an AIDS-ravaged era.
© 2006 Daniel Alberto Rugna

over the course of the past four decades. Noteworthy examples of this phenomenon are Andrew Lloyd Webber and Tim Rice's *Evita* concept album (1976), which led to the theatrical Che in *Evita* (1978); Alan Parker (1996), Walter Salles (2004), Josh Evans (2005) and Steven Soderbergh's (2008) cinematic Che; and John Blackthorn's suggestive Che character in the novel *I, Che Guevara: A Novel* (2000) as well as the ethereal Che in Ana Menéndez's *Loving Che: A Novel* (2003). Charged with different dramatic/novelistic tasks,[15] Che, the *dramatis persona*, as arbitrary abstraction of the original Korda image, is a fitting extension of Pop Art's tendency toward appropriation and reproduction, while also serving as a stereotypic distancing of icon from reality.

## The Revolutionary in the Global Market: From Reproduction to Parody

In Baudrillard's *For a Critique of the Political Economy of the Sign* (1981, chapters 2, 3, and 9, in particular), the author explains the role of the media in general and advertising in particular in the relationship that is fostered between commodity and consumer. Baudrillard recognizes the aura created around an object by contemporary advertising and the ways in which ads encourage consumers to construct their own agency through the auratic object of desire or identification. This theory helps explain the ongoing commercialization of a plethora of Che-related products

for largely middle-class, capitalist consumers. One can also easily acquire Korda's Che *branded* on "posters, watches, skis, lava lamps, skateboards, surfboards, . . . beer-huggers, lighters" (Fontova 2007, xxix) without having to identify with the Cuban rebel's original ideology. In fact, consumers who choose to construct their personal identity through Che paraphernalia—from the requisite Guevara T-shirt to a rifle-toting Che bobblehead doll—can "Find all their Revolutionary Needs" in the virtual marketplace at *www.thechestore.com*. In our post-capitalist consumer culture, Guevara becomes a sort of twenty-first-century inversion of the eighteenth-century *fétiche*, as contemplated by Charles de Brosses, as well as an example of Marx's notion of commodity fetishism where social relationships become objectified relationships between both commodities and money.

Within this postmodern framework, consumers' understanding of Guevara as an ideologically driven doctor or a revolutionary ideologue becomes unimportant, even irrelevant, to their ability to identify with a commodified Che. David Kunzle suggests that "putting Che on anything from a T-shirt to a lapel pin" is really just business capitalizing on an existing nostalgia for revolution (1997, 21). Referencing the different adaptations of the Korda image that appear in the Christian appropriation of Che in the small Bolivian town of La Higuera where Guevara was executed, Kunzle points to the mixed message implied in the baptism of Guevara as "St. Ernesto de La Higuera." Che imagery in the village appears with contradictory dove symbols and rainbows in the background or foreground, in spite of Guevara's manifest atheism and his embrace of violence as a path to social justice (1997, 78–87). Yet this dissonance too, notes Kunzle, is part and parcel of the postmodern consumer's none-too-binding identification with icons of his or her choice:

> Wearing Che on your chest does not necessarily mean bearing him in your heart. The habit does not make the monk, nor the Che necklace the revolutionary, any more than a statuette of Jesus makes the Christian. A symbol should be the outward and bodily sign of an inward and spiritual grace but often is not; religious and political reformers alike have long been disturbed by the dissonance between outward show and inner substance. (1997, 21)

In this final phase, argues Baudrillard, the image comes to have "no relation to any reality whatsoever: it has become its own pure simulacrum" (*Simulacra* 6). Che exists as a parodic counter-statement of himself. Here the parody implies some degree of prior knowledge of the Guevara legacy but no ideological commitment to that history. Thus, we see T-shirts with Korda's Che wearing a Korda's Che T-shirt, Homer Simpson wearing a Korda-inspired T-shirt of Homer Simpson striking a Che pose in a Guevara beret and beard, or even New Yorker cartoonist Matthew Diffee's 2004 image of Guevara wearing a Bart Simpson T-shirt. In today's obsessively consumerist and parody-mad culture, even Guevara can be easily turned into a for-profit cause. In the ultimate ironic reversal of the revolutionary's rebel fate, the global market co-opts the communist rebel as a marketing ploy.[16]

Yet given our understanding of the ambivalence and ambiguity of postmodern signs, one can never be sure if the use of the Korda matrix image on T-shirts, bandanas, graffiti-strewn walls, a *Rage Against the Machine* album cover, or in soccer stadiums the world over, stems from Che-inspired acts of resistance and rebellion

against neo-imperialism and its attendant late capitalism, as a generic act of resistance and rebellion against any hegemonic authority, from the Left or the Right, as an *adhesive* act subject to the precepts of some sort of perceived "guerrilla chic," or simply as a blunt tool with which to create one's personal identity, whatever it may be. In other words, within a postmodern world, Che the icon becomes little more—but little less—than a dense visual text open for interpretation from an unending number of perspectives, with the concomitant danger that condition implies in terms of signification.

## Notes

1. To state Guevara's iconic relevance seems to be uttering the self-evident. It is surprising, therefore, to see Guevara *not* included in Nicola Miller's recent analysis of Latin American icons. Whereas she does include icons with their corresponding iconic "values"—José Martí (independence), José Enrique Rodó (spirituality), José Carlos Mariátegui (revolution), Gabriela Mistral (education), Diego Rivera (epic artistry) and Gabriel García Márquez (marvelous reality)—it seems that Guevara as an icon, in many ways, could embody virtually all of these aspects in different ways. Her oversight in the case of Guevara leaves a prime void in the identification of Guevara as an icon, especially given her belief that "an icon is not a passive symbol, but one which in itself is deemed to be a touchstone of transformative power" (Miller 2003, 62).

2. Guevara's biography, like that of any mythical personage, is fraught with lore and often lacks objectivity. Patrick Symmes sums it up best by stating, "Despite the best efforts of biographers to set down a factual account of Che's life—and the best efforts of the Cuban government to curate an alternative, more palpable history—the myth of Che is essentially a living, oral tradition, an amalgam of a thousand fables, some of them true, others invented" (xvii). I therefore cautiously remit the reader interested in Che's biographical details to the abundant resources available, including but not limited to Jon Lee Anderson's *Che Guevara: A Revolutionary Life* (1997), Jorge Castañeda's *Compañero: The Life and Death of Che Guevara* (1998) and Paco Ignacio Taibo II's *Guevara, Also Known as Che* (1999). Documentary films such as Maurice Dugowson and Aníbal de Salvo's *El Che: Investigating a Legend* (1997), based on the 1997 book by Pierre Kalfon, *Che, Ernesto Guevara, una leyenda de nuestro siglo*; Manuel Pérez's *Che Guevara donde nunca jamás se lo imaginan* (2004); and Douglas Duarte and Adriana Marino's *Personal Che* (2007) are also sources of biographical detail.

3. For a discussion of the relationship between photographic messages and press photography, see Barthes (1980).

4. Frequently print reporters, not academics, are the ones reporting on specific, first-hand conditions in Cuba. This is most likely related to the fact that US travel restrictions to Cuba allow for more regular travel to the island by journalists who cover Latin America, as well as a certain degree of impunity because of their journalistic credentials.

5. Salles also tapped Guevara's travel companion, Alberto Granado, author of the 2004 *Traveling with Che Guevara: The Making of a Revolutionary*, as a consultant to the film.

6. This article made no secret of Guillermoprieto's ambivalence toward Guevara's ideology and his *modus operandi*: "The slogans that defined those furious and hopeful times—'Two, Three, Many Vietnams!' and 'The First Duty of a Revolutionary Is to Make the Revolution'—were Che's slogans." Guillermoprieto leaves no doubt, however, as to the powerful pull of Che's iconic seductiveness (2001, 73).

7. *La Coubre*, carrying a load of Belgian weapons for the Cuban Revolutionary government, was a French freighter docked in Havana harbor. The ship exploded on March 4, 1960, leading to numerous deaths and injured dockworkers. The incident and the subsequent mass funeral

service were crucial moments in which the Cuban Revolution began to coalesce in a more unified fashion.

8. "Thanks to Castro, whose provocative and history-making speech assured him of front-page press, and the two French intellectual tourists, who were superstars in the eyes of a young government eager for intellectual legitimacy, Che didn't appear in the next day's papers" (Casey 2009, 28).

9. See Barthes, "The Photographic Message" (1980, 20–25) and Chanan (2001). Korda's image has also been the object of study in the realm of documentary film, for example in Héctor Cruz Sandoval's *Kordavision* (2005), Chea Prince's *Imagen del Hombre Nuevo* (2006), and Trisha Ziff and Luis López's *Chevolution: The Man. The Myth. The Merchandise* (2008). I would like to acknowledge my colleague David Richter's kind assistance in bringing to my attention Chea Prince's *Imagen del Hombre Nuevo*.

10. Ziff notes that "Korda made a small print for himself, a cropped portrait, and pinned it casually on his studio wall where it remained for years." She also conjectures that Guevara most likely "would have seen the photograph that would later contribute to his iconic status" (15–16).

11. The essay in which the image appeared, titled "Les Guérilleros," was written by Jean Lartéguy, the pen name of Jean Pierre Lucien Osty, a French writer known for his war correspondence work. According to Ziff, this article and reprinting of the photo "was clearly responsible for the image being seen and disseminated for the first time not only in Europe, but also to a wide European audience" (2006, 19).

12. For a discussion of the attribution of the Warholian Pop Art Guevara, and to see the image itself, see Ziff (2006, 79).

13. Kunzle brings this tendency in contemporary art to the forefront, with respect to the Korda matrix: "Why do the artists return again and again to the face, and so often the same, single 'matrix photograph' of the face? Is it a sense that Korda's version was the result of a unique and (one is tempted to say loosely), divine inspiration? . . . Or is it the 'copycat' instinct of artists today, who feel that art is at its most modern (postmodern) when it adapts rather than invents?" (1997, 24).

14. Following Baudrillard's discussion in *Simulacra* (1994, 6), this phenomenon can be seen in the somewhat indiscriminate use of Korda's imagery without a proper "grounding" in the "profound reality" of Ernesto Guevara. Examples of the use of the image can also be seen in a broad spectrum of environments. The image is commonly used by soccer teams—it can be seen amongst the banners used by *hinchas* of the First-Division Argentine soccer team "All Boys," dubbed the *Peste Blanca*, as well as the "Che Guevara Fútbol Club," based in the city of Jesús María, Córdoba, Argentina ("El club Che Guevara se abre camino en el fútbol cordobés" 2010). The use of his image in public murals is perhaps even more noticeable, if not also more complex (Ziff 2006, 58–68). A well-known mural in the San Telmo neighborhood of Buenos Aires, inspired by the Korda matrix, serves the public good in its message to use condoms. In a tongue-in-cheek semantic twist, nonetheless, it also parodies Guevara's belief that a "true revolutionary is motivated by love"—a sexual connotation that conjugates the "free love" message of the 1960s within the context of a world that suffers from the ravages of AIDS. The appearance of a Diego Maradona tattoo on the arm of the Korda-inspired Guevara image in the mural also serves as an ironic meta-reading of the Korda image due to the veritable fact that Diego Maradona does have a Che Guevara tattoo on his shoulder, and plainly identifies with both Cuba and the Cuban Revolution.

15. Lloyd Webber and Rice's Che serves as conscience and counterpoint to character Evita's narcissism—within the framework of the human rights abuses of the Argentine military government that ruled the nation from 1976 to 1983. Parker's filmic Che repeats this critical discourse, with Antonio Banderas's good looks. Following in Parker's footsteps, Salles, Evans, and Soderbergh take advantage of the virile charisma of Gael García Bernal, Eduardo

Noriega, and Benicio del Toro in their respective replications of Che. Their storylines reflect a filmic tracing of different stages of Guevara's life: romantic visionary (Salles); captured rebel leader who pauses to reflect upon his life (Evans); and committed ideologue, bureaucrat, and guerrilla leader (Soderbergh). Blackthorn's Che is a suggestive, elderly—but intellectually spry—Che who critiques contemporary Cuba and seeks to incite change from the country-side toward the cities, much along the lines of the guerrilla movement that led to the success of the Cuban Revolution. Ana Menéndez's Che is much different. Based upon the reflections of a Cuban American emigrée to Miami who discovers her Cuban mother's old letters—which imply that she had carried on an affair with Guevara in the early years of the Revolu-tion—Guevara has a spectral presence in the plot's background.

16.  In yet another case in point, in an episode of the cartoon *South Park*, the character Kyle wears a Korda's Che T-shirt as a counter-hegemonic gesture in response to the character Cartman's efforts to rid the boys' hometown of "hippies" through his management of a pest-control company.

# Joaquín Murrieta and Lola Casanova
## Shapeshifting Icons of the Contact Zone

*Robert McKee Irwin*

The conflictual "multicultural" context of a contact zone, unlike that of a space that may more easily be symbolically unified through a shared nationality, language, race, or religion, produces a particular kind of iconic figure that tends not to assume fixed forms, but instead takes on palimpsestic qualities. Icons of the US-Mexico borderlands, such as Joaquín Murrieta or Lola Casanova, seem unable to submit to any particular official or hegemonic dictate of what they ought to represent. Embraced simultaneously as protagonists—or antagonists—of popular cultural histories of diverse groups, while held at the margins of or outright rejected by elite borderlands cultures, these figures resist fixed forms. Their legends are constructed differently and produce divergent meanings in the various cultural contexts of the contact zone, and these iconic figures themselves often assume distinct characteristics that are often at odds with traits assigned to them in other cultural contexts within the same region.

Thus, the Joaquín Murrieta known to Anglo-Americans (savage Mexican invader) does not concur with the Murrieta known to Mexican Americans (heroic defender of Mexicans in the face of Yankee racism), and both differ from the image of Murrieta circulating in northern Mexico (embarrassing case of a Mexican criminal)—or the one reterritorialized in Chile by Pablo Neruda, among others (Latin American hero in struggles against Yankee imperialism). Likewise the Lola Casanova of Seri Indian legend (Creole woman who fell in love with and preferred to live among Indians) is not the same one popular among non-indigenous Sonorans (Creole beauty tragically kidnapped by savage Indians), much less the Lola Casanova who briefly became a national symbol in Mexico (catalyst for indigenous assimilation to Mexican national culture). Joaquín, master of disguise, was black haired or blonde; Lola was dark enough to be mistaken for a Seri Indian, or could be represented as a proto-flapper in a drawing by Carlos Mérida, or as a blonde beauty in her film portrayal by *rumbera* Meche Barba.

In the context of the contact zone, legendary figures such as Murrieta and Casanova became known first through word of mouth, and as their stories of racial conflict were discomfiting for borderlands elites, they remained at the margins of official history. The cultural texts through which they were most widely

disseminated were popular novels, films, or songs. Indeed literature and film came to trump history as half-Cherokee author Yellow Bird's *The Life and Adventures of Joaquin Murieta* (Ridge [1854] 1955), the Hollywood film *The Robin Hood of El Dorado* (1936), and Francisco Rojas González's novel *Lola Casanova* ([1947] 1984) and its film adaptation by Matilde Landeta (1949) would eventually become the definitive versions of their biographies, cited by historians when finally incorporated into mainstream historiography decades later—although no single representation would exercise enough authority to silence other conflicting relations of their lives. It is the marginalization of such borderlands icons by elites, and the strength and multiplicity of popular representations in the context of the contact zone from which they emerged that have maintained these and other borderlands icons as shapeshifters to this day.

## Cultural Icons of the Contact Zone

A "contact zone," following Mary Louise Pratt, is a social space "where cultures meet, clash, and grapple with each other, often in contexts of highly asymmetrical relations of power, such as colonialism, slavery, or their aftermaths" (1991, 34). This concept is useful for treating the borderlands, as it provides "an optic that decenters community (and its corollary, identity) to focus on how social bonds operate across lines of difference, hierarchy, and unshared or conflicting assumptions" (Pratt 1993, 88). Iconic figures of the borderlands do not merely signify on one side of a clearly delineated border, but instead travel in and out of different borderlands' cultural contexts, shifting in shape as they do so, and thereby offering insights into the dynamics of cultural relations among different groups sharing the physical or symbolic space of the borderlands, in which they may clash, cooperate, intermix or otherwise relate—or not.

A "cultural icon," following dictionary definitions, is "a very famous person or thing considered as representing a set of beliefs or a way of life" (*Cambridge International Dictionary*), or "a person or thing regarded as a representative symbol, especially of a culture or movement" (*Oxford English Dictionary*). Nicola Miller, who has studied Latin American intellectuals such as José Martí, José Carlos Mariátegui, and Gabriela Mistral as cultural icons, elaborates further, stating that "icons are touchstones of . . . 'intrinsic meaning': they are telling about the cultural concerns of any particular moment in history" (Miller 2003, 75). Borderlands icons, too, resurface at different moments, deployed by different groups navigating the particular dynamics of cultural contact of a given period. However, icons of the contact zone differ in one important way from the more hegemonic icons that Miller studies. She writes that the different constructions and deployments of her intellectual icons "are telling about the cultural concerns of any particular moment in history, but . . . *do not allow for conflict or debate* about those concerns" (2003, 75; emphasis mine). With regard to borderlands icons, the situation is reversed. The deployments of these icons from the multiple cultural contexts in which they signify play out conflicts and debates that are never really resolved. No single group comes to own them, and no one version of their story trumps others. The contact zone, then, is a space of dialogue, often heated, whose dynamics are reflected in the conflictive stories

constructed around the shapeshifting figures of borderlands icons such as Joaquín Murrieta and Lola Casanova.

## The Many Heads and Tales of Joaquín Murrieta

In the early 1850s in gold rush Alta California, a band of Mexicans under the leadership of a shrewd leader putatively named Joaquín became notorious for its bloody assaults on miners and other inhabitants of the region. Many Californian communities lived in a state of terror as daily news stories reported one attack after another, often in multiple regions of the state. Soon a reward was offered for Joaquín's head. In the summer of 1853, Captain Harry Love and a troop of California Rangers set off after the Mexicans, eventually killing Joaquín and his notorious henchman, known as Three Fingered Jack. They beheaded the former and cut the hand off the latter, preserving them in jars of alcohol to display around the state to prove that the Mexican bandits had at last been defeated (see Irwin 2007, 38–90).

This story was initially pieced together from newspaper reports by the half-Cherokee writer Yellow Bird (also known as John Rollin Ridge), author of the 1854 novel that serves as the foundation for the Joaquín Murrieta legend, *The Life and Adventures of Joaquin Murieta*. Since then, his story has been reformulated in hundreds of novels, plays, *corridos*, poems, histories, movies, and other visual representations in the United States, France, Spain, Chile, and Mexico by Anglo-American, Native American, Chicano, Sonoran, Latin American, and even Soviet writers and storytellers, among whom there is no consensus on many important details of the case, and even less so on the cultural meanings Murrieta's legend is constructed to evoke.

Is it Murrieta or Murieta or Muriata or Muliati? Was there only one Joaquín, or were there two, five, or even more? Was Murrieta from the northwestern Mexican state of Sonora, or Chile? Was he dark-haired or blond? Was he killed by Harry Love or by someone else? Or did he escape and flee back to Sonora, where he died many years later of old age? Was his wife named Rosa, Carmela, or Carmen? Did he act out of revenge, desperation, or a sadistic urge to kill? Was his head destroyed in the 1906 San Francisco earthquake, or can it still be seen today?

Borderlands cultural critic José Manuel Valenzuela Arce writes, "Myth is not validated in historical truth, but in its social functionality" (1992, 15),[1] and as María Rosa Palazón Mayoral puts it, Murrieta can be found "wherever an imagination creates him or protects him, or assimilates him and feels represented by him . . . Joaquín is a hub of projections" (1993, 49). Joaquín Murrieta's legend endures as long as the borderlands conflicts it puts into play remain unresolved.

Most representations of Murrieta present themselves as works of fiction, though most claim basis in historical fact. And even texts that present themselves as objective history, including, for example, Hubert Howe Bancroft's *California Pastoral* (1888), brazenly cite Yellow Bird's novel as primary source material (Jackson 1977, xxxviii). Mexican philosopher and essayist José Vasconcelos, in his *Breve historia de México* (1937), went so far as to base his Murrieta on the Hollywood film *The Robin Hood of El Dorado* (1936) (Leal 1999, 63). Other texts freely plagiarize Yellow Bird. Examples include Carlos Morla Vicuña's *El bandido chileno Joaquín*

Joaquín Murrieta. Illustration from *The Life of Joaquin Murieta* (anonymous, published by *California Police Gazette*, 1859).

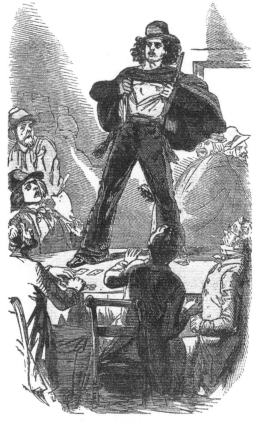

"I am Joaquin! I dare you to shoot!"

*Murieta en California* (1867), which was the first version to switch Joaquín's national origin from Mexico to Chile, and *Vida y aventuras del más célebre bandido sonorense, Joaquín Murrieta* (1904), which brings Murrieta back to Mexico and restores the missing "r" to his common Sonoran last name. Although commonly attributed to Ireneo Paz, this 1904 version was actually only published from his print shop, and its writer/translator/plagiarizer remains unidentified (Wood 1974, 77–78).

While Anglophone newspapers of gold rush California, which rarely gave Joaquín a last name, portrayed him as a menace, Yellow Bird's novel describes the circumstances that led Joaquín to turn to banditry, including the murder of his brother, the rape of his wife, and his own beating and loss of thousands of dollars' worth of gold by racist Yankee prospectors. Joaquín's ability, documented in the newspapers and the novel, to escape authorities due to his alliances with local landowners, his ability to disguise himself as an Anglo and speak unaccented English, and his ingenuity established him as either a fearsome enemy or a superhero. In an emblematic anecdote printed first in the *San Francisco Herald* and later in Yellow Bird's novel, several peaceful-looking Mexicans stopped at a house in Salinas Plains asking for refreshments. They chatted amicably, in English, with their host, who eventually raised the topic of Joaquín's band, asking them if they had heard any news about them back in the placers. One of the Mexicans then dramatically leaped upon the table and declared, "I am that Joaquín, and no man takes me alive" (quoted in Castillo and Camarillo 1973, 47).

The phrase "I am Joaquín" would be repeated in key scenes of novels, plays, and films, and would also be uttered by Joaquín in the many *corridos* that tell his story, from a distinctive first-person perspective. It would be an emblematic phrase for Chicano identity when Rodolfo "Corky" Gonzales employed it as the title and first line of the poem that came to define Chicano identity politics in the late 1960s. This image of defiance and the fact that it seemed that a range of criminal acts were being attributed to Joaquín all over the state, often simultaneously in places hundreds of miles away from each other, led on the one hand to Joaquín coming to represent all Mexicans, and on the other to all Mexicans being associated with banditry. While the Mexican press tended not to report at all on the Joaquín hysteria in the north, a story that all Mexicans were being expelled from Calaveras County, where authorities had agreed on a resolution "to exterminate the Mexican race" and to shoot any Mexicans on sight who refused to comply with orders to leave, attributed to the *San Francisco Times and Transcript* (1/31/53), raised alarm in Mexico City (*El Siglo XIX*, 2/15/53) and Sonora (*El Sonorense* 3/25/53). While the Mexican press rarely mentioned any Mexican bandit by name—indeed Joaquín's name did not appear in the Sonora press at all during his lifetime—its attention to xenophobic violence in the borderlands set the stage for Joaquín to assume the role of just avenger.

Yellow Bird/Ridge's novel is in many ways sympathetic in its portrayal of Murrieta. Yellow Bird was something of an outsider in the United States, for his mixed-race identity and his first-hand knowledge of government abuses committed against the Cherokees, in whose leadership several of his close relatives took part, and his novel captures the injustices suffered by Joaquín and other Mexicans, as well as the violence of Murrieta's band's acts—although most of the worst brutality is attributed to Three Fingered Jack, while Murrieta himself takes on more of the role of social bandit, exhibiting noble characteristics that would be developed further in other representations. As historian Susan Johnson observes, "Once Ridge published his tale of atrocity and its retribution in 1854, Anglo recollections of unprovoked Mexican attacks on mining camps would never again seem credible" (2000, 46). In many *corridos*, for example, Murrieta is not only a victim of Yankee brutality, but also a friend to all Mexicans and Indians, an image fully consolidated by Hollywood in its silver screen adaptation of Walter Noble Burns's 1932 novel, *The Robin Hood of El Dorado*.

From Yellow Bird/Ridge's popular novel, and its equally popular serialized plagiarization by the *California Police Gazette* in 1859, which gave Murrieta more "depraved and bloodthirsty" traits than the original (Streeby 2000, 179), emerged an endless production of popular texts in the Anglophone US, where he became a frequent figure in wild-west novels, sometimes portrayed as a ravaging bandit, other times as a more noble outlaw allied with Anglo heroes, in many ways a model for other romantic borderlands semi-outlaw heroes, including Zorro and the Cisco Kid (see Thornton 2003, 121–24).

While too numerous to mention them all, the endless stream of representations of Murrieta in US Anglophone literature and cinema, even when positive, tends to promote certain racist assumptions, as exemplified in Lydia Hazera's reading of the Charles Snow pulp novel *The Fighting Sheriff* (1929), whose Harry Love character, when faced with the opportunity to execute his archenemy, cries: "'I can't do it! It's

too hellish, I am a white man.' The obvious inference is that 'white men' do not resort to sadistic measures, in contrast to dark-skinned men like Mexicans" (Hazera 1989, 205).

In Chile, the Morla Vacuña edition of 1867 gave rise to a range of representations in which Murrieta's adventures played out tensions in a hemispheric context much broader than that of the US-Mexico borderlands and held implications for US imperialism in Latin America and beyond. Roberto Cornejo Hernández's history text *Los chilenos en San Francisco* (Chileans in San Francisco) established for Chilean readers Mur(r)ieta's Chilean identity. Also in the 1930s, a play titled *Joaquín Murieta* by Antonio Acevedo Hernández located the gold rush legend in a context that evoked not the ghost of Santa Anna but that of South American independence hero Simón Bolívar, as his text exhorts Latin Americans to "unite, move toward the ideals of Bolívar, and form a single and great power that will counteract the actions of all who dominate unreasonably" (quoted in Pereira Poza 2000, 83). However, it is Pablo Neruda whose representation of Joaquín in his cantata *Fulgor y muerte de Joaquín Murieta* (*Splendor and Death of Joaquín Murieta*) is most responsible for making Mur(r)ieta relevant for Chileans. Neruda's combative rhetoric assails "those who razed, enveloped in hatred, and trampled flags of errant peoples" and "those irascible crude warriors who have everything and want everything, and mistreat and kill everything" (1973, 137). Neruda's Mur(r)ieta would be taken up in protest songs by Chilean Víctor Jara, and even as far away as the Soviet Union, where Pável Grushkó wrote the libretto for a rock opera based on Neruda's *Fulgor* (Leal 1999, 62), which transformed Mur(r)ieta into an important figure of peasant resistance there (Figueroa 1996, 7). In recent years the Chilean Mur(r)ieta— and Chileans, along with many US writers, insist upon what Chilean-born scholar Carlos López Urrutia argues is a misspelling, just as he refutes the hypothesis of Murrieta's Chilean identity—has remained alive in his broadly hemispheric context in such novels as Isabel Allende's *Hija de la fortuna* (*Daughter of Fortune*) (1999) and Ariel Dorfman's *Americanos: Los pasos de Murieta* (2009).

Mexican versions of the Murrieta legend, including patchwork stories by historians such as Manuel Rojas, paint Murrieta as a patriot and incorporate him belatedly into nineteenth-century Mexican history. And while early Mexican versions, such as that of Paz, follow US versions in locating the story as "an integral part of the true early history of California" ([1904] 1919, 242), more recent literary representations, such as Carlos Isla's *Joaquín Murrieta*, insist that it "can be considered [ . . . ] part of the history of Mexico" (2002, 152).

The legend has, however, taken on most importance for the Chicano movement in the United States. While *corridos* typically report news and tell stories of legendary figures with a tone of ironic objectivity that sometimes articulates moral lessons through an outsider's (third person) perspective, the Murrieta *corridos* most often are narrated in the first person, allowing Joaquín to declare "I am Joaquín," the phrase that would be repeated in the 1967 Gonzales poem. The Joaquín of *corridos* is more than the Mexican American everyman; he is a survivor. His death and decapitation are not part of the *corridos*' narrative; he is a hero who emerges victorious and defiant. The subversiveness of this image was such that some Mexican Americans were warned "not to sing it in the United States" (Figueroa 1996, 3). Thus, Murrieta enters a constructed Chicano pantheon: along

with Aztec warrior Cuauhtémoc, poet king Nezahualcóyotl, and revolutionary hero Emiliano Zapata in Gonzales's "I Am Joaquín," and later with the Chicano movement's greatest icon, César Chávez, in a mural at the United Farm Workers' Teatro Campesino Cultural Center. Chicano studies scholars such as Américo Paredes and María Herrera Sobek questioned Murrieta's image as bandit outlaw. Herrera Sobek sees "these so-called 'bandits' as revolutionary warriors or heroes of the resistance against the Anglo-Saxon invasion" (1992, 139). The Chicano Alfredo Figueroa, president of the International Association of Descendants of Joaquín Murrieta, recasts Murrieta at the head of an organized movement to "regain California" (1996, 1), whose initial goal was to round up and steal enough horses "to supply Joaquín's liberating army" (6).

## Lola Casanova: A Tale of Captivity—or Borderlands Romance

In February of 1850, Dolores Casanova was traveling from her hometown of Guaymas to nearby Hermosillo along with several relatives when their party was attacked by a group of Seri Indians, who killed some of the travelers and kidnapped others. The Seris, a nomadic people who had never been conquered by Spanish or Mexican settlers and were considered the most "savage" of the indigenous peoples of the Mexican northwest, were being driven from their traditional lands, and assaults of this kind had become common. Lola Casanova did not return home, whether because she died in captivity, because she was simply never freed, or because she chose to stay of her own free will. Her legend has her falling in love with her captor, Seri chief Coyote Iguana, whom she would marry and with whom she would bear several children (see Irwin 2007, 91–143).

While primary sources of the day, including letters from military officers and newspaper reports, imply that Casanova died in captivity soon after this raid, it is more likely that she did survive to bear the children of Coyote Iguana. While she disappears from printed sources for the rest of the century, she is revived beginning in the early twentieth century, first in a history/ethnography of Sonora published in Mexico City by Fortunato Hernández as *Las razas indígenas de Sonora y la Guerra del Yaqui* (1902). In Hernández's account, she appears dressed as a Seri and looking more indigenous than white near a late 1880s Sonoran ranch and tells her story to a servant there, confessing that she chose to stay with the Seris upon the birth of her first son. In this version of her story, she does not necessarily prefer the Seri lifestyle to the Mexican Creole one, nor does she fall in love with an Indian. Instead, she has fallen prey to her maternal instinct; after all, "woman is born a female animal and nothing more" (Hernández 1902, 64).

Mexican writer Juan de Dios Peza, in a review of Hernández's book, immediately repositions her legend as an interracial romance: "the story of the famous Lola Casanova, beautiful woman of the white Sonoran race, and whom her lover Coyote Iguana, Chief of the Seri Nation, imposed on the tribe as Queen" (1902). While her story likely remained alive through oral traditions among whites and Seris in Sonora, Hernández's book and its endorsement by a respected intellectual brought it into a national context, where it began to resurface periodically. For example, in *El Universal Ilustrado*, it appears first in an article titled "Lola Casanova,

la reina de los seris" (2/15/1918) and then again in "Escenas de la vida nacional: una mujer blanca reina de los seris: el rapto de Lola Casanova" (7/8/1920). While the former follows Hernández in attributing Casanova's extraordinary choice to her maternal instinct, now described in more scientific terms as "the complexity of female psychology," the latter provides an interesting new contextualization through its description by Guatemalan-born Carlos Mérida, who had just relocated to Mexico, portraying Lola decked out in 1920s-style flapper gear. This diva Lola was "tall and striking, white, golden haired and blue eyed, . . . a rare beauty" who remained with the Seris due to both "the love she felt for her husband and her maternal sentiments." The story becomes even more glamorous, as Coyote Iguana, too, possesses movie star qualities: "tall, well built, his naked legs, arms and chest revealing a powerful musculature. His copper skin shone with golden highlights. . . . His abundant black hair, falling across his back, was carefully cut at the ends like the long hair of an artist."

This romanticized retelling of the story coincides with a locally published and not well-distributed novel by Carmela Reyna de León, *Dolores o la reina de los kunkaks* (1943), which would initiate a brief period of heightened interest in the Casanova legend. In this novel, Dolores "civilizes" the Seris by introducing Mexican customs, insisting upon living not in "a makeshift hut, but a well organized house" (36), but in this love story, it is not the Seris who hold her captive, but her family in Guaymas, who have her sequestered from her comfy Seri home. There she witnesses the racism her mixed-race son suffers, and the novel ends with her triumphant return to the Seri stronghold of Tiburón Island, where she is joyfully welcomed: "Long live . . . Queen Dolores!" (49). This version would be revived, with some variations, in the 1960s by Sonoran *cronista* Fernando Galaz.

A more typical Sonoran perspective is that of the better-known regional writer Enriqueta de Parodi, who introduces her 1944 recounting of the Casanova legend as "a complicated and dark passage from the history of aboriginal Mexico" (1985, 25). Her Lola is enthroned "by force" by the Seri people, who, in Parodi's view, "will have to be extinguished one day" due to their "legendary rebelliousness, indolence, laziness" (1985, 31). This attitude persisted among many Sonorans until much later, as in Alfonso Iberri's midcentury recounting, which characterizes the event as a "rapto" [kidnapping] in which Casanova stayed with the Seris because she had become "ashamed of her pitiful condition" (1993, 276), and historiographer Horacio Sobarzo's 1981 version, which casts Coyote Iguana as a "troglodyte" and Casanova as "unfortunate" and implicitly stupid (1981, 178–79).

The 1940s indeed was a decade of intensified interest in Lola Casanova. In addition to the two texts mentioned above, Casanova makes an important appearance in two other novels of the *indigenista* school, Armando Chávez Camacho's *Cajeme: novela de indios* (1948) and, more prominently, Francisco Rojas González's *Lola Casanova* (1947). The Chávez Camacho novel offers a creative reconstruction of the life of the Yaqui hero Cajeme, and it is fitting then that he tells the tangential story of Lola Casanova by placing Coyote Iguana, and not Casanova, in the center. Here, Coyote Iguana seduces Casanova, who remains with the Seris out of love for him.

Rojas González, an anthropologist, concerns himself not so much with vindicating Coyote Iguana or the Seris as with promoting his vision for Mexican Indian policy. His Casanova not only fell in love with the strappingly handsome noble

| From the film *Lola Casanova* by Matilde Landeta, 1948. Courtesy of Agrasánchez Film Archive.

savage, Coyote Iguana, but also came to respect his culture. However, she also be-
came an instrument for assimilation, as she introduces ideas of modern medicine
to the Seris and helps facilitate their initiating trade relations with the Mexicans,
which ultimately leads to their relocation to a reservation-like location known as
Pozo Coyote, from which the new generation of Seris would be educated as Mexi-
cans. This vision gained more diffusion with a 1949 screen adaptation by Mexico's
pioneering woman director Matilde Landeta, offering a more glamorized repre-
sentation of the story by casting blond rumba dancer Meche Barba as Lola and the
beefy and handsome Armando Silvestre as Coyote Iguana.

Although Lola became a protagonist on the national stage for this brief period,
in Sonora she was granted little attention by historiographers, who at best would
mention her story as an oddity, citing Fortunato Hernández as their only source.
The discovery of the papers of Cayetano Navarro in 1952 led some historians to
begin reporting that Casanova had died soon after being taken into captivity and
that there had never really been a Lola Casanova, Queen of the Seris, much less a
white woman who renounced the privileges of Creole society to live among the
savages (Córdova Casas 1993, 14).

Meanwhile, research carried out beginning in the late 1950s began to yield the
first published Seri versions of the story. Interestingly, these versions, which all
have Casanova becoming Coyote Iguana's wife or even queen following her kid-
napping, end with Casanova being forcibly removed from the Seri camp where
she had given birth to Coyote Iguana's first son and taken back to Mexican terri-
tory, never to return (Lowell 1970). However, in the 1960s the name Lola or even
Lola Casanova was common among the Seris, and many claimed to be related to
Casanova both then and in the 1990s (Córdova Casas 1993). The Seris appreciated
the particular construction of *mestizaje* implicit in the legend, which went against

the grain of most Mexican representations in which a white man rapes or seduces an indigenous woman, the emblematic case being that of Hernán Cortés and la Malinche. The Seris were proud that "the Coyote Iguana clan . . . comes from the Indian seed planted in white flesh" (Mimiaga 1989, 395).

## Borderlands Icons as Palimpsests

As Murrieta and Casanova were border crossers, marginal figures during their day—one a bandit, the other a traitor to her race—neither was embraced by elites of any group or incorporated promptly into any official version of regional or national history. Instead, their legends were kept alive in oral histories and popular novels, entering more easily into literature and cinema than historiography. This lack of official attention to their stories meant that there was no single authoritative version capable of trumping others. Meanwhile, as was inevitable in the contact zones in which they lived and from which they were remembered, many competing versions of their stories developed in different cultural contexts, each producing its own set of meanings. Thus the Chicano Murrieta is not the same as the Mexican one or the Anglo-American one or the Cherokee one or the Chilean one—indeed there might be many different Murrietas within or moving between each of these contexts, which can hardly be defined as discrete or pure cultural units. Likewise, the Sonoran Casanova does not coincide with the Mexican national one or the Seri one. In the latter case, especially, it might be argued that a gendered perspective comes into play as well, with Landeta's choice of Casanova as the protagonist of her first film carrying a certain feminist inspiration behind it that resignifies her actions (Arredondo 2002). In any case, as this brief analysis has aimed to make clear, borderlands icons are up for grabs, functioning as common themes of discussion through which the cultural tensions of the borderlands play out.

## Note

1. This and all further translations from Spanish, unless otherwise indicated, are mine.

# Golden-Era Icons at Home and in Hollywood

# Tango International
## Carlos Gardel and the Breaking of Sound Barriers

*Rielle Navitski*

"Cada día canta mejor" ("His singing gets better every day"), declares a popular saying about Carlos Gardel, the beloved Argentine singer of the 1910s, 1920s, and 1930s who continues to enjoy unparalleled popularity with tango lovers all over the world. As the phrase suggests, the tributes of present-day fans keep the singer's memory and recorded voice alive: tourists who make the "pilgrimage" to his grave in the Chacarita cemetery in Buenos Aires often bring flowers and place lit cigarettes in the hand of the tuxedo-clad statue that marks his resting place. In suggesting that Gardel's musical performances become even more triumphant as the singer's life recedes further into the past, the saying points to the pivotal role of intense nostalgia in his star image. In Gardel's case, this nostalgia stems most immediately from his premature death in an aviation accident in 1935, but it is also a central theme of the tango genre as a whole. Suggesting the effects of this nostalgia on the listening experience, the saying "cada día canta mejor" implies that replaying a Gardel record is not a mere repetition of the same. Rather, it implies that the passage of time and the intervention of the technology that allows us to hear the voice of a dead icon have in fact added something to the aesthetic experience. Arguing that in Gardel's case the sense of loss produced by technological mediation amplified the emotional experience of audiences who were physically and culturally distant from the singer, I will explore the pivotal role of sound recording and reproduction in the elevation of Gardel to iconic status and the preservation of his popularity into the present day.

The circumstances in which Gardel's music has been produced and consumed complicate prevailing discussions of sound recording technology, in which cultural critics emphasize the loss of immediacy resulting from a recorded performance. Tom Levin and Mary Ann Doane draw attention to the problematic way that the mediation of sound recording technology is assumed to all but "disappear" in advertisements for technical improvements that promise an ever-greater fidelity to the "real" sound (Levin 1984, 55–59; Doane 1985, 163–64).[1] Yet the intense emotional experiences produced for contemporary listeners by Gardel's scratchy recordings, which to modern ears are full of "noise" (dust damage, limited recording range), suggest the extent to which a sense of distance from the listener, whether

defined in terms of space, time, or cultural identity, can become central to the ex-
perience of a musical recording or sound film.

The appeal of distance and loss rather than possession and proximity seems
to have been central to Gardel's popularity. He is considered an icon of national
culture, despite, or perhaps because of, his frequent physical separation from his
adopted homeland, Argentina, beginning in 1923, when he embarked on extended
tours in Spain, France, and the United States to perform onstage, in radio broad-
casts, and on film. Gardel's recordings were felt to exemplify the tango's nostalgic
and pessimistic themes: economic misfortune, shattered romances (often between
pimp and prostitute), and longing for one's distant homeland. The lyrics of Gardel's
tangos often register a dislocation in historical time as well as geographic space,
hearkening back to a way of life—the semi-lawless existence of the Buenos Aires
*arrabales* (suburbs)—that was being eradicated even as the tango rose to national
popularity.[2] In fact, as Tamara Falicov argues in "Argentine Cinema and the Con-
struction of National Popular Identity, 1930–1942," the tango's broad popularity is
in some ways contingent on this very disappearance, linked to the reshaping of ur-
ban space as well as the influence of emerging mass media that created a sense of
a shared national culture between the working and middle classes. In a nostalgic
phenomenon similar to the tango lyrics of the 1920s and 1930s that glorified a type
of neighborhood that no longer existed, Gardel's music remains popular precisely
because of its distance from us in history. The technological mediation that sepa-
rates the contemporary listener from Gardel's voice is precisely what allows it to
travel in space and time, creating a sense of dislocation and loss that contributes to
his tangos' emotional potency.

The role of technological mediation in the impact of Gardel's music is humor-
ously explored in Argentine director Eliseo Subiela's fantastical film *No te mueras
sin decirme adónde vas* (*Don't Die Without Telling Me Where You're Going*, 1995), a self-
reflexive tale of love and reincarnation involving a television-like apparatus that
records visions. In a subplot of the film, an inventor constructs "Carlitos," a Gardel
robot sporting a wide painted grin and luminous bow tie, with the capacity to re-
spond to humans' emotional conundrums with a series of pre-recorded tangos and
lines from his films. Programmed to serenade any woman in his presence with
"El día que me quieras" ("The Day You Love Me"), the title song from the 1935
film starring Gardel, Carlitos mechanizes and standardizes emotion through au-
tomated response and playback. The implied absurdity of this project makes the
robot a laughable figure; yet it also evokes some of the contradictory images of
technological progress and nostalgic affect that have continued to cluster around
the figure of Gardel up to the present day.

The singer has been credited with a series of "firsts" in Argentine media his-
tory, the best-known being his 1917 performance of the first tango-canción (tango
song) "Mi noche triste," with lyrics by Pascual Contursi. This performance, which
became one of the first tango recordings, created a genre considered much more
emotionally moving than the tango-danza (tango dance), a form that included only
improvised lyrics or lacked them entirely. Gardel also appeared in some of Argen-
tina's earliest experiments with optical sound in a series of musical performances
and one comic short directed by Eduardo Morera in 1930, and he even featured in
an experimental television broadcast in 1931 (Peluso and Visconti 1990, 137–38,

Carlos Gardel with renowned Uruguayan jockey Ireneo Leguisamo, at the Hippodrome of Palermo (Buenos Aires), 1930s. *Revista Gente y la actualidad.*

159). Between 1931 and 1935, Gardel appeared in the first wildly popular Spanish-language films to be viewed in Buenos Aires, though these were productions of the Hollywood studio Paramount rather than the emerging Argentine industry. Fully synchronized sound features would not be made in Argentina until 1933, when *Tango!* and *Los tres berretines* (*The Three Amateurs*) premiered. Like Gardel's Paramount films, these productions focused on tango performances, indicating the importance of the genre to the emerging national industry's attempts to develop both domestic and export markets for its films.

Gardel's participation in this series of media experiments suggests a hope that new technologies could bring tango culture to an ever-broader national audience and even win fans abroad. As Donald Castro has argued, after the first Buenos Aires radio stations opened in 1923, radio transmission had increasingly allowed tango to be consumed in domestic spaces, where "respectable" women had access to it, and in the interior of the country (1999, 94–95). The tango was thus distanced from its unsavory origins in the crime- and prostitution-ridden port areas of Buenos Aires. The radio catalyzed the genre's transition from a marginal to a middle-class musical form, even as it helped catapult Gardel to mass stardom in the mid-1920s (Vila 1991; Castro 1999, 96). Gramophone records, which became popular in upper-class Buenos Aires households in the early 1920s before the popularization of radio, provided a performance that could be relocated not only in space, but also in time (Castro 1999, 94). Recordings could be consumed repeatedly and at will in domestic as well as public spaces, but this convenience was only available to those with the means to purchase the expensive machines and records, which excluded the working classes.

In the late 1920s, the development of more powerful electronic amplification and effective synchronization of projectors and sound equipment allowed for the successful premiere of films that added a visual dimension to recorded musical performances. This possibility was considered to be a key aspect of the new technology's novelty and audience appeal, as is evident in the production of short films made up of a single song or multi-song musical act, such as the Warner Bros. Vitaphone shorts that premiered in 1926. The 1930 Gardel shorts produced by Morera manifest a similar logic, this time expressly intended to consolidate a viable film industry in Argentina for the first time (Peluso and Visconti 1990, 138). The fact that the breakout 1927 film *The Jazz Singer*, generally considered the first "talkie," was silent except for scenes featuring musical numbers by prominent vaudeville performer Al Jolson indicates the centrality of musical performance to the development of an internationally popular sound cinema.

*The Jazz Singer*'s combination of silent and sound sequences also signals the uncanny effects of the transition to sound films, as detailed by Robert Spadoni in his work on early horror films of the period. As he points out, contemporary reviewers felt that when the film reverted to dialogue intertitles and a recorded soundtrack after Jolson's first musical performance, the characters who had been speaking were suddenly struck "deaf and dumb" (Spadoni 2007, 21). Even in the absence of such a mixture of silent and sound strategies, or the technical defects that plagued early sound films (problems with volume, timbre, and synchronization), contemporary responses to sound film manifest a feeling that, as Spadoni suggests, "something vital had been added along with the sound, but also something vital had been leached away," namely the physical presence of the actual performer (2007, 22). The coming of sound film thus rendered audiences aware of the heterogeneity of the medium—the source of the actor's voice is not his or her mouth, but rather a loudspeaker (Altman 1980)—and made actors seem like grotesque composite figures. While few films in the period adopted this strategy, audiences often associated the spectacular novelty of sound film with an awareness of technological mediation or merely a sense of the loss of the performer, simultaneously experienced as strangely present and keenly absent.

Addressing the effects of transportation and media technologies, Gilles Deleuze reflects on the capacity of "the telephone, the radio . . . 'gramophones' and cinematographs" to "summon up phantoms" and evoke "affects which are uncoordinated, outside all coordinates" (1986, 100). This sense of ontological destabilization in turn evokes Deleuze's and Guattari's notion of "deterritorialization" and helps explain the ways in which media technologies can work to unsettle the categories of space, time, and identity, categories that firmly locate us within a "territory" (2004, 165–84). By creating ghostly effects of sound or image separated from the body, media technologies can provoke irrational emotional responses.

Just as his voice crossed international frontiers by means of the phonograph, the radio, and later, the sound film, the singer himself crossed oceans and continents using the latest transportation technologies: the transatlantic ocean liner—featured prominently in his films *El día que me quieras* and *Tango Bar*—and the fatal airplane he boarded in Medellín while promoting his films and RCA recordings throughout Latin America. The extensive publicity surrounding Gardel's travels suggests the importance of these modern transportation vehicles for the imagina-

tion of a cosmopolitan international culture in the period, supplemented by the circulation of Gardel's records in places he could not physically reach, to win him new fans across Latin America and in Spain and France.

While debates over whether he was born in France or Uruguay continue to rage up to the present day, all agree that he rose from a life in the slums of Buenos Aires to international fame and fortune. As Blas Matamoro suggests in *La ciudad del tango*, Gardel's success held out a promise of upward mobility for the working classes (1982, 94–96). These two types of mobility, geographic and social, were intimately linked in Argentina, a nation that has always emphasized its origins in massive European immigration and prided itself on its cultural cosmopolitanism (roundly criticized by leftist intellectuals as an extension of colonization by cultural means).[3]

The tango itself was a product of cultural mixing in the ports, slums, and red-light districts of Buenos Aires, although its mode of hybridization was far removed from the adoption of French and English literate culture conspicuously displayed by the elites. The musical form emerged from the collision of the Cuban *habanera*, African rhythms, and several other musical genres of diverse national origin around 1880 (Loza 2000, 791). As Pablo Vila noted in his 1991 article, "Tango to folk: Hegemony construction and popular identities in Argentina," published in *Studies in Latin American Popular Culture*, the intricate eight-step pattern was originally danced in brothels between prostitutes and male clients, or between clients waiting outside for their turn, as men significantly outnumbered women in Buenos Aires at this time. The tango did not become respectable until fashionable Parisians adopted the steps taught them by young Argentines from wealthy families making their grand tour of Europe (quoted in Matamoro 1982, 80–86). After the emergence of this Europeanized, and somewhat sanitized, version of the tango, the dance attained massive popularity in the United States, where it retained its associations with sensuality and passion. "Tango teas," afternoon parties attended by society women accompanied by male dancers for hire (who were often immigrants and almost exclusively working-class) rather than their husbands, became a craze in Jazz Age America, sparking a panic about these "immoral" events where liquor flowed freely and sensual dance steps were the norm. As Gaylyn Studlar has written, the dance was felt to have the power to undo class and ethnic distinctions by forging intense erotic connections, and thus to undo the social order itself (1996, 161–63). This association followed the tango in its appearances in Hollywood movies, most famously *The Four Horsemen of the Apocalypse* (1921), in which former dancer and matinee idol Rudolph Valentino performs a provocative version of the dance, although he is incongruously dressed as a gaucho rather than a stylish denizen of a Buenos Aires cabaret.

Hollywood once again sought to capitalize on the international appeal of the tango during the transition to sound, as it moved into the production of foreign-language films in an effort to maintain its overwhelming dominance of foreign markets in the face of the language barrier posed by synchronized sound. Yet it has been suggested that profit was not the only motive for this production strategy; rather, an attempt to neutralize the uncanny effects of novel sound technologies may also have been at work. Nataša Durovicová argues that Hollywood studios began to produce multiple-language versions in an effort to avoid the strangeness

of what she calls a "synthetic 'transnational' body"; that is, a disquieting figure that combined the image of an actor speaking one language with the voice of an actor speaking another (1992, 148). In remaking entire films with dialogues translated from English and spoken by entire casts of foreign actors, the organic unity of the actor's speaking mouth and audible voice was maintained. As Ruth Vasey notes, foreign-language versions were soon superseded by dubbing, which became technically feasible with the introduction of sound mixing technology (1997, 91–93). Yet resistance to the practice remained, expressed in terms that resonate with Durovicová's formulation. Jorge Luis Borges wrote in 1932 that "Hollywood . . . by means of the malignant artifice of dubbing, proposes monsters that combine the illustrious features of Greta Garbo with the voice of Aldonza Lorenzo" (quoted in Durovicová 1992, 336).[4] Borges's objection to the grotesque fusion of an anonymous, unsophisticated voice with the celebrated face of Garbo also suggests some of the problems that made Hollywood's versions of Latin American films unpopular with spectators overseas. These productions, hastily made on low budgets, lacked the American stars that the studios had elevated to the status of demigods and were thus distinctly lacking in drawing power for audiences. Few recouped their modest investments, and the practice had been almost entirely discontinued by 1932 (Vasey 1997, 96).

A notable exception to the system of foreign-language production described above was a group of seven Paramount musicals featuring the real voice and image of Gardel, the most celebrated media personality Argentina had produced until then. These films were based on original Spanish-language scripts rather than translated English dialogues and thus did not produce the sense of cultural dissonance provoked by films spoken in a language other than English, but the characters had American mannerisms and, often, American names as well (Durovicová 1992, 146). Shot in studios established for foreign-language production in Joinville on the outskirts of Paris and in Astoria on Long Island, Gardel's films attained massive popularity across the Spanish-speaking world. Domingo di Núbila judges them to be the "decisive factor" in creating an audience for Spanish-language films in Argentina, a significant first step for the establishment of a national industry (1998, 107). Gardel's musical melodramas—tales of romance across continents and social classes punctuated by tangos and other popular tunes—provided effective models for domestic film production in Argentina, winning fans at home and abroad.[5]

In addition to being transnational in terms of their production—made by an American studio in France or on Long Island, the Gardel musicals feature Argentine tango performers but also actors with varied accents from across the Spanish-speaking world—Gardel's films tend toward transnationality in their settings and themes. This is most notable in the films made on Long Island in 1934 and 1935: *Cuesta abajo* (*The Downward Path*) and *El tango en Broadway* (*The Tango on Broadway*), directed by Louis Gasnier; and *El día que me quieras* and *Tango Bar*, directed by Reinhardt. Evoking Gardel's international travels and implying an address to film audiences across the Spanish-speaking world (Collier 1986, 241), these films thematize voyages to Europe and the United States, often linking such globe-trotting to the erosion of traditional moral values or cultural authenticity. For example, in *Tango Bar*, most of which takes place aboard an ocean liner, Gardel's character

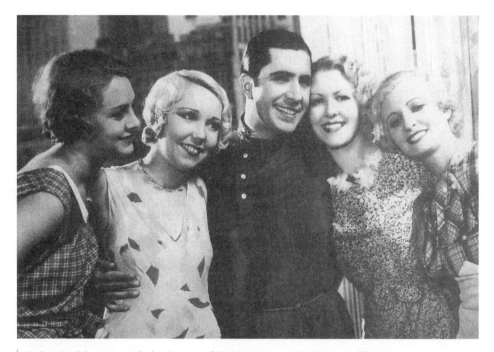

Carlos Gardel posing with the dancers of "Rubias de Nueva York," in the film
*El tango en Broadway*, Louis Gasnier, 1934. Archivo General de la Nación.

meets a beautiful young singer (Rosita Moreno), who is forced to moonlight as a
jewel thief. Arriving in Barcelona, he reluctantly employs her in his club but even-
tually protects her from the police when she becomes a victim of blackmail.

Treating similar themes with a more humorous tone, *El tango en Broadway* por-
trays New York's entertainment world as a space of leisure, amusement, and dis-
sipation, which Gardel's character Alfredo enjoys as the head of a musical booking
agency. This idyllic situation is threatened when Alfredo's rich uncle from Buenos
Aires arrives to investigate the use being made of his money and the moral tenor
of his nephew's life. Falling prey to a series of deceptions (Gardel disguises his
disgruntled mistress as his secretary and one of his performers, played by Blanca
Vischer, as his fiancée, predictably leading to a new love affair between the two),
the uncle is seduced by the charms of the American metropolis and decides to
stay. Although the film opens with Gardel's performance of the foxtrot "Rubias de
New York" ("New York Blondes"), indicating the lure of both American women
and American musical forms, the film's plot reaffirms the appeal of the tango
singer played by Blanca Vischer, whom Gardel serenades with the tango "Soledad"
(Navitski 2011, 46).

Similarly, in *Cuesta abajo*, Europe becomes the site of economic ruin and
personal decadence for Gardel's character as he stalks his unfaithful lover, played
by Mona Maris. Forced to hire himself out as a professional dance partner (à la
Valentino), he finally decides to return to Buenos Aires to be reunited with his in-
nocent former love (Anita Campillo). Gardel's performance of "Mi Buenos Aires
Querido" ("My Beloved Buenos Aires"), which announces his return at the end

of the film, exemplifies media technologies' creation of irrational conjunctions of places and times, and its production of the "phantoms" referred to by Deleuze. The refrain of the tango—"My beloved Buenos Aires, when I see you again, there will be no more sorrow or forgetting"[6]—emphasizes the joy of a reunion which would erase all sense of loss or displacement. This refrain is made literal in a superimposition of an image of Buenos Aires's skyline with an image of Gardel singing in medium shot against the railing of the ocean liner he has just boarded (accompanied by Vicente Padula, who plays the ship's captain). While this optical effect suggests the complete erasure of distance, its transparency also renders Buenos Aires ghostly, visibly a product of imagination and longing rather than an empirical geographic location. Suggesting the phantasmatic quality of technologically mediated perception, this sequence embeds the affectively charged contradictions of Gardel's transnational career.

In *El día que me quieras*, an ocean liner again becomes the stage for the cinematic performance of one of Gardel's most famous tangos, "Volver" ("Returning"). The performance has little connection to the melodramatic plot, in which Gardel plays Julio Argüelles, heir to a family fortune but disowned by his father when he marries a young dancer played by Rosita Moreno, who becomes ill and dies after the birth of their daughter because they cannot afford medical treatment. Heartbroken, he changes his name and becomes a celebrity, touring the world with a father-daughter tango act, but while traveling back to Buenos Aires on an ocean liner, his background threatens to thwart the plans of his daughter, also played by Rosita Moreno, to marry a young businessman. Standing on the ocean liner's deck contemplating his impending separation from his daughter, Gardel muses aloud, "To return, to depart again as before, leaving behind my heart," then breaks into song. The tango's lyrics emphasize both the passage of time that leaves the singer "with a weary brow, temples silvered by the snows of time," and the negation of this temporal distance: "to feel that life is but a breath, that twenty years is nothing."[7] Eschewing the special effects used in the "Mi Buenos Aires querido" number, the scene includes only two simple camera set-ups showing Gardel in medium close-up and medium long-shot, and uses a bare-bones set (a railing with a rear projection of a shimmering ocean horizon in the background). Gardel almost seems to be performing in front of an animated theatrical backdrop, which de-materializes the setting of the ocean liner, setting his performance adrift in space and time. Even as this sequence betrays the limited budgets of the foreign-language productions, it also suggests that Gardel's singing was accorded with an emotional power strangely disconnected from all sense of location.

Gardel's earlier films made in Joinville do not emphasize geographic mobility or liminal spatial locations as do the musicals produced in Astoria. Their action is confined to a single country: Argentina in *Las luces de Buenos Aires* (*The Lights of Buenos Aires*, dir. Adelqui Millar, 1931) and *Melodia de arrabal* (*Suburban Melody*, dir. Louis Gasnier, 1933), and Spain in *Espérame* (*Wait for Me*, dir. Gasnier, 1932), a rather incongruous location that caused the film to become Gardel's least popular with audiences. Yet as Currie K. Thompson has noted, these earlier musicals similarly focus on social oppositions and moral polarities coded in spatial terms (1991, 25–27). *Las luces de Buenos Aires* traces the journey of two sisters from the interior to become entertainers in the capital, where they fall victim to the loose morals

of modern urban life. Anselmo, played by Gardel, arrives to retrieve Elvira (Sofía Bozán), with whom he is in love. He fails, but two of his gaucho associates lasso her during a performance onstage and return her to the provinces and Anselmo's embrace, a stereotypical vision of rural rubes in the city that aroused reviewers' ire (Peluso and Visconti 1990, 142, 169). By contrast, in *Melodía de arrabal*, Buenos Aires's entertainment districts promise redemption from a marginal existence. An incorrigible gambler, Gardel's character Roberto is redeemed by the good intentions of a genteel piano player (Imperio Argentina) and goes on to become a nationally prominent tango star, in an explicit parallel to Gardel's rise from humble origins to celebrity. As in the case of *The Jazz Singer*'s Al Jolson, the plots of Gardel's films often echoed certain aspects of the tango singer's biography. As Marta Savigliano suggests, they produce a sense that the singer was "playing himself" and thus invited fans to confuse the character with the flesh-and-blood Gardel (1995, 65–66). In *Espérame* and *Cuesta abajo*, this impression is strengthened by the fact that the characters played by the singer share his first name.

This double image of Gardel as melodramatic film character and real-life performer increased the currency of Gardel's Paramount films across the Spanish-speaking world. The films' massive popularity and the emotional response they stirred suggest the power of his performances to overcome the sense of cultural distance or dissonance created by the often incoherent mixture of accents and dialects among the Spanish-speaking actors employed by Paramount, and their reception in the many countries to which the studio exported its Spanish-language films (Navitski 2011, 37). While Gardel's lyricist Alfredo Le Pera worked to purge the songs and dialogues of his films of the *lunfardo* slang specific to marginal populations of Buenos Aires (D'Lugo 2008, 16), the singer's musical numbers were hailed as providing an emotional authenticity that redeemed the films' low production values, mixture of actors from a variety of nations, and occasional plot absurdities. A review in Barcelona's *El Mundo Deportivo*, reprinted for publicity purposes in the Spanish-language house organ *Nuevo Mensajero Paramount*, asserts that "Gardel realizes a decisive triumph, especially in his rendition of the barroom tango from the tavern (i.e., *Tomo y obligo* [which literally translated means 'I drink and expect you to drink with me']). The emotion Gardel infuses into this tango had wide appeal for audiences, who were moved to tears by it. This tango is the definitive moment of the film and it gives it its forceful emotional appeal" (quoted in *Nuevo Mensajero Paramount* 1932, 14). Similarly, Argentine tango lyricist Homero Manzí, who was generally quite skeptical about Gardel's collaboration with Paramount (which he suggested was depriving the developing Argentine cinema of its biggest potential star) wrote in a review of *Melodía de arrabal* that only "two tangos saved a thousand meters of celluloid apparently filmed in Marseilles cantinas and streets of indeterminate geographical region" (quoted in Peluso and Visconti 1990, 334).

As the *Nuevo Mensajero Paramount* proudly announced, at the premieres of his films in several Latin American cities, the audience demanded that the projectionist rewind the film after Gardel's musical numbers and replay them as many as three times (*NMP* 1934, 147; *NMP* 1935, 7). This mode of film consumption can be seen as a kind of celluloid encore, one that evokes the feel of a live performance (where the audience can demand an encore from the performer), or the on-demand playback of the gramophone record (Navitski 2011, 36). The audience's outpouring

of enthusiasm for these tango films suggests the excitement produced by the simultaneous reproduction of Gardel's voice and image, but also the pleasures of a mechanical repetition that is not in conflict with, but in fact supplements, the incomplete but still compelling effect of his presence.

In conclusion, and foregrounding the relationship between emotional excess and sound technology in Gardel's career, I would like to end with a discussion of Fernando Solanas's 1985 film *Tangos: The Exile of Gardel*. Solanas's film chronicles the lives of political refugees in France who are staging a hybrid musical and theatrical performance they refer to as a *tanguedia*, a fusion of tragedy (*tragedia*), comedy (*comedia*), and tango. Gardel "appears" in a scene in which two exiles are frantically trying to reach a creative collaborator in Buenos Aires. A threatening figure (who later identifies himself as Enrique Santos Discépolo, a renowned tango lyricist in the first decades of the twentieth century) approaches the booth but merely offers to fix the malfunctioning telephone, which begins to emit "Rubias de New York" as soon as a connection is established. After the phone call is truncated by the still unreliable connection, leading the exiles to despair, the bright headlights of an automobile approach, and an actor playing Gardel, appearing only as a silhouette, exits the car accompanied by the shadows of several other musicians. He then "performs" his classic tango "Anclado en París" ("Stuck in Paris"), whose lyrics express a fear that death will preclude a return to Buenos Aires, which is heard on the sound track but not synchronized to the lips of the partially visible performer. While the tango's subject matter dramatizes the exiles' entrapment, the sudden manifestation of Gardel's ghostly figure also suggests the nomadic nature of a national culture that circulates internationally by means of sound reproduction technology. The spectrality of this "live" performance is emphasized by Gardel's final "appearance" in the film, during which the liberator San Martín converses with one of the Argentine exiles and Gardel sips a maté while "Volver" plays on a record in the background. This diegetic use of music divorces the performance from the body of the performer, visualized on screen as a spectre. Circulating by means of the telephone and the gramophone, Gardel's phantasmatic figure is resurrected bodily in Solanas's film through the intervention of cinema.

In her interpretation of Solanas's 1980s films, Kathleen Newman suggests that the appearance of the figures of Gardel and San Martín signals nostalgia for the nation itself. In her view, the national culture invoked by Solanas, a leading Peronist militant in the 1960s, has been invalidated as a basis for political action by the state-sponsored violence and disastrous neo-liberal economic policies of the last military dictatorship (Newman 1993, 242–47). While Newman's reading of Solanas's use of Gardelian iconography in the context of re-democratization is incisive, Gardel's posthumous appearances also speak to the broader contradictions of his career and of Argentine national culture itself. The processes of "cultural colonization" at work in Argentina's self-conscious cosmopolitanism and Hollywood's attempt to manufacture national culture abroad are both exemplified and undone by Gardel's international stardom. While the singer's appropriation by a Hollywood studio indicates the historical and continued dominance of the United States in international media markets, the reception of his Paramount musicals indicates how emerging media technologies can produce a countercurrent to this largely unidirectional circulation of cultural forms. The Gardel films helped create an

Argentine cinema audience that imagined itself as national in its consumption of tango-themed musicals, and thus bolstered ambitions to create a domestic film industry. In addition, Latin American spectators' enthusiastic response to Gardel's musical numbers suggests that a privileged sense of emotional authenticity is made possible by sound recording technology's simultaneous disavowal and inscription of spatial and temporal distance. Gardel's movements across continents and social classes are intertwined with the irrational affective repercussions of media technologies, which make possible the emotionally charged repetition and replay that have perpetuated the singer's legacy into the present.

## Notes

1. This discourse has been questioned in recent scholarship emphasizing the social determination of sound reproductions, which makes it impossible to conceive of an "original" sound event outside of the recording situation in which a "copy" is produced. See Sterne (2003) and Lastra (2000).

2. The most relevant change in the life of *arrabales* was the decriminalization of prostitution in 1919. For the paradigmatic example of these nostalgic accounts of the life of the *arrabales*, in the guise of a biography of the titular poet, see Jorge Luis Borges's *Evaristo Carriego* in *Obras Completas 1: 1923–1949* (2007).

3. The most influential statement on this dynamic of national culture made in the context of cinema is Fernando Solanas and Octavio Getino's "Towards a Third Cinema: Notes and Experiences for the Development of a Cinema of Liberation in the Third World" (1997), which calls for the eradication of films on a classical Hollywood model, as well as productions influenced by European art cinema and its focus on individual bourgeois consciousness, in favor of a radically transformative "Third Cinema."

4. Aldonza Lorenzo is the "real" and very unromantic-sounding name of Don Quixote's Dulcinea in Cervantes's novel.

5. Emerging film industries in Mexico and Brazil would adopt similar narrative formulas, creating the musical genres of the *comedia ranchera*, an idealized view of rural life that featured popular songs in traditional styles, and the *chanchada*, which grew out of the samba culture diffused by radio and Carnaval, in the mid-1930s.

6. "Mi Buenos Aires querido, cuando yo te vuelva a ver/no habrá más pena ni olvido." Lyrics by Alfredo Le Pera.

7. In the film, the spoken portion of Gardel's performance is "Volver. Para volver a partir, como antes, dejando el corazón"; the lyrics cited are "Volver, con la frente marchita, las nieves del tiempo platearon mi sien / Sentir, que es un soplo la vida / que veinte años no es nada." Lyrics by Alfredo Le Pera.

# Lupe Vélez Before Hollywood
## Mexico's First Iconic "Modern Girl"

*Kristy Rawson*

hen Mexican actress-dancer Lupe Vélez landed a starring role opposite the legendary Douglas Fairbanks in the film *The Gaucho* (1927), she became, arguably, Hollywood's first Latina icon.[1] Soon after, hers became an immediately recognizable Mexican face gracing the covers of US popular magazines. She would go on to star with Rod la Roque in war-torn Greece (*Stand and Deliver*, 1928) and William Boyd in Second-Empire France (*Lady of the Pavements*, 1929), as well as in dozens of other lesser-known roles. Her high-profile romance with Gary Cooper (1929–1932) sealed her notoriety and shaped the course of her public persona in the United States.[2] But the stock market crash and the beginnings of the Great Depression turned the American public increasingly resentful of foreigners on screen and off, and Vélez soon became a lightning rod for "scandal," increasingly demonized by the industry.[3] Her notoriety even served as a cautionary note to other Latin American stars who would learn to avoid Vélez's mistakes—or try to. Before her death by suicide, however, Vélez succeeded in making over thirty-five Hollywood films, even as the industry increasingly framed her, on screen and off, as an embodiment of excess, a caricature from a "wild," lawless Mexico, and comic prototype of a specifically Hollywood "Latinidad" (Beltrán 2009, 3).[4]

In the decades that followed the spectacular accounts of her suicide, Vélez's story fell into neglect. It is with much enthusiasm, therefore, that those of us familiar with the originality of Vélez's early career welcome the renewed academic interest in Mexico's first "chica moderna" of the stage.[5] Recent scholarship on Vélez has resulted in several excellent articles on her Hollywood career. Works by Chicana artists and performers are further restoring Vélez's status as a Latina icon.[6] As I write, Mexican actress Ana de la Reguera is preparing to produce and star in a biopic based on Vélez's life. Planned as a Mexican/US co-production, the film is well positioned to recuperate her celebrity history for what it was: a quintessentially transnational phenomenon.

There are almost no records of Vélez's brief stage career in Mexico. There are no scripts or narrative summaries characterizing her stage roles, and no recordings

Lupe Vélez as she appeared in
*¡No lo tapes!*, June 29, 1925.

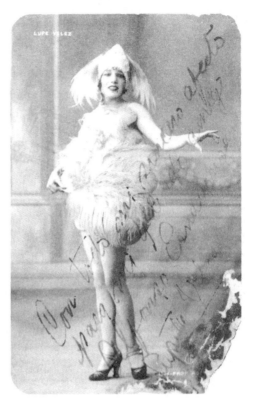

survive documenting her apparently untrained voice.[7] From the perspective of her journalist fans, nevertheless, such matters of fine artistic consideration paled in significance next to the force of Vélez's "aggressive" sensuality, her idiosyncratic dancing style, and her gift for audacious mockery. It is to the writings of the *cronistas*, who shared space in prominent periodicals, and to the articles published in the popular weekly supplement *El Universal Ilustrado* that I turn to in order to document both Vélez's early stardom and Mexico City's dynamic network of visual and cultural debates regarding popular entertainment and theater in the years following the revolution.[8] As I intend to show, Vélez's role in the new type of popular spectacle known as Ba-ta-clán or Ra-ta-plán has important resonances for cultural and media studies, as the young dancer was among the first to contest national models of femininity and sexuality. As such, the young singer-dancer-comic sparked debates that led to early reconsideration of gender enactment in the context of the era's notions of nation, taste, class, and ethnicity. Vélez's modern iconicity, I maintain, is intrinsically related to the spirit of freedom promised (if not delivered) by revolutionary slogans. Ironically, her satirical enactments of traditional types of femininity and feminine sexuality would pose a threat to respectable postrevolutionary national ideals.

This essay traces the earliest years of Vélez's transnational star currency, addressing the young Lupe—*la niña* Lupe—of the mid-1920s. To US audiences, her seemingly instant fame read as a model Hollywood success story: the intrepid if naïve foreigner emerging "out of nowhere" to join the grand cast of the Hollywood elite. But Vélez's Hollywood success was less a lucky break than a significant career decision, marking both a crossing of national borders and a crossing over from

stage to screen. Mexican fans who already knew Vélez's popularity on the stages of Mexico City's dynamic popular theater circuit would not have been surprised to hear of her success in Hollywood, or of the way she delighted unsuspecting audiences with her dynamic performances mimicking her co-stars in the live stage shows that accompanied the film's tour of every major US city, since such performances had been key to her renown on the stages of Mexico City's dynamic popular theater circuit.

## Popular Theater in Postrevolutionary Mexico: Revista and Ba-ta-clán

In 1925, Madame Berthe Rassimí succeeded where Emperor Napoleon III had failed, by conquering Mexico, not by force of French arms, but rather through the beauty of French legs.

Jeffrey M. Pilcher, *Cantinflas and the Chaos of Mexican Modernity* (2001, 20)

On February 12, 1925, two women entrepreneurs—one Mexican, Esperanza Irís, and one French, Madame Berthe Rassimí—together "conquered" the city of Mexico with a bomb of feminine flesh. The French theatrical import *Voilá Paris: La Ba-ta-clán* debuted at Teatro Iris, clearly targeting a middle- and upper-class audience and thus competing with the more established Teatro Lírico. *Voilá Paris* showcased nearly nude, though elaborately decorated, French female performers who danced to choreographed musical numbers.[9] The explosive popularity of the show immediately inspired a number of imitations, from the crassly imitative to the stylistically nationalized to the pointedly parodic and satirical.[10]

The parallels between Mexican *revista* and European or US versions of vaudeville are obvious.[11] *Teatro frívolo*, musical theater on the more comical end of the *revista* spectrum, shares a close affinity with vaudevillian parody and "low," bawdy humor.[12] But Mexican *revista*, in the context of postrevolutionary Mexico, was especially keen on political parody.[13]

A product of both the Mexican *carpas*—outdoor-tent "popular" entertainment aimed at the working classes—and the Spanish *zarzuela* or operetta, as well as the French "revue," *revista* spectacles became popular and lucrative enough to move to permanent locales in the capital. As they did so, they quickly began to attract Mexico's emerging middle classes. While the traditionalists among *revista* critics found the genre's highest value in its sociopolitical relevance, by 1925 it was increasingly clear that audiences wanted distraction from the somber realities of the revolution and its aftermath.[14] Colorful musical spectacles provided frivolous but welcome relief from years of bloodshed and the infrastructural chaos that reigned. The witty or naughty charm of the lovely *tiples* provided, as was traditional in vaudeville, the focal point of musical and visual entertainment. Their slight, fanciful costumes and risqué sensuality could be seen, depending on one's viewpoint, as either broadening or toning down the *revista*'s more politically explosive commentary. As Carlos Monsiváis points out in his 1982 study of Celia Montalván, the wry irony by which crucial matters of local and national policy were treated within such a highly sexualized space was, in itself, politically provocative in its irreverence (1982, 60–65).[15]

According to Argos, one of *El Universal Ilustrado*'s regular columnists, Lupe Vélez deserved credit for the furor of parodic imitation that took Mexican popular theater by storm in the late 1920s.[16] Under the headline "The Fever of Imitation," Argos (1925c) writes that

> It is the [Teatro] Lírico that is at this moment the theater of imitations and, as such, is the object of great emulation. Is this theater not a concave reflection of the unforgettable Ba-ta-clán? There, it was the emphatic success of our *compañerita*, Lupe Vélez, who was the first to imitate–as an artistic possibility–her *compañeras*. . . . Before, the practice of imitation was discreet and timid. . . . *The applause stolen by Lupe Vélez initiated a drive towards improvement, furthering the path of imitation.* (emphasis added)

Vélez's sensational stage debut, the night to which Argos refers, occurred on February 28, 1925, at the Teatro Principal, just weeks after *Voilá Paris* had opened at Teatro Iris. The Principal revue, provocatively titled *¡No lo tapes!* (Don't cover it!), was styled to both capitalize on and parody the spectacle of nudity presented in Madame Rasimi's production.[17] It is worth noting, in the context of stylistic parody, that the show's Mexican diva, Lupe Vélez, was short in stature compared to the "deco bodies" and "living caryatids" of *Voilà Paris*. Vélez, who would very quickly become known for her distinctly audible presence, would hardly be mistaken for one of the silent, Greek-column bodies of the French Ba-ta-clán (Sluis 2010, 471, 473).

## "La tiplecita Jazz" (The Little Jazz Singer)

Lupe Vélez (born María Guadalupe Vélez Villalobos) grew up in a middle-class environment, though her family's modest fortunes suffered during the revolution. After the family's financial difficulties during wartime forced her to abandon the convent school she had been attending in San Antonio, Texas, she moved with her family from San Luis Potosí to Mexico City, where her job in a department store accounted for a significant portion of the family's income (Ramírez 1986, 27).[18] Biographies of Vélez recount her slipping off to the theater in the evenings after work and, once home among her sisters, imitating the songs, dances, and personae of those she sought to emulate (28). Far from ignorant of the theater, Vélez possessed the fervor of the fan, an unusual talent for comic-parodic imitation, and the temperament of an autodidact infiltrator.

The *primera tiple*, the female lead of the *revista*, was generally chosen for her skills as a dancer, singer, and entertainer. Just as importantly, though, each individual *primera tiple* came to be identified by a unique stage persona, a persona that became attached to her offstage and defined her public image and popularity in the illustrated weeklies. As expected given the genre, some of the iconic *tiples* represented national archetypes (although many of these types could be seen in similar spectacles in Europe and the Americas). Among the best known of these were Lupe Rivas Cacho as *la tiple folklórica*, María Teresa Renner as *la tiple* "flirt," Delia Magaña as *la tiple vacilón* (the tease), and María Conesa as *la tiple gatita* (the kitten). In effect, the *tiples* collectively performed a staged ethnography of the types available to young Mexican women—and men.[19]

The addition of Lupe Vélez as the *tiple* "jazz" introduced an instantly new and modern type into the *tiple* repertoire. Thin enough to resemble a flapper and with bobbed hair to match, Vélez could be self-parodic not only about her own role but also about that of the other *tiples*. Between her ironic impersonations and the responses she could elicit from the other *tiples*, Vélez ushered in a period of competitive impersonation that lent a self-reflexive epistemology to the dynamics of *revista*'s gendered stage. Vélez's unique jazz persona and her related flair for parody ushered in a new kind of female stardom. For a time, at least, she was the most recognizable face of Ba-ta-clán-style theater.

Successful almost from the start, Vélez thrived within a popular Mexico City theater circuit presenting a combination of vaudevillian performance and social satire that had become enormously popular in the years immediately following the revolution. It is this Lupe Vélez that *Contemporáneo* poet and essayist Salvador Novo revisited in the years following her death. Novo's classic *Nueva Grandeza Mexicana* ([1946] 1967), a paean to the postrevolutionary city that witnessed the glory days of both his and Vélez's youth, includes an homage to Vélez as emblematic of the kind of bawdy appropriative performance celebrated in the Ba-ta-clán.[20] With obvious appreciation for the combination of parodic imitation and sexuality characteristic of Ba-ta-clán, and singling out Vélez's contribution to the popularity of the genre, Novo writes:

> We Mexicans have a special talent for imitation. . . . I believe the [imitative form] that had the greatest and most lasting influence was *Ba-ta-clán*. . . . For the first time it shows us pretty, naked, lissom girls, whose voices did not matter. . . . Its precedent allowed us the discovery, from behind the counter of the *FAL Stores* on the corner of Gante and Madero . . . of the aggressive, beautiful and determined young girl, who reduced the addicts of the *Lírico* to howling frenzy when she bawled out *Blue Beard* and mounted the catwalk, back to the public, and gave her gluteal region an incredibly swift and violent rotary motion, which was her personal interpretation of the hawaiian (*sic*) hula-hula. . . . She used to the full her very Mexican talent for mockery. Her name was Lupe Vélez. (Trans. Lindsay, 1967, 49)

Vélez's quick rise to popularity in the *Revista* provoked considerable envy among more established performers. In his memoirs, Pablo Prida Santacilia, one of the coproducers of *¡No lo tapes!*, recalls that Vélez's casting as a "*primera tiple*" or "first soprano jazz singer" was declared to be in violation of the rules of the actors' syndicate organized by more established *revista* members of the cast. Consequently, the producers had no choice but to demote her from the starring role. It was from the floor, then, that she made a cheeky appeal directly to the audience, winning (*stealing*, even) enthusiastic support and staking a populist claim to the stage (Prida 1960, 178; Ramírez 1986, 29–30). Prida Santacilia recalls Vélez as performing with a uniquely personal lexicon that immediately intrigued her public. Her "ambition and fearlessness," according to Prida, proved more than adequate to compensate for her "lack of training" in theater. Prida's characterization of Vélez's inexperience is complicated somewhat by his own account of that opening night, during which Vélez pointedly ("*sangresamente*") impersonated the popular *tiples* of the day, with a comic timing and skill to rival that of the more experienced entertainers

on the stage (1960, 178–79). The audacity of her debut is underscored by the fact that "*la niña* Lupe" displayed neither the physical traits (voluptuousness) nor the European birth that accounted for the more famous *tiples*' fame in *revista* theater culture.

If Vélez was unique in having been able to make the successful journey from the FAL department store sales counter to the coveted *tiple* pantheon, she was more so for having reached almost immediately—if briefly—that pantheon's pinnacle. Her stardom not only flew in the face of professional values of long-term dedication to craft and professional training but, more importantly, did so while going against type. In her years on the *revista* stage, Vélez's name was rarely in print without her moniker, "*la tiplecita* jazz," which indicated her youth and her distinctive "*inquietante*" dancing style. The jazz appellation pointed, of course, to the 1920s flapper—the Charleston was Vélez's favorite dance—, the figure most readily associated with the influence of Hollywood cinema, the growing popularity of ragtime, and the modern city. Vélez's overnight rise to stardom further suggested a specifically Hollywood-style spectacle, including a "star-struck" public reception, marking a clear shift in the exigencies of artistic prominence within Mexican artistic culture.

Two months after her debut as a *tiple*, Vélez joined the cast of Roberto Soto's *Voilá Mexique: El Rataplán*, which had by then become the year's critical and popular favorite (León Sarabia 2008, 49). Soto's revue emphasized political commentary more than other Ba-ta-clán imitations did—as indicated by the title *Rata-plán*, or "rat program"—and could showcase Vélez's wit. Working with Soto had the effect of polishing her star currency and reinforcing her image as an entertainer with comic vaudeville skills. Soto's production also brought Vélez to the Teatro Lírico, where she teamed up with the era's then most beloved *tiple*, Celia Montalván. Previously an object of Vélez's ironic impersonations, Montalván was a voluptuous dancer who perfectly embodied the national (and possibly international) standard of feminine sexuality and sensuality. The unlikely pairing underscored Vélez's thinness and wiriness, which must have struck at least the artists in the audience as a challenge to conventional Mexican femininity. Prida describes her as "la muñequita de alambre" ("little wire doll")[21] and Monsiváis notes that she was undisguisably skinny (1982, 81). In the postcards she distributed to her fans and which circulated for decades, Vélez stood out distinctly for the bold display of her thin, straight, "androgynous" body, which was often discursively associated with her *inquieta, nerviosa* personality and her modern, flapper iconicity.[22]

Yet too much could be made of Vélez's uniqueness. After all, Vélez's modern image would not have resonated as wholly foreign within Mexico City entertainment culture. Cropped hairstyles were introduced by the *pelonas* (bobbed-haired women) and had become familiar. Similarly, the flapper mode of dress and jazz culture itself would not have scandalized the readership of the illustrated weeklies. But jazz and *pelonismo* were looks of the street, hitherto appropriate only for secretaries and other new female members of the work force. To the extent that the flapper image had invaded the *revista* stage, it was represented as grand spectacle within the large choruses of the French and then Mexican *bataclanas*; jazz did not represent the culture of the exalted *revista* divas. Vélez embodied a *chica moderna* persona that her *tiple* rivals might stylistically affect but for which they would never be mistaken.[23] So while the perceived artlessness by which the "ultra modern" Vélez (Hershfield 2008,

59–60) stole the stage represented an invasion of the unserious, Vélez's insurgency itself became an occasion for intense national introspection.

Though *Ilustrado cronistas* occasionally referred to Vélez as *criolla* (white), they were just as likely to point to her name, Lupe, as evidence of a *mestiza* identification, despite her light complexion.[24] Critics consistently celebrated Vélez as "muy mexicana" and "mexicanísima." Such an appellation was significant at a time when the most celebrated divas of *revista* were still those born abroad; most were Spanish (Prida 1960, *passim*; Dueñas 1994, 33). Lupe Rivas Cacho, having come from the *carpas*, provides a more humble precedent in the pantheon of *tiples*. As the quintessential *tiple folklorica*, though, Rivas Cacho's class and femininity represented a romanticized image of the rural working-class *mestiza*, *revista*'s image of the *china poblana*.[25] Carrying the international persona of the independent "modern girl," Vélez's new-world identity was indeed new to the *tiple* pantheon.[26]

## National Popularity Contests and Popular vs. Modern(ist) Taste

> The fragile and edgy Señorita 1925 seems an adorable child—a child who gets angry and stomps her feet. A child who laughs charmingly— in her smile there is no pretending, no frozen expression on her face— and who dances an unrestrained jazz as easily as jumping rope or playing with dolls.
>
> Our youth who shun the slow streetcars in favor of the dizzying speeds of the automobile or the airplane, enjoy and appreciate the "new theater" brought from and influenced by the Parisian company of Madame Rasimi.
>
> Jorge Loyo, "Lupe Vélez," *Ilustrado*, July 18, 1925[27]

The *Estridentista*-affiliated playwright and *cronista*, Jorge Loyo, recognized in Lupe Vélez a youthful embodiment of Noriega Hope's image for the journal; Loyo identified a certain something "hidden under an agreeable superficiality," by which Vélez spoke to and of the moment. Five months after her stage debut, Loyo designated Vélez "la señorita 1925," and *Ilustrado* placed her illustrated portrait on its cultural splash page. The gesture touched a nerve in the theater sector. Loyo's designation of "*señorita* of the year" was soon interpreted as "*tiple* of the year," which then invited attention to Vélez's salary, the highest among the divas. Relatedly, Vélez's Lincoln car became a controversial feature of her offstage *chica moderna* persona. Shortly after Loyo's "señorita-of-the-year" designation, *El Universal Ilustrado* published an issue dedicated to the modern automobile with Lupe Velez on the cover. Seated behind the wheel and wearing a cloche hat, she was photographed with an exaggeratedly toothy smile.[28]

Public interest in Vélez's pay resulted in the publication of all the *tiples'* incomes. Ensuing debates regarding the true measure of *revista* talent instigated a high-profile, reader-driven popularity contest playing out in the pages of the weekly.[29] A running tally of votes—ultimately cast by tens of thousands of *Ilustrado* readers —appeared prominently in each issue. While never clearly articulated as such, the contest was, in effect, taking the measure of a significant backlash against Loyo's

championing of *la tiple* jazz. Gradually it became clear that the contest was over the title "*la tiple* 1926," the chosen diva who would effectively unseat Lupe Vélez from her short-lived reign. Initially in second place, Vélez dropped to third and then fourth position as the weeks went on. Undaunted by her drop in the poll, she brazenly pursued Celia Montalván's significant lead, taking up the mantle of modern, insurgent iconoclast. The two rival *tiples* eventually took their competition to the streets. Vélez and Montalván both ventured to factories and armories to greet the region's workers and soldiers.[30] Pictured in *Ilustrado*, posed amidst their respective devoted legions of *mestizo* masculinity, the stars stand out in dramatic contrast to their dark-complected fans.

Predictably, on October 1, 1925, Celia Montalván was announced as "*la tiple* 1926." The result undoubtedly reflected Montalván's popularity with a major segment of the public. Perhaps owing to her prominence within the narrative of the contest, however, Vélez's fifth-place finish accorded a full-page feature within *Ilustrado*'s coverage of the results. Vélez, as the upstart challenger, emerged as the star antagonist of what may have been, in effect, *Ilustrado*'s first serialized documentary melodrama.[31] While Sluis characterizes her as "Ba-ta-clán's first real star" (2010, 475), Vélez may more accurately represent Mexican mass culture's first modern celebrity. What is more interesting than the fact of her celebrity is its iconoclastic nature: Velez's personality translated as an unlikely combination of aggressive, arrogant irreverence on the one hand and warm, utterly sincere congeniality on the other. The pages of *Ilustrado* document her cheerfully strident challenge to the normative image of femininity.

The contest took its toll on Vélez's public image. While she continued to embody the boyish, modern-girl persona (Pilcher 2001, 20), she was no longer described as the "child" Jorge Loyo had praised just four months earlier.[32] Her aggressive pursuit of the *tiple* title even after it was clear the public preferred her competitor deprived her of the ingénue image she had projected and made her ambiguous sexuality and her irreverent stage presence suddenly more problematic. Poised between "the girl, Lupe" and the new, postrevolutionary woman, Vélez was a split emblem. She was pictured in the popular press bent over the raised hood of her automobile even more often than she smiled from behind its wheel.[33] Perched on the threshold between the wiry but naïve seductress and the "public woman," she could no longer evade the scent of scandal and promiscuity that the term *mujer pública* implied. There was an aggressive and almost nihilistic aspect to the high-profile battle she waged over her own position. Her persona defied any singular, unified ideal that might replace the traditional image it flouted; it sought to topple a treasured idol, in the sense of the iconoclast, but did so with cheerful ambivalence rather than conviction or faith. Just as Vélez's capricious persona was born of the revolution, the force of her iconoclasm underscored the fragility of an as-yet unconsolidated national identity.

## "Should the Ba-ta-clán be stopped?"

In early March of 1926, just over a year after the debut of Madame Rasimi's explosive *Voilá Paris*, *bataclanismo* faced the opposition launched by the Group of Seven

(*Grupo de los Siete*), a respected contingent of modernist playwrights that included the editor of the supplement, Carlos Noriega Hope.[34] The group championed work by Mexican playwrights over that of European authors.[35] As a part of their 1926 manifesto, the authors circulated a call to put an end to Ba-ta-clán. *Revista*'s productive critical/topical edge had been dulled, and the broad consensus placed the blame on Ba-ta-clán. Those who opposed the wholesale banning of the practice— among them Roberto Soto and Celia Padilla—held that the problem was not with *bataclanismo* itself, but with the deteriorating quality of its mediocre imitations, which had lost their satirical edge and degenerated toward vacuous pornography. Celia Montalván agreed, but she sided fully with the Group of Seven. Lupe Vélez was not mentioned by name in these debates.

By the latter half of 1926, *Ilustrado* columnists were writing of a perceived crisis regarding the extent to which local theatrical talent was being lured away from the city's stages. Montalván, among others, blamed the "crisis" on the increasingly pornographic nature of *revista* spectacles. With the show cancelled, Vélez began a tour of provincial Mexico—never a good sign for an actress or entertainer. Reflecting on Vélez's tour of northern Mexican cities following her stellar rise on Mexico City's Revue stage, Argos is kind. He notes that she no longer has the freshness ("the perfume of her grace") that made her so wildly popular when she first arrived on the stage, but he also notes that she retains the public's interest. Noting the wide chasm that separates Mexico City from the rest of the country with regards to new trends, Argos points out that, to the provinces, Lupe still has something new to offer: "Lupe Vélez, after exhausting completely the perfume of her grace—but not yet that of her likability—in the limited venue of the Lirico, departed at the head of the [Lírico] company in order to indulge a provincial public—one who missed the popular Charleston and that still ignores the existence of balloon pants—with her delicate [*grácil*] figure" (1926).

Clearly, someone with Vélez's personality and stamina would not have been satisfied with touring provincial stages. When Vélez again surfaced, she did so on the Hollywood screen and as a star capable of seducing not just Mexican but international audiences. To those who always identified her with a modernity that originated in foreign influences, Vélez's move to Hollywood may have seemed inevitable. Her triumph in the US was augmented, in no small part, by the craft she had honed on *revista* stages. While her theatrical talents came as a revelation to her audiences, reports of Vélez's uncanny impersonations of exalted Hollywood stars during the accompanying live shows to her film debuts came as no surprise to the *cronistas* of *Ilustrado*.

By midcentury, as Salvador Novo was penning his remembrances of post-revolutionary Mexico City, Lupe Vélez was back in Mexico, making what would be her second Mexican film and her last screen role. *Nana* (1944), directed by Celestino Gorostiza and Roberto Gavaldón, was an adaptation of Emile Zola's famous novel by the same name. In the starring role as the erotic "Blonde Venus," Vélez's Nana becomes embroiled in a rivalry not unlike the one that marked Vélez's early exit from Mexico City's stage years before. The film's director, *Contemporáneo* playwright Celestino Gorostiza, would surely have been aware of the resonance of his casting Vélez in this role (García Riera 1992, 83). While the film was greeted with

controversy, polarized Mexican critics and audiences seemed in full agreement on one point: the dual nature of Lupe Vélez's public image as icon and iconoclast would remain intact.

## Notes

1. Vélez was the first Hollywood star to be immediately and fully understood in the context of her Mexicanness. Dolores Del Rio's star rose a few years prior to Vélez's, but her Mexicanness was not an important element of her star persona (see the essay by López in this anthology).

2. Vélez and Cooper met in late 1928 on the set of *The Wolf Song* (Paramount, 1929; dir. Victor Fleming). Vélez, on loan to Paramount from United Artists, was by far the more widely known star at the time, commanding four times Cooper's salary from *The Wolf Song*. But Cooper, newly under contract with Paramount, was given top billing.

3. On the "desired other" and the "demonized other," see O'Connor and Niebylski's introduction in this volume. I am grateful to the anonymous readers for feedback that has strengthened this essay. I am especially grateful to the editors of this volume for their generous and dedicated attention through my revisions. I am very grateful to Sonia León Sarabia for her encouragement at the early stages of my research.

4. Some of Vélez's best comedic performances on screen were realized in her most obscure Hollywood films. See, if you can, *High Flyers* (1937), *Honolulu Lu* (1941), and *Redhead from Manhattan* (1944). Rawson (2012) provides a comprehensive account of the many phases of Vélez's seventeen-year Hollywood/Broadway career. Dubious accounts of Vélez's 1944 suicide, published in filmmaker Kenneth Anger's *Hollywood Babylon* books (1959, 1965, 1975, 1984) have taken on enormous currency. See Ramirez Berg (1992, 284n15) Rawson (2012, 352–57).

5. Pinto (1977) provides an early instance of excellent Lupe Vélez scholarship. From there, popular-press writing initially outpaced scholarly work, with scholarship at times deferring to popular histories for biographical material. For semi-scholarly and popular-press histories, see Parish (1974), Conner (1993), and Vogel (2012). A comprehensive scholarly literature review of Vélez's history and cinematic representation includes López (1991), Rios Bustamante (1991), Ramirez Berg (2002), Fregoso (2003), Sturtevant (2005), Rodriguez (2004), Jenkins (2007), Nericcio (2007), and Rawson (2012).

6. Rita González's video, *The Assumption of Lupe Vélez* (1999), meditates on Vélez's prominence as a queer icon and recalls José Rodriguez-Soltero's film, *Lupe*. For creative treatments of Lupe Vélez, see also the work of Patricia Crespín and Xandra Ibarra (a.k.a. La Chica Boom).

7. *Ilustrado* rarely published the full bill describing an evening of variety performance. On July 2, 1925, however, it printed an announcement for the "compañía cómica," the Lírico theater (69). Vélez was listed as performing *Salomé* in the third act, presumably an Oscar Wilde interpretation.

8. I am grateful to the Screen Arts and Cultures department at the University of Michigan, Ann Arbor, for supporting my research at Hemeroteca Nacional de México, where I reviewed original copies of *El Universal Ilustrado*.

9. Sluis details the contrast between the already risqué *revista* costumes and the new level of nudity introduced with the Ba-ta-clán (473n.11). The *bataclanas* wore no stockings. Prior to the "French invasion," *tiples* wore body stockings, although their costumes were indeed revealing.

10. Aside from its heightened degree of nudity, *bataclanismo* differed from the established Mexican *revista* in their privileging of group spectacle over individual performance. In Ba-ta-clán, individual stars became less important, and plot and narrative likewise suffered. When Armando de Maria y Campos states that *bataclanismo* "revolutionized" *revista* theater, he refers to the stylistic impact of the genre, the popular sensation caused by its chorus of sexy *tiples segundas*, and the number of copycat productions and parodic appropriations it spawned. The ironic appropriation of foreign styles came to stand in for the more pointed political

content characteristic of traditional *revista*. Thus, the genre mediated—on a visceral, visual, if frivolous level—a local cultural encounter with an ever-encroaching global modernity.

11. Although *revista* shared with burlesque the genre's strong dose of humor and parody, unlike most versions of burlesque, nudity was relatively absent from the Mexican *revista* prior to 1925.

12. The generic terms *revista* and *teatro frívolo* were more or less interchangeable in relation to Ba-ta-clán. That is, Ba-ta-clán developed as a subgenre of both. *Frivolo* is useful in underscoring *revista*'s distinction from traditional dramatic theater or *teatro serio*, though not all *revista* was referred to as *teatro frívolo*. Generic terms were particularly fluid as theater of the postrevolutionary period saw rapid creative innovation.

13. Political parody has been an element of vaudeville and "revue" theater since at least the eighteenth century, but it was new to Mexico, and it became one of the genre's most notable and popular elements.

14. A good deal of political instability preceded Plutarco Calles's consolidation of power. In January 1924 the progressive Felipe Carrillo Puerto was killed. José Vasconcelos, the Secretary of Education from 1921 to 1924, resigned in opposition to the Obregón regime.

15. Monsiváis's analysis almost seems to play down the specifics of the Ba-ta-clán influence as such, reminding us that *bataclanismo*'s identifiable markers—nudity, spectacle, irreverence, irony, self-conscious "frivolity"—were all elements within *revista*, to varying degrees, before the genre's bataclanization.

16. "Argos" is a pseudonym for Carlos Díaz Dufóo Sr., a playwright with an elder-statesman affiliation with the "Group of Seven" authors (Ruiz Casteñeda and Márquez Acevedo 2000, 229–31; Magaña Esquivel 1964, 43–44).

17. *¡No lo tapes!* was produced by the prolific production trio of Pablo Prida Santacilia, Carlos M. Ortega, and Castro "el güero" Castillo, who were probably on par with Soto's production company in terms of *revista* clout and popularity, though their work has not exhibited the lasting cultural significance that Soto's had.

18. Lupe Vélez was born on July 18, 1908 or 1909; there is no firm agreement on the year. The Villalobos family was among the prominent upper-class sector of San Luis Potosí, Mexico. Vogel quotes Vélez's second cousin, Pedro Quintanilla Gómez-Noriega, remembering, "most if not all of the male members of that family were university educated professionals" (2012, 9). Vélez's father, Jacobo Villalobos (b.1879), was said to be a revolutionary colonel, though his allegiances during the revolutionary wars are not clear. Vélez used the name of her mother, Josephina Vélez (b. 1883), as her father didn't approve of the theater. Vélez and her older sister, Josephina, were sent to school at Our Lady of the Lake Convent in San Antonio when Vélez was fourteen. Legend has it she learned to dance the Charleston in Texas. She was there for about a year, returning when her father disappeared and was thought to be dead. Though Villalobos was not dead, he became unreliable as a family presence and source of financial support. Lupe sought work in the city.

19. True to the traditional roots of vaudeville, these *tiple* archetypes corresponded to modes of femininity one could expect to encounter in a bordello. Thus the mediation of *revista*'s social and political narratives and commentary would be, in this context, particularly provocative. The *tiple* personae encountered in the magazines in 1925 are a combination of the archetypal and the contemporary. That is, *tiple* stars were becoming known for their individual iconic images. Celia Montalván, for example, was "the *tiple* with the enchanting smile"; Celia Padilla was "the *tiple* of the moment."

20. See Oropesa (2005, 12–27) on *Nueva Grandeza Mexicana* and its relationship to state, culture, and the "neo-baroque."

21. Photo caption, *El Ilustrado*, November 8, 1925, 14. The words *frágil* and *grácil* were also used to describe Vélez's body, though she was never associated with weakness or passivity.

22. Vélez's androgyny is not immediately recognizable in the postcards still available, but it was notable enough to be implied in almost every description of her at the time.

23. In 1924, a year prior to Vélez's stage debut, a violent assault was perpetrated on several young female students—*pelonas*—by young male medical students. See Rubenstein (2007, 69) for the process by which the *pelona* image was eventually folded into the national revolutionary project.

24. The Virgin of Guadalupe, for whom Lupe Vélez is named, is a specifically New World religious icon associated with *mestizaje*. José Vasconcelos's publication that year of *La raza cósmica* (*The Cosmic Race*), the foundational articulation of *mestizaje* as national identity, may have served to underscore the perceived significance of Vélez's name and identity.

25. Hershfield theorizes the *china poblana*, the Indian girl from Puebla, as an instance of *la chica moderna* who represented, in the postrevolutionary years, a romantic version of Mexico's "domestic exotic" (2008, 128–32).

26. For the "Modern Girl" (versus New Woman) as a global phenomenon and "heuristic device" see Weinbaum (2008).

27. *El Ilustrado*, July 18, 1925, 39; full text in Prida (2008, 181). Loyo enjoyed a relatively high profile in the theater and a notable rivalry with Salvador Novo. To the extent that he is remembered, it is for his production *Ulises* (1928), which mocked the Contemporáneos' *Teatro Ulises* (Ortiz Bullé Goyri 2005, 188).

28. *El Ilustrado*'s resident artist and illustrator, Andrés C. Audiffred, created both portraits.

29. Argos writes that she makes $50 (pesos) a day (1925b, 10). The following week all major *tiple* salaries are published: Lupe $3,850 / Celia Padilla $3,775 / Celia Montalván $3,125 / Emma Duval $3,335.

30. The vast majority of the voters in the *tiple* contest were undoubtedly women. As Mahieux points out, the weeklies offered women "a novel way to participate in civic life [by inviting] them to vote in various contests and competitions, something they were still denied in the public sphere" (2010, 20).

31. *El Ilustrado*, September 24, 1925, 43–47. Celia Padilla, placing second, also received a full-page feature; Delia Magaña and Maria Teresa Renner, capturing third and fourth place respectively, shared a one-page article.

32. Fregoso (2003, 119–20) rightly recognizes a certain queerness attributable to Vélez's unconventional femininity. While I am unable to speak specifically to that topic within the scope of this essay, I should underscore the relationship between Fregoso's historical gesture and her writing on Vélez's iconic status within queer Chicana/o culture (120–22). See Rawson (2012, 342–92) on Vélez's posthumous (queer) appropriation.

33. *El Ilustrado* often repeated photographs. One that turned up in multiple articles—whether about stars, cars, or modern women—pictures Vélez's automobile with its hood up. Vélez, in a fur-trimmed coat, leaning over as if to check the engine, has turned to smile at the camera (*El Ilustrado*, July 1925, 61).

34. Grupo de los Siete. "¿Se debe acabar el Ba-ta-clán?" *Revista de Revistas*, September 13, 1925.

35. The Group of Seven are Noriega Hope, José Joaquin Gamboa, Francisco Monterde, Ricardo Prada León, Victor Manuel Diez Barroso, and Carlos and Lázaro Lozana García. Usigli (1976, 129–30) notes their connection with the Estridentistas' *Teatro Sintético*.

# From Hollywood and Back
### *Dolores Del Río,* a Trans(National) Star

*Ana M. López*

## Images of a Star

Chicana artist Amalia Mesa-Bains produced a series of seven installation pieces or "altars" between 1983 and 1993 paying homage to Dolores Del Río. Simultaneously of the home and of the public sphere, these altars reinscribe the figure of Dolores Del Río into the museum and the Chicano imaginary. In David Avalos's experimental Chicano video *Ramona: Birth of a Mis-ce-ge-Nation* (1991) the figure of Del Río—in *Ramona* but also in other films—is one of the narrative engines used to unpack a century's worth of stereotypes in the US representation of Latinos. A contemporary Los Angeles restaurant menu includes as one of its salads, the "Dolores del Rio," which is described as "a combination of tomatoes, red onions, zucchini, celery, carrots, cucumbers, and mushrooms, all on a bed of lettuce. Your choice of dressing." This is the only salad on the menu that offers such an option. In addition to copious press coverage, in 1930, even before she had made the transition to sound, Dolores had already been the subject of a book-length study, published simultaneously in Madrid, Barcelona, and Buenos Aires: *Dolores del Río: La Triunfadora* by Rafael Martínez Gandía.

Many Mexican artists have used the figure of Dolores Del Río in paintings, poetry, plays, and fiction, among them Adolfo Best Maugard, Diego Rivera, José Clemente Orozco, Salvador Novo, Carlos Pellicer, Alfonso Reyes, Jaime Torres Bodet, Paco Ignacio Taibo I with *Siempre Dolores* (1984) and Carlos Fuentes with *Orquídeas a la luz de la luna* (1982). A 1998 Internet search disclosed not only several places in the world where her films were being shown, but also a bevy of sites in which her name appears, among them the site "Romantically Linked," in which she is associated with a series of nine personalities other than her husbands, including Orson Welles, of course, but also Porfirio Rubirosa, Walt Disney, and Greta Garbo.

The central question which these facts and images suggest is, on the surface, straightforward: how to study a transnational star, an actress whose career overlapped with at least two national cinemas and who continues to have a presence in the US, Mexican, and Latin American imaginaries? First we must question the relationship between stardom and nationness. Hollywood stars and stardom have been copiously studied, but always through a hegemonic and often unconscious national prism, which presumes that Hollywood stardom is stardom in and of

itself. Even the most recent books and anthologies on stars and stardom barely acknowledge the troubling presence of other star systems, other bodies, and other nationalities.[1] Furthermore, Hollywood star studies rarely acknowledge stars' acting forays in other national cinemas or the repercussions of stardom—Hollywood or otherwise—in other cultural contexts.

In other national cinemas, stardom as a phenomenon has barely begun to be theorized, and most so-called star studies are little more than biography. There are a number of star biographies in Mexican film studies, for example, but the kind of transnational focus that I am calling for here goes against the grain of a scholarly project—the chronicle and defense of Mexican cinema—which is usually articulated in relation to the national. Beyond a consideration of stars, the cinemas of Latin America, be they the New Latin American Cinema or the "Golden Age" cinemas of the 1930s and 1940s, have generally been studied as discrete national phenomena, framed primarily by the socio-political vagaries of each state and only incidentally linked to continental or international social changes and movements.[2] This focus on nation and the corollary search for difference and uniqueness has obscured a series of important transcontinental forces and exchanges in the classical period, because in the 1940s and 1950s the cinema in Latin America was already—and perhaps had always been—a transnational phenomenon.

Thus, the issue of transnational influences in the classical period, which the case of Dolores Del Río highlights, is a fascinating historical puzzle that questions the viability of the "national" as the signpost of film histories by highlighting the hybridization potentially inherent to all national cinemas. Against the prevailing myth of national cinematic insularity and histories of national achievements and failures, I want to argue for the need to look at the history of Latin American cinema from a continental perspective that includes, but mediates, the national. The Mexican cinema, for example, was a national and nationalist cinema, but also profoundly transnational (see Fein 1994). It is precisely its transnational contexts and alliances that allowed it to develop some of its most "nationalistic" characteristics, icons, and stars like Dolores Del Río. I want to use Del Río's unique career, which began in Hollywood in the silent period, continued and climaxed in Mexico in the 1940s, and also featured a few subsequent appearances in Hollywood, as a catalyst to enable a discussion of the transnationality of Hollywood and of postwar Mexican cinema and their mutual industrial and ideological linkages. Thus the figure of the traveling actor—Del Río—as a site for tracing the mediation of nationness should function as a key for opening up a space for transnational analyses of the classic cinemas, be they Mexican or Hollywood.

Del Río's transnational stardom suggests a series of overlapping questions: Why does Dolores Del Río become a significant Hollywood star when so many others—especially Latin American women—failed? How and why does her return to Mexico shift her star persona and produce her as a national myth? What does it mean that she still fascinates us? How does she function as a symbol of Latinidad in the US imaginary? In order to provisionally answer these questions, I shall attempt to weave a web of socio-historical and cinematic evidence that addresses various levels of agency and determination, ranging from the individual herself—that is, from biography—to the social/national and the transnational.

## How Hollywood Created a Star

"Lolita" was born Dolores Asunsolo López Negrete on August 3, 1905, into an aristocratic Durango family that fled from Pancho Villa to Mexico City in 1910. After studying in a convent, where she was educated in French, and taking private lessons with a famous dancer, Lolita married her first husband, Jaime Martínez del Río, shortly after her sixteenth birthday. He was eighteen years her senior, a lawyer educated in Europe, and part of an old aristocratic Castilian family that had been in Mexico for decades and was socially prominent. After a long honeymoon in Europe, the couple settled into the elegant life of the Mexico City aristocracy: parties, dances, and teas.

Her entry into the cinema was accidental: Hollywood director Edwin Carewe, honeymooning in Mexico in the summer of 1925, was brought to her house by painter and family friend Adolfo Best Maugard for a "tea" and convinced her and her husband to go to Hollywood. The rationales for the move appear to have been multiple. First of all, like most young women of the period, Dolores adored the movies, read movie magazines, and collected star photographs. Simply meeting stars, much less becoming one, was an exciting prospect. Furthermore, there had already been several well-publicized Hollywood "star searches" in Mexico City, which surely would have captured her interest (see De la Vega Alfaro and Torres San Martín 1997, 13–19). Perhaps most importantly, the move to Hollywood offered her and Jaime an opportunity to begin a new life away from the conservative values of their respective families. For both the move represented affirming themselves against their families. In any case, within days of their arrival in Hollywood in late 1925, Dolores was in front of the cameras in a secondary role as a Spanish countess in *Joanna* (1925), the film Carewe was then directing.

Del Río's rise to stardom was as quick as the disintegration of her personal life. The cinema, rather than bringing the couple closer, tore them apart. Jaime did not like being "Mr. Del Río," and his own career as a writer was going nowhere. After two trial separations, Dolores filed for divorce in 1928,[3] while rumors about her relationship to Carewe were flying high. He was her manager and successfully got her roles in First National, Fox, Metro, Universal, and United Artists productions, several of which he directed himself.[4] While he directed her in *Ramona* in 1928, he also divorced his wife, Mary Aiken, and he and Del Río traveled together to Mazatlán on his own yacht for some location shooting for their next film, *Revenge*. Dolores denied their relationship, but called her mother to live with her to suppress the gossip. As she said years later: "Everything happened to me. Things broke down around me. Terrible and tragic things" (quoted in Parish, 1978). In late 1928, Jaime del Río died suddenly of blood poisoning. Now Dolores was ostensibly free to concentrate upon her career in a different way. In the silent period, Carewe was perhaps Del Río's best director; certainly they aided each other's careers. To begin with, Carewe's press agents were responsible for circulating constant releases about Dolores and gave her a "name" even before she had any starring roles. As Rafael Martínez Gandía, her first chronicler, astutely complained as early as 1930, "What is most surprising in Dolores del Río's (sic) lightning fast climb to fame is that her triumph was not due to impeccable acting

before the cameras. . . . Dolores del Río became a personality without proving her merits. Thanks to Carewe and to his publicity campaigns her name was known throughout the world much before her first films" (Martínez Gandía 1930, 15, 16–17).[5] This same press machinery is also the central topic of Paco Ignacio Taibo I's novel *Siempre Dolores*, in which the author's alter ego is none other than the young press agent/lover responsible for creating Dolores's Hollywood star image. In any case, critics did notice that in Carewe's films, Del Río seemed at her best, and he perfected her silent image as the "female Rudolf Valentino," a dark beauty with cupid lips who acted above all with her face and secondarily via hand and body movements. After the tremendous success of *Ramona* and *Revenge*, the couple arranged a lucrative five-million-dollar contract with United Artists. As their fortunes rose, however, their relationship cooled. Perhaps because of Jaime's death, Dolores withdrew from Carewe, and after they filmed *Evangeline* in 1929, Carewe sold her contract to United Artists.[6]

Carewe's role in the "creation" of Del Río as a Hollywood star is important and linked to the already significant cinematic relations between Mexico and Hollywood. Carewe may have been on his honeymoon when he went to Mexico, but he must also have been thinking about his business. The previous two films that his small independent company had produced had been threatened with bans by the Mexican government for their depiction of Mexicans. And an independent producer with limited means like Carewe could not afford to lose the lucrative Mexican market, since his success was dependent upon quick returns on investment. The Mexican government's censorship policies were already well known and somewhat feared by Hollywood producers: rather than banning an individual film, the Mexican government had begun to ban all the films produced by companies distributing or producing offensive titles. Furthermore, they sought and began to obtain the solidarity of other Latin American nations who followed the Mexican example with similar legislation. Hollywood stood up and listened: First National, the first producer whose entire output was banned by Mexico, immediately published a statement that "the wishes of the government would be respected" (cited by Woll 1978, 13; corroborated by García Riera 1987, 109–11, 125–26). In fact, however, rather than present "dignified" Mexicans, producers resorted to inventing imaginary countries and to "hispanicizing" California without making it either Mexican or Spanish. Nevertheless, following the spirit of the period, Carewe was careful not to offend Mexican sensibilities and stated to the press during that first visit: "The production companies have been wrong to exploit Mexican characters of the 'with a gun in their belts' types as bandits and traitors when in Mexican society there are so many distinguished women and cultured men" ("La vida en Hollywood," 26 July 1925, sec. 2, 4; cited by De los Reyes 1988, 320). These sentiments were echoed by Dolores shortly after her arrival in Hollywood:

> What [Hollywood] needs is a high-society Mexican woman, one who may have been exposed to foreign culture and customs through travel, but who maintains our customs and the traces of our Mexican land. And then the vulgar picturesque type, so damaging because it falsifies our image, will disappear naturally. . . . This is my goal in Hollywood: all my efforts are turned toward filling this gap in

the cinema. . . . If I achieve this it will be the height of my artistic ambition and perhaps a small glory for Mexico. (De los Reyes 1988, 320)

Dolores became a Hollywood star, but she never achieved this dream.

## What Price Glory? The First Hollywood Star Image

Dolores Del Río's first successful starring role was her fifth film, *What Price Glory?*, directed by Raoul Walsh and one of the *New York Times*'s ten best films of 1926. As Charmaine, a French bar girl during World War I, she steals the hearts of two feuding American marines (Victor McLaglen and Edmund Lowe), who stoically face the horrors of war but would rather fight each other for her favors. In this film she solidified her image, and there seems to be somewhat of a "fit" between her star image and her onscreen role. In other words, she fulfills the promise of stardom that the star's onscreen characters give audiences some kind of access to the personality itself. As in most of her other Hollywood films, especially in the silent period, she was a heavily sexualized and exotically beautiful foreigner, but here she also had a feisty humorous spirit, which allowed for curiously independent actions. Charmaine is, above all, spontaneous, natural, innocently sexy—precisely the characteristics attributed to her great native/foreign beauty and a "fit" which Dolores herself underlined to the press: "I am not, by nature, melancholy, weepy, sorrowful, languishing, or sweet. . . . I am the girl of *What Price Glory?* There, for a bit, I could show my real self. I am, by nature, tempestuous, fiery, stormy, eager" (cited in Bodeen 1967, 266–67).

Our first introduction to Charmaine crystallizes the naturalizing mechanics of her sexualization: rolling a heavy barrel on the floor of the barroom, her prominently displayed derrière is the compositional center of a rather unusual image in which the camera assumes the lecherous point of view of Captain Flagg (McLaglen), and what Dolores herself cannot possibly appreciate is displayed for all to see. This introduction tellingly turns the table on the conventional marking of a star's entrance into the narrative via luminous close-ups that underline the star's presence. Rather than the face as the window onto the soul, her sexy derrière is what the audience first recognizes as characteristic of her persona.[7] However, as her appreciative once-over of Captain Flagg when she turns around demonstrates, seduction and seductive looks are something Charmaine can return as well as receive, and her sexual freedom is the focus of the nonbattle parts of the film: both marines fondle her outrageously and frequently, and she sleeps with both of them (off screen). In fact, Charmaine is the only site of visual pleasure—with frequent close shots of buttocks, legs, and half-bared shoulders—in a film which is otherwise concerned with detailing the horrors of war. Curiously for a film of this period, she is not condemned for her explicit sexuality, what Kevin Brownlow has described as "the utterly unabashed sexual content of the love scenes" (cited by Johnson 1982, 1210); on the contrary, it empowers her. When her father (Cognac Pete) attempts to force one of the men into a shotgun wedding for "ruining" her, the men acquiesce to the situation while she is the one that rebels, venting her fury on all the men around her with a virulence and freedom rather unthinkable for an "American" girl in an equivalent film situation. She is certainly neither a rebellious New Woman, an independent bachelorette, a fallen woman, nor a flapper.

At the end of the film, the men are at war and at war with each other, but Charmaine, in the act of choosing one over the other, is also able to reconcile them: Captain Flagg has her heart, but Sergeant Quirt her love. Positioned as a sexual object but also as a redeeming force—the power of love and a "pure" heart despite sexual freedom—her pathos at the men's departure to yet another battle ends the film and allows Del Río one of her best acting moments in the film.

Although she went on to work with a variety of directors, Del Río's image in the silent period remained fairly stable albeit with a complicated degree of inter-penetration between her publicly available private life and her films. Despite being insistently identified as Mexican in the public sphere, she played sexy Russians (*Resurrection* [1927] and *The Red Dance* [1928]), sexy Spanish dancers (*The Loves of Carmen* [1927] and *The Bad One* [1930]), sexy half-breeds (Andean in *The Gateway of the Moon* [1928] and North American in *Ramona* [1929]), sexy gypsies (*Revenge* [1928]), and even a fairly sexy Acadian (*Evangeline* [1929]). She was not identi-fied with Latin American characters. Rather, hers was a vaguely upper-class exoti-cism articulated within a general category of "foreign/other" tragic sensuality. As a sensual "other"—an object of sexual fascination, transgression, fear, and capitula-tion—her onscreen image did not have a specific national or ethnic provenance, but simply an aura of foreignness that accommodated the disruptive potential of her explicit sexuality. Her "otherness" was located and defined on a sexual register conflated over the foreign/exotic rather than the ethnic.

Within the industrial context of Hollywood, Dolores, who was still very young and a great beauty, was well situated in the late 1920s international constellation of talent. At a time of great expansion for the industry, the Hollywood studios had begun to attract—and recruit—a bevy of international stars and directors, not only to preclude competition from other national cinemas (such as the German) but also to increase its appeal to international audiences. Dolores Del Río fit in per-fectly with the new international crowd, which included, among others, Pola Negri, Greta Garbo, and Rudolph Valentino; with her elegant ways reminiscent of the "old Spanish tradition," the many stories circulated by the press about her exotic upper-class upbringing and travels, and her glamorous marriage (at least while it lasted), she complemented Hollywood's new self-conscious international image. Hollywood had needed a Mexican female star—few reviews or press releases failed to comment upon her nationality—and had finally produced it. Yet this particular brand of Mexicanness (albeit based on the colonial legacy of the old Spanish tra-dition) that was so essential for her image was not specifically tapped onscreen. Rather, her ethnicity was submerged under the signpost of exoticism.

## The Height and Fall

Her success in Hollywood in the silent period was spectacular, peaking after the release of *Ramona*, when United Artists also released a record which included Del Río's rendering of the "Ramona" title song, which sold by the thousands. And she was also well liked by the Mexican public, even if some reviewers had mixed feel-ings. In 1926 she had been selected as one of the "WAMPAS Baby Stars," a yearly selection by the Western Association of Motion Picture Advertisers of thirteen

young starlets headed for stardom. Among others, the 1926 roster included Mary Astor, Fay Wray, Joan Crawford, and Janet Gaynor (Parish 1978, 16). She was picked the winner by the US public. A year later, trying to determine which of its previous roster of thirteen had in fact been most successful, WAMPAS held another contest that was open to voters from all nations. Dolores solicited the help of her compatriots via ads in *The Los Angeles Times* and *The Universal* in Mexico City, and she received hundreds of thousands of votes, winning the contest by more than two hundred thousand.

But the arrival of sound complicated her career. Del Río had put off the transition to sound for as long as she could. As late as 1928 she dismissed the new talkies as "a passing fancy" and tried to argue that sound would destroy the kinds of movies which were "Hollywood's greatest works" (*New York Times*, Aug. 19 1928; cited by Woll 1978, 40). It was already well known that the US public rejected foreign actors with accents, and she was rightly worried about hers. As is evident in the *Ramona* recording, as of 1929 her accent was thick and her English almost unintelligible. Thus, to rationalize her accent, in *The Bad One*, her first sound film of 1930, she played a Spanish singer and began to fall into the trap of having to portray some kind of Latin American character. And this trap—added to a series of personal problems such as a protracted illness (or nervous breakdown) and a scandal surrounding her attorney, Gunther Lessing, who sued her "for ruining his marriage" and disclosed to the press a series of unsavory allegations—would sully her image significantly. Perhaps in an effort to reconstruct a version of her previous dignified, aristocratic and "happily married" image, in 1931—the only year since her arrival in Hollywood in which she did not appear in a single film—she married the well-known MGM set designer Cedric Gibbons, the arbiter of style for the Hollywood jet-set. Rather tellingly, in a *Photoplay* interview, she explained her marital choice in transnational terms, mentioning but eliding her nationality as well as Cedric's.[8] "'Cedric is perfect,' she asserted, and her eyes lighted up like burning candles. 'First, he is American, with that dash most American men seem to possess. And he is understanding and sympathetic. He has never been to Mexico and does not know my people—but he is an artist, and in his artist's appreciation he has been endowed with the sensitivity of the Latin. A perfect husband, no?'" (*Photoplay*, April 1934; cited by Woll 1978, 42)

But sensitive to Latins was exactly what her second sound film, *Girl of the Rio*, was not. This film was a remake of *The Dove*, a 1927 Norma Talmadge vehicle which had been banned in Mexico and other Latin American countries, primarily because of its central character, Don José María López y Tostado (Leo Carrillo), a stereotypical bandit villain. In *Girl of the Rio*, Del Río is a singer in the Purple Pigeon Night Club, just over the border. Outfitted in a Spanish-dancer white-lace dress, huge hair combs, and a white mantilla, she entertains the bar patrons and falls in love with a good-hearted American, Johnny Powell (Norman Foster). Don Tostado decides he wants Dolores and arranges several mishaps for Johnny, including shooting him, but in the end relents and allows Dolores to go off with her American. Although *Girl of the Rio* was not banned by the Mexican censors, when it was exhibited as *La Paloma*, it generated much ill will toward Del Río in Mexico. According to one historian, "The theater which showed the film in Mexico City received continual threats of violence and a special delegation visited Mexican

President Ortiz Rubio to request immediate suspension of the film" (Woll 1978, 42). And Luz Alba, film critic for the Mexican newspaper *Ilustrado*, wrote a scathing critique of her acting abilities: "Dolores del Río is always the same. Endlessly she inflates her nostrils and manipulates her eyes with an excessive desire to make them seem incendiary. Her mannerisms are as bothersome as a speck of dust in the eye" (May 12, 1932; cited by García Riera 1987, vol. 1, 161).

Although she remained a visible presence in the Hollywood jet set until her departure in 1942, Del Río never regained her former fame. She moved among the Hollywood elite, but over the next decade her roles became less and less significant, and she became much more identified with Latin American and/or Mexican characters. Furthermore, her decline was also linked to the shifting imperatives of the industry throughout the 1930s and early 1940s.

Most significantly, sound had opened the floodgates to music, and by the mid-1930s it was almost impossible to conceive of "Latin-ness" in Hollywood without music. Although Del Río starred in four musical vehicles in the early 1930s and ostensibly had musical talent, especially dancing, she did not "take" as either a singer or a dancer. For example, although she was the top-billed actress of *Flying Down to Rio* (Thorton Freeland, 1933), she lost the film to the introduction of Fred Astaire and Ginger Rogers as a dancing couple. In *Wonder Bar* (Lloyd Bacon, 1934) she is only a featured player, lost in the shuffle of a cast that included Al Jolson, Kay Francis, Dick Powell, Ricardo Cortez, and Busby Berkeley choreographies. To add insult to injury, another one of her musicals, *In Caliente* (Lloyd Bacon, 1935), had a border setting and was banned by Mexican censors because of its undignified depiction of Mexicans that included songs with lyrics such as "In the language of the gringo I'm so hotcha, muchacha, I'll watchya . . . just like a cat would watch a little cucaracha" (Crowther 1949, 21).

In addition to sound and the emphasis on musicality, other forces were also shifting Hollywood's interests. First of all, the July 1934 enforcement of the Production Code—the industry's self-censoring mechanism designed to forestall federal intervention—radically changed the level and intensity of sexuality that could be portrayed onscreen. That which had been Dolores's forte—her body, unabashed sensuality, and extraordinarily explicit sexuality—could no longer be represented. In fact, her first film to be submitted for Production Code approval, *Madame DuBarry* (William Dieterle, 1935), was a major cause of dispute between the studio and the Hays office, primarily because it presented the court of Louis XV as a sex farce centered around Del Río.

Secondly, shortly thereafter the beginning of World War II shifted Hollywood's priorities. Prior to the war the industry had derived a large percentage of its gross revenues from foreign markets, and upon the closing of the European and Japanese markets, it set out, in Bosley Crowther's words, on "a campaign to woo Latin America" with films of "Pan-American" interest. Pan-Americanism led to the creation in 1940 of the State Department Office of the Coordinator for Inter-American Affairs (OCIAA), headed by Nelson Rockefeller, and to the resurrection of the Good Neighbor Policy. In addition to sponsoring the production of documentaries, newsreels, and shorts "to carry the message of democracy below the Rio Grande," the OCIAA worked with the Production Code Administration's newly appointed

Latin American expert to pressure the studios to become more sensitive to Latin issues and portrayals (see Woll 1977 and De Usabel 1982).

Thus, the Good Neighbor Policy, among other things, further reinforced the musical tendency, which was perceived as politically harmless and also redefined the terms of Hollywood's Latin/Latino representation. Dolores Del Río's kind of ethnically undifferentiated sexual persona was no longer either adequate or desirable. For example, in a precursor of the Production Code and the Good Neighbor films like *Flying Down to Rio*, the explicit and irresistible sensuality of her aristocratic Carioca character (all she has to do is look at a man across a crowded nightclub and he is smitten forever) could be articulated, because in the end it would be tamed by marriage to the North American hero; in the films of the Good Neighbor period, that resolution/partial appeasement of the ethnic/sexual threat of "otherness" she unleashed was no longer available. A kind of embryonic identity politics was beginning to emerge—symbolized by demands for authenticity in representation—which called for a sanitizing of sexuality: instead of Del Río's sultriness, Hollywood produced Carmen Miranda in a tutti-frutti hat, and tropicalization became the dominant trope for Hollywood Latins.

In order to recognize this shift, it is useful to analyze Del Río's image in the pre-Production Code and pre-Good Neighbor Policy period films: as an elegant and sensual aristocrat in *Flying Down to Rio* and as the no less sensual, albeit less elegant, South Seas princess Luana in *Bird of Paradise* (King Vidor, 1932). Both films are significant within her filmography and demonstrate not only her new "look" but also her search for a different star image. In both, but especially in *Flying Down to Rio*, Del Río appears sporting an absolutely "modern" look. Possibly influenced by the makeup revolution introduced by Joan Crawford and Marlene Dietrich or by her husband's (Gibbons) well-known fascination with art deco set design, almost overnight Del Río's physical appearance changed: short soft hair rather than a severe center-parted chignon; a wider, softer mouth rather than small, heart-shaped lips; makeup that emphasized her high cheekbones and called even more attention to her luminous—also well-made up—eyes; and, in *Flying Down to Rio*, elegant white or black svelte clothing that highlighted her famous *esqueleto rumbero*, the dancing skeleton of Mexican folklore.

Playing Carioca aristocrat Belinha Rezende in *Flying Down to Rio*, she is still extraordinarily sensual but now suffused with elegance, sophistication, and glamour. As Aurelio de los Reyes has commented, this is the first time that her onscreen image fully coalesced with her off-screen persona, the elegant socialite Mrs. Cedric Gibbons who hobnobbed with the elite and had weekends at San Simeon with the Hearsts (De los Reyes 1996, 80). However, already we can see traces of the changes about to come, which would radically alter Hollywood's representation of Latinos and the place and function of Latinos in the industry. In the crucial scene early in the film when Belinha easily seduces Roger, the gringo bandleader, simply by setting her smoldering eyes upon him (emphasized in a close-up in which the rest of her face is framed by an evening hat low on her brow, the billowing sleeves of her white gown, and an evening-purse mirror which she uses like a flirtatious mask), there is a clear hint of an important displacement. After Belinha and Roger begin to dance, one of the four blonde American women left behind at the table remarks

Dolores Del Rio in a publicity photo for the Argentine magazine *Cinegraph* in 1935, sporting her new look.

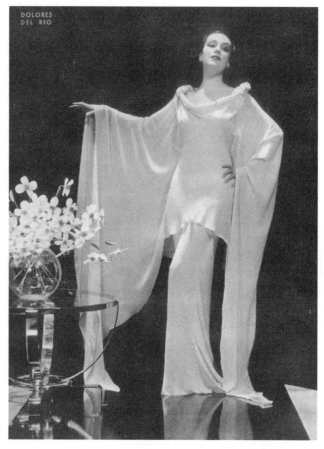

to her companions: "What do these South Americans have below the equator that we haven't?" Ostensibly an innocent remark, her comment is nevertheless extraordinarily telling of how the film maps Del Río's sexuality on a geopolitical axis. First, it is obviously a statement which textually produces the effect of difference ("What do they have that we don't have")—an "us" and a "them" with well-defined essentialized boundaries—but it can also be read as referring explicitly to Del Río's sexuality ("What do these South Americans have below . . . the waist?") and how it can stand in as a characteristic of South Americans, especially women, in general: no matter how elegant, aristocratic, and/or glamorous, Latin American women are above all erotic, passionate, and mesmerizing. In the conjunction of region/ nation ("South Americans") with implicit sexuality (below the waist), the statement also figuratively displaces that sexuality onto the map, and, by suggesting its tropicalization ("below the equator"), somewhat diffuses its implied threat.[9] This tropicalization, albeit subtle, is pervasive: Belinha is, like her theme song in the movie, like an exquisite orchid, an exotic flower from a lush hot house like Del Río herself, who was described by at least one critic as "orquidaceous" (Shipman 1970, 154). Similarly, within the diegesis, the "native" rhythm the "carioca" is easily learned and "transformed" by dancing stars Astaire and Rogers despite their original dismay at its verve, complexity, and entertainment value.

*Flying Down to Rio* was one of Del Río's last pre-Production Code screen ap-
pearances, but the film already seems to embody a consciousness of the repression
of sexuality about to come.[10] When Belinha and Roger—who also happens to be
a pilot—find themselves having to spend the night alone on a desert island (it is
actually Haiti, and the bandleader has tricked her), they begin to fall in love as they
sing "Orchids in the Moonlight." But what is most fascinating about this scene is
not only the commonplace that a Latin American woman and an American are
falling in love, but also the way the scene's potentially explicit sexuality is displaced.
To avoid showing their explicit interaction, the characters' encounter is displaced
onto "others," ghostly apparitions of themselves (alternatively their conscience or
ids), who are then empowered to act out the forbidden (their kiss and passion) and
are only subsequently—after the "fact"—incorporated into the "self."

*Birds of Paradise*, although produced a year earlier, is significant for pointing in
a different direction—one which Del Río would not follow—toward the explicit
tropicalization that would eventually produce Carmen Miranda as an exuberant
tropical rather than only a sexualized fetish. As the South Sea princess Luana, she
is exquisitely sensual and given great freedom to display herself erotically and
barely clothed in leis and sarongs (the Cecil Beaton photographs of her in costume
are among her most revealing and exquisitely display her great beauty).[11] She is
the object of the hero's (Joel McCrea) desire and reciprocates freely, unfettered by
social taboos other than those of her own tribe. But here, as a racialized other, her
sexuality, although available in terms of an interracial romance and played out on-
screen explicitly—especially in the nude underwater sequence in which she lures
McCrea off his friends' yacht like a mermaid, as Variety commented, "an eyeful
of undraped symmetry" ("Bird of Paradise" [1932] 1983)—cannot be assimilated.
This white American hero is one she cannot marry: "East is East, and West is West,
and never the twain shall meet," as one character says at the end of the film right
before Luana gives up Johnny and walks into a roaring volcano off screen.

Both films are significant because of the explicit sexuality of the characters
Dolores plays, but in both we can also see why Del Río could not establish herself
as a musical star: in contrast, say, to her swimming or when she is being seductive,
her dancing is stiff and tense. She already appears aware of herself as performer: the
great star condescending to dance rather than a dancer. In contrast to the native
extras' far more rhythmic moves in *Bird of Paradise*, for example, her tribal danc-
ing sequences are stiff and self-consciously performed for the camera and/or white
voyeur. Similarly, while dancing to "Orchids in the Moonlight" in *Flying Down to
Rio*, she manages to look utterly uncomfortable in Fred Astaire's arms, posing for
the camera/diegetic nightclub audience rather than dancing with her partner.

In her 1930s/early 1940s films, Del Río demonstrated her already sculptural
great beauty—what Mexican poet/playwright Salvador Novo described as "only
the material form of talent" (cited by Monsiváis 1997, 79)—but not her acting
skills or popularity. As Aurelio de los Reyes remarks, "It seems that Dolores got
her roles more because of her social relations than her box-office success" (De los
Reyes 1996, 83). Her life in the Hollywood jet-set was, simultaneously, her high-
est achievement and part of her downfall. On the one hand, it secured her status
(star-studded Sunday lunches, couture fashions, the best social connections) and

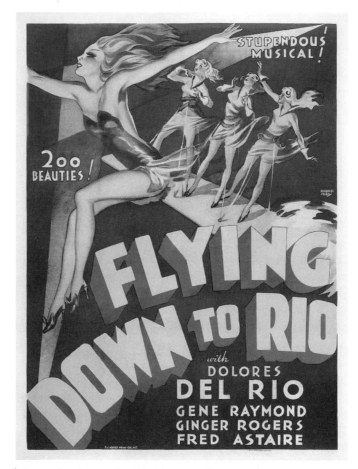

STUPENDOUS MUSICAL!

200 BEAUTIES!

FLYING DOWN TO RIO

*with*
DOLORES
DEL RIO
GENE RAYMOND
GINGER ROGERS
FRED ASTAIRE

Promotional poster for *Flying Down to Rio,* released in 1933.

international recognition: as one of the "Universal Mexicans," she was an official guest at the 1934 inauguration of the Palacio de Bellas Artes in Mexico City. On the other, it brought her to Orson Welles: their 1938–1940 secret affair caused a great scandal and led to her repudiation by the Hearsts and their crowd (because of *Citizen Kane*) and to her divorce from Cedric Gibbons in 1941. Welles cast her in his new film *Journey into Fear* (1943), but unfortunately, he lost the film—it was finished by Norman Foster—and Del Río lost Welles, who left her for Rita Hayworth and the filming of *The Lady from Shanghai* (1947).

In *Journey into Fear*, Del Río is a travesty of her former star persona. She is still exotic, but now she is a secondary character, a nightclub entertainer dressed in a catsuit, whom Joseph Cotten, the protagonist, constantly refers to as "the girl that meant nothing to me" in his voice-over narration. Above all, here we recognize that, as Novo had intuited, her beauty was her talent. In *Journey into Fear*, she remains magnificently beautiful but static, immobile, a frozen effigy in the midst of a para-doxically fast-moving and convoluted espionage plot (based on the Eric Ambler novel). It was obviously time to leave: she sold her Hollywood home and fled back to Mexico, where, after all, the film business was looking good.

# The Myth is Reborn

But in Mexico, although recognized as an "achiever," Dolores was not necessarily well liked by the public. As she remarked in the 1970s to Elena Poniatowska, "If my going to Hollywood was criticized by all Mexican society, my return was much worse. You can't imagine the rumors when I said that I wanted to make films in Mexico. They began to say: 'With whom are you going to make films here?' I wanted to help to make Mexico known throughout the world" (Poniatowska 1993, 25).

Nevertheless, astoundingly quickly, in Mexico Dolores Del Río was reborn as a, if not *the*, great star of the newly thriving national industry. She was a founding member of the most famous filmmaking team of the industry, joining forces with director Emilio "El Indio" Fernandez (the "Pygmalion" of her Mexican career), cinematographer Gabriel Figueroa, screenwriter Mauricio Magdaleno, and the actor Pedro Armendariz, her most frequent onscreen partner (of her seventeen Mexican films between 1943 and 1966, she costarred with Armendariz in ten). With this team, she starred in two of the most significant films of *el gran año* [the great year] of the Mexican Golden Age, 1943: *Flor silvestre* and *Maria Candelaria*, the more significant of the two because of its subsequent success at the first post-war Cannes Film Festival.

Now ensconced in an industry with an ostensible nationalist agenda, Del Río's persona underwent a radical transformation. Her previous sophisticated exoticism disappeared under the weight of a new image premised on a then-fashionable *indigenismo*. Advised by Diego Rivera and other intellectuals and artists, she jumped at the opportunity to be "Mexican" and took on "El Indio" Fernandez's nationalist project: "If to your beauty and fame we add the tragic spirit of the Mexican people, Lolita, you can be sure to conquer Europe. You must win the hearts of the Mexican people, who have been resentful of your contemptuous attitude. . . . You must communicate that you are Mexican and proud of it and, moreover, that you identify with the oppressed classes"[12] (Fernández 1986).

Stripped of her high-fashion gowns and Hollywood glamour, Dolores assumed the onscreen image of a prototypical meek, ignorant, and barefoot Indian girl. She was finally portraying a Mexican woman, but not the sophisticated, cultured one that she had dreamt of introducing to Hollywood in 1925. With some exceptions, from *Flor Silvestre* in 1943 on, Del Río played essentially the same character: a humble and/or quietly dignified indigenous and/or rural woman who suffers and must subordinate herself and her desires to a man and/or the nation. Confined to the melodramatic genre, her characters—although physically perfect, especially when photographed by Gabriel Figueroa or Alex Phillips—were always controlled or driven by others or external forces. The immobility already evident in her later Hollywood films was exacerbated, the phenomenon Monsiváis has dubbed a "facial ideology": "In order to excuse the unrepeatable beauty of a native, local racism makes her hieratic—the negation of happiness, a reservoir of suffering and dignity" (Monsiváis 1997, 81). In the 1940s, Del Río became a larger-than-life archetype, a crucial emblem of Mexicanness, one of the great "myths" of the Mexican cinema. As Emilio García Riera argues: "The new tragic Dolores del Río who has had to return to her country in order to no longer be the impassive exotic

beauty that Hollywood created, in the future will never stop playing this role, being faithful to her image rather than to her characters" (1970, vol. 2, 121).

It is rather curious, however, that, internationally, this second "impassive" version of "Dolores Del Río," star, crystallized in *Flor silvestre* and especially *Maria Candelaria*, was perceived as real, as the "authentic" version. For example, Georges Sadoul, after watching *Maria Candelaria* at Cannes (where the film was well received and awarded), wrote the following in *Les Lettres Françaises* in 1946: "We thought we knew her . . . , but all we had seen was the Hollywood mask. . . . Without artifice, her pure face framed by long braids, and dressed with the simple clothes of a Mexican peasant, Dolores del Río appeared completely new and speaking her native tongue. Like her face, her acting lacked artifice. We did not face an actress, but rather, a woman" (quoted in García Riera 1970, vol. 2, 169).

Sadoul's comment about Del Río's acting is rather perceptive, not because in *Maria Candelaria* she lacked artifice, but because after *Maria Candelaria* and once again winning an international reputation, cinematically Dolores Del Río's star image functioned very differently in the Mexican cinema than it had in Hollywood. Despite her Hollywood "defeat," despite the Mexican public's initial resistance, she returned to Mexico a star, and all her Mexican films, especially after *Maria Candelaria*, are overpowered by her presence as a star. The performative self-awareness that was already evident in her Hollywood dancing sequences in the 1930s was adopted as an acting style. In other words, the process of manufacturing the star image became an integral part of her acting. It is as if the distinction invoked by Jean Louis Comolli (1978) between the "body acting" (the actor) and the "body acted" (the character) to explain the disjunction that occurs in historical films because the characters have real historical referents had become naturalized: the real historical referent here is always Dolores Del Río, the star. She doesn't act anymore; she simply is Dolores Del Río, la grande dame, the great face which after *Bugambilia* (Emilio Fernández, 1944) will be endowed with even more expressive eyes and extraordinarily mobile eyebrows.[13]

The visible split between her star and onscreen images in this period—society lady/all-powerful star versus endless humility, suffering, and abnegation—is disconcerting, producing fascinating tensions (for example, as *Maria Candelaria* she constantly walks around holding a pig, "la marranita," that will allow her to buy a wedding gown, but all we notice is her impeccable designer-Indian dress and the perfection of her features). Paradoxically, however, these tensions are most evident in the films in which she does not play indigenous, rural, or historical characters. In *La otra*, a 1945 urban melodrama directed by Roberto Gavaldón, for example, she plays a double role as physically identical but vastly different twin sisters (María, a manicurist, and Magdalena, a millionaire), one of whom kills the other and takes her place. The narrative of the film is about otherness and María's struggles to pass herself off as Magdalena, but, as Emilio García Riera perceptively noted in a capsule review of the film: "a film which could have been about otherness—after all it is called The Other—ended up being about the film star being herself" (García Riera 1970, vol. 3, 50). Nevertheless, *La otra* is perhaps her best Mexican film— rivaled only by *Doña Perfecta* (Alejandro Galindo, 1950)—and its double roles and byzantine plot (written by José Revueltas) allow Del Río to turn the tables on her

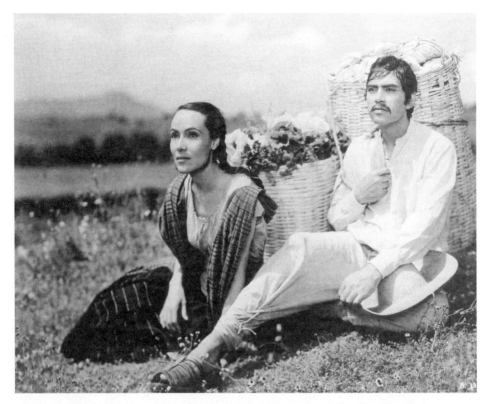

Dolores del Río and Pedro Armendáriz in *Maria Candelaria*, 1943. Colección Filmoteca UNAM, México.

traditional melodramatic submissiveness to be simultaneously arrogant and aggressive. The diegetic emphasis on identity and the film's many scenes in which a silent María/Magdalena struggles with her fears, guilt, and the practical difficulties of pretending to be someone else are a perfect frame for Del Río's kind of acting. For example, shortly after burying her sister, when she struggles with how to falsify her signature convincingly, we watch as frustration, fear, and ingenuity criss-cross her face in complete silence, culminating in her decision to maim her right hand with a fire-iron in order to be able to justify signing with her left. The camera closes in on her face, marked by the shadows of the flickering fire, and the marked arching of her right eyebrow—inordinately sustained—communicates her decision to maim herself. An even tighter close-up documents the burn as her face becomes a mask of pain, relieved only by satisfaction when she realizes she has accomplished her objective and can now have a new signature.

If, as Christine Gledhill has argued (1991), the first promise of the star is access to the personality, in this film the visibility of the star system itself discloses that possibility as an illusion. Here there is an excess of stardom produced by the emphasis on identity that the narrative can never fully recuperate. What is obvious in *La otra*, a film which includes a tremendous number of scenes without dialogue, is that Dolores Del Río always remained a silent cinema actress even though it was the Mexican sound cinema that produced her as myth.

## Transnationality and Returns

Del Río's triumphant return to a thriving industry and her transformation into a national myth and an international icon of Mexicanness must also be understood in the context of transnational relations. First of all, the OCIAA wartime programs instituted in Mexico had led to the modernization and expansion of Mexican film production in the style of Hollywood, providing raw film stock, equipment, and personnel. As Seth Fein (1998) has argued, working through Hollywood, the OCIAA sought to develop the Mexican cinema sector as a publicly autonomous and culturally authentic source of mass-entertainment propaganda for Latin America. To a large degree, it was these economic arrangements that enabled the Golden Age of Mexican cinema. After the war, this integration and collaboration climaxed in the partnership between RKO and the group headed by Mexican media magnate Emilio Azcarraga to build Estudios Churubusco. Earlier, RKO had already been the studio that had collaborated the most with the US government's cultural/ideological agenda. Now, by providing a transnational mode of producing Mexican mass culture, RKO's investment in Estudios Churubusco was central to postwar US propaganda production in Mexico.

Coincidentally, these transnational arrangements were crystallized in a film which was also Del Río's first return to a "Hollywood" now located in Mexico City: John Ford's *The Fugitive* (1947). Produced by Argosy, Ford's independent company, filmed at the Churubusco studios, and distributed by RKO, *The Fugitive* shrewdly featured the Mexican cinema's best-known screen couple—Del Río and Pedro Armendáriz—with well-known US star Henry Fonda and reproduced the Golden Age visual style through Gabriel Figueroa's cinematography and Emilio Fernandez's (uncredited) collaboration as assistant director.

Although an adaptation of Graham Greene's *The Power and the Glory*, a novel indicting Mexican anti-clerical policies in the 1930s, the film takes place in an anonymous Latin American nation controlled by a corrupt authoritarian state that invokes pseudo-communist rhetoric and oppresses Catholic peasants and the clergy in the name of social equality and modernization.[14] The film not only fit the United States' Cold-War ideological international imperatives, but also coincided with the Mexican state's domestic policies: as its previous (1930s) commitment to social justice and agrarian reform waned, the regime needed to justify social status quo as consistent with the nation and to equate radicalism with subversion while simultaneously clarifying the state's ideological stance during the Cold War.

In *The Fugitive* we have not only an example of transnationality that reveals the profound economic and ideological connections between the United States and Mexico in this period, but also Dolores Del Río's first reassociation with Hollywood. No longer the elegant exotic, she was now its antithesis, although just as narrowly defined. Her character in the film, Maria Dolores, is an indigenous woman who, of course, suffers with great dignity. Seduced and abandoned by the Armendariz character, a despotic police chief, she bears his child, works as a cantina girl, but risks all for her faith and its pursued representative, the intense priest played by Henry Fonda. She is appropriately introduced in the shadowy interior of a church, wrapped in a modest *rebozo*, holding a sleeping infant in her arms, and illuminated only by the sun streaming through a church window. She is

silent, almost immobile, and the mise-en-scene compounds the tension by post-poning the full revelation of her beauty. She is more sexualized here than in *Maria Candelaria*—the prototype for her character—since this is after all a Hollywood film, but she is on display as an object of desire only once, when she dances on top of a cantina table to distract the policemen from searching for the priest she has hidden in the back room. But even here, the moment is narratively contextual-ized, and the camera treats her figure with devotion. When the exhausted priest arrives at the cantina, she offers to run away with him to "save" him by pretend-ing that she is his wife and that her child is his. But, immediately, she realizes that this suggestion of a forbidden sexuality is perhaps offensive and apologizes, even though the priest has fainted and cannot hear her. Thus, narratively, her sexual potential is relegated to an other, secular, and inaccessible realm. Similarly, when she flirts with the police sergeant and offers to dance, it is clearly done in the spirit of a great sacrifice rather than of pleasure. Visually, her sexuality is dissected— her sexualized, beautiful legs and feet are self-consciously separate from her face/ soul. Thus, when she emerges from the back room in a flirtatious dress, an unex-pected fast track follows her in a blur of movement from the doorway to the top of the cantina bar and ends in a level close shot of her bare feet and legs marking the beginning steps of a dance. A low-angle canted close-up then shows us her face, animated and fairly seductive, alternatively masked by the fan she rhythmi-cally waves, but also in a very distinct visual space. It is only the third shot of the sequence that "joins" the sexualized body and the face: beginning with a medium shot of her bared legs and a policeman trying to peer up her skirt, the camera tilts up slowly on her body until it reaches her oddly animated face, which can now be read as utterly artificial. When several shots later the dancing is interrupted by the arrival of Rafael (Pedro Armendariz), a visual echo corroborates her "purity" and, simultaneously, the high price and perhaps even the inadmissibility of sexu-ality as his entrance is marked by a close-up of his shiny black boots entering the doorway. In *The Fugitive* Del Río's stardom is sanctified: she is a Madonna, the Vir-gin of Guadalupe, the ultimate figure of devotion. By 1947 Del Río was already a national and Latin American icon with an immutable image, and *The Fugitive* was the vehicle that reinscribed this new persona permanently within the Hollywood imaginary.

In all her subsequent Hollywood work, it was this quintessential Del Río— framed by braids, as Sadoul says, but obviously no less a construct than her first star persona—that prevailed internationally. In other Hollywood forays she would al-ways play strong yet suffering indigenous women: the "Spanish Woman" in John Ford's *Cheyenne Autumn* (1964), Elvis Presley's Indian mother in *Flaming Star* (1960), and the grandmother in Hall Bartlett's *The Children of Sanchez* (1978), her last screen appearance.

## Memory and Re-Iconicity

In the US imaginary, once the distinction between the star as person and the star as performer had collapsed, Dolores Del Río was wedded to her Mexicanness, this time not as an exotic other, but explicitly as an indigenous and/or ethnic other.

Rather than across the axis of nationality, her star persona is now plotted upon a class-based register: as a too-youthful looking grande dame, she condescends to play "others" because she is a great actress and, as a great actress, literally condescending. Above all, we remember Del Río as an image rather than as an actress, silent and unsmiling, a visual icon in stasis rather than in movement. In 1952, for example, the Parisian entertainment magazine *Cinemonde* featured her in an "exclusive" article in which she ostensibly "presents" an exhibit of Mexican art at the Louvre, but which really functions to position her on the same artistic altar—stanced, appreciative, priceless—as the works: the large earrings of a rare pre-Colombian figurine are just like her own gold hoops; the statue of Chacmol is significant because she appeared in a film with it; strategically positioned in front of David Alfaro Siqueiros's *Imagen de nuestro tiempo*, she is the object offered to the world by the painting's outstretched hands (Beaume 1952, 9–11).

Thus, perhaps the Amalia Mesa-Bains altar installations cited earlier provide us with the most prescient—and most problematic—representation of her transnational stardom.[15] First of all, Dolores was herself a fan of "altars" and displayed objects: "When I was a little girl I collected all kinds of things: I had small boxes filled with rings, bracelets, earrings, beads . . . and boxes full of ribbons that I classified by color and width" (De los Reyes 1996, 192). When she went to Hollywood she took along many family heirlooms, which she exhibited in her homes and in many publicity stills as if to invoke her own personal and cultural identity. Secondly, she self-consciously positioned herself on altars of stardom, high art, elegance, and sophistication—and was therefore enshrined as a sculptural icon. The Mesa-Bains altars, filled with myriad personal objects that could have been hers, and publicity stills echo her own self-representations. They capture her as image and, while providing a personal or human context through objects of everyday life, simultaneously transform her star glamour into a kind of divinity (the photos, lace, and glitter linked to the candles and religious icons): her Mexicanness, synonymous with her beauty, is reinscribed as sacred.[16] The altars contextualize her image domestically, but as a cinematic icon she is, by definition, not of the world of domesticity. In fact, the altars return her to the museum, the one site that most productively condenses her image and secular sainthood. But the altars also reinscribe her nationality: she is Mexican but of two "nations": the world of Hollywood and a Mexico now also located in the United States. Ironically, in the heterotopic space produced by these altar-installations—her greatest transformation—the elite socialite Del Río becomes a Chicana cultural heroine, rescued from Hollywood and Mexico for the transnation.

## Notes

Research for this essay was made possible, in part, by grants from the Royer Thayer Stone Center for Latin American Studies at Tulane University. My thanks to Rebecca Ellner for her diligent research of Dolores Del Río's Hollywood career. Versions of this paper were presented at the National Film Theater (London) and the King Juan Carlos I of Spain Center (New York University).

A version of this article first appeared in *Studies in Latin American Popular Culture* 17 (1998): 5–32. It is reproduced here with minimal changes approved by the author.

1. With one notable exception, Christine Gledhill's *Stardom: Industry of Desire* (1991), which recognizes this problem and includes an essay on three Indian female stars and an essay on Dorothy Dandridge, Lena Horne, and questions of race.

2. One exception is the work of Paulo Antonio Paranagua, beginning with *Cinema na America Latina: Longe de Deus e perto de Hollywood* (1985) and continued in "America Latina busca su imagen" (1996).

3. It is a curious coincidence that Gunther Lessing, her attorney for these proceedings, was the same lawyer that some years earlier had negotiated the contract between Pancho Villa and the Mutual Film Corporation.

4. For First National: *Joanna* (Carewe, 1925), *High Steppers* (Carewe, 1926), and *Pals First* (Carewe, 1926). For Fox: *What Price Glory?* (Raoul Walsh, 1926), *Loves of Carmen* (Raoul Walsh, 1927), *The Gateway of the Moon* (Raoul Walsh, 1927), *The Red Dancer of Moscow* (Raoul Walsh, 1928), and *No Other Woman* (Leon Tellegen, 1928). For MGM: *The Trail of '98* (Clarence Brown, 1928). For Universal: *The Whole Town's Talking* (Edward Laemmle, 1926). For United Artists: *Resurrection* (Carewe, 1927), *Ramona* (Carewe, 1928), *Revenge* (Carewe, 1928), *Evangeline* (Carewe, 1929), and *The Bad One* (George Fitzmaurice, 1930).

5. Unless otherwise noted, all translations from foreign-language sources are my own.

6. Either because he had lost his star or for other reasons, Carewe's career fizzled after he lost Lolita. He remarried his former wife, Mary Aiken, remade *Revenge* with Lupe Vélez in the Del Río role, and committed suicide in 1940.

7. As Eileen Bowser describes it, "this kind of shot is almost a Raoul Walsh trademark" (1969, 62).

8. Eliding not only their nationalities but, in light of Gibbon's well-known preference for men and Del Río's own relationship with Garbo at the time, their sexual preferences as well. See Alex Madsen (1995).

9. This part of the analysis is indebted to Rebecca Ellner's excellent thesis, "Tropicalizing Latin Americanness: Hollywood, Ethnicity, and the Colonial Discourse" (1997).

10. Of course, although the Production Code was not fully enforced through the Production Code Administration until 1934, it had already been adopted in 1930. For more details, see Lea Jacobs (1991).

11. Cecil Beaton was apparently not taken with her at all, and he described her as "difficult" to photograph because "she had fixed ideas on how she should pose" (see Hugo Vickers 1985, 130, 158). The famous Beaton photograph with Del Río clad only in a lei was reprinted, illustrating Carlos Monsiváis's article "Dolores del Río: Las responsibilidades del rostro" (1983, 52).

12. Emilio Fernández's words, recalled by his daughter Adela Fernández in *El Indio Fernández: Vida y mito* (1986, 190–91).

13. Aurelio de los Reyes credits her eye/eyebrow expressivity to Emilio Fernández's influence (see De los Reyes 1996, 105–7).

14. A significant prologue added to the film at the insistence of Joseph Breen, the head of the Production Code Administration, disclaims any identification with Mexico and links the story to contemporary Cold War issues, describing it as a "timeless and topical story" that is "still being played in many parts of the world."

15. Mesa-Bains's *An Ofrenda for Dolores del Rio* (1984) was reconstructed in 1990 for the CARA (Chicano Art: Resistance and Affirmation) show at the Wright Gallery at UCLA. See Del Castillo, McKenna, and Yarbro Bejarano (1991, 63).

16. For an interesting analysis of the Mesa-Bains altars see González (1993).

# EIGHT

# Carmen Miranda as Cultural Icon

*David William Foster*

C armen Miranda (born in Portugal in 1909; died in Los Angeles in 1955) is
Brazil's most famous performance personality. Although Brazilians today
are very proud of her, this was not always the case, and Miranda was very
harshly criticized during her life for portraying a kitschy and ultimately falsified
image of Brazilian culture. Of particular concern, at a time during the fascist-
inspired nationalism of the New State between the late 1930s and the mid-1950s,
was her enactment, as a woman of the sort of European origins meant to prevail in
a "civilized" Brazilian society, of aspects of Afro-Brazilian women. Subsequently,
Miranda would go on to play in Hollywood and in other popular show venues
in the U.S. the flamboyant, hot-tempered all-purpose Latin woman that was also
questionable in terms, first, of Brazilian cultural nationalism and, second, cross-
cultural interests.

Solberg's film explores, through the first-person narrative voice of the direc-
tor, various contradictory aspects of Miranda's iconic artistic persona. For Solberg,
Miranda's U.S. career denied her the opportunity to evolve into a powerful Brazil-
ian icon, although one might well wonder what sort of career she would have had
in Brazil had she not been discovered by Lee Schubert and taken to New York in
1939 to perform in his *Streets of Paris* revue. The decline of her health and her early
death are, for Solberg, reflexes of the dark side of U.S. commercial interest in Latin
American culture and the backside of the méprise and expropriation of foreign
cultural icons.

Carmen Miranda was always struggling to mediate U.S. ignorance regarding
Latin American culture, even while she was, in the end, collaborating with the per-
petuation of that ignorance. Helena Solberg's and David Meyer's documentary on
Miranda describes the considerable skill with which she was able to negotiate the
Hollywood star system: she is reputed to have told the almighty Darryl Zanuck on
one occasion when he balked at letting her have her own way that, unless he ac-
ceded to her requests, she would adopt an American accent and thereby destroy
her zany image that allowed him to make so much money off her. Solberg and
Meyer present this incident as iconic of the profound fissures in Miranda's artis-
tic persona, as indicative of the tragic flaw in the Carmen Miranda that she first
created for the Brazilian cultural industry and then, with something like sinister
success, transferred to the film, dance hall/nightclub, and later television venues

of the burgeoning U.S. popular culture of the period 1935–1955. In this transfer, Miranda served both the interests of Brazil in projecting an international image (important for the growth of American tourism both before and after World War II and for economic investments) and the interests of the U.S. cultural industry in finding a marketable cultural icon of Latin America, which had become increasingly popular during and after the war.

The fact that Miranda's versions of Brazilian culture provoked angry responses from some Brazilians, who objected to her kooky eroticizations, and the fact that the American public took (was meant to take) her routines as examples of all Latin American culture speak as much to the disingenuousness of the U.S. culture industry as to the pathos of the only role into which Miranda could ever be slotted. In this sense *Bananas Is My Business* is informed by a postcolonial understanding of how Brazil/Latin America came to be interpreted from the base of the cultural industry in the United States, how someone like Miranda could never stand outside the processes of that cultural industry and how she was, in fact, consumed by it. If there is any tragic dimension to Miranda's artistic persona, it lies in this circumstance, to which the documentary returns over and over again.

Fragmented identity is the principal organizing interpretive feature of *Bananas Is My Business*, which deals with an identity built around the intersection of gender identity and cultural identity. Solberg and Meyer devote a disproportionate (and dangerously dull) long opening segment of their documentary to showing how Miranda was not really or not completely Brazilian. The daughter of Portuguese immigrants, she was actually born in Portugal in 1909 and moved with her parents to Brazil when she was still a small child. The film underscores how her distant family in Portugal and the villagers of her place of origin still claim her as Portuguese, while at the same time her sister, who is interviewed extensively in *Bananas*, is able to insist that Miranda was thoroughly Brazilian. Miranda's fiery green eyes and her honey complexion are repeatedly evoked as the *verde-amarelo* (greenyellow) of the Brazilian flag: Miranda was educated in Brazil, began her career within the very active Brazilian cultural industry (which became increasingly nationalistic with the fascist Estado Novo of Getúlio Vargas in the 1930s), and attained notoriety, first in Brazil, then in New York, and finally in Hollywood, for her unique interpretations of Afro-Brazilian rhythms. Repeated mention is made of the ways in which her iconic images are versions of Bahía peasant women of African slave descent in her body language, the structure of her dance routines, the clothes she wore, especially her hats, and the lyrics of her song routines.

Although Miranda did come to know enough English to sing in that language (she also sang in Spanish, and it is safe to say that for the majority of her U.S. audiences, there was no distinction to be made between Spanish and Portuguese), she always sang with the heavy accent that—as she appeared to have argued convincingly with Zanuck—was the basis of her success. Someone in the film observes that Miranda might as well have sung in Japanese, for all the sense her singing made to her audience. One could add that her lyrics never made much sense in Portuguese to begin with. The important point was that she produced something of a Gestalt cultural image that could be specified as "Latin American" or, when it was particularly necessary (and I repeat that for U.S. audiences that would have been minimally), "Brazilian."

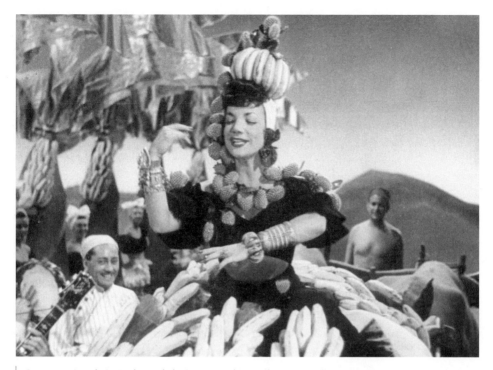

Carmen Miranda in Busby Berkeley's campy classic, *The Gang's All Here*, 1943.

An abiding theme of *Bananas Is My Business* is how Miranda's identity, split as it is between her Portuguese roots and her Brazil-American formation, is irreparably destroyed as a consequence of her American experiences, especially as she began as a U.S. cultural icon (see Davis's review of *Bananas Is My Business*, 1996, 1163). Indeed, the opening and closing scenes of the documentary are of her collapsing on the floor, holding a hand mirror, which shatters into innumerable shards as it hits the floor—a sign of how Miranda had, at the time of her death, hit bottom, living a persona that no longer had any personal or sociocultural coherence. Miranda's marriage to David Sebastian was disastrous and abusive. And as César Romero points out in the interview with him, her image had come to be a parody of itself—indeed, it was parodied extensively by others, including, as we see in one clip, Bob Hope (Mickey Rooney and Milton Berle also performed as Miranda, as did even Bugs Bunny).[1] Finally, Miranda was receiving very bad press in Brazil as a sellout: the Solberg and Meyers film is part of a renewed interest in Miranda as a valued Brazilian cultural phenomenon. Also of interest is Abel Cardoso's 1978 book on Miranda as a Brazilian singer (*Carmen Miranda*), part of a musicological revindication of her career.

Vargas had returned to power, and the climate in Brazil was ugly. Although Brazil had continued to maintain good commercial and political relations with the United States since World War II, sectors of the cultural industry, and especially of the educated elite, were ill disposed toward the racist images of Latin America in U.S. popular culture, especially in film. Because of the international enthusiasm for American films and their intensive distribution (many would say, imposition) in the cultural marketplace, film ended up being viewed throughout Latin America

differently from literature and journalism. And they were even more ill-disposed toward a woman (one cannot rule out a dimension of sexism here) whose routines seemed often more to be ridiculing Latin American culture than representing it: how could the extravagant woman with the funny hat and even funnier accent be a legitimate ambassadress for Brazilian culture in a society that essentially had no serious interest in Latin American society?

Thus, Solberg and Meyer would have the spectator understand that Miranda had come to occupy a no man's land: repudiated in Brazil, unloved and abused by a husband whose personal sexual drama may have been the reason for his alienation, and now parodied in American popular culture. Miranda's near collapse on the Jimmy Durante Show, only to die of cardiac failure the same night in her Beverly Hills mansion, is viewed as virtually psychosomatic, if not suicidal. In a sense Miranda's persona was the consequence of the cultural inauthenticity promoted by the Hollywood system and the U.S. popular cultural industry. One does not have to be a cultural nationalist to understand how Miranda's routines were more interesting the less they had to do with lived Brazilian culture of whatever stripe. The fabrication of a specific cultural image that fed American stereotypes and fantasies and that responded to particular interpretational forces in the context of the draconian racism of the Cold War years encouraged the persona Miranda created. Today one can be fascinated with Miranda as a camp figure (an aspect that Solberg and Meyer do not explore) and can even be entertained by a rereading of her as a gay icon (something else Solberg and Meyer do not touch upon, although it would be interesting to investigate whether her image has any symbolic currency in contemporary gay and queer cultures in Brazil). But these and other current enthusiasms have little to do with how Miranda and Latin American culture were being read in the United States and in cultural frameworks dependent on Hollywood models of a half-century ago.

The other dimension of identity with regard to Miranda that Solberg and Meyer deal with (without ever addressing the questions of a gay/queer inflection) is that of gender. It is significant that in the film there are a series of fantasy sequences performed by the female impersonator Erik Barreto. The scene with which the film opens and closes—Miranda's collapse in her bedroom—is performed by Barreto, as is a sequence that depicts her arrival in New York in 1939 and her initial interviews with the press in which she establishes many of the basic elements of what will be her Brazilian bombshell/Latin American sex symbol/exotic woman with funny English persona throughout the decade and how the selling of Miranda as an exotic, foreign product had little to do with her origins (real or fantasized by her) or with a personal artistic vision on her part and everything to do with popular culture demands in the United States (although an image of Carmen Miranda decorates the cover of their book *Machos, Mistresses, Madonnas: Contesting the Power of Latin American Gender Imagery*, 1996, it is unfortunate that Marit Melhuus and Kristi Anne Stølen do not mention her in the text).

Barreto's role in the film serves to open up the question of Miranda's self-construction as a sexual object. She unquestionably exploited many of the features associated with sexualized women in film and other entertainment media in the United States (and it should he remembered that her stature, although she was actually not very tall, enhanced by the high platform shoes that were one of her trade-

marks, was in line with that of other impressive women like Barbara Stanwyck, Joan Crawford, and Katharine Hepburn). Miranda exploited physical features that objectify woman as a sex icon like sensuous dancing, the bare midriff, the exaggeratedly defined mouth, and the constant tutti-frutti display of colors that denoted strong tastes and aromas, not to mention the explicit phallic bananas that were, after all, as the title of the film announces, her dominant trademark (cf. the famous dancing bananas sequence, choreographed by Busby Berkeley in the 1943 musical *The Gang's All Here*). The total effect, whether by Miranda herself or by others, was that of a fantasy icon of Latin American female sensuousness that was meant to contrast with the decorum demanded of American women in the period (for example by the Hays Code in film). As sexualized as an American star might be for purposes of portraying a fallen woman in the emerging noir (Mary Astor in *The Maltese Falcon*, for example), there was no competing with the extravagantly erotic model of Miranda, and it is clear that her portrayal of the feminine was meant to mark itself off in categorical ways from the representations pursued by other female stars during the period.

Three issues can be raised with respect to Miranda's construction of the feminine. In the first place, it is questionable whether or not she ever attained any significant level of agency. Although she played the role of the spitfire who was always able to win her own way with men, one cannot escape the fact that her self-definition was always in terms of matching her character to that of a man and her demands were always those of the conventionally defined woman: the attributes of costume and luxury and the undying, undivided attentions of a male admirer. In her famous film with Groucho Marx, *Copacabana* (1947), Miranda so overshadows and dominates Marx in order to get her way that he has barely any starring role at all. Martha Gil-Montero reports that he took the part only because he was desperate for work and that he told his biographer that he had "played second banana to the fruit on Carmen Miranda's head" (1989, 176). Indeed, during one of the few scenes Marx has on his own, he hides in a closet in a dressing room, disguised as one of Copacabana's dancers, to escape from the police, who are pursuing him for alleged fraud in his contract dealings as Miranda's agent. As they pull the cross-dressed Marx from his hiding spot, one of the police officers says to the other: "They always end up in the closet." This throwaway homophobic allusion only contributes to the diminishment of Marx in his dealings with Miranda as an invincible woman who, indeed, plays two separate parts in the film, thereby doubling her exercise in the construction of the feminine.

Miranda's overconstruction of the feminine, nevertheless, in addition to leading to the mocking caricatures mentioned above, comes, from a semiotic point of view, to burst at the seams. It is so overdetermined, so full of redundancies, so self-referential, and so replete with symbols that lend themselves to problematical interpretations (for example, Busby Berkeley's giant dancing banana sequence in *The Gang's All Here*) that it results in occupying a gender no-man's land: Miranda appears to be a woman playing a man playing a woman. If we can understand drag as something other than an imitation of the feminine, and therefore as something other than a mocking putdown of women, it becomes possible to see it as a critical commentary on the construction of the feminine: femininity comes to be portrayed as an articulation of gender imposed on women by the hegemonic sexism of a

masculine-dominated society. Thus, when men perform as women they underscore the way that men are, in fact, in control of a standard definition of the feminine; for this reason it is immaterial whether the cross-dressing performer constructs his own gender identity (it is an erroneous generalization to believe that all men who impersonate women are gay, that they are men who want to be women; see Garber, *Vested Interests*). The consequence in Miranda's case is that she becomes after all her own worst caricature, and this is patently obvious as the fetishistic fascination of American culture with the Latin American exotic fades by the end of the 1940s. As Shari Roberts notes:

> Miranda performs a femininity so exaggerated that it becomes comical, undercutting any threat that her female sexuality might pose but also calling into question society's assumptions about feminine essence. Additionally, while Hollywood representations of different ethnicities often draw on, emphasize, and contribute to stereotypical ethnic clichés and myths, Miranda's ethnic persona nears hysteria with its exaggeration. Miranda's costumes lampoon both feminine fashion and traditional and stereotypical Latin dress—stacks of accessories, shoes so high they impede walking, and cornucopia hats. Miranda's outfits suggest female sexuality in excess, revealing and accentuating her sexually invested body parts: the navel, breasts, and legs. (1993, 15)

The third issue associated with Miranda's gender construction has to do with her fortunes back in Brazil. As Solberg points out, Miranda found to her dismay that Brazilians were not always enthusiastic about her success in the United States. Although Getúlio Vargas contributed to her move to New York in 1939 (Lee Schubert, who had traveled to Brazil to see if she was worth contracting, was willing to pay for her, but not for her band; Miranda insisted that she could not perform without her band, and Vargas footed the expense for their travel), the way in which Miranda fed a uniquely American fantasy about Latin America, one in which her specific association with Brazil was lost, was disconcerting. Moreover, that fantasy had an unmistakable ugly racism associated with it to the effect that Latin American women are all sexpots, and this interpretation hardly jibed with Brazil's energetic efforts to establish its international importance in the arena following World War II.

When Miranda returned to Brazil in 1954, she was received coldly in official cultural circles (see Gil-Montero 1989, 236 ff.), although popular audiences continued to respond enthusiastically to her performances. The combination of Miranda's representation of Latin sensuality and, perhaps more than anything else, her insistence on the incorporation of black culture motifs at a time when racism continued to be virulent in the United States, struck a sensitive nerve in a Brazilian establishment that knew very well that part of the difficulty of its participation in the new world order led by the United States was the perception of Brazil as a country of blacks and mulattos. Thus, not only was Miranda's female sexuality overdetermined in a strictly gendered way, but race (both Indian and black) functioned as a powerful subtext that could simply not be ignored: Miranda was dangerously invoking a motif of nonwhite women as virtual sexual perverts. As one defamatory article mentioned by Gil-Montero states in its headline, Carmen Miranda "should go back to the savages" (1989, 224).

Solberg and Meyer's documentary unfortunately does not probe any of these issues of race and gender in any depth. They are basically interested in demonstrating the disintegration of Miranda's personality under the effects of her success in the United States, but it apparently does not occur to them that part of this success was built on a construction of feminine sexuality that was tightly bound up with Brazilian and Latin American identity—and in turn with questions of race—that could have been profitably explored.

One of the particularly successful rhetorical strategies of the film is Solberg's own narrative voice. She begins by telling how her mother had not allowed her to participate in the public spectacle of Miranda's funeral, which included street manifestations and collective expressions of grief, and says that her film is one way of understanding a figure that she felt had eluded her because of her mother's prohibition. This manner of personalizing the director's relationship with her own material is characteristically feminist and breaks with a documentary norm of nonpersonal involvement with the material being reported (see Burton's interview with Solberg, 1990, 81–102). As Teresa de Lauretis has argued in her analysis of a woman's cinema that is marked less by feminine content and more by a feminist consciousness vis-à-vis cultural production, it has become important to demonstrate that filmmaking, or any cultural production, is artifice and not a "natural" and transparent privileged window on reality. Culture is a construct, and as such it is mediated interpretation. Thus, she argues that the conditions of that interpretation require encoding into the document itself:

> The novelty of the direct address . . . is not only that it breaks the codes of theatrical illusions and [masculinist] voyeuristic pleasure, but also that it demonstrates that no complicity, no shared discourse, can be established between the woman performer (positioned as image, representation, object) and the male audience (positioned as the controlling gaze); no complicity, that is, outside the codes and rules of the performance. (De Lauretis 1991, 143)

In this way, Solberg, by bridging the aesthetic distance between herself and her subject and by involving herself in the events she herself describes, makes Miranda of direct pertinence as a female artist by suggesting a correlation between the two women, which is even more pertinent in view of Solberg's own professional formation in the United States.

*Bananas* does in fact avoid gender issues in a theoretically grounded way: none of the individuals interviewed on camera refer to Miranda as exemplifying women's history, and Solberg's narrative exposition returns time and again to Miranda as a Brazilian figure, but not as a woman whose pathos is related to the treatment of women by a masculinist society or by a masculinist entertainment industry. In this sense, there is the color of bourgeois uniqueness about Miranda, at least on the level of the film's ideology, and the meaning of Miranda for the experience of women emerges only in a critical reading such as this one. By the same token, my identification of a possible interest from the perspective of drag, while it is more explicit, through the use of a transvestite to represent Miranda at strategic points, still remains an insinuation in the film; it is not clear if the transvestite figure is only a felicitous choice to represent Miranda's exuberant theatrical persona or if there are, in fact, interesting observations to be made about how Miranda constructed

a female Brazilian/Latin American identity for U.S. audiences. If Solberg perceives this dimension of Miranda, she never says so in any immediate way.

Thus, the most salient feature of the film dealing with the construction of feminine identity is the way in which the film is contestatorial on the level of the filmic text itself. The interpretive commentary, while it may go against the grain of the film's specific interpretation of women's issues, necessarily begins by recognizing the way in which the film itself is a critical reading of masculine hegemony.

As the first Brazilian woman to become a big international attraction, Miranda is shown in Solberg's film to be as much a metaphor of the status of Brazilian culture on the international marketplace as of women's difficulties in achieving artistic transcendence. The image of the broken mirror that frames the documentary speaks as much to the individual schizophrenia of the big-name star Carmen Miranda as it does to the fragmented lives of the forgotten women who were the victims of torture during the dictatorship. Miranda continues to be a cultural icon, but these women are forgotten both because they are women and because there is a tendency in Brazil to consign the dictatorship to a period that is now over and done with, an attitude that only serves, in the opinion of the women interviewed, to invalidate the traces of that period that are still written on their bodies.

## Note

The essay that follows here appeared originally in a study on *Gender and Society in Contemporary Brazilian Cinema* (University of Texas Press, 1999). Rather than dealing directly with Miranda, it is an analysis of the 1995 documentary film by Helena Solberg, *Bananas Is My Business*. Solberg's film is as much about Miranda's life as reconstructed from a traditional documentary point of view as it is a meditation on Solberg's own relationship as a woman and as a Brazilian to Miranda's persona and the person behind it. Solberg places a special emphasis on the problematical natural of the dimensions of Miranda's iconicity, with particular reference to the American imaginary. In Solberg's view, the distortions imposed on Miranda by that imaginary damaged her psychologically as a woman and complicated enormously her relationship to Brazil. The editors of this volume are grateful to the University of Texas Press for permission to reprint this material, with minimal changes.

1.  Roberts also notes that Miranda was always a popular favorite among female impersonators in the U.S. armed forces entertainment troops, including the fact that "the gay servicemen who turned Miranda into an immediate camp icon recognized her parody of gender roles and were able to use her text in impersonations at camp shows as an allowable expression of their subjectivity" (1993, 19). Furthermore, Bérubé, writing on gays in the U.S. armed forces during World War II, notes: "The female character most impersonated by GIs, whether they were gay or not, was also the campiest movie star of the early 1940's—Carmen Miranda. . . . The Carmen Miranda drag routine was so common in GI shows that it became a tired cliché and the subject of parody. . . . Gay GIs who did Carmen Miranda could easily slip a gay sensibility into their acts" (1991, 89). From what Bérubé says, if Miranda was parodied, the parodies themselves were parodied.

# Porfirio Rubirosa
## Masculinity, Race, and the Jet-Setting Latin Male

*Lizabeth Paravisini-Gebert*
*Eva Woods Peiró*

So I have not seen in the colorful obituaries of the late Rubirosa in the American press, any reference to race. Had he been an American citizen by birth, the headlines probably would have read: NEGRO PLAYBOY DIES.

Langston Hughes, "Commentary," *New Pittsburgh Courier*, July 24, 1965

Porfirio Rubirosa (1909–1965), the legendary Dominican playboy known for his suave, seductive charm, died early in the morning on July 5, 1965, when he crashed his dashing Ferrari into the trees at Paris's Bois de Boulogne after all-night celebrating and heavy drinking at "Jimmy's," the well-known Paris club. The death of Rubirosa—or Rubi, as he was popularly known—was emblematic of his peripatetic life. The 1950s Latin lover *par excellence*, an international symbol of masculinity and sexuality, died in the city of his greatest sexual exploits, at the wheel (he had been, after all, a well-known race-car driver) and following a glittering late-night party honoring the winning team in the Coupe de France polo cup, a sport in which he had attained world-class player status. Rubirosa's life ended "fittingly," according to the *New York Times* (Grimes 2005). Yet for Langston Hughes, perhaps then the United States' leading African American writer, news of the death finally opened up the possibility of addressing that crucial race question: Rubirosa was "a front page face out of international news, one of the famous playboys of the Western World. And not white!" (Hughes).

Although questions of race surfaced only peripherally during Rubirosa's twenty-five-year career as the world's most famous lover, it is precisely the race of his face (and the face of the race) that most interested and concerned Hughes, and it is this discussion of race and mobility to which we would like to return. As part of a larger project on Rubirosa's hyper-masculinity and problematically racialized subjectivity, here we emphasize the proliferation of meanings at play in the non-Dominican (US and European) perspective of Rubirosa's iconicity. Our aim is to address Rubirosa's status as a Latin American icon through three interrelated lenses. First we will read his face as an icon that indexes complex discourses of racialization in the Dominican Republic, the United States, and internationally. Such racial

semantics propelled Rubirosa's movement both socially and physically through the spaces of international modernity. Secondly, we will conceptualize Rubirosa's mobility, his association with technologies of movement and speed (his career as race-car driver and amateur pilot), and contiguously, a globe-trotting Don Juanism he deployed through a sexuality of conquest (as seen through the series of high-profile affairs with celebrities and heiresses). Finally, we will consider the persistent reverence in which he is still held as an icon of Dominican maleness (chiefly through the focus of one ardent admirer, Dominican musical star Johnny Pacheco). This discussion of Rubi's body, and by extension, of his ability to pass or not into the invisibility or naturalness of whiteness, can help us critically approach and re-engage the representations of a man who has come to represent the international—"macho's macho."[1]

## The Iconicity of the Face

Rubirosa's perpetually smiling face and elegantly clad body are keys to understanding the compelling gravitational pull of a countenance that emerges from the intersection of a cosmopolitan "white" identity and a racialized Dominican hyper-sexuality. Rubi's face was a signifier of both individual male identity and group identity, in this case both Dominican and international. As such, the way in which his face and body were commodified, marketed, and fetishized through hundreds of articles and photographs in the international press illuminates the tensions between the social and psychic production of subjects.

In his article about Rubirosa and race, Langston Hughes focuses on the intersections between a trajectory that found the latter "on the receiving end when divorce time came" so that he had "died with a golden spoon in his mouth" (a trajectory that implied "whiteness") and his own perception of the famous playboy as "a handsome colored boy" (Hughes). Hughes's placing of Rubirosa's "race" within the context of international politics is telling, since it points to a disconnection between differing American and international acceptances of racial hybridity at the official and popular levels. Hughes, who had two memorable encounters with Rubirosa in New York City, compared him to controversial Harlem Congressman Adam Clayton Powell Jr., himself a light-skinned, often-married charmer: "In his youth, Rubirosa was a handsome colored boy. In middle age, he was still good looking, dashing and dynamic. He must have possessed the same sort of personality attraction for women as does our Congressman from Harlem, Adam Clayton Powell, who, although Negro, is several shades lighter in complexion than was Rubirosa" (1965).

For Hughes, Rubirosa's social success—his access to places from which the likes of him were barred on racial grounds in Jim Crow America—rested on his Dominican identity, a Latin identity that protected him politically from racial classifications that would have proven socially excluding in the United States and Europe. "Mulatto Latins," Hughes wrote,

> in their own Caribbean or South American lands, are not classed as Negro in the U.S.A. sense of the term, especially if their tongue is Spanish. American military records class even black Puerto Ricans as "white" which creates considerable confusion at Southern Army posts. But apparently Washington dares

not apply the word NEGRO (which in Spanish means BLACK) to Latins against their will. We have enough problems with Latin America now in maintaining a clean American image. (Hughes 1965)

Hughes refers to the fact that in midcentury, both on US soil and in the Dominican Republic, Hispanicity was an alternative to blackness. US and international journalistic readings of Rubi saw Hispanicity as a whitening agent.[2] Thus, although Hughes saw Rubi as an undeniably "colored" man, he astutely recognized the complex categorizations of Rubi's race, which triangulated from white (as seen in the Dominican Republic), to Hispanic and therefore colored but not black (as seen in the United States), to American and formerly colonized (as seen in Europe). Whereas Rubi's whiteness was an achieved status, despite his mulatto-ness, in the United States there was no escape from, or passing on, the fact of blackness. For Hughes, this arguing for the fact of blackness was a political stance he took alongside his smirk of appreciation for Rubirosa's ironic accomplishment. Even if he could not dupe Hughes, Rubi had duped many. In this sense, his face proffered a strategic ambiguity and allowed for "purposeful self-presentation strategies and for equivocation in dynamic interplay between the internalization and externalization of official identity discourses" (Candelario 2007, 33).

Rubirosa's fame—as exemplified by the international press's obsessions with his every move—was most evident through his continual presence in American magazines. His fame, one could argue, was played out most manifestly in the United States, the very place in which his hybrid race, as Hughes pointed out, was most socially problematic. Thus, for Rubirosa's many fans, for these expert readers of his face and impeccably-tailored elegance, how might his mixed-race heritage have been mitigated or expanded by the history and materiality of his Dominican-ness, an identity inscribed by colonialism, slavery, and the detritus of empire in the mid-twentieth century and beyond?

## Mobility

In a reverse conquistador mode, Rubi's exploits, based on legendary abilities to seduce and conquer rich and famous white women, had made him the stuff of legend and gained him acceptance into the most exclusive social circles, as Hughes would ironically but admiringly note. Stories about Rubirosa's sexual exploits—his spectacular if brief marriages to the most famous rich women of the day (Dominican dictator Rafael Trujillo's own dark-skinned daughter Flor de Oro, and white heiresses of tobacco and dime store empires, Doris Duke and Barbara Hutton) and to French movie stars (Danielle Darrieux and Odile Rodin); and his notorious affairs with Hollywood's more racialized sex symbols like Zsa Zsa Gabor, Rita Hayworth, and Ava Gardner—assured him international stature in an ambiguous and ambivalent terrain where race, power, and sexuality joined to produce lasting obsessions among the reading public.

Rubirosa's life, although played against an international backdrop, was rooted in the tensions between his access to the international stage (he spent some crucial years of his childhood and adolescence in Paris, where his father had held a diplomatic post) and his dependence on the support of the infamous Trujillo

regime (for which he himself worked for decades as a diplomat) to maintain his international status. Entry into the higher echelons of the international social world for a suave but relatively impecunious Dominican (whose local upper-class status did not remotely translate into the wealth required for belonging to the international upper classes) was conditioned on his diplomatic position, which in turn was dependent on Trujillo's continued approval. Such sanction, despite Rubirosa's divorce from the dictator's daughter, grew out of shared notions of light-skinned masculinity, particularly of how Rubirosa's über-maleness (as exemplified through ever-more-admiring reports on the size of his penis and capacity for sexual endurance) matched Trujillo's desires for power and international respect as well as his agenda for national (racial) purity.

From the Dominican perspective, Rubi was the quintessential *tíguere* (the colloquial expression for a *tigre* or alpha-male), and his career trajectory is situated within a particularly complex period of Dominican history: commencing in the wake of the 1937 Haitian massacre and taking off under the shadow of the Cold War and the consolidation of Trujillo's dictatorship, Rubirosa nevertheless managed to invade the international media imaginary, resituating Dominican marginality in the discourse of stardom and modernity. A light-skinned Dominican whose family had deep ties to the diplomatic corps and the military, he channeled his considerable charm into acquiring the wealth through which he could become "[a] tireless presence at chic nightspots and watering holes, a keen race-car driver and polo player, a friend to the rich and infamous, a relentless pursuer of women with huge bank accounts" (Grimes 2005). The path to international playboy status was cleared through Trujillo's conviction that his son-in-law—often described as one of the regime's henchmen—exemplified to the world the potency of the Dominican male identity. In Trujillo's symbolic family, Rubi would play the role of the conquistador, honoring the father, bringing back booty, reversing the claims of coloniality, forever distancing the Dominican Republic from Haiti. As conquistadores used boats and weapons, Rubi would harness twentieth-century technologies in the enterprise of sexual conquest and media control.

## Technology

William Grimes, in his discussion of Rubirosa as the inventor of the playboy image, which he defines as the "sleek, fast-moving animal perfectly adapted to the modern era of jet travel, night clubs, film stars and gossip columns," underscores Rubi's attachment to technologies of mobility and travel. One of the first international jetsetters, Rubirosa seemed always in movement and was photographed most often standing alongside some fast-moving vehicle—from the polo horse, which implied exclusive knowledge about the difficult transport of horses across seas and international borders, to the race car and the airplane, which became emblematic of his superstar status. Perceived as someone who had traveled from the periphery of power (the Dominican Republic) to the very centers of modernity (Paris and New York), Rubirosa's eager embrace of the latest technology, especially cars and jet engines, was patently a fascination with futurity. Rubirosa's iconic relationship with the vehicles of modernity, coupled with his prowess at the wheel, cemented

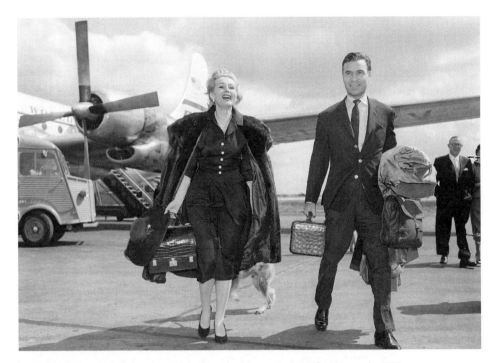

Porifirio Rubirosa and Zsa Zsa Gabor disembarking at Paris's Orly Airport in 1955.
© Associated Press

his reputation as one of the world's best-known amateur racers and pilots. In these photographic moments, the racial hybridity of his iconicity is surpassed by the figure of the man at the controls of machines that, as Paul Virilio (1994) has argued, are technologies of vision. Rubi's access to the latest technology, as we noted, allowed him symbolic access to futuristic vistas and seemingly erased the racial hybridity that signaled his colonial origins. As a Dominican, this connection made him more remarkably modern than those for whom modernity was a given.

Rubi's clear enjoyment of speed, moreover, translated into an allure that went beyond the modern into a connection to the primitiveness of momentum, danger, and recklessness. For someone like Rubirosa, who was depicted in the press as charmingly untamed and insouciant, the link between technology and speed—between modern control and the pre-modern adrenaline rush of the hunt—placed him, as a colonial mulatto, comfortably in the hybrid space where modernity and the titillation of the erotic meet. As the photo of Zsa Zsa and Rubi rushing off the airplane insinuates, Rubi was racing not to catch up with modernity, but to embody and perhaps overcome it. His death in a car crash, therefore, was generally seen as a fitting end for a playboy who had begun to lose his sexual élan (he was fifty-six at the time of his death) and was becoming too accustomed to staying home and working on his garden. Better to go in swift flight at the controls of a Ferrari—a more appropriate end to the life of speed and motion that had been one of his surest paths to "whiteness." But his fatal accident was also the appropriate punishment for a man who unhinged white male superiority. Not only did he defy white control of technology, but perhaps more importantly, his consumption of females turned the tables on the racial equation, as we presently discuss.

## Sexual (Im)mobility

It was as a lover that the contrast between Rubirosa's purported modern "white-ness" and less easily whitewashed attributes was most blatantly clear. Rubirosa is habitually celebrated for his charm and elegance, which the camera caught lov-ingly in tender and gentlemanly gestures and the graceful movements that were his trademark. He was, on the one hand, considered by men to be a gentleman to the end. John Gerassi's story of his relationship to Rubirosa is typical of the man's generosity and commitment to friendship, of which there were ample references in the press:

> My parents and I had come to the United States in 1940 as political refugees from Franco's fascism and Hitler's nazism, but that was unacceptable to U.S. authori-ties. So my father, who . . . had been a general in the Spanish Civil War and was hence deemed a "premature anti-fascist" by Washington, used his diplomatic passport to get us past Ellis Island. That document said we were diplomats from the Dominican Republic. It had been given to my father by one of his prewar poker-playing chums, a very high-class Trujillo hitman and diplomatic trouble-shooter (and son-in-law) by the name of Porfirio Rubirosa. In fact, Porfirio had given my father the whole kit and caboodle, that is, the seal, the stamp and so forth, with the understanding that he could use it to save whom he wanted. And my father did just that: he gave some eight thousand Spanish Republican refugees Dominican passports so they could escape the approaching Gestapo. (Baker 1989)

On the other hand, Rubirosa was derided by the press for posessing sexual attributes that separated him from other "white" lovers, racializing him into well-known stereotypical categories of black men's sexual prowess. Interestingly, many of the instances in which he is derided by the media for his erotic appetites are linked to his foreignness, or Dominicanness, as when the *New York Times* referred to him as "the Dominican Republic's answer to Pepé le Pew" (Grimes 2005). The comparison was based on the popular Warner Brothers' *Looney Tunes* character, an amorous skunk who parodied the stereotypical French lover, one who not only spent his days looking for love but also believed every woman was actually in love with him. The French skunk did have, however, two unpleasant traits: the odor to which his last name refers and his inability to understand that "no" means "no." Pepé shares some of Rubirosa's less celebrated attributes—a potential malodorous side (Rubi had a problematic relationship with an unpleasant regime for which he was reputed to be a hitman) and a reputation for physical violence against women (Le Pew was notorious for his blissful inability to acknowledge lack of interest from members of the opposite sex).

In fact, when it comes to outright sexuality, conversations about Rubirosa tend toward the graphic and the bawdy, venturing into the terrain of racial carica-ture. Truman Capote famously wrote in his unfinished novel *Answered Prayers* that Rubirosa's principal attribute was "an 11-inch *café au lait* sinker as thick as a man's wrist," while his state of permanent erection won him the nickname of "ever ready." Rubirosa's first wife, Flor de Oro Trujillo, is often quoted as complaining that the organ in question was "too big" and describing her post-coital pain. Doris Duke

was fond of remarking that it was "the biggest penis I had seen in my life," while a former lover describes it as a "long and pointy" pain-causing device. Parisian waiters would refer—and still do—to their large, dark-wood pepper mills as "rubirosas." References to Rubirosa's phallus, of which one can find hundreds in the contemporary press, essentialize his body as a sexual instrument of unusual proportions, linking him, in turn, to notions of black sexual potency that were the subject of critical discussion in the contemporary press. Even writers as different as James Baldwin and Frantz Fanon, both living in Paris during the heyday of Rubirosa's career in that city, addressed the media fascination with Rubirosa's mythical penis size and sexual performance, a facile adherence to the crass cliché that "Black men have larger genitals, keep their erections longer, and are more easily aroused sexually, are more passionate in their lovemaking, and are better able to satisfy women sexually" (Schmitt 2002, 39).

Similarly, an anecdote about a 1955 treasure hunt in Colombia was used by *Time* magazine to suggest a lechery that is shocking even in "primitive" surroundings and encapsulates Rubirosa's embodiment of unbridled "colored" sexuality:

> Dominican Playboy Porfirio Rubirosa moseyed into Bogotá, Colombia to make preparations for a genuine treasure hunt. Bracing himself for his safari's plunge into the Choco wilds on Colombia's Pacific Coast, Rubi, out to make the jungle give up some platinum and gold, first tested his luck at a race track, won a cool 9,600 pesos on a 100-to-1 shot. He also took his ease in Bogotá's elegantly stuffy Jockey Club, where he complained about the absence of vodka (he thirsted in vain for a Bloody Mary). Colombia's press hailed his expedition with gleeful gibes. Item: a caricature of Rubirosa whiling away his safari time by pinching a beautiful nude Indian maiden. Asked for his slant on honest labor, the Ding Dong Daddy from Santo Domingo yawned languidly: "It's impossible for me to work. I just don't have time." ("People," 1955)

Rubi's sexuality, both hyper-racialized and Disneyfied by the press, suggested a return to the troubling mixture of primitive charisma and physical brutality characteristic of the Latin American *caudillo*.

## Sexual Piracy

When it came to self-invention, Rubirosa would meet his match in Hungarian starlet Zsa Zsa Gabor, in the 1950s an aspiring actress and relentless self-promoter who was also fetishized for her slightly silly, kittenish sexual persona. The media, which diligently catalogued Rubi's affairs, feasted on the photogenic and tempestuous couple's torrid trans-continental, trans-racial affair, which had more of bathos than pathos in it. The relationship between Rubirosa and Gabor is interesting in our context because of the ways in which her own urge toward legitimacy as a European subject was often built on relegating him to the margins of his original (colored) marginality by constantly underscoring her own blondness against his Latinity. Gabor, who as a Hungarian had limited claim to a dominant European identity defined by Western Europe, often sought such legitimacy by playing against Rubirosa's more questionable claims as a "Latin gigolo" (it was Gabor, for example, who

kept making allusions to the press about his marrying women for their money). In Zsa Zsa's self-promoting script, he had been relegated to the role of non-European Latin lover subserviently devoted to her. In photo after photo she monopolizes the lens, and he is demoted from his usual glamorous protagonism to being the bearer of her abundant travel paraphernalia.

Gabor, like Rubi, constantly shuffled a variety of personas. Whereas he was the perfect gentleman, the avid sportsman, the suave lover, and the embodiment of sexual potency, she played the reckless adventuress, the glamour girl, and the woman-with-a-past (Allen 1988). She epitomized the "triumph of shamelessness over hypocrisy, of the feminine ethic of doing what you can with what you've got, a sort of avatar of that Vaseline-lensed heaven you see on the covers of a billion paperback books" (Allen 1988). When these personas clashed—which often happened as they wove in and out of their relationships between marriages (nine for her, five for him), we get glimpses of the ways in which their relationship racialized him, as she constantly reminded the public that as a "Latin" lover, he was unable to hold on to her blonde European self.

We can see this underscoring of his racialized identity in the infamous episode of Rubirosa's announcement of his plans to marry Woolworth heiress Barbara Hutton. Angry at the news, Gabor throws a lamp at Rubirosa—or so she tells a pack of reporters she called to a press conference the day after his wedding—who slaps her face. Wearing an eye-patch to cover her purported black eye—a mock pirate about to hijack his new marriage—Zsa Zsa announces that he only married Hutton for her money (reducing him to gigolo status), that he "beat" her (hence the piratical eye patch), and that he settled for Hutton because Zsa Zsa turned him down (the ultimate and now rejected lover has met his match). Such was the power of the affair in the public eye that the next day all the mannequins in the windows on Rodeo Drive and 5th Avenue were decorated with eye patches. Zsa Zsa's transformation of the somewhat queerish, dandyesque Rubi into the dark, Latin, and rejected brute, victimizer of blonde beauties, represents a transformation of the Rubirosa persona, a forced return to an abandoned Dominicanness and to the Rubirosa-as-Trujillo-henchman avatar that he had worked so hard to leave behind. In this particular episode, the blonde Zsa Zsa claimed the last laugh. Or did she?

## The Persistence of Memory and Iconicity

In 2009, asked about his most memorable encounter during a fifty-year career as a musician, world-famous Dominican salsa bandleader Johnny Pacheco replied that it had been, unquestionably, his meeting fellow Dominican playboy Porfirio Rubirosa at the old Palladium Club in New York in the mid-1950s. Realizing that Rubirosa was in the audience as he was going up on the stage, Pacheco could only gasp: "ese tipo es un barbarazo"—a truly Dominican phrase that can be translated perhaps as "that is quite a guy" or "he is a man's man," which conveys a certain type of über-maleness greatly admired on the island. Pacheco's comments add one more grain of stardust to the myth of Rubirosa, reminding us of a figure that could only have materialized out of the excesses of the "era de Trujillo." Describing his memorable encounter, Pacheco recalls that Rubirosa was "impeccably dressed," without

a single flaw in his appearance: "he was exquisitely groomed, from his nails to his hair, and he was accompanied by two well-known personalities, Kim Novak and Doris Duke." Most significantly, Rubirosa, Pacheco comments, was "very elegant and looked like a real man"—he was "impressive and loved" despite the fact that he "beat and later abandoned Trujillo's daughter" (Flor de Oro, his first wife). Asked if Rubirosa was his idol, Pacheco replied, "Anyone would like to be Rubirosa" (Cruz Tejada 2009).

Pacheco's adulation stands for the countless admirers of this Dominican legend of masculine *savoir-faire*, who see his carefully manicured hands and elegantly clad body as erasing those very marks of race that the foreign press—particularly the American press—hinted at so subtly, and which Langston Hughes calls by its name after Rubirosa's death. As we can see from the discussion above, Rubirosa skirted the defining lines of race—and as his public we have no notion of whether his hybrid racial identity was an issue he ever faced himself. As an icon of Latin masculinity, however, this upper-class-born son of a Dominican general continues to be the subject of numerous books, articles, and countless websites that obsessively explore his career as seducer, polo player, race-car driver, and diplomat for the controversial Trujillo government. None, so far, seem devoted to his race. The continued attention is evidence that Rubirosa still holds enough symbolic capital to keep legions of fans nostalgically returning to the debonair images they remember from *Life* magazine, now archived in labyrinthine websites, virtual memorials that easily compete with those dedicated to Selena or Che Guevara. Porfirio Rubirosa stood for the modernity wished for by Rafael Trujillo's regime, and he skillfully negotiated the tensions between his self-constructed image as a gigolo and the burden of pre-modernity that the Trujillo regime's actions often imposed on him. For Trujillo, Rubirosa's value was in his iconicity, which when read from his regime, necessitated that Rubirosa be seen by the world as white. From the perspective of Trujillo, who continued to be loyal to Rubirosa even after his daughter divorced him, the latter's value could be summarized in elements that had nothing to do with race: Rubirosa was "an excellent diplomat because women adored him and he could lie with the best of them" (Cruz Tejada 2009).

## Notes

1. Needless to say, he was primarily the Dominican Macho's macho, but here we will be focusing on the image of him as interpreted primarily by the international press.
2. While cultural critic Silvio Torres-Saillant has argued that ninety percent of the Dominican population is black and mulatto (2000, 126; Candelario 2007, 23), Trujillista ideology had institutionalized anti-Haitianism, Negrophobia, and Hispanophilia (Candelario 2007, 21).

# Contemporary Latin American Icons: National Stars and Global Superstars

# The Face of a Nation
## Norma Aleandro as Argentina's Post-Dictatorial, Middle-Class Icon

*Janis Breckenridge*
*Bécquer Medak-Seguín*

Flowing wildly and provocatively upward and outward, Norma Aleandro's highly stylized and extravagantly voluminous hair in Sara Facio's photograph intimates an identity subtly reinforced by neatly swooshed eyebrows, a seemingly unblemished but carefully made-up face, and a fashionable blouse. Sara Facio's emblematic photograph, a dramatic close-up, frames Argentina's internationally acclaimed and most recognized actress as a powerfully sophisticated, bourgeois woman. Her stagy coiffure, styled according to upper middle-class conventions (hairspray, perm), has been described as "an iconic trait of femininity" that "suggests the wild woman of radical feminist conduct" (Foster 1998, 178). Her inclusion in the much-lauded portraits published by Argentine photographer's Sara Facio in *Hechiceras* (*Temptresses* or *Enchantresses*) confirms Aleandro's place among Argentina's prominent female cultural emblems[1] (1990).

Indeed, Facio's portrait captures Aleandro's most successful cinematic persona. As David William Foster notes, "for those familiar with her persona as an actress, it is impossible to see this photograph and not think of . . . roles she has played" (1998, 178). Since her celebrated appearance in the box-office blockbuster and critically acclaimed *La historia oficial* (*The Official Story*, 1985), Aleandro continues to achieve both national and international recognition for her performances as an upper middle-class woman in numerous productions, including that of a lonely, middle-aged Jewish spinster in *Sol de otoño* (*Autumn Sun*, 1996), an aging but beloved Alzheimer's patient in *El hijo de la novia* (*Son of the Bride*, 2001), and a rebellious retiree seeking an adventurous escape from a stultifying marriage in *Cleopatra* (2006). Not coincidentally, the actress's escalating fame, as film historian Tim Barnard discerned as early as 1986, accompanied a significant change in the Argentine film industry's production under democracy: namely, a thematic shift more inclusive of the national middle class and, at the same time, distribution consciously directed toward more lucrative foreign markets in an effort to elevate the international prestige of Argentinean cinematic production.

Norma Aleandro by photographer
Sara Facio, 1976. © Sara Facio

Three of Norma Aleandro's particularly salient post-dictatorial works—
*La historia oficial*, *Cama adentro* (*Live-in Maid*, 2004), and *Andrés no quiere dormir la
siesta* (*Andrés Doesn't Want to Take a Nap*, 2009)—remain critical of Argentina's last
military dictatorship and its legacy by casting national crises within strained and
precipitous (if not overtly calamitous) middle-class familial frameworks.[2] These
films bring to light the dramatic impact of political repression and economic chaos
upon middle-class society and, consequently, each uniquely approaches middle-
class domestic space. Much as tight framing remains key to Facio's photograph, the
claustrophobic, private arena becomes a battleground for maintaining appearances
and stability.

A landmark film in Argentine cinema history set during the fall of the dictator-
ship and released during Argentina's turbulent transition to democracy, *La historia
oficial* metaphorically presents a complicit middle class's intellectual and emotional
struggle to come to terms with its increasing awareness of the military's recent
crimes against humanity. *Cama adentro* likewise uses domestic space as allegorical
of a national crisis, directing its critical lens at the 2001 economic collapse. Widely
considered the direct result of the regime's neoliberal policies, the economic disas-
ter is shown to threaten the very existence of the middle class. The film chronicles
the protagonist's desperate attempt to "save face" in the face of disappearing wealth
and status. In the end, the once privileged *señora* Beba must rely on the maid who
has cleaned her house for decades for her immediate survival. The 2009 *Andrés
no quiere dormir la siesta* takes place in 1977 Argentina, and depicts middle-class
acquiescence to the military regime in the guise of a conservative matriarch who
struggles to protect the family's safety amidst extreme military repression.

Considered together, these films constitute a diverse yet representative sampling of Norma Aleandro's work that has established her as an iconic representation of Argentina's middle and upper middle-class woman and, by extension, an embodiment of the challenges faced by the nation's privileged classes. This essay explores Aleandro's iconography as the face of Argentina's post-dictatorial, bourgeois society. Subtle changes in the physical appearance of Aleandro's various roles—especially hair, makeup, clothes, and fashion accessories—function as material indicators of the unstable nature of their privileged middle-class status. Filmic techniques, including the use of frequent close-ups and sets that feature intimate, claustrophobic domestic spaces, accentuate repressive situations and asphyxiating societal norms.

## Conscious Coiffure: Hair as a Bourgeois Discursive Strategy in *La historia oficial*

What begins as a festive social gathering, a reunion of classmates fostering conversation between women of similar social and economic status who nonetheless espouse radically different political ideologies, ends with terse exchanges and open hostility. Alicia, whose late arrival unearths cordially snide comments from the party's participants, sports a black dress of "the latest style" and wears her hair neatly swept up into a bun that is, as her friends unsympathetically observe, "still long" and terribly "old-fashioned." As novel as her dress may be, its plain darkness differs starkly from the outfits of her fellow bourgeois women, who wear vibrant shades of red, purple, and blue. It is as if her fashionable, black cocktail dress were not new at all, but rather another iteration of Alicia's naïve conservatism that leads her to blithely ask, "What are you talking about?" when the discussion turns to the kidnapping of several "subversives." Her traditional hairstyle and conservative dress, much in line with the fashion codes dictated by the regime, perhaps best indicate her intellectual position vis-à-vis that of the other women at the table, all of whom remain aware of the current socio-political reality of the military dictatorship, of which many are openly supportive.[3] In this way, Luis Puenzo establishes Alicia as a fully-fledged, albeit sheltered, member of Argentina's upper middle-class elite in his canonical film.

*La historia oficial* initiated a series of cinematic productions critical of Argentina's last dictatorship while simultaneously launching the career of one of the nation's most iconic figures, Norma Aleandro. For her portrayal of Alicia Marnet de Ibáñez—a history teacher whose marriage to a wealthy businessman (Roberto, played by Héctor Alterio) symbolically represents the bourgeois society's complicit relationship with the military junta—Aleandro was awarded Best Actress at Cannes, and the film would later go on to win an Academy Award for Best Foreign Language Film. As Constanza Burucúa points out, "the Oscar award followed a series of international prizes garnered not only by the film but also by its leading actress Norma Aleandro, who, after so much international recognition, obtained five roles in Hollywood" (2009, 122).[4] At the same time, *La historia oficial* inaugurated the Argentine film industry's renewed attention to and dedication toward the nation's then burgeoning middle class (Barnard 1986, 61).

*The Official Story* situates issues of national transition in the bourgeois household, as Alicia struggles to come to terms with her unwitting complicity in the violent legacy of her country. Set at the end of the military regime, the film plots Alicia's determination to learn the truth regarding her adopted daughter, a frantic quest for knowledge that encapsulates the collective soul-searching that was taking place in Argentina at that time.[5] Horrified at the knowledge that Gaby is likely the daughter of *desaparecidos* and equally appalled at her own previously blissful ignorance of the violent situation (both personal and national), Alicia undergoes a profound transformation. As film historians have noted, "the plot allows, given Alicia's victimization, an expiation of guilt for the Argentine middle class" (Jakubowicz and Radetich 2006, 168).[6] That is, the film provided an opportunity for the same intense emotional process to be shared by the record-breaking number of filmgoers who attended screenings of *La historia oficial* across the country.

While her ultimate disassociation from the crimes committed by Argentina's military junta occurs literally—she walks out on Roberto after he assaults her—, Alicia's rise to consciousness of the atrocities with which she has been complicit takes place over the course of the film.[7] Her conservative hairstyle repeatedly elicits critical remarks—not only during the reunion but also from fellow upper middle-class housewives during a dinner party that marks the film's first overtly political critique.

In the film's final scenes, Alicia's hair again takes center stage, but with precisely the opposite effect. Now freely flowing down and away from her face, it is no longer contained in a bun suggestive of conservative conformity in bourgeois society. Rather, this looser style implies, at least to the progressive Professor Benítez (played by Patricio Contreras), that she has radically altered her perception of the national reality and, by extension, begun to come to terms with her own collusion in the nation's violence and repression. "There's nothing more touching than a guilty bourgeois lady," he tells her after noting the change in hairstyle, thereby drawing a parallel between Alicia's socio-political realization and her conscious decision to wear her hair down like a "wild lady." Professor Benítez's reaction, indicatively, contrasts with that of Roberto, who rhetorically asks Alicia in a scene minutes earlier, "What is happening to your hair lately?" Roberto's subtly disapproving accusation, together with Professor Benítez's overtly complimentary reaction to these changes, indicates that Alicia's hairstyle serves as a conscious discursive tool she adeptly deploys as an upper middle-class woman; this deliberate fashion statement further illustrates Foster's observation that Norma Aleandro's hair remains "a signature feature of her persona" (1998, 178).

## Dislocated Appearances: *Cama adentro* and the Legacy of El Proceso

A spotless, upper middle-class apartment filled with symbols of comfort and even luxury, including a baby grand piano that no one plays, are the object of daily dustings and mopping at the hands of Mrs. Beba's live-in maid. Dressed in flat shoes and a standard blue uniform and with her hair pragmatically pulled back, a maid whose face remains obscured while she methodically polishes and dusts recedes

into the background as the furnishings take center stage. Cut to a colorful, boisterous city scene. Three independent extreme close-ups draw attention first to stylish high-heeled black leather boots; then to a shopping bag and purse casually dangling from the fingertips and arm; and finally to wavy hair, bold lipstick, and designer sunglasses: a seemingly confident middle-aged urbane woman appears to be shopping. A full body shot shows a trendily clad woman, head held high, who seems out of place in a thrift store. The viewer experiences the protagonist's anxiety and discomfort upon discovering that she is not on a shopping spree but is instead attempting to sell a china teapot and claiming to do so for an elderly neighbor so as to avoid the sense of shame she attaches to this action. With this revelation, the dark sunglasses suddenly take on new significance as a means to keep up appearances; they surreptitiously conceal personal identity while brazenly flaunting the image of a social class. By means of such intensely dramatic flair, Jorge Gaggero presents the opening credits of the award-winning *Cama adentro*.[8]

In sharp juxtaposition, the final scenes show a beleaguered Beba (Aleandro) herself cleaning what remains of her once elegant apartment in order to rent it. With disheveled hair hastily drawn back with a clip and day-old makeup, Señora Beba tenaciously sports a chic blouse and summer heels while cautiously picking up the broken china she threw in rage. Though her appearance still suggests an upper-class attention to detail, Beba must come to accept the loss of nearly everything that once defined her, as Argentina's vertiginous economic decline hits home. In the next scene, Beba quickly sizes up the humble home of her former maid, Dora (Norma Argentina), on the outskirts of Buenos Aires, as she fights to maintain her composure while her baby grand is unceremoniously left on the maid's porch after the movers determine the impossibility of getting it through the narrow door. In response to Dora's concern regarding the abrupt translocation of large furniture that now fills her entrance, Señora Beba replies evasively, "Don't worry, Dora. I'll move it as soon as I move to a larger place." This unwillingness to accept her own displacement from the privileged position she has occupied all her life recalls the history teacher's initial inability to comprehend current events in *La historia oficial* and foreshadows Doña Olga's obstinate refusal to face the extremely violent repression occurring in her very neighborhood in *Andrés no quiere dormir la siesta*.

On first viewing, *Cama adentro*—a film which centers on Argentina's financial collapse after the banking crisis of 2001—appears temporally and thematically distanced from the dictatorial atrocities that ravaged Argentina between 1976 and 1983. Specifically, the film chronicles the fall from grace of Beatriz Pujol or Beba, the upper middle-class protagonist who desperately attempts to maintain appearances despite Argentina's dire economic crisis during the first few years of the new century. However, as Nora Strejilevich contends in *El arte de no olvidar: Literatura testimonial en Chile, Argentina y Uruguay, entre los 80 y los 90* (2006), the economic, social and cultural crisis confronting Argentina nearly two decades after the country's return to democracy was the devastating result of the military regime's neoliberal policies. Strejilevich promotes the theory that the economic nightmare exposed a direct link between "exclusion through extermination" and "social exclusion" (2006, 9).[9] While the author/activist goes on to assert that the collapse fostered changes in public discourse, forms of collective memory, and governmental policies, what is of interest for this study are the ensuing tensions between social classes.

With its depiction of the economic crisis's catastrophic effect upon a particular bourgeois family, *Cama adentro* continues Argentine cinema's thematic shift toward the middle class initiated by *La historia oficial*. At the same time, however, it features a radical stylistic shift. Gaggero eschews the melodramatic flourishes employed by Puenzo and instead borrows numerous cinematographic techniques from the European *auteur* tradition such as those employed by classic Italian and French directors—Rossellini and Fellini; Truffaut and Godard. *Cama adentro* remains outstanding among Argentine films for its minimal plot (focusing on quotidian drama) and nominal use of musical score. The translocation of Italian neorealist attention to the social struggles of society's less fortunate allows for a significant regional variant: attention to the ruinous excesses of a class in decline.[10]

Throughout the film, alterations in personal appearance, household objects, and domestic space become the primary markers of ever-shifting social status. Beba, whose introduction in the film's early scenes includes a standing ovation for her investment in skin-care products, later furtively pleads for an extension of her debts. Beba's voluminous locks, flashy gold earrings, and arresting array of trendy jackets initially reinforce her overly confident demeanor; however, the complexity and ostentation of Beba's outfits, together with her proud independence, noticeably wane as the film progresses. Her hair becomes progressively more neglected and unkempt. The expensive earrings are pawned and replaced by opaque and simple jewelry, and the jackets disappear altogether. Her once well-furnished home lies bare, revealing stains and erosion that evidence the deterioration and neglect also visible in her personage.

As Beba's posh standard of living rapidly deteriorates, Dora's living conditions steadily improve. Dora upgrades her wardrobe, replacing her work uniform and frumpy attire with coordinated dress outfits, fashionable hand-me-downs from her former employer. Likewise, Beba's gifts of make-up samples and a beauty treatment awaken Dora's desire to emulate "Ivana Trump." Perhaps most revealing of all are Dora's aspirations to build a refined home. Her selection of "classy" floor tiles that she cannot afford indicates a taste, and ultimately an attitude and lifestyle of living beyond her means, acquired from her benefactor—despite the fact that Beba's status has noticeably declined and she is forced to downsize.

The final shot, an ironic and unnervingly long take, closes in upon a single bed that, like the baby grand, will be stored indefinitely at Dora's. In this way, *Cama adentro* concludes with a symbolic role reversal. Presumably, Señora Beba will stay at her maid's small quarters for just one night; nevertheless, this act directly parallels the housekeeper's previous position in Beba's home. The shot's painful duration suggests that this situation could continue longer than expected and that there will not be, at least for the foreseeable future, a swift return to the affluent lifestyle she once took for granted.

## Posing Blind Indifference: *Andrés no quiere dormir la siesta* and Middle-Class Conformity

A cinematic portrait captures a grandmother and grandson primping for a photograph, subtly revealing the *abuela*'s rigidly protective posturing as she pats his hair

and indicates with a gentle tap that he ought to sit up straight. The nondescript out-fits they wear, ordinary attire from decades past, paradoxically stand out precisely for their everyday, non-ostentatious nature. The woman's beige cardigan and light brown blouse, mature face and short, kept-up hair corroborate her uncompromisingly proud and vitriolic claim: "I'm 'Doña Olga,' and they respect me in the neighbor-hood." The child's outward appearance mirrors his grandmother's conformity. He wears a lightly striped turtleneck, dark shorts and high socks: the standard uniform of an elementary school boy. The portrait, taken in a pristine, blue-tiled kitchen—her dominion—underscores routine domesticity in the late 1970s. With this "Kodak moment," the trailer and publicity poster present Daniel Bustamante's first feature film, the 2009 *Andrés no quiere dormir la siesta*, a work that dramatizes the complex role of "blind seeing" assumed by a large sector of the Argentinean population dur-ing the last dictatorship.

Coining the term *percepticide* to refer to the fact that the public learned what to focus upon and what to overlook, Diana Taylor describes the process of a willed self-blinding that became part of quotidian existence during the dictatorship. Given the fact that citizens were frequently detained (disappeared) in full public view, "People had to deny what they saw and, by turning away, collude with the violence around them" (Taylor 1997, 123). Instances of such complicity perme-ate *Andrés* with increasingly uncomfortable dramatic intensity. The boys opt not to view their mother's body at her funeral, the family vows to never mention com-promising leaflets found in her closet as they frantically burn all traces of her exis-tence, and Andrés is both silenced and punished (his favorite toys cruelly burned) when he excitedly attempts to report something he has seen on the streets.

This ingrained behavior reaches a crescendo when the overly pragmatic Doña Olga (Aleandro) forcefully pulls Andrés away from the window (covering his mouth in order to silence him) as he witnesses a disappearance, the film's only overtly violent scene. Her calm denial of what they have seen intensifies the hor-ror: "You dreamt it," she persists the following morning, much to the boy's incre-dulity. As if to confirm this attitude, a neighbor purposively hoses down blood on the street, casually eliminating any visible traces of the abduction. The film's clos-ing shots feature extreme close-ups of Andrés's eyes as he aggressively plays with his toys, even as his grandmother suffers a heart attack. With a show of complete indifference, Andrés demonstrates that he has fully incorporated Doña Olga's les-sons of middle-class conformity.

Winner of the Glauber Rocha award at the Montreal International Film Festi-val for Best Latin American Film (2009) as well as Special Mention at the Mar del Plata Film Festival (2009), *Andrés* is set during the most violent period of the last military dictatorship. As a headline announcing the film's public release makes clear, this familial drama serves as a mirror for Argentine society at that time.[11] In fact, Doña Olga's primary concern is her family: "I want to be able to sleep peace-fully," she articulates at the dinner table, "not thinking they might come after one of my loved ones." The emotional currents of love, fear, and a fierce desire to protect form the backbone of Doña Olga's domestic agenda, one that evolves throughout the course of the film from obstinate unwillingness to acknowledge her daughter-in-law's political involvement—best captured by her off-hand remark "I won't be-lieve it until I see it"—to an intractable denial of the sinister reality of a clandestine torture center in the neighborhood.

*Andrés*, much in keeping with *La historia oficial* and *Cama adentro* though uniquely focalized through a child, incorporates the paradigmatic structure whereby intimate personal relationships metaphorically denote larger social relations. As Bustamante elaborates, the film "is a personal look at the family. . . . It is, in a reduced scale, a look at how society functions" (Filosi 2010). Concomitantly, the film's use of compact space reflects the fact that because he is a child, Andrés's world primarily consists of his domestic space and the street around it. The former remains a restrictive place belonging to adults, where children's opinions remain unwelcome; the latter belongs to the children, a space where they can play according to their own rules with one formidable exception—the forbidden site of the clandestine torture center.

In what has been labeled "a characteristic role" (Brodersen 2010) for Norma Aleandro and one clearly reminiscent of Alicia's disciplined restraint as well as Beba's excessive vanity, Doña Olga commands respect as she relentlessly imposes order in the face of increasingly apparent familial and social dysfunction. Stringent household rules (no music, no shouting, short haircuts for the boys, and a strong disapproval of women changing their hair color) reveal a strict adherence to middle-class *pudor* (decency) and a hyper-awareness of what the neighbors might think. Her personal appearance likewise reflects these old-fashioned, conservative values.[12] Doña Olga maintains a carefully controlled, sensible hairstyle that never interferes with or distracts from her matronly duties. Nor is it coincidental that she consistently dons outdated attire, wearing only skirts or dresses—never slacks—in muted tones. Perhaps most revelatory are her spectacles; perched authoritatively on the tip of her nose, these bifocals create a stern appearance that reinforces her venerable age and points toward her keen and insistent penetration of otherwise-concealed details. Doña Olga's prudent fashion sense and no-nonsense demeanor stand in stark contrast to her liberal daughter-in-law Nora, who wears her hair long and loose, dresses in bright clothing, prefers pants, and flaunts makeup despite suffering severe financial difficulties.

In this way, Aleandro's role encapsulates conservative middle-class comportment: the cultivation of close ties within the family and the neighborhood together with a strong disassociation from dictatorial atrocities. *Andrés no quiere dormir la siesta* does not simply criticize the dictatorship, but instead explores the generational effects of "en esto no meto" ("I don't get involved in this"). In the words of the actress, "Olga, the grandmother, is one of the many women who thought and continue to think 'they must have done something' about the *desaparecidos*" (Minghetti 2010). As with *La historia oficial* and *Cama adentro*, Norma Aleandro fashions an emblematic character with which national audiences can readily relate as they confront contemporary issues facing Argentine society.

## Conclusion: La Norma

Norma Aleandro, Argentina's most critically acclaimed actress at this writing, has become, as Bertazza fervently asserts, "one of the most emblematic, most celebrated, and most renowned personalities of our [Argentine] show business" (Bertazza 2010). In the last four years, the hard-working and talented actress has

appeared in no fewer than six cinematic productions (*The City of Your Final Destination*, *Música en espera*, *Anita*, *Andrés no quiere dormir la siesta*, *Cuestión de principios* [all released in 2009], and *Paco* [2010]) as well as continuing to headline Mercedes Morán's adaptation of Tracy Letts's Pulitzer Prize-winning *Agosto: Condado Osage* at the Teatro Membrives in Buenos Aires.

Throughout her film and theater career, Norma Aleandro has maintained a selective pattern of performances. Her judiciously chosen appearances in *La historia oficial*, *Cama adentro*, and *Andrés no quiere dormir la siesta* represent the travails of Argentina's middle class in the wake of the last dictatorship; at the same time, these roles complement an extensive oeuvre that captures the heterogeneous nature of this complex social strata. By becoming immediately identifiable both on the big screen and onstage as an emblematic middle or upper middle-class Argentine woman, Norma Aleandro has secured her iconic stature for decades to come.

## Notes

1. Sara Facio's photographs of famous Argentine women include Griselda Gambaro, "one of Argentina's leading playwrights"; María Luisa Bemberg, "one of Latin America's first successful feminist filmmakers"; Susana Rinaldi and Mercedes Sosa, urban and folksingers. With the important exception of Sosa, however, none of these other subjects comes near the iconic stature of Norma Aleandro (Foster 1998, 173–74).

2. The period 1976–1983, officially labeled the Process of National Reorganization (*El Proceso de Reorganización Nacional*) but more commonly referred to as the "Dirty War" (*Guerra sucia*), saw an estimated 30,000 people abducted, detained, tortured and disappeared. The Junta initially received broad public support, especially from the conservative upper and middle classes. In addition to profiting from the imposition of "order" on the country's social, economic, and political chaos, these social sectors further benefited from easy access to imported goods, including household appliances. In *La historia oficial*, Roberto's father, a Spanish anarchist, accuses his son of involvement with the regime, citing just such material acquisitiveness.

3. Diana Taylor succinctly details the approved look for women during the dictatorship: "Females: hair pulled back, white apron covering shirt, blouse or sweater, shirt buttoned at the neck or white undershirt. If trousers are worn, they must be navy blue; no makeup" (1997, 105).

4. Burucúa specifically cites *Gaby: A True Story* (Luis Mandoky, 1987), *Dark Holiday* (Lou Antonio, 1989), *Vital Signs* (Marisa Silver, 1990), *One Man's War* (Sergio Toledo, 1991), and *Cousins* (Joel Schumacher, 1991).

5. As noted by Diana Taylor, "Even before the collapse of the Junta in 1983, the population had begun its effort to look at the atrocity of the past decade. . . . There was a hunger to see, to know" (1997, 12). As she explains, the truth commission report, *Nunca más*, became a best seller in 1984, the trial of the generals was aired on national television in 1985, and cultural productions representing Argentina's recent history began to proliferate.

6. From Spanish: "La trama permite, a partir de la victimización de Alicia, la expiación de las culpas de la clase media argentina." Unless otherwise noted, all translations are ours.

7. Cynthia Ramsey notes that "Aleandro, the actress who played the role of Alicia, was part of a group of persecuted intellectuals and artists who fled Argentina in 1976" (1992, 159). It could thus be postulated that a form of intertextuality exists with the history teacher she portrays in the film. Aleandro's political consciousness, both of the regime's imminent violence and of the relationship between the upper middle-class intellectual elite and the military junta, has consistently manifested itself in public discourse. Alicia's more intimate and decidedly belated awakening to consciousness ultimately results in a violent physical assault by her financially connected husband, Roberto, and the disavowal of her privileged position. This shared

dissociation redefines Aleandro and Alicia's class identity to oppose the (knowledgeable or ignorant) complicity borne by other members of the same social strata.

8. *Cama adentro* won the Special Jury Prize at the Sundance Film Festival and received a nomination for the Grand Jury Prize in the World Cinema—Dramatic category.

9. From the Spanish: "la exclusión exterminadora" and "la exclusión social."

10. In many ways *Cama adentro* echoes the themes and styles of Lucrecia Martel's domestic feature, *La ciénaga* (*The Swamp*, 2001). Both films belong to the so-called New Argentine Cinema, a movement inspired by the economic crisis that culminated in the 2001 collapse. Characterized thematically by its critical attention to the bourgeoisie and stylistically by its approximation to Italian neorealist films of the 1940s and 1950s, the movement includes a diverse group of filmmakers (including Pablo Trapero, Daniel Burman, and Lucía Puenzo) from vastly different regions of Argentina, who address localized social concerns connected to the country's economic, political, and social situation. Many of these films, including *Cama adentro* and *La ciénaga*, use domestic space as a locus to reveal characteristics of bourgeois decadence such as deep-rooted prejudices, narcissistic behavior, and rampant self-indulgence.

11. From *La Nación*: "Relato familiar que también es espejo social." ["A family portrait that is also a social mirror"] (Martinez 2010).

12. In this repressive atmosphere where austere silencing in the household stands in for societal indifference, facial expressions, gestures, and body language become paramount. Bustamante elaborates that for this very reason, the casting of Aleandro was essential: "Doña Olga [is] a woman who knows everything and sees everything. But she's a character that doesn't have any great lines, therefore I needed an actress that could develop a corporal language that the entire family and neighborhood could identify. And I thought Norma was the right woman for this" (Castillo 2010). "Doña Olga, [es] una mujer que todo lo sabe y todo lo ve. Pero es un personaje que no tiene grandes frases, entonces necesitaba una actriz que pudiera desarrollar un lenguaje corporal que toda la familia y el barrio identificara. Y me parecía que Norma era la indicada para esto."

# The Neoliberal Stars
## Salma Hayek, Gael García Bernal, and the Post-Mexican Film Icon

*Ignacio M. Sánchez Prado*

Determining the exact moment when an actress becomes an icon is a difficult, perhaps questionable endeavor, but some milestones may provide a clear indication. In the case of Salma Hayek, this may have happened on May 6, 1996, when *People* magazine first included her in its influential Fifty Most Beautiful People list. While Hayek had, at the time, already appeared in a considerable number of films and TV shows both in the United States and Mexico, it was her sultry, intense performance as Carolina in Robert Rodríguez's *Desperado* (1995) that truly established the hue of her public image. Hayek was already perceived as a "sexy Latina," who was so proudly Mexican that she had refused to get a speech coach to lessen her accent and who worked for eight years to be able to portray Frida Kahlo on the big screen. In her *People* portrait, actor David Arquette compares her to a "Spanish Marilyn Monroe," giving her a very clear form of consecration, that of a media diva whose sex appeal defines her public persona.

A similar moment of *People* magazine stardom came on October 11, 2004, when Gael García Bernal was interviewed for the publication (Dagostino 2004). The presence of García Bernal in such a prominent magazine is striking if one considers that, at the time of the interview, he was yet to appear in his first major English language roles, having performed only in the independent British movie *Dot the I*. Nonetheless, he was riding the wave of two unprecedentedly successful Latin American films, Alfonso Cuarón's *Y tu mamá también* (2001) and Walter Salles's *Diarios de motocicleta* (*The Motorcycle Diaries*) (2004), and was on his way to play one of Pedro Almodóvar's most iconic characters, Ángel, in *La mala educación* (*Bad Education*) (2004).

In what follows, I will discuss the ways in which Hayek and García Bernal—or Salma and Gael, as they are more commonly known in the discourse of tabloids and fandom—represent two distinct forms of "Post-Mexican" iconicity, born out of the globalizing impulse that characterized Mexico in the wake of the implementation of neoliberal policies and the signing of NAFTA. Hayek has an equivocal relationship with "Mexicanness" in two ways—her Lebanese descent and her intersection

with Latino iconicity in the United States—but remains strongly committed to "representing Mexico" in the global arena. Conversely, García Bernal's embodiment of Mexico is consistently deterritorialized in his performance of characters from diverse national and cultural origins. While Hayek's characters are for the most part Mexican, even in films where such identification is not organic to the movie's plot, García Bernal has been able to play Spanish, Argentinean, and even French characters throughout his film career. In this brief analysis, I hope to show the ways in which iconic representatives of Mexico have followed cultural trends that have resulted in the gradual fading of hegemonic markers of national identity since the beginning of the twentieth century.

The notion of a "Post-Mexican" condition was coined by Roger Bartra, a leading anthropologist and public intellectual, in order to discuss the "profound crisis of identity and legitimacy" that resulted in the collapse of the signs and symbols of "Mexicanness" built around the postrevolutionary political regime that ruled Mexico for most of the twentieth century (1999, 60–61). Bartra's work has consistently argued that cultural productions in search of "Mexicanness" (from the work of literary figures like Octavio Paz to the identities coined in film to the philosophical and psychological ruminations on the Mexican self) constituted "imaginary networks of political power" which were essential to sustain the single-party regime constructed by the PRI. The "condition" that replaced these networks emerged as a result of a perfect storm of deterritorializing forces, including the growing democratic and societal pressures on the regime in the wake of the 1968 Tlatelolco massacre, the 1985 earthquake, and the 1988 alleged electoral fraud, as well as the emergence of regional and ethnic identities in the wake of the Zapatista uprising and the formation of supranational "Americanized" or "Westernized" identities through the cultural impact of NAFTA. In this climate, both Hayek and García Bernal emerged from a Mexican cultural industry that gradually intersected with transnational circuits of cinema, granting them unprecedented access to global audiences.

Cinema is a crucial cultural genre through which to read the transformations of the Mexican cultural industry in the neoliberal crucible. Hayek's and García Bernal's careers emerge in a moment when longstanding structures of film production and exhibition collapsed. On the production side, the 1994 crisis led to a decline in state funding for cinema and to the creation of private structures of production and co-production. To be sure, this does not mean in any way that filmmaking became "privatized." Rather, it means that the state film institute IMCINE's monopoly on production developed into a more complex model that allowed private investors to be part of the process via co-financing and tax credits. On the exhibition side, Mexico experienced in the mid-1990s the closure of its historical infrastructure of *barrio* and public cinemas and the rise of private multiplex companies. This led to a displacement of cinema spectatorship from the working to the middle class. In a way, one could claim that Hayek and García Bernal's rise in Mexico takes place partly due to the changing aesthetics brought about by privatization, which required actors who appealed to middle-class audiences, as opposed to the men and women from *sexy comedias*, like Rosa Gloria Chagoyán, whose style was addressed to the mores and desires of urban popular spectators. However, the more important point is that the transition in the Mexican national market created an imperative of internationalization for Mexican cinema, given that the local cir-

culation did not provide sufficient economic guarantees for the costs of privately financed cinema, or even for a state-sponsored cinema undergoing an economic crisis. Thus, Mexican cinema's circulation in film festivals and art-house circuits in Latin America, Europe, and the United States intensified, creating the space for Mexican actors to emerge as international stars.

This is the case in Hayek's early success in world circuits. While her career began, like most Mexican actresses, in television, the pivotal moment in her career came thanks to her role in Jorge Fons's *El callejón de los milagros* (1995), a Mexican rendering of Egyptian writer Naguib Mahfouz's novel *Midaq Alley*. This film was among the first of the so-called *Nuevo Cine Mexicano*, a trend fueled by production money from IMCINE. Hayek owes her leap to Hollywood to her success as spokesperson for the film in the international festival circuit, where she caught the eye of producers in venues such as the Berlin Film Festival.[1]

Hayek's image at the time provided an interesting contrast with media figures from Mexican television. Most actresses in the *telenovela* landscape of the late 1980s and early 1990s were light-skinned and blonde: Edith González, Leticia Calderón, Christian Bach, and Adela Noriega are good examples. When Salma Hayek got the main role in *Teresa* (1989), her casting spoke volumes about the ethnic economy of Mexican media: she played a poor girl out of a *vecindad*, who pretends to be rich in order to transcend her origins.[2] Actresses of Hayek's complexion are usually relegated to roles of servants and comedic sideshows, given the racially defined notions of beauty in *telenovelas*. The exceptionality in Hayek's casting is shown by the fact that in the 2010 remake of *Teresa*, the role went to Angelique Boyer, a blonde actress of French descent, and the actress in the original 1959 version, Maricruz Olivier, was also blonde and French.

Teresa, in Hayek's portrayal, clearly plays into Mexico's elite class fears by representing the ruthless poor woman who is capable of anything, thus threatening the affective imaginary of the privileged. The *telenovela*'s catchphrase was "*Me das miedo, Teresa*" ("You frighten me, Teresa"). Interestingly, *Teresa*'s unusual ending— her rich suitor's family lets him marry her to stop him from committing suicide— might have doomed Hayek's chances to achieve Mexican television stardom, since it made her image in such an unusual show incompatible with the narratives and imagery of more popular *telenovelas*. However, *Teresa* announced the ways in which Mexican film would ultimately break with the semiotics of *telenovela*, considering that in addition to Hayek, director Antonio Serrano, producer Isabelle Tardán, and actors Daniel Giménez Cacho and Gael García would also move on to cinema in the 1990s.

Hayek never again appeared in a major Mexican television role.[3] She moved to the United States in 1991 to study acting and to try to start a career in Hollywood. While Hayek landed minor roles in episodes of assorted TV series and in the Hispanic movie *Mi vida loca* (1993), it is meaningful that her breakthrough came with *El callejón de los milagros* in a role very close to Teresa. In the movie, Hayek plays Alma, another *vecindad* girl who tries to climb the class ladder. Unlike the *telenovela*, the movie plays closely to the semiotics of Mexican film melodrama, leading Alma to a pimp who transforms her into a high-class prostitute and who ends up killing the working-class man who is in love with her. Nonetheless, Alma and Teresa work within the same notions of the Mexican working class, and the fact

Salma Hayek at the Festival Internacional de Guadalajara in 2010. Photo courtesy of Festival Internacional de Guadalajara. Creative Commons license.

that Hayek ended up playing an iconically similar role five years after her debut performance speaks of the impasse faced by Mexican actresses at the time.[4]

Hayek's answer to this conundrum was to insert herself into an altogether different economy of female beauty: that of the emerging US Latino culture. There, Hayek's dark-haired voluptuous beauty, a product, in part, of her Lebanese heritage, played straight into perceived notions of Latina beauty constructed by the US media. It is interesting to note that American audiences are not usually aware of her Lebanese origins, which are seldom mentioned in media coverage. However, this erasure of Middle Eastern physical traits under the semiotics of Latina beauty is far from uncommon: the very same process was undergone a few years later by Colombian singer Shakira, who had to put her Lebanese origins under erasure due to the cultural effects of 9/11.[5]

Still, Hayek's image was no longer within the notion of "Mexican" produced by Mexicanist discourses. Rather, it presented challenging forms of iconicity, given that she literally embodied different cultural semiotics in her physical appearance and media representations. Isabel Molina Guzmán and Angharad Valdivia, for instance, have argued that "Due to their mixed cultural heritage, Hayek, [Frida] Kahlo and [Jennifer] López as hybrid women often problematize and work against the discursive field of popular ethnic and racial categories. . . . Their ability to occupy and shift between racial and ethnic categories ruptures dominant identity discourses while the commodification of ethnicity within mainstream U.S. popular culture reifies difference" (2004, 214). These critics argue that in some films (like Kevin Smith's *Dogma* or Mike Figgis's *Timecode*), Hayek's ethnic identity is "absent" from the text. Even so, one should recognize that Hayek's better-known roles tend

to move to the second part of the equation, playing straight into the "commodification of difference" mentioned in the article.

Hayek's iconicity in the US film world comes fundamentally from two movies: Robert Rodriguez's *Desperado* (1995), her first title role in English, and Julie Taymor's *Frida* (2002), which she produced and in which she starred. The contrast between these two films well illustrates Hayek as a post-Mexican icon in a very precise way. Bartra (1999) argues that one of the central issues in the post-Mexican condition lies in the construction of identities no longer constrained by the "cage" of the nation. Thus, the use of Mexican identity icons in a cultural semiotics unrelated to their ties to the imaginary networks of political power allows for a resignification of the very meaning of being a "Mexican" or "Latino" icon. While *Desperado* and *Frida* may seem two completely different cultural products, they actually operate in similar ways, as metacinematic and metacultural portrayals of Mexico constructed upon metafictional worlds that have questionable referential ties to Mexican "reality."

*Desperado* belongs to a cinematic model born out of Quentin Tarantino's work, where, as Bruce Isaacs has described, metacinema is no longer "cinema about cinema" but "a cinematic spectacle that is always already of cinema" (2008, 188). While this notion requires a development that exceeds the space and scope of the present essay, it is important to point out, following Isaac's contention, that *Desperado*'s aesthetic is not a film "about" Mexico, but a film where "Mexico" is a metacinematic construct fully structured around the signs and symbols of cinema itself. In other words, *Desperado* is a film about Mexico in the same way that Tarantino's *Kill Bill, Vol. 1* is a film about Japan: not an attempt at representing a reality or a history, but a self-referential system built from signs and symbols that are already cinematic.

Arguably, one may assert the same thing about Taymor's *Frida*. While the movie's plot is built around the conventions of the biopic, its language is fully immersed in a visual palette that appeals to the ideologemes and perceptions American cultural audiences have of Mexico. This is demonstrated in gendered readings of Hayek's role, such as the one attempted by Molina Guzmán in her article on the film (2007), where Hayek continuously asserts her commitment to a Mexican identity based on her preference to be called Latin rather than Latina and on her reluctance to shed her Mexican accent. While this reading does offer some insights regarding Hayek's Mexican attachments in a post-Mexican condition, it misses the aesthetic in which her work is inscribed. This point may be further illustrated by Taymor's movie *Across the Universe* (2007), where she recreates the *ethos* of the 1960s through the music of the Beatles. I would contend that *Frida*, just like *Across the Universe*, cannot be read as a "historical movie." Rather, like *Desperado*, it constructs a metacinematic system of signs that, in themselves, carry a cultural meaning that renders historical referentiality meaningless.[6]

Within these metacinematic worlds, Hayek embodies a post-Mexican identity insofar as she represents not a historically substantial semiotics in connection with identifiable networks of political power or social meaning, but rather a self-referential semiotics of the "Mexican" to be consumed as a cultural commodity of Mexicanness by a non-Mexican audience. While Hayek was able to attract some viewers to Mexican theaters, neither movie was particularly successful in Mexico.[7] This fact shows that Hayek's embodiment of "Mexicanness" lacks

the use-value of cinematic identities of the 1940s and 1950s in Mexico, when national audiences closely followed icons like María Félix. Rather, I would argue that Hayek's Mexicanness operates in the realm of exchange value, as a symbolic commodity circulated in the exchange of symbols that accompanied economic trade in post-NAFTA North America, thus allowing her reading not only as "Mexican" but also as "Latina" and even as a nondescript character.

It is telling that this metacinematic identity follows Hayek in her later movies. For instance, in Robert Towne's *Ask the Dust* (2006), based on John Fante's novel, Hayek's character Camila López is an allegorical representation of the emerging Hispanic immigration in 1930s L.A. In another movie, Joachim Roenning's *Bandidas* (2006), she teams up with Penélope Cruz in a highly metacinematic portrayal of two Mexican bank robbers in the late nineteenth century. These two films clearly show that Hayek's iconicity is, ultimately, a signifier for a peculiar form of Mexicanness to be circulated as a commodity in the marketplace of identities that characterizes North American neoliberal culture. Still, she does not represent the ultimate manifestation of this phenomenon and, as I will show with Gael García Bernal in the remainder of this essay, the capacity of post-Mexican icons to become empty signifiers is crucial to understanding how globalized culture resulted in the removal of cultural anchors constructed by twentieth-century Mexicanist ideologies.

In his peculiar biography of García Bernal, British journalist Jethro Soutar (2008) contends that García Bernal is the "leading man" of the "new wave" of Latin American cinema that achieved internationalization in the past decade. Soutar's book is more anecdotal than analytic, mostly because its author is not a scholar or a critic but a biographer to the stars, whose previous book focuses on soccer player Ronaldinho. The fact that a British freelance journalist decided to write a book on the actor attests to García Bernal's iconicity as a transnational cinematic figure, one whose range of recognition has transcended the binational space of Hayek's stardom.

García Bernal's beginnings in media are similar to Hayek's. He too was a soap-opera fixture, reaching the status of child star in the *telenovela El abuelo y yo* (1992), opposite Ludwika Paleta in his role as a poor orphan who befriends a wealthy blonde girl. Like Hayek's, García Bernal's Mexican career was clearly marked by the ethnic economy of Mexican media. Three of his four major Mexican cinematic roles frame him as a working-class adolescent. In *Amores Perros* (2000), he plays a young man from the slums who tries to overcome a life of poverty; in Alfonso Cuarón's *Y tu mamá también* (2001), he plays the working-class best friend of a wealthy politician's son, while in *Rudo y cursi* (2008) his character is a poor rural youth who reaches stardom through soccer.[8] García Bernal thus faces the same impasse as Hayek. In late-1990s Mexican TV, so many roles were for light-skinned actors that a major wave of performers from the Southern Cone, led by Argentinean Juan Soler, filled starring roles in *telenovelas* due to their appearance.

By the time García Bernal was profiled in *People*, he faced a completely different media landscape than the one that allowed Hayek to become a star in the mid-1990s. For starters, the Latino wave that brought Ricky Martin, Jennifer López, and Shakira to leading roles in US culture had become *passé* and, regardless of his international accolades, room for a Latino leading man was never quite created in the US film industry. Thus, García Bernal's major English-language roles have

Gael García Bernal and a friend of the author in Madrid. Courtesy of Tamara Falicov.

consistently been in independent films, mostly from Europe, which have reached very small audiences in the United States. Martin Parkhill's *Dot the I*, James Marsh's *The King* (2005), and Michel Gondry's *The Science of Sleep* (2006) all played with little-to-moderate success in the festival circuit and had very modest commercial releases in the United States. Even the star-studded *Blindness* (2008), directed by Fernando Meirelles, which received a certain degree of hype because it was based on José Saramago's iconic novel, ultimately flopped in the US market. In fact, the first *bona fide* mainstream Hollywood movie with García Bernal in the cast, Gary Winick's *Letters to Juliet*, came in 2010, in a modestly performing romantic comedy in which García Bernal did not play the leading man but the fiancé dropped by the protagonist.[9] The point in emphasizing García Bernal's lack of success in the American film industry lies in asserting that, unlike Hayek, he cannot be read as a cultural commodity of "Mexicanness" for North American consumption, because he has never operated as such in that cultural market. I would rather contend that García Bernal's iconicity lies in a different form of post-Mexican condition, where he is able to shed his Mexican markers of identity in order to become an empty signifier, both culturally and ethnically, that may be filled with a wide array of national and postnational cultural meanings.

García Bernal's transformation into a post-Mexican film star happened in 2004, thanks to his casting in two completely antinomic roles that helped him render his performative masculinity in opposite ways. This connects with García Bernal's role in a genealogy of Mexican actors who have historically defined "Mexicanness" alongside masculinity and machismo. As Sergio de la Mora shows, however, García Bernal presents a very peculiar form of masculinity that is both "feminine" and "phallic" and that clearly contrasts with the performance of maleness that defined Mexican stars of the Golden Age (2006, 164). One could make the case that García

Bernal's ability to transcend his role as a signifier of "Mexico" is closely tied to his capacity to play a wide array of masculinities.[10] In this, García Bernal has been able to go even further than Hayek, since the gender roles usually allotted to Latino-American female film stars keep Hayek firmly grounded to a performance of ethnic femininity that remains at the core of her actoral identity.

García Bernal's first rupture with his iconicity as a Mexican actor was his portrayal of Ángel/Zahara in Pedro Almodóvar's *Bad Education*. As Fouz-Hernández and Martínez-Expósito document, "The controversy created in Mexico around his disguised accent, his female impersonations and the gay sex scenes missed much of Almodóvar's point about a trans-identitarian transvestism, because, for some critics, García Bernal's physical and linguistic cross-dressing was a form of 'betrayal' to a supposedly fixed identity based on external features" (2007, 155). These authors further argue that García Bernal's playing of multiple roles (as the main character, the alias of the main character, the main character's brother, and a transvestite) is not merely a device through which Almódovar constructs a manipulative cinematic gaze: "Almodóvar's constant play with the idea that nothing is what it seems to be, finds, in the morphed body of the characters played by García Bernal, a graphic and eloquent confirmation" (159). The notable point here is García Bernal's performative plasticity, his capacity to become a vehicle for Almodóvar's convoluted game of shifting identities. By renouncing the masculinity fixations and Mexican markers constructed around his body by his Mexican spectators, García Bernal became an empty icon, whose symbolic value lies not in his specific Mexican origin, but on his trans-Hispanic performances.

The contrast with his second 2004 movie, Walter Salles's *The Motorcycle Diaries*, shows the thrust and consequences of this point. In this movie, García Bernal plays the young Ernesto "Che" Guevara, an icon of 1960s revolutionary masculinities and a further erasure of his Mexican persona. Here, García Bernal brackets the femininity identified by De la Mora, in his portrayal of the emergent alpha masculinity of the revolutionary (2006).[11] Claire Williams has identified the movie as a "Pan-American travelogue," which, at its core, narrates the formation of young Ernesto's identity (2007, 11). This characterization shows well the importance of García Bernal's iconic versatility for the movie's narrative. He not only has to impersonate an Argentinean accent,[12] but he must also allow his body to become the signifier of a cultural symbol with a very complex pre-defined set of historical and cultural meanings and expectations. One could argue that García Bernal here portrays a figure who is the very opposite of Almodóvar's Ángel: a clearly defined self that can never become the multiple identities that his other roles have created.

When comparing García Bernal and Hayek as Post-Mexican stars, it is possible to conclude that they ultimately represent opposite consequences of the same historical phenomenon. Neither one is subject to the imaginary networks of identity that dominated Mexican cultural discourses in the twentieth century. By inserting themselves as commodities in different circuits of cultural meaning—Hayek in the US Latino market, García Bernal in the trans-Hispanic cinema that circulates in film festivals and art houses—, they emerged as empty signifiers that evolved into icons of a post-Mexican cultural condition. However, once meaning is invested in their bodies, they ultimately represent opposite movements. Hayek's work as a

consistent repository of metacinematic images of the Mexican represents a reter-ritorializing icon, whose performances consistently attempt to fill the identitary void left behind by traditional notions of Mexican and Chicano identity. It is not insignificant that Hayek has invested some of her star power in the creation of two cultural artifacts aimed at the presentation of a Latino identity for American audiences: *Frida* and the American TV rendition of *Ugly Betty*.

Conversely, García Bernal's circulation in the international market—and even in his ironic portrayals of Mexican stereotypes in Mexican cinema—speaks of a deterritorializing force that resists inscription in an identitary paradigm. This is the reason why his most recent returns to Mexico have been highly parodic of Mexicanist paradigms. In *Déficit* (2007), his directorial debut, he wages a critique of the values and masks of the Mexican middle class. Even though the film tanked at the box office and is aesthetically flawed in many ways, it remains surprising that it has not secured DVD release in Mexico, considering García Bernal's star persona. Yet at the same time the failure of this production illustrates my point that Bernal is not fully in tune with Mexican cinematic expectations. More successfully, García Bernal teamed up again with Diego Luna and the Cuarón brothers in *Rudo y cursi* (2008), a kitschy rags-to-riches story that presents many symbols of contemporary Mexican popular culture, from soccer to *banda* music, in a light that exposes their exploitation of the dreams and aspirations of the working classes. Ultimately, Hayek's career has trafficked in the emergence of alternative forms of identity, something that García Bernal's work has resisted so far. Nonetheless, as icons-in-progress, their role in contemporary culture is wide open, and perhaps they will end up developing a cultural legacy beyond the post-Mexican condition.

## Notes

1. This has been confirmed to me in personal conversations with Jorge Alberto Lozoya, the director of IMCINE at the time, who mentioned that Salma Hayek was instantly a magnet for journalists at festivals around the world.
2. A *vecindad* is a form of overcrowded tenement in Mexican working-class neighborhoods.
3. Her only other appearance in a *telenovela* happened in one episode of the historical soap *El vuelo del águila* in 1994.
4. The rise of Mexican cinema in the late 1990s allowed actresses with appearances and complexions similar to Hayek's, such as Ana Claudia Talancón, to be cast in leading roles. However, *telenovelas* kept, and keep, relying on the same physical types as in the 1980s.
5. For a good discussion of Shakira's crossover and the impact of her Lebanese heritage post-9/11 see Cepeda (2010).
6. In fact, I believe one could claim that Hayek is not a particularly important figure in Latino mainstream cinema. If one sees accounts of this tradition, such as the one pursued by Beatriz Peña Acuña (2010), it is quite clear that post-Mexican film stars have little to do with a form of moviemaking closely linked with the cultural politics of ethnicity. I thus believe that, while Molina Guzmán's argument is relevant to actresses such as Jennifer López (who came to fame in a more straightforward biopic of singer and Latino icon Selena Quintanilla), it may be a stretch to put Hayek in the same category.
7. *Desperado*'s box office numbers in Mexico are not available, and my assertion is based on my own recollections. According to the website *Box Office Mojo*, *Frida* collected about 3.5 million dollars in box-office receipts in Mexico and ranked thirty-nine in 2002 ("Box Office Mojo: *Frida*"). As

a comparison, *El crimen del Padre Amaro* (*The Crime of Padre Amaro*), the most watched Mexican movie that year, brought in 16.3 million dollars ("Box Office Mojo: *El crimen del Padre Amaro*").

8. The semi-exception is *El crimen del Padre Amaro* (2002), where he plays a priest whose class origins may be implied but are not an explicit part of the text.

9. I do not count García Bernal's role in *Babel* (2006), not only because it was minor, but also because Alejandro González Iñárritu directed the film, so it cannot be an indicator of García Bernal's status in the US film industry.

10. This is clear in the homoerotic world of *Y tu mamá también*, where García Bernal and co-star Diego Luna play a homosocial form of maleness that is based in the performance of masculinity but that ultimately drifts into a gay sexual encounter. For a different development of this argument, see Lewis, who presents Cuarón's movie as part of a new canon based upon the failure of masculine figures.

11. In fact, this work-in-progress masculine identity is well complemented by Benicio del Toro's remarkable performance as Che Guevara in Steven Soderbergh's marathonic *Che*, where one can find a more clearly defined masculine revolutionary who still shows traces of the affectivity invested by García Bernal in the role.

12. He also does this in the Argentinean romantic drama *El pasado* (2007), where the main character Rímini is, tellingly, yet another case of an identity faded and recovered, a man who faces the loss of love through a descent into the hells of drugs and oblivion.

# Diego Armando Maradona
## Life, Death, and Resurrection (with One Act to Follow)

*Juan Villoro*

## The Opinions of a Left Foot

On October 8, 2000, Napoli, Southern Italy's beleaguered soccer team, permanently retired jersey number 10. The scene, played at the foot of Mt. Vesuvius, was yet another tearful aria in the opera starring Diego Armando Maradona. When Maradona, already viewed as a slightly shorter version of the Messiah two decades earlier, came to the team's rescue, Napoli was one point away from forced retirement from the raucous Serie A, and the inexplicable devotion of its long-suffering fans could only be attributed to their taste for Italian-style tragedy. In 1984, during a fifteen-minute welcoming ceremony at the San Paolo stadium, eighty thousand of these hard-core, faithful-unto-death Neapolitan believers witnessed the Argentine's second most identifiable public trait: uncontrollable weeping. Truth be told, Napoli's would-be savior was in no better shape than his new team. To begin with, he was coming off his long bout with hepatitis, still mourning his nasty left-ankle fracture—courtesy of the Basque Goikoetxea—and his failure to secure the World Cup for Argentina in 1982. Added to these woes were his long contract disputes with Barcelona's management and his most recently acquired vice of choice: cocaine. At twenty-three, the left-footed god of soccer was also on the verge of forced retirement.

Medicated by unscrupulous doctors and willing to travel fifteen thousand miles to play a "friendly" game, in Italy Maradona started playing four games a week, a rhythm he kept up amid a circus-like mob of photographers and reporters. Thus it was that the infant born at the run-down Eva Perón Hospital became proof, once again, that Argentines have a weakness for soap-opera-inspired second acts. Napoli was meant to be Diego's Pompeii, a lavish cemetery with a view of that legendary sea. Instead, the down-on-its luck team from the much-maligned city was enough to ignite Maradona's sense of outrage at the injustices perpetrated against those from below and thus feed his much-publicized enthusiasm for lost causes. Well paid and well loved by his devoted Neapolitans, he decided to remake Italy's southernmost team with the sky-blue uniforms into "a team from nowhere and

against all." Here was a chance for him to prove himself a Hercules of sports again by beating all the odds.

During his first game with his new Italian team in Milan, Maradona experienced first-hand the racism that the rest of Italy reserved for the South. On that occasion, the Neapolitan team was ushered into the stadium with banners proclaiming, "Welcome to Italy; wash your feet before entering." The kid from the poverty-stricken Villa Fiorito had joined the ranks of the Italian underdogs, the outcasts whose ancestors, decades earlier, had made the long and arduous voyage to Argentine shores fleeing their mind-crushing poverty. Never one for subtle gestures, Maradona announced that he was putting his left foot and his monumental sentimentality at the service of San Gennaro, patron saint of Naples. What happened next defied all logic: the team that had been dismissed as a barbarian horde in the exalted dressing rooms of the Milan stadium started winning all the matches.

An amazing game for many reasons, soccer is first and foremost a display of physical wonders and freakish feats of corporal prowess. Maradona stands five feet five inches tall. During his glory days on the soccer field he would sleep until eleven, train reluctantly, and eat amply. Saturday's generous portions of *tallarines* (home-made spaghetti) would weigh visibly on his Sunday games. Despite all this, Maradona's body never failed to project a sense of compact aggression and crafty compulsion. Even in a tuxedo, he looked ready to stop the ball with his chest at a moment's notice. He gave the sport its greatest improvised plays. He has been, unquestionably, soccer's most dramatic and most influential member on any team for which he played. Not even Pelé could boast of inspiring that kind of unlimited team spirit. In the 1986 World Cup, Diego made us believe that any national team could be champion with him at the helm. During the Eurocup in 2000, Platini compared the then-reigning king of the sport, Zidane, with Argentina's number 10 to the detriment of the former by noting that "Maradona could juggle an orange better than Zidane dribbles a soccer ball."

In 1987, two years after joining the team, Maradona led the Napoli to its first important national trophy in sixty years, the fabled *scudetto*. The Italian Serie A league has been known for its formidably rough players, and Maradona accepted without complaint his role as the most publicly "kicked" man of the twentieth century. For a time, a veritable global village witnessed his feats on the field of the Roman circus. From the foggy steppes of Eastern Europe and the sunny Serengeti of Africa would come teams with their own gladiators, all hoping to break number 10's ankles or destroy his shins. Throughout it all, the Argentine virtuoso played according to his own private psychology: as Rookie of the Year, trying to win his place on the team. The performance was well within character: without a soccer ball, Diego is lonelier than Adam on Mother's Day. He has never stopped portraying (and believing) himself as the poor barrio kid whose necktie Menotti had to tie so that he could accept the trophy for best player at the U-20 World Cup in Tokyo in 1979.

Naples turned itself over to its foreign savior with a fanaticism bordering on blasphemy and affection knee-deep in sentimental sap. *Bel cantos* adopted arias in his honor, each *tavola calda* included the "Pizza Maradona" on the menu, and the names of the country's founding fathers were erased from street signs in order to make way for the nomenclature of their new hero: *Via Maradona* led to *Piazza Mara-*

*dona.* In 1990 Argentina beat out Italy in the World Cup semi-final. The game, as fate would have it, was played in Naples's San Paolo Stadium. The drama exceeded the talents of columnists writing in the *Gazzetta dello Sport*; it required a Puccini libretto instead. Now the Spartacus of the South was fighting against the Imperial Roman army. On the streets of Naples, Argentina became a more authentic version of Italy. The opera ended in penalty kicks. When Maradona prepared to take his shot, the long-suffering Neapolitans couldn't bring themselves to shout him down. They suffered his offense in silence as the ball, slowly, perfectly, and totally unstoppable, scored the final, decisive goal. With tears in their eyes, his Naples fans cheered in what must have felt like sheer emotional suicide.

## "They say I talk too much, and they're right"

It was October 8, 2000, when Napoli's number 10 became a number for nostalgia. Maradona, via satellite and weeping uncontrollably, seemed to be mourning the fate that destiny reserved only for ill-fated gods. Right around that same time, bookstores started to display his flamboyant memoir, sold to the publishers to the tune of a cool million. Its maudlin title, *I Am Diego (of the People)* [*Yo soy el Diego . . . (de la gente)*], would have made Libertad Lamarque blush.[1] Leonardo Tarifeño quickly noted that Maradona had just become the highest-paid Argentine non-author. Written in the first person, the autobiography was ghostwritten and doctored by Daniel Arcucci and Ernesto Cherquis Bialo, two seasoned journalists whose reporting had freed them from any sentimental connection to the soccer fields. We owe to them the recreation of an authentic and impassioned, if slightly

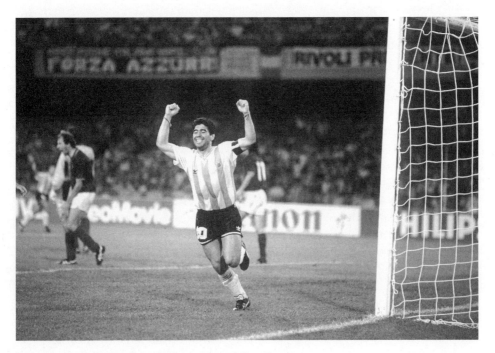

| Maradona celebrating Argentina's win in 1986. Getty Images

dazed, voice, a voice Argentina's soccer god could never put down on paper him-
self. As might be expected, the book serves as an elaborate conduit for Maradona's
gargantuan egomania. In a business full of exhibitionists, Diego never hid his nar-
cissism, going as far as to "baptize" the hand that scored the famously controversial
goal against England in 1986 as the "hand of God."

Yet in the autobiography the display of such a colossal ego is accompanied by
a frankness that makes its presumed author vulnerable and open to attack. For
Maradona, tears are punctuation marks and bursts of copious weeping chapter
breaks. He sees his life unfold in tango lyrics and never hesitates to pile on the
*mea culpas*. When recounting the many cars he was offered as gifts, he stops long
enough to remember the day he turned down a one-of-a-kind Mercedes because it
had an automatic transmission. His gaucherie and bad taste would overwhelm the
décor of a Vegas casino. Yet even the most sober of readers will find it hard not to
root for him when he recalls the puerile joy he felt when his wife gave him a pair
of Versace briefs gaudy enough to make a drug dealer blush. Incapable of making
a well-reasoned argument to justify his drug use, he arrives at an unexpected con-
clusion: "I would rather be a drug addict than a bad friend," as though friendship
doesn't stand a chance outside the brusque camaraderie of the drug cartel.

Defeated by his own fame and addicted to the reporters who constantly misun-
derstand him, the man who lays out his confessions in *I Am Diego (of the People)* sees
his tantrums as a legitimate form of political dissidence. His outbursts are reminis-
cent of the rock star who tosses a TV out the window as he trashes his hotel room.
No one will ever accuse Maradona of being consistent, and his autobiography
bears this out. Ever volatile, he openly despises everyone in management only to
flatter them later. Out of personal dignity, he lashes out against the sharks of the
soccer league only to return to its ranks after a few days of deep-sea fishing. He
insults the board who would control his team only to applaud the same manage-
ment for drafting the players of his choosing for Napoli. His spot-on criticisms are
of limited reach: João Havelange did not deserve a place on the field because he
was basically a water polo player who had become a politician; FIFA should never
allow eleven men with diarrhea to play in the midday Mexican sun at 7,200 feet
altitude just after lunch. Commenting on the media's feast with Maradona's im-
promptu pronouncements and off-the-cuff diatribes, Jorge Valdano described the
cruel irony of the tabloid god's fate when he noted that "people listen to Maradona
with awe, as if the words were issuing from his left foot" ("Valdano, Jorge" 2010).

Next to these incoherent but genuinely passionate confessions, nothing could
be duller than the sober and well-documented biography by Jimmy Burns, *The
Hand of God* (1996 and 2001), which rummages through the dirty laundry of its
protagonist in order to link him to the Neapolitan mafia, to long-legged Heather
Parisi, to possible illegitimate children, and to the terrible addictions of the court
jester / king of Naples. Burns leaves too many loose ends, but this is not what makes
his book vastly inferior to *I Am Diego (of the People)*. He fails to convey the tone with
which Maradona, admitting his foibles, admits to having fucked up royally. It is
difficult to imagine another legendary sports hero writing about his larger-than-
life screw-ups, or the sons of bitches he despises, with such unabashed sincerity.

Maradona gets it right when denouncing the abuses suffered by the players on
the field, but he badly misses the target when he proclaims himself as the game's

long-suffering native hero-victim: a Tupac Amaru in a polyester jersey. His knack for negotiating incongruity through an excess of sentimentality abandons him when he starts talking politics. The schmaltzy but strangely convincing scenes of self-flagellation that humanize him when talking about soccer or his daily struggles contrast sharply with the bad faith with which he sets himself up as the "ethical" soccer player, in the style of, say, Eric Cantona. When he tries to give a political overtone to his personal struggle for survival, he fails to sound sincere. His assortment of public heroes is problematic, to say the least: Fidel Castro, Carlos Saúl Menem, and Che Guevara, the last of whom he has tattooed on his arm. In 2001 he gave an extensive interview with the Italian journalist Gianni Mina from his medical retreat in Cuba. In a patois of Italian and Spanish balanced by equal parts isolation and painkillers, he compared Celia Cruz to an orangutan because she opposed the island's government. Arguing that Latin American history, as told in school, was full of inaccuracies, he claimed to base this pedagogical conviction on the fact that while flying across the Andes in a Lear jet, he realized the area was too vast and rocky for General San Martín and his soldiers to have crossed it on horseback in the 1810s. A man who questions his nation's official history from the window of a private jet can hardly be considered a hard-line leftist. And yet Diego's anarchic but unreflective side is what separates him from other *divos* and endears him to his fans. *El Pelusa* is a tribal Guevarist. Place him in a luxury *villa* and he will make it look like he's in his summer campground.

Perhaps because they envy their players too much, the managers at FIFA never miss an opportunity to put their feet in their mouths. The League's survey to name the soccer player of the century turned out to be as ill-conceived as if the United Nations had proposed a list of the twentieth century's most livable nations. In the end, Pelé was chosen by the experts and Maradona by the fans in the online community. Diego could enjoy this triumph: the infantry had chosen against the generals. In Maradona's reading, Edson Arantes was left to look like the game's tamed idol: easily manipulated by the system and incapable of speaking in his own voice.

Even though Pelé's stats are higher, no player has commanded his team as completely as Maradona. It would not be overstating the case to say that Brazil would have obtained the same titles without its emblematic number 10.[2] No one with a modest knowledge of soccer would dare to suggest that Argentina could have won the 1986 championship in Mexico without Diego. Maradona's role as his team's leader has always been unquestionable and absolute, especially when he and his teams were fighting the odds (Napoli, or the Argentine Selection to the World Cup under Bilardo in 1986). When the wind blew in his team's favor, he was much less effective. As the projected winner with F. C. Barcelona of the 1982 World Cup, when Argentina was the reigning champion, he failed to deliver. To win, Diego needs to be nurtured by paranoia and mistrust. In the 1986 World Cup, trainer Carlos Salvador Bilardo was for Maradona what Iago was for Othello: he whispered enough rumors in his ear to make his young, impressionable player unleash his creative fury.

Maradona was gargantuan on the field. It was enough for him to receive a standard pass at midfield in order to decide the fate of the game. Perhaps it was his superhuman control of the game, at once compact and devious, that took a nerve-breaking toll. Goalkeepers—the lonely ones—and left-wingers—the far-out

ones—live according to their own private rules. The ultimate team leader is made out of the same stuff. Maradona, the ultimate team leader, could not conceive of a problem he could not solve. In the field, he invented a world made in his own image so rarefied as to leave little room for the utterly banal but real world that surrounded the stadium.

In his own self-created epic battles with the other great number 10, Maradona likes to cite Rivelino and the fabled question the left-winger sports columnist once posed to the incomparable Pelé: "Tell me the truth, wouldn't you rather have been a lefty on the field?" For Maradona fans, the superior virtuosity of the left foot is a moral conviction, not a physical peculiarity.

Is there a single scene capable of encapsulating the tortuous career of this gladiator with a butcher's build? If forced to choose, I would say it would be his "roaring" performance before a US camera in the World Cup of 1994.[3] Diego was returning to the World Cup after his 1990 loss in Italy, his cocaine-filled "raviolis," and mounting proof that his golden feet were really made of the clay of Villa Fiorito's streets. His biggest battles now took place off the field, and his body showed obvious signs of an impending retirement. Yet in the game against Greece, he played as in old times, when scoring was something he did for fun. After Argentina defeated Greece, Diego was "randomly" selected (how randomly remains a matter of debate) to be tested for drugs. He tested positive for ephedrine, a drug which could help him breathe more easily but could hardly help him to kick the ball better. No matter. We saw him leave the field smiling, accompanied by a blonde nurse. Commenting on the scene, the Argentine writer Juan Sasturain recalled the Spanish translation of a famously dark Raymond Chandler line in *The Long Goodbye*: "all blondes have something fateful about them." (2010, 198) That day, under the Boston sun, a fateful blonde accompanied Maradona to his scaffold.

From that point on and for several years to come, his fall would be definitive and his fame index would be relegated to the compensatory notoriety of newsworthy scandals: for years there were only his crazy statements, his expensive drug-addiction cures, his car crash in Cuba, his terrible image as an exhausted, exterminating angel with orange hair, a bloated chest, and rings under his armpits.

But I digress. Let's go back for a moment to that emblematic 1994 World Cup moment, right after his last goal. After passing the goalie, as Diego ran toward midfield to celebrate the point with his teammates, he suddenly saw a television camera. Standing as close to the camera as possible, he roared like a wounded Metro Goldwyn Mayer lion. The outcast, the lion, dismissed from the field but still a lion in FIFA's eyes, was retiring to his domain. The victim of too much fame, he now looked for revenge.

He wouldn't get it.

## The Night Diego Saved Maradona

Just when no one expected it, Argentina's most talked-about messiah decided to play the gods' favorite trick: a resurrection. In 2002, when *el Pelusa* announced that he was planning a "David Letterman style" talk show, the announcement was met with disbelief mixed with malicious glee.[4] Even in 2004, he looked like an aspir-

ing sumo wrestler: his eyes had an unfocused, glazed look about them, and his candid, off-the-cuff statements seemed wildly disconnected from reality. Yet in August 2005, when the idol who had tried everything to self-destruct appeared on television, he projected the same confident self-assurance he had displayed on the field in his best days. The first surprise for his television audience was to see him in tip-top shape. It is well known that Diego's metabolism has never been of Olympic quality. The man starts to pack on the pounds as soon as he smells a plate of macaroni. But a gastric bypass surgery in Cartagena, Colombia, had helped him to recover the athletic physique he had once shown during his days as captain of the national team.

Nevertheless, the most relevant fact about his appearance wasn't that he seemed reasonably fit, but that his previously glazed gaze had begun to regain the focus and precision of someone aiming for the inside edge of the goal post. On the opening night of his show *La noche del 10*, the over-the-top variety show he hosted, he was so self-possessed that he failed to shed a single tear. The show itself was built to the measure of his fantasies: exuberant samba dancers gave way to soccer fields that doubled as Caribbean beaches; a sports car showroom competed with a beauty pageant, and all of it was set to music. A lover of excess, Argentina's number 10 turned out to be a natural to feed television audiences' hunger for bling and gossip with a dash of controversy and the requisite scantily dressed models. Yet by far the most memorable episode of his first show turned out to be Maradona's surprising guest: King Pelé himself.

History loves a paradox: here was the loud-mouthed, rude soccer rebel playing host to soccer's suave and well-respected ambassador. After tossing well-publicized darts at each other via the tabloids for decades, the meeting of the two soccer greats, live and uncensored, was for many soccer fans the closest that soccer could ever come to replaying the famed and much-depicted historic encounter between San Martín and Bolívar when the two liberators decided to meet to see who would lead the continent in future decades. But the historical metaphors stayed backstage. On the show, everything was more low-key than anyone would have predicted. There was even a family-reunion feel to it when Pelé and Diego, without an ounce of self-restraint, started howling a tango-like ballad in which they set their joint woes to music.

In 2005 Pelé was working through a difficult time in his own life. His son had just been arrested for his ties to drug traffickers. The first thing the King said to his old rival was, "you set a good example." He was not talking about Diego's stratospheric soccer record but about Diego's conquering the inner demons of his cocaine addiction. In an unpretentious voice, *el Pelusa* responded, "it didn't take a miracle, just hard work." Viewers wept at the miracle they themselves were fortunate enough to witness.

In addition to directing *La noche del 10*, in 2005 Diego was collaborating with the Serbian filmmaker Emir Kusturica on a biopic about his star-studded but deeply flawed life.[5] Premiering that year was Javier Vázquez's own carefully researched documentary, *Amando a Maradona (Loving Maradona)*.[6] The Vázquez documentary offers an impeccably researched testimony of the fanatical passions that flourished around the short, underprivileged kid from Villa Fiorito. These range from the founding of the *Iglesia Maradoniana* or Church of Maradona, an

oddly apostolic organization with its modest see in Rosario but seemingly hundreds of thousands of Internet converts, to the Maradona River, named by a group of teenagers during an excursion to Southern Argentina, to an inventory of the wide variety of tattoos Maradona fans display on various parts of their bodies.[7] But the documentary also recounts the other side of Diego's galactic-scale rise to fame: his lack of privacy, the media's incessant harassment, journalists' nasty ways of getting him to make pronouncements when he has nothing to say or nothing he wants to say.

Vázquez's documentary, footage for which was compiled a few years before Maradona's impressive reappearance on *La noche del 10*, captures the soccer great during his all-time low. In the most recent footage, the idol looks like an overblown little dictator hiding in a Caribbean Xanadu. Although he displays traces of his disarmingly simple humor ("as a kid I wanted to be a doctor. What a nerd!"), the film is painful to watch. In the few shots that are not taken from archival footage of his glory days, Vázquez shows the star as a deteriorated shadow of his former self. At an age when many other successful men are just becoming fathers, the idol looks as if his real life is behind him. The interviews show an intense longing for the golden past: memories of childhood friends mix with happy recollections of his devoted Neapolitan fans. Through a strange symbiosis, the old soccer player begins to look, in the film, more and more like the beaten-up soccer ball to which his fortunes were linked. There's no resemblance between the worn-out, overweight Maradona (who was then undergoing treatment for addiction in Cuba) and the star kid player with the restless, slightly confused look captured in archival images.[8] *Amando a Maradona* thus feeds almost entirely off the idol's past until the documentary's last scene, where the *divo* is shown dancing in a television studio amid a cloud of smoke, as if he were floating above some heavenly cloud. After years of self-destruction, the single fact of his survival is nothing short of miraculous.

As the thirteenth-century hagiographer Santiago de la Vorágine showed in the famous saints' lives he researched and illustrated in *The Golden Legend*, any story shrouded in faith can be simultaneously banal and utterly incredible. Around the time of *La noche del 10*, the faithful followers of *Iglesia Maradona* were just as ready to accept their god's devastating martyrdom as his miraculous resurrection. Diego had been capable of anything, so anything could happen. In one of the documentary's scenes, the interviewer asks one of Maradona's younger brothers if he ever compares himself to Diego. With wide-eyed innocence, the child replies: "My brother is an alien." *La noche del 10*, full of lights and smoke and deafening noise, turned out to be the ideal landing platform for the extraterrestrial's comeback. In his television debut Maradona showed the stuff heroes are made off. He also understood the importance of second acts and of being, once again, the "comeback kid."

But Argentina's resilient number 10 wasn't about to be satisfied with a comeback on television only. In June 2005 he announced that he would return to his beloved old team, Boca Juniors, this time as vice president and manager.

As the great soccer fan Samuel Beckett once wrote, "there is no rematch between a man and his destiny." Before turning forty, Maradona had sufficiently ruined himself and his body to make this verdict a truism. During the 1982 World Cup in Spain, midfielder Claudio Gentile viciously marked him, ensuring Argen-

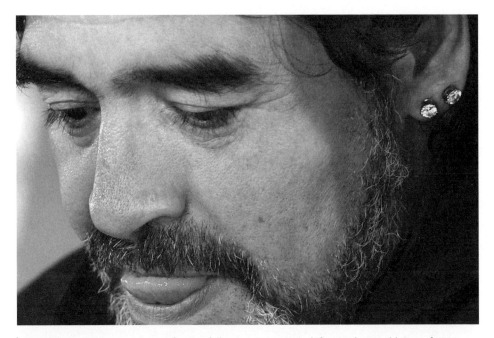

Coach Maradona at a press conference following Argentina's defeat in the World Cup of 2010, Pretoria, South Africa. Photograph by Daniel García

tina's loss and showing how ironically misleading last names could be on the field.[9] During his years of retirement, Diego became the victim of more serious kicks to the shins, as if his destiny were being decided by the likes of Helenio Herrera, master of strategic defense.[10] However, when reality cornered him with either death or shame, Argentina's team captain would find the renewed joy of being pursued. Beckett rarely got a forecast wrong. One afternoon, on a rainy field, fate throws the die, and there is no rematch. Diego accepted his toll.

Resigning his post as Boca Juniors' manager, a tearful and self-loathing Diego decided to admit his failures with a confessional harshness comparable to Rousseau's or Saint Augustine's but in a syntax that required many fewer words. "I fucked up," he admitted. Thus, with destiny already hungrily grazing at his ankles, he came up with his own brilliant counter-move to ensure the players', and the public's, forgiveness. In an unparalleled strategy for saving face on and off the court, the soccer star who years before managed to fool a half dozen sober and self-righteous English players in the Azteca Stadium decided to show the last card he held in his hand: the joker. The joke, he admitted, was on him.

Maradona refers to his blurry, drug-addicted years as, "when I was dead." *La noche del 10*, his widely popular television program, is the closest that the world has come to witnessing a "real" return of the walking dead. Elvis's pathetic downward spiral during his last years, in many ways so similar to Diego's, led the king of rock and roll to a grotesque end but ensured the idol's afterlife through the compensatory rumor that the King's ghost was alive and well in the hallways of Graceland. Maradona managed to achieve the same benefits awarded only to icons in their afterlife without the bothersome inconvenience of a real death. What his 2005 TV variety program showed was that he could indeed return from the place of no return.

Since Diego's tastes are measurable only on a Taj Mahal scale, on his TV program the level of sentimentality would be as super-sized as its host. In one episode, number 10 silenced the orchestra in order to sing a tango about a street kid who dreams of being like him: "*Mamita, mamita,* I'll get rich. I'll be a Maradona, a Bati, a Pelé." In his new incarnation, Diego "wanted to be Maradona." The great challenge of his return was to portray himself as a runner at the very starting point. In this fable of beginnings made of mass TV, he was able to regain his youthful innocence. A child in love with soccer once again, he asked for Pelé's autograph on the show. Afterward, he invited his Brazilian avatar to juggle the ball à deux.

For those indifferent to the passions inspired by soccer, the sight of two middle-aged men using their heads to keep a ball afloat will hardly raise an eyebrow. To true fans it was a rare, once-in-a-lifetime spectacle. Floating weightlessly from Diego's forehead to Pelé's, the ball was proof that the laws of gravity sometimes fail to hold and that soccer madness has a basis in science. What does it matter that two men can keep a ball suspended in mid-air without letting it fall? As the Earth spun on its axis, Pelé and Maradona decided the fate of the planet through their own cordial agreement to keep the ball afloat.

A self-conscious Achilles returned from the dead to promote his own song ("Sing, O muse, the wrath of Achilles") would be laughed off the stage today. Yet Maradona's currency has remained intact. Achilles-like down to his own damaged heels, Maradona, like the famous Greek, has never known humility. To wit: when talking to the press, he often refers to God as his personal spokesperson. He has screwed up so badly for so long and lived through so many reincarnations already that no one is too surprised to see him return as yet somebody else to tell his story. Endowed with great physical endurance, Maradona has thus far survived his life of excess. His addictive personality led him to try a great many ways of exiting the human scene. Each one of them led to unexpected paths back on stage.

Regarding Diego, the Spanish novelist Vázquez Montalbán (2005, 40) said, "He had been one of the Olympians. To what other post could he aspire?" In 2005, television, capable of making ghosts appear live, afforded Maradona a singular rite of passage: Maradona as a spectator of himself. The idol, immersed in the fantasy of fame, played the role of the adoring fan.

The fallen hero was saved by the child.

## D10s or Suicide?

In 2008, Diego Armando Maradona made the daring move to coach Argentina's national team in preparation for the 2010 World Cup. The country held its breath, suspecting the move could easily be the kiss of death for its favorite son. Under suspicion for his drug-infected past, Maradona might yet be the cure for what ails soccer at present. Unlike many of his colleagues, the old captain of the blue-and-white team has never stopped searching for challenges. It is not entirely outrageous that he is currently (in 2010) the spokesman for a medical insurance company that aims to tout its services to clients who live on the edge.

In November 2008 I headed to the offices of the newspaper *La Nación* to meet with Daniel Arcucci, co-author of the book *I Am Diego (of the People).* After years of

tracking the ups and downs of a life which seemed to be as unstable as the needle on an EKG, Arcucci read Maradona's new reincarnation in the following terms: "Diego lives in cycles: when he seems completely down and out he finds a way to rehabilitate himself and head back to the summit. It's always been this way. The first time he said he was walking away from the sport was in 1977! Diego has been 'finished' many times. What has changed is that these cycles have become of shorter duration. In the past, there were years between failures and successes. Now the things change from one day to the next."

Superheroes suffer from a bipolar condition: in the morning they breakfast on an ordinary bowl of cereal; by dinnertime they have to fight the kryptonite that might destroy them and the planet. Like all mythical figures, Maradona has been an extreme case of bipolar disorder. Surely the fascination he elicits among his fans is due in large part to his nature as a self-destructive superman. Just as Arcucci suspects, the passing years have intensified the ways in which this phoenix rises and falls. No longer kept in shape by the disciplines required of his former training as an active athlete, he depends completely on his own will to avoid the temptations of a society which promises instant gratification to those with a credit card.

Less than two years away from the World Cup in South Africa, Diego had at his disposal enough time to build up dreams which would not hold up in the long term. He hired the pragmatic Bilardo as an advisor so that his fantasies could be countered with a sufficient dose of reality. In November 2008, upon learning the news that their best-known player would be leading the national team without coaching experience, most Argentines regarded the decision with justifiable nervousness. But, as I noted earlier, Maradona's lack of experience with training players worried them less than the damage the idol could inflict on himself. For some, the announcement was comparable to seeing the statue of San Martín suddenly galloping toward a battle for which the General was not fit.

It was perhaps inevitable that Argentina's soccer god would decide to play with fire. When referring to his ultimate spokesperson, Diego sometimes calls him "the *true* God." More often, he's likely to refer to the God of Moses, affectionately, as "the Bearded One," as if only seniority could explain the present hierarchy. Trapped thus in the circus of media-fed idolatry, Maradona has gone to extreme lengths to prove his claim to an all-too-human condition. Oddly, he has failed.

Without any real qualifications other than his passion for a sport he helped reinvent, Maradona accepted early on that he would become both the subject of idolatrous adoration and of abject and virulent criticism. Those who wrote him off as a has-been who might as well have died years ago had to admit defeat when they saw him resurrect as a successful and fit TV personality in 2005. Then, just as the tabloids were starting to show photos of him as a tamed family man eager to impart basic soccer lessons to the grandchild his daughter conceived with Kun Agüero,[11] the icon felt the temptation to cast himself into the abyss yet again.

Like the immortal in the Borges story by the same name, Maradona has searched in vain for the rivers that will confer on him the status of mortality. His personal disasters have not brought him any closer to this goal. Thus far he has proved unable to destroy himself. It would appear that when this god shoots himself, he maintains the steady pulse of supernatural beings whose bullets are blank.

The elimination round leading to the tournament in South Africa was not quite a display of self-annihilation, but it came close. Argentina was stunned by Bolivia's six-to-one win and barely qualified against Uruguay during a rainy match that was virtually impossible to watch on the field or on the air. When, at the end of the latter game, Diego was overcome with emotion, his tears were more genuine than any he had cried in years. Needless to say, he took the opportunity to get back at his nemesis the press: "let them suck it."

For a moment, it seemed as if history would repeat itself. Argentina's 2010 team looked quite a bit like the Argentine team that Maradona had led to victory in 1986. The theme of the double, so central to Argentine literature, was reinforced by the presence of Lionel Messi, who had recently scored a carbon copy of Diego's goal against England while playing for the Spanish league. The similarities which were beginning to emerge were uncanny: in 1986 no one thought much of a team with too many forwards and utterly dependent on the talents of the single number 10; the team's performance was mediocre in the elimination games; and only in the quarter-finals did the lineup finally solidify into what would be remembered as the team's definitive profile.

So it seemed that, if Messi's genius could be maximized, everything would fall into place. Maradona debuted in South Africa 2010 with a new look about him: a beard which made him look a bit like a Greek Orthodox pope, a grey suit, a rosary clutched in hand as a way to calm his nerves. He looked like an earnest high priest. Not surprisingly, each time that the ball went out of bounds and he touched it with his street shoes, the crowd went wild, remembering the magic touch of Diego's feet years earlier. At the edge of the field, he searched for a way to transfer his charismatic aura to the new Messiah, whose last name seemed only a slightly abbreviated version of the old one.

Much to Maradona's dismay, Messi played very well but not spectacularly well, an unpardonable crime from someone who is a genius on the field. He was not, as he has been known to be, an invincible cannon. At the end of each game, Diego gave himself over to grand displays of sentimentality, hugging and kissing his players as if he longed to be one of them. But affection was his primary strategy. Is it possible to coach a team through brotherly embraces? If so, perhaps the miracle would repeat itself.

In a BBC documentary about the Berlin Philharmonic, a musician recounts a rehearsal in which the orchestra began to play as if led by an otherworldly burst of inspiration. What had happened? the musician asks in the interview. At this particular moment of the rehearsal, they were being led by the principal violinist, but a door at the back of the stage had opened, and through the opening the players could see conductor Furchtwangler's silhouette cut out against the stage light. The mere presence of a genius in their midst had inspired the orchestra to greatness.

It is not difficult to speculate that Maradona must have hoped something similar would happen in South Africa. His image was his greatest asset. He had players of enough quality that they could decide on game strategy themselves. Argentina convincingly won the first four games of the series. The magnetism of this god-turned-missionary seemed to be working. But in soccer, mystical illusions often seem to give way to religious reform, which is just another way of saying they give way to Germany. Argentina lost zero to four in their match against the in-

dustrious and well-trained Teutons. This humiliation made obvious what everyone already knew from the start: as a coach, Diego lacked all tactical ability. As is always the case, luck and the sudden moves of the opposition played their part in the game, but Argentina's impotence against the better-trained, better-coached team became plainly and painfully evident.

As it turns out, Argentina's humiliation at the World Cup wasn't a failure for the books. The almost respectable nature of the team's performance would have allowed the coach to keep his job. To do so would have been the safe choice. Addicted to risk, Maradona opted to resign.

It is impossible to exhaust Diego Armando Maradona's story. His presence at the World Cup in 2014 in Brazil, Argentina's sworn enemy, might just provide him with yet another comeback scene worthy of being told. For now, the god of soccer reserves the right of issuing further revelations.

*Translated by Dianna C. Niebylski and Stephen Buttes*

## Notes

Unlike our other contributions, Mexican award-winning novelist and essayist Juan Villoro's piece is not a scholarly essay but a writer and soccer fan's rendition of Diego Armando Maradona's story. Villoro's creative take on an icon as volatile and long-lasting as Maradona invites us to reflect on the new price of fame in a world in which a celebrity's every move is recorded and analyzed for immediate consumption and endless post-play commentary. With his comic-ironic understanding of Maradona's larger-than-life talents and foibles, Villoro captures both the popular media and the public's love-hate relationship with popular icons—a relationship that may be all the more intense when the idol is a world-famous soccer player. All footnotes in this essay have been added by the translators. Bibliography added by the editors.

1. The memoirs have been translated as "I Am The Diego," an adequate enough title but one that completely misses the meaning of the original. Libertad Lamarque was Argentina's queen of sentimental melodrama in the 1940s and 1950s.
2. This was Pelé's number.
3. At the 1994 FIFA World Cup, Maradona played in only two games, scoring one goal against Greece, before being sent home after failing a drug test for ephedrine doping. In *Yo soy el Diego* Maradona argued that the test result was due to his personal trainer giving him the power drink Rip Fuel. His claim was that the US version, unlike the Argentine one, contained the chemical and that, having run out of his Argentine dosage, his trainer unwittingly bought the US formula. FIFA expelled him from USA 1994, and Argentina was subsequently eliminated in the second round. Maradona has also separately claimed that he had an agreement with FIFA, on which the organization reneged, to allow him to use the drug for weight loss before the competition in order to be able to play. According to Maradona, this was so that the World Cup would not lose prestige because of his absence.
4. One of Maradona's nicknames, it refers to his ample head of hair, or "pelo."
5. Kusturica's documentary, *Maradona*, was first shown in Italy in 2007. It premiered in France's Cannes Festival in 2008.
6. The film was released to English-speaking audiences in 2007 as *Loving Maradona*.
7. "The *Iglesia Maradoniana* was founded in 1998 in the city of Rosario, Argentina, but it did not hold its first gathering until 2001. Via blogs and other Internet sources, the "church" claims to have over 100,000 members from more than sixty countries around the world. The church's symbol is made up of Diego's first initial, his jersey number, and a final "s," or "D10S" (or "Dios"), but one of its most vocal founding members, Alejandro Verón, argues there is no

conflict between one's faith in the Catholic Church and one's veneration for Argentina's soccer god: "*somos todos católicos romanos, nosotros tenemos un Dios de razón, el cual es Cristo, y un Dios del corazón, que es Diego*" [all of us believers are Roman Catholics. With our head we worship the Christ-God, but with our hearts we worship our Diego-God]" (See "Iglesia Maradoniana" 2013).

8. Maradona went to Cuba to be treated for drug addiction. His friendship with Fidel Castro stems, supposedly, from his time on the island. In 2004, at a time Vázquez was still filming the documentary, Maradona had returned to Buenos Aires from his Cuban retreat only to be hospitalized for high blood pressure, breathing problems, and a lung infection. Evidently he required the aid of an oxygen pump to breathe. He was only forty-three at the time.

9. During the 1982 finals, in the match against the title-holder Argentina, Gentile man-marked Diego Maradona out of the game, thus ensuring Argentina's defeat.

10. Helenio Herrera, an Argentine-French soccer player and trainer from the 1930s to the 1960s, was known for his use of "*catenaccio*," a particularly effective form of defense intended to guarantee the least number of possible goals against the defending team. It was Herrera's emphasis on this system of defense in Italian football that is credited with spawning the rise of defenders like Claudio Gentile, Maradona's arch-nemesis in 1982.

11. Kun Agüero is an Argentine soccer player currently playing for Real Madrid. He was World Champion "under twenty" in 2005 and 2007.

# The Afterlife of Fame: Consuming Iconicity

# Fetishizing Frida
## (excerpted from *Devouring Frida* [1999])

*Margaret A. Lindauer*

Popular interpretations of Frida Kahlo's paintings make ample reference to the artist's social position as a Mexican woman married to famous muralist Diego Rivera, both of whom created works of art during the postrevolutionary decades. But the complexities of the political, historical, and social contexts in which Kahlo worked have been divorced from her paintings and instead fervent attention has been paid to her private life. Clearly Kahlo's life makes for a dramatic narrative and is itself a sensational context with which to place her art. As her name has risen out of obscurity following her death in 1954 into the art history canon, art museums, documentary films during the 1980s, and then into popular culture in the 1990s, the drama of her life has become zealously coupled with her paintings. Indeed there often is little distinction between Kahlo and her paintings, which converge into a single entity, Frida's-life-and-art. For example, in a 1992 review of Herrera's abridged biography and catalogue raisonné, *Frida Kahlo: The Paintings*, and Malka Drucker's less "sordid" biography *Frida Kahlo: Torment and Triumph of her Life and Art* (consciously written without references to the artist's sexuality or drug and alcohol use as an "inspiration" for an audience of "young women"), Roger Cardinal notes "the kinship of biography and art" in both publications (Cardinal 1992, 15). The "Frida Kahlo Home Page" on the World Wide Web introduces the artist by explaining that her "art was influenced by the pain she suffered throughout her life" which she concretized "by adding such things as thorn necklaces and nails to her portraits." In a review of the 1991–1992 traveling exhibition *Pasión por Frida*, which displayed objects related to academic scholarship, creative inspiration, and popular fashion/kitsch, Robert Cauthorn states, "Kahlo suffered terrible physical hardships. Polio in childhood and an auto accident in her youth shattered her body and ruined her health for the rest of her life. Miscarriages frustrated her desire to have children and wounded her spirit." And, he asserts, "All of it found its way into her paintings. In her self-portraits, Kahlo would present her torso opened up for inspection while tortuous medical instruments lurked nearby. . . . The torment of a woman who lost a child in the womb took literal shape on the canvas" (Cauthorn 1993, 12F).

In some respects, the historiography of Frida Kahlo is nearly as dramatic as her life story. Rescued from oblivion, with social, political significations of her paintings erased, she became exalted as a "life and work that match the sensibility of our times," according to Peter Plagens's 1991 *Newsweek* essay about Kahlo's popularity, which he calls "Fridaphilia" (Plagens 1991, 55). In this essay, I would like to demonstrate that the historiography follows, and indeed exemplifies, paradigmatic art history production in which artists and art, Griselda Pollock argues, are "evacuated from history . . . [and] history from art history" through "psychobiographical" interpretation (Pollock 1980, 96). In other words, at the same time that the product (painting) becomes synonymous with the producer (painter), the artist is reduced to personal, psychological, and biological histories parallel to, but separate from, social histories.

To counteract the reductive artist = paintings = woman, I have argued for distinguishing between the "painter" and the "paintings" and for analyzing Kahlo's work as a product of labor implicated in dynamic political negotiations to liberate women from the construct of "woman."[1] My interpretations of Kahlo's paintings accordingly re-place her paintings within the "work" of societies and reexamine the compositions for ways in which her work can be put to work, resisting and subverting hegemonic, modernist narratives that implode art and artist and reduce women to woman. Here I will argue that the tacit application of patriarchal prescription saturating popular interpretations of Kahlo and her paintings is perpetuated in the artist's 1990s popularity in the United States, a phenomenon variously referred to as Fridamania, Fridolatry, Fridaphilia, and Frida fever.[2] (Remarkably, each term metaphorically connotes a potential association with some sort of pathology.) However, I also assert that a proper re-examination of her paintings effectively dislodges the artist's current "cult" status from patriarchal prescription to, instead, fortify feminist resistance.

Generally speaking, Kahlo was well known and symbolically significant to feminist art history of the 1970s and 1980s as a "forgotten woman artist." The productions of essays and films about the artist's life coincided with traveling exhibits of her work. At the same time that feminist art historians and filmmakers reproached the injustice of art historical oversight, they celebrated the artist's forbearance in the face of relentless physical and emotional traumas. The artist's fortitude resonated with feminist art history's resolution to challenge chronologies and narratives that privileged men and disregarded women. Elizabeth Blakewell notes that, prior to the work of feminist art historians, women's primary association with the art canon historically has been as symbols or objects, not as individual subjects (Blakewell 1992, 196). Blakewell explains that women artists always have faced a challenge of breaking art "tradition" to project themselves as subjects rather than objects (Herrera 1991, 163). Feminist art historians face a further challenge in that delineating the ways in which Kahlo projected herself as subject still abides by the "artist = oeuvre" paradigm that relegates art works to an apolitical, ahistorical realm. For example, Kahlo's 1943 *Self-Portrait as Tehuana*, in which the artist depicted herself in traditional Tehuana wedding headdress and with Rivera's portrait painted on her forehead, generally is interpreted as representing her "desire to possess" Rivera. Herrera remarks that Kahlo first donned Indian clothing when she married Rivera and asserts: "When she put on the Tehuana costume,

*Self-Portrait as a Tehuana*
(Diego on My Mind), 1943.
Gelman Collection, Mexico
City. © Banco de Mexico
Diego Rivera Frida Kahlo
Museums Trust, Mexico,
D.F. / Artists Rights Society
(ARS), New York

she was choosing a new identity, and she did it with all the fervor of a nun taking the veil" (Herrera 1983, 109). Herrera characterizes the Tehuana dress as a marker that refers simultaneously to Kahlo's unique, personal identity and to her marriage with Rivera. The metaphoric comparison of her vows as wife to those of a nun entrenches the dress as a symbol of Rivera's purportedly determining influence on Kahlo's appearance. Richmond explicitly connects the dress to Rivera as she explains, "we owe the glorious sense of style that we associate with Frida to Diego's influence on her as a young woman, establishing her mature sexuality and body image" (Richmond 1994, 81).

As Kahlo's "identity" is circumscribed by her marriage to Rivera, her appearance, politics and aesthetics are prone to being determined by her husband. For example, in the 1994 cookbook *Frida's Fiestas: Recipes and Reminiscences of Life with Frida Kahlo*, Guadalupe Rivera and Marie-Pierre Colle claim that Kahlo shared Rivera's views, "whether they were of politics or art" (Rivera and Colle 1994, 172). Zamora explains, "Always ideologically in tune with Diego, Frida became involved in his left-wing political activities to promote revolutionary struggles. . . . She spent hours typing Diego's speeches and statements, letters of support for individuals and causes they considered worthy . . ." (Zamora 1991, 91). While Zamora accords Kahlo some political awareness, her description of Kahlo's political views in relation to Rivera's disregards the potential for statements to have been written

jointly. She assigns Rivera the dominant intellectual, political role without investigating the social reasons why Kahlo may have allowed or indeed chosen her name to not appear on articles and statements. Thus Kahlo is cast as the stereotypically supportive wife who turns to her husband for instruction and approbation at the same time that she is reduced to surface image and charm, assembled to captivate Rivera's admiration.

When Kahlo actively exhibited her paintings nationally and internationally in exhibitions in the late 1930s and 1940s, newspaper and journal reviews noted her "extravagant" clothing and "exotic" appearance, which eclipsed discussion of her paintings.[3] Kahlo became synonymous with a "look" rather than with her creative production. Mulvey and Wollen explain, "when she visited New York and Paris for her exhibitions, Frida Kahlo's style was . . . taken up in high-fashion circles, featured in *Vogue* and adapted as a 'look' by [Elsa] Schiaparelli" who designed "La Robe de Madame Rivera" after Kahlo's distinctive Tehuana costume (Mulvey and Wollen 1982, 94). *Vogue* used a photograph of her hand weighted with jewelry for one of its 1939 magazine covers. Essentially, Kahlo became famous for her exotic, ethnic appearance—her dress, her jewelry and her explicitly Mexican self-representation. According to Robin Richmond, Kahlo's appearance, rather than her art, attracted attention (1994, 108). According to Zamora, the artist's "exotic clothing and unusual jewelry turned heads wherever she went" (Zamora 1991, 56).

The emphasis placed on Kahlo's dress has continued in recent years. Multi-page features in the May 1989 *Elle* magazine and the February 1990 *Vogue* confine the artist to an over-determined femininity by consecrating the Frida Kahlo "look" of passion, indulgence, and ostentatiousness. The *Elle* feature states, "Flamboyant and extravagant in her life and appearance, her self-conscious adoption of native Mexican costumes inspired our fashion director, Debbi Mason, to re-create the Frida Kahlo style in the following pages. . . . We also try to capture a sense of her story and her art with extracts from a major new biography" (quoted in Baddeley 1991, 10–17). The combination of "exotic," "ethnically" dressed fashion models and excerpts from Kahlo biographies sustains the notion that dressing-up constituted Kahlo's sense of her own identity. Indeed, Herrera contends that Kahlo is readily adaptable to representation in fashion magazines because Kahlo's dress essentially was a masquerade with which she constructed an identity, as the many women for whom "dressing up in a different outrageous outfit every night [to afford] the pleasure of trying out alternate personas" (Herrera 1990, 41).

The "Frida-look" as a fashion "commodity" accentuating the seductiveness of her persona completely obliterates any suggestion that Kahlo was a producer of socially, politically meaningful paintings. When her self-portraits are mentioned they also are caught in the reduction of Kahlo to provocateur. The fashion model, as John Berger asserts, is defined by her disinterested gaze, as she watches herself gazed upon (Berger 1977, 55). In the November 1990 *Mirabella*, Peter Schjeldahl interprets Kahlo's gaze accordingly—"for Kahlo, to be seems to have been identical with to be seen." Based on the preponderance of self-portraits, he suggests that Kahlo "needed our recognition in order to feel that she was real" (Schjeldahl 1990, 66). Thus he implicitly considers her work as an aspect of her purported consuming desire to be desired. To "admire" Kahlo's paintings thereby becomes

synonymous with "admiring" the artist as an adorned female body. Richmond accordingly characterizes the Tehuana dress displayed in self-portraits as "a source of pure physical pleasure" (Richmond 1994, 124).

Richmond's description of Kahlo's alleged motives for masquerading or portraying herself in masquerade invokes Freud's definition of the narcissistic woman, a feminine parallel to fetishism, which Freud distinguishes as a primarily male practice. The narcissistic woman, who disavows her own symbolic castration and displaces the value of the phallus onto her own body, is implied in descriptions of Kahlo that suggest she consciously assembled a particular appearance in order to draw attention. For example, according to Zamora, Kahlo knowingly reduced her persona to a "look," for she claims that "Frida *liked to say* that her unconventional appearance . . . inspired magazine cover designs and haute couture gowns" (Zamora 1991, 56; italics mine). And Herrera claims that by wearing a Tehuana dress, Kahlo "transformed herself into an icon for herself and others to worship" (Herrera 1990, 41). These intimations relate to Freud's claim, as Elizabeth Grosz explains, that a narcissistic woman compensates for her recognized social inferiority to men with an "investment in her own body, treating it as the corresponding male would an external love-object. She pampers her body, treats it with loving care; it becomes a vital instrument, her means of ensuring that she is loved." According to Freud, this narcissistic investment is "a kind of compensation for her recognition of her inferiority." In other words, the narcissistic woman accepts her secondary status and comforts herself with an obsessive interest in her body as a fetishized object (Grosz 1991).

But, Grosz emphasizes, the woman who fetishizes her body is not, as Freud suggests, equating the fetish with the penis but rather with the phallus as symbolic signifier for power and authority. The woman with a narcissistic investment in her body considers it an agent for captivating the male gaze, and it thereby assumes a power to command attention and manipulate male behavior. Thus, Grosz continues, "It is also her way of developing criteria for measuring her own self-worth. She phallicizes her whole body, treating it as if it were the phallus: if man believes he has the phallus (the object of desire), then woman believes she is the phallus. The man's penis and the whole of the woman's body are rendered psychically equivalent. In Lacanian terms, he has the object of desire while she is the object of desire" (1991, 48).

Descriptions of *Self-Portrait as Tehuana* connote the Freudian characterization of the narcissistic woman. Kettenmann claims that Kahlo's face, "framed by her starched Tehuana headdress, . . . looks as devouring as a carnivorous flower. The roots of the leaves which she wears in her hair suggest the pattern of a spider's web in which she seeks to trap her prey" (Kettenmann 1993, 67). In other words, Kettenmann contends that Kahlo considered her appearance as a potent, effective means through which to attract and contain Rivera. An assumed futility of the narcissistic woman also is inscribed in interpretations of the painting. For example Herrera suggests, "Like a female spider, Frida watches from the center of her web. She has consumed her mate and trapped the thought of him inside her forehead. . . . Still, Rivera does not look possessable" (Herrera 1991, 163). Herrera subscribes to the patriarchal assumption that the narcissistic woman cannot actually maintain

power and authority over male behavior. Her interpretation exemplifies Grosz's explanation of Freudian theory: "Ironically, in this aim of becoming the phallus, the object of the other's desire, she is revealed as the site of rupture, lack, or castration, both idealized and debased, bound up with the masquerade of femininity, the site of both excess and deficiency" (Grosz 1991, 48). Thus the painting is reduced to biography and biography to gender dichotomy. In addition, the assertion that Kahlo "dressed up" in order to attract and manipulate Rivera, as purportedly exemplified in *Self-Portrait as Tehuana*, is cast not merely as coquettish flirtation, but also in accordance with binary gender distinction according to which woman is an object of desire with a futile and potentially self-destructive tendency to crave the power and authority to orchestrate social relations, disavowing her symbolic castration. Popular interpretation of Kahlo and her paintings, which is analogous to Berger's characterization of the fashion model, relates to what Pollock calls the "sexual politics of looking . . . which divides into binary positions, activity/passivity, looking/being seen, voyeur/exhibitionist, subject/object" (Pollock 1980, 87). In other words, interpretations imply that Kahlo recognized herself to be the object of the male gaze and painted/dressed/exhibited herself accordingly. Although she may have had aspirations to be the active subject in control of the relationship between voyeur and exhibitionist, she generally is regarded within gender dichotomy as actively yet hopelessly attempting to construct a determining authoritative position within her relationship to Rivera.

Kahlo's alleged obsessive need to create herself for Rivera's approbation paints a rather pathetic portrait of the artist, one that intimates she acknowledged but refused to accept Rivera's purportedly unalterable tendency toward philandering and neglect. Herrera links Kahlo's selection of the Tehuana costume for a wedding dress in 1929 with the 1943 *Self-Portrait as Tehuana*, produced fourteen years after Kahlo and Rivera first married and three years after they married for the second time. She reduces both the dressing up to wed and the dressing up in the self-portrait to an obsessive focus on attracting Rivera and casts Kahlo's lifelong consuming desire to be desired as futile. Herrera asserts that the Tehuana headdress has the opposite effect because it is obviously a desperate masquerade (Herrera 1991, 170). She proceeds to diagnose Kahlo's dressing up as psychosomatic and associates the artist's Tehuana clothing with her presumed chronic psycho-biological distress, asserting that "the greater Frida's pain, emotional or physical, the more desperately festive her packaging became" (Herrera 1990, 41). Kahlo's so-called masquerade thus is interpreted as a refuge from the emotional pain associated with her incessant attempts to solicit Rivera as well as from the physical maladies and deformities that are often associated with Kahlo's obsession with Rivera's attention. For example, Richmond suggests Kahlo's dress made her look "whole and confident. Underneath them, she must have felt contingent and vulnerable" (Richmond 1994, 124). The Tehuana clothing is firmly entrenched in the artist's purported emotional "disease" and is considered a mask (or armor) with which she transformed (or protected) herself. This shift from being passive to actively luring the male gaze prompted Jean Franco's remark, published in a 1984 review of Herrera's first book about Kahlo's life, that the artist "was always a seductress to the point of turning her tormented body into a work of art, a glittering display of embroidered clothing, folk art, jewelry, and shawl" (Franco 1984, 54).

Frida Kahlo with Diego Rivera and friend Malu Block in 1932. Library of Congress,
Prints & Photographs Division, Carl Van Vechten Collection, LC-USZ62-103971

The popular market for the Frida-look perpetuates a process of disavowal and displacement associated with the narcissistic woman, for it emphasizes seductive qualities and deemphasizes the relationship of dress to infirmity or deformity. A caption in the 1990 *Vogue* notes the "passionate spirit" with which the contemporary version of the Frida-look "emerges, vivid as an artist's palette," as "it blazes with soulful splendor, ruffles, embroidery, shawls, and opulent beads [that] evoke the romance of Frida Kahlo's Mexico." Fashion magazines accentuate the provocativeness of Kahlo's masquerade. As Baddeley describes it, "overtly sexual, Kahloesque models lounged and pouted in their 'Mexican' interiors." Moreover, the magazines downplay the artist's maladies, her imperfections, thereby disavowing Kahlo's alleged struggle with presumed feelings of uncertainty. Following this train of thought Baddeley notes, "There is a poignant irony in the way clothing, which on one level served to hide Kahlo's broken body, falls or is lifted by the model to reveal a luxuriantly perfect physique" (Baddeley 1991, 12). Thus Kahlo's broken, deformed body is displaced, taken over by a "healthy," more seductive feminine "ideal."

Fixation on Kahlo's captivating appearance parallels characterizations of her represented in exhibit catalogues and other publications. For example, in the introduction of her 1992 exhibition catalogue featuring photographs of Kahlo, Carla Stellweg writes that "the viewer is invited to penetrate the mask [Kahlo] consciously designed, and to be emotionally moved by the ways she shifted and changed to create her persona" (Stellweg 1992, 118). Stellweg's prose, inviting the viewer to "penetrate" Kahlo's mask in order to dwell in her most private thoughts and emotions, is an evocative invitation; and the title of the catalogue, *Frida Kahlo:*

*The Camera Seduced*, implies that it is Kahlo herself who invites this penetration. The opening pages reinforce this interpretation; they proceed from a two-page close-up of Kahlo's mouth to a two-page close-up of her eyes, followed by another page with a photograph of Kahlo standing in front of a mirror. The artist's purported narcissism is thereby revealed as Poniatowska's description of Kahlo, which is included in the catalogue, explains the significance of this series and reveals the artist's purported narcissism: "One Frida has gone, the other is here [in this collection of photographs]. The one who stays has a pure brow, full lips, and a profound gaze" (Poniatowska in Stellweg 1992, 20). In other words, Poniatowska intimates that the displayed photographic portraits sustain a constructed persona, one that is based on, but distinct from (and often considered to have supplanted) the "authentic" person.

The artist's 1990 notoriety achieved through circulation of her image as a fashion look or in photographs and self-portraits suggests to Borsa "a rather obsessive preoccupation with self and the possibility of reading Kahlo's work as narcissistic, excessively focused on the female form, femininity, and traditional accounts of the feminine sphere" (Borsa 1991, 35). But there are notable differences between the "real" artist and the reduction of the artist to seductress. The Frida-look, a distinct "product" of Kahlo's current celebrity, is based on, but discrete from, the reduction artist = image = woman as the biographical is acknowledged and then deemphasized to promote the pure visual pleasure of gazing upon exotic Kahloesque models. For example, popular magazines routinely note, but do not reproduce, the artist's unplucked eyebrows and "mustache." The text in an April 1990 issue of the *Independent* announces, "rediscovery of the work of Mexican painter Frida Kahlo has inspired a far-fetched fashion for summer. Her unforgettable face and revolutionary dress sense are provoking enthusiastic imitation," and then queries, "but will the eyebrows catch on?" (quoted in Baddeley 1991, 12). Acknowledging the incongruity of Kahlo as fashion inspiration, one caption states, "A woman with eyebrows that meet in the middle and dark shadow above her lip may seem an unlikely fashion idol" (quoted in Borsa 1991, 29). Dan Hofstadter dramatizes the artist's "neglect" of her toilette as he muses, "there is a moment in the early life of Frida Kahlo that uniquely illumines the evolution of her myth. . . . It is the moment, apparently in her eighteenth year, when, gazing into the mirror, she decided to stop trimming her eyebrows. . . . For those eyebrows made possible the cult of Kahlo: they were the providential condition of her celebrity" (Hofstadter 1996, 96). The consistent comment on the artist's "unfashionable" eyebrows and mustache explicitly distinguishes the Frida-look from the actual subject, Frida Kahlo. Moreover, her paintings are distinguished from the Frida-look when critics note that the artist emphasized her facial hair in self-portraits.

The intensity of the artist's gaze also distinguishes the artist from the Frida-look. Schjeldahl remarks that Kahlo's depicted eyes are as "riveting as the aimed barrels of loaded guns" and notes that the self-portraits "look at us as we look at them, catching us in the act of looking, and challenging us to be present with even a fraction of the sheer ferocity of being with which they are Frida Kahlo incarnate" (Schjeldahl 1990, 66). In other words, Schjeldahl intimates that Kahlo's looking is not a disinterested woman watching herself gazed upon, for the intensity of Kahlo's gaze denies the visual pleasure of the voyeuristic masculine gaze.

According to Borsa, Kahlo's self-portraits "play with the outward appearance of self; the projection and image that is presented for public consumption versus the screened, masked and complex inner workings of the subject behind the representation" (Borsa 1991, 32). Thus Kahlo's "looking" problematizes the fetishization, or assumed narcissism, of the artist because her intense stare does not passively allow active voyeurism. Instead it makes the voyeur consciously aware of the voyeuristic act, diluting the pure pleasure of undisrupted gazing.

Kahlo's visually "exotic" adornment translates with seeming seamlessness into captivating fashion, first into the "Robe de Madame Rivera" and the 1939 *Vogue* magazine cover, and then, decades later, in a range of popular and fashion magazines. The translation exemplifies Teresa de Lauretis's assertion that women are reduced to the paradigmatic woman "in the very practice of signs by which we live, write, speak, see. . . . This is neither an illusion nor a paradox. It is a real contradiction—women continue to become woman" (De Lauretis 1984, 186). However, resistance to this ubiquitous reduction can be facilitated through critical examination of paintings in association with subversive feminine practice, in order to analyze precisely where Kahlo is contained as woman and in what ways her paintings problematize containment. In other words, the relationship between the "real" and the "represented" Frida Kahlo is fluid. On one hand, they often are considered one and the same, reduced to prescriptive paradigm. As Borsa notes, "Kahlo's use of costume does call attention to appearance and self in a way that approximates spectacle and masquerade" (Borsa 1991, 37). On the other hand, the reduction of Kahlo to woman may be considered in opposition to the subversive potential inscribed in her paintings and enacted by her 1990s admirers. Borsa accordingly asserts that "body adornment does not only or necessarily mean fashion or exotica—a desire to make yourself the object of the gaze"; rather, Kahlo's paintings represent "a much more critical and political position" (1991, 38). Borsa's assertion parallels Grosz's suggestion that "feminists may read patriarchal text against the grain, so that they may be actively worked upon and strategically harnessed for purposes for which they were not intended" (Grosz 1991, 40). For example, though fetishism is, in the Freudian sense, a strictly masculinist discourse, Grosz encourages its potential for feminist subversion. She notes that Freud diagnosed fetishism as a sexual "pathology" among men who, as boys entering the oedipal phase, could not "disavow" the perception of associating the castrated woman with the threat of their own castration and thereby displace woman as the object of desire with another object. In the strict Freudian sense the narcissistic woman, despite displacing the phallus with her body and disavowing symbolic castration, is not a fetishist. Women are foreclosed from becoming fetishists because, already castrated, they are not threatened by the perception of the castrated woman. But if one considers the process of fetishizing not in terms of narcissistic investment but rather in terms of resisting socially invested heterosexual prescription (as the male fetishist does), the significance of *Self-Portrait as Tehuana* becomes a commentary on rather than illustration of Kahlo's purported "plea" for "Rivera's love."

The painting clearly implicates Kahlo as fetishized object constructed in relation to the male gaze, but it does so excessively by containing Kahlo as an object marked on her forehead with her husband's portrait. Compositional features can be cast against the very interpretations which reduce it to "evidence" of Kahlo's presumed

agonizing overcompensation for her lack of health and lack of ability to sustain status as object of desire. This is possible if Kahlo is granted the privileged position of actively producing meaning rather than mimicking patriarchal prescription. In other words, popular interpretations of Kahlo as narcissistic woman enlist the assumption that she created a persona abiding by masculinist discourses of fetishism wherein the most active category for woman is one in which she exaggerates her femininity in order to become the fetish, the object of desire. Conversely, if Kahlo is allowed the position of fetishist, and the desired objective is not unquestioningly assumed to be prescribed as the masculinist symbol of the phallus, her self-portrait as excessively contained woman can be interpreted to disrupt the objectification of woman. For example, rather than interpreting the Tehuana wedding headdress and the miniature portrait of Rivera as manifestations of Kahlo's feminine desire to be desired, Danielle Knafo reads these compositional features against gender prescription when she uses "spider" and "web" metaphors in opposition to other authors' connoted reductions of Kahlo to woman. She suggests that the "fancy headdress closes in on her face and threatens to suffocate her with its spiderlike web of lacy tendrils" (Knafo 1993, 295). In other words, rather than considering the "spider's web" as Kahlo's trap, Knafo suggests that it ensnares Kahlo, who is nearly obliterated by her clothing and then branded with her husband's image, all of which clearly emphasize a restricted, contained position for woman.

Elaborating on the wife/nun analogy noted earlier, Sarah Lowe remarks that *Self-Portrait as Tehuana* "closely resembles a colonial prototype of the *monjas coronadas* or 'crowned sisters' . . . [which] commemorate one of two events in a nun's life: her initiation into monastic life or her death." Lowe goes on to explain that in *monjas coronadas* paintings the novices' faces are "surrounded by an exuberance of detail, imparting a mystical quality to the disembodied heads." The female body, the object of normative male desire, is removed, denied, as the novice makes a spiritual vow to Christ. In Lowe's words, the depicted Tehuantepec wedding dress "substantiates the implied correspondence between Kahlo and the novitiate." Thus like an asexual nun, Kahlo is distinguished from her female body, thereby differentiating her from the prototypical object of male desire. Lowe's observations indicate that the painting distinguishes an intellectual or spiritual person from the corporeal woman. She proceeds to note, "Another point of similarity is the inclusion of a second party portrayed in a small medallion. In the *monjas coronadas*, the nuns usually hold an image that depicts either the Virgin or Christ, indicating to whom the painting is dedicated. Instead of a medallion, Kahlo paints a portrait of Rivera as a 'third eye,' thus dedicating the image to him" (Lowe 1991, 54). In this comparison, despite the potential to consider Kahlo as an individual apart from, or in addition to, a female body, the artist is put back into a category that defines her in relationship to patriarchal discourses, symbolized by her husband's image centered on her forehead. Smith finds that the painting "stamps her male/god husband on her forehead, obliterating the mind of the bride" (Smith 1993, 274). Some critics intimate that Kahlo literally relied on Rivera for a sense of her own identity—as, for instance, in Zamora's remark that despite "all the strength of her personality, Frida felt insecure without Diego to praise her talents, cleverness, and beauty" (Zamora 1991, 47). Observations of this type imply that Kahlo's paintings are a mirror of the artist's psyche rather than a product of critical thinking

to which Knafo's and Lowe's observations allude. Lowe, apparently not recognizing the subversive implications of her own observations, repeats the presumption asserted by other authors that the portrait represents Kahlo's ceaseless devotion to securing Rivera's adoration. Accordingly, she explains, "Kahlo's attachment to Rivera, as expressed most profoundly in her diary, bears comparison to the nun's mystical marriage to Christ: 'Diego is the beginning, the constructor, my baby, my boyfriend, painter, my lover, 'my husband,' my friend, my mother, myself and the universe'" (Lowe 1991, 54). Lowe perpetuates the interpretation of the painting as an expression of the artist's desire to be desired with her parallel interpretation of the diary, which privileges masculine authority to consecrate the "desirable" and places Kahlo in the feminine role as perpetual object constructed to seduce Rivera.

However, just as Kahlo is excessively contained in the painting, her diary entry expresses extreme devotion comparable to the disavowal and displacement enacted by fetishists. Kahlo's lavish devotion is suspect; its excessiveness mocks masculine presumption. If the painting is considered in terms of fetishism in which the woman, not the man, actively fetishizes, disavowing socially invested sexual difference and displacing a threat of essentialized gender reduction analogous to symbolic castration, its excessiveness is recognized as feminine compulsion rather than patriarchal prescription. *Self-Portrait as Tehuana* depicts Kahlo without stereotypically seductive characteristics, as a head without a body contained within restrictive headdress and marked by paternal ownership, disavowing the reduction of woman to object of desire and displacing seductive qualities with signs of possession. In this sense, the painting exaggerates gender dichotomy, not in terms of sexual difference but rather as subject versus object. As long as this distinction is unacknowledged, the painting is available, and is employed, to uphold paradigmatic gender difference. Conversely, as the painting's excessive restriction and containment are acknowledged, it becomes available as a means of critiquing and subverting the containment of Kahlo herself within patriarchal prescription.

Just as some interpretations of Kahlo's paintings inscribe patriarchal prescription while others note the subversive potential of her work, some aspects of "Fridamania" accommodate while others resist masculinist reduction of the individual, Frida Kahlo, to the category "woman." The various forms of celebration associated with the artist's current popularity call for the same degree of scrutiny as popular interpretations of her paintings. The Frida-look circulated in the fashion magazines and exemplified by Kahloesque models (who lack facial hair) abides by the masculinist construct of the attractive woman who is defined by her alleged satisfaction in pleasing a masculine eye. Conversely, contestants in Frida Kahlo look-alike contests, who paint on mustaches and connected eyebrows, emphasize Kahlo as personification of resistance to gender prescription. Some contests are fund-raisers; others are held in association with *los Dias de los Muertos* or other celebrations such as exhibition openings. Reporting on the look-alike contest trend, Jane Meredith Adams focuses on the contestants' painted facial hair. "The idea crept up on Karen Armstead," Adams notes. "The next thing she knew she had drawn her eyebrows into a bat-wing shape, penciled in a faint mustache and put flowers in her hair to impersonate . . . Frida Kahlo"; and at the contest she stood "in a cluster of 14 heavy-eyebrowed women" (Adams 1992, 23). Adams's report indicates that the eyebrows and mustache are essential to the contestants' self-representations as Kahlo. Thus

"dressing" as Kahlo in the 1990s results in two distinct appearances: the fashion-look fetishizes the female body, whereas the impersonation or contestant-look exaggerates "masculine" facial features. As Adams proceeds to cite the contestants' reasons for participating, it is clear that Kahlo's appearance represents a very different political signification than the fashion magazines' promoted Frida-look. One contestant, Rosa Chavez, explained that she participated in the contest, dressing as Kahlo and painting on facial hair, because Kahlo has "given people courage" to validate their social positions outside normative prescription. Chavez explained, "I'm 40 years old and I don't have any children and I'm Mexican. . . . That's almost criminal for a Mexican woman." And Armstead, winner of the contest, explained that "though flattered that the judges thought she resembled Kahlo physically, . . . she hoped to emulate some of the artist's inner fire" (Adams 1992, 23). Thus, in the so-called Frida cult, the look-alike contest does not devotionally serve gender dichotomy.

The 1990s flood of musicals, films, biographies, exhibitions, look-alike contests, and kitsch objects is embedded in a complex exchange. The so-called Frida-mania, or widespread notoriety of the artist, venerates the artist, thereby appearing to represent an intimate relationship between "worshipper" (consumer) and "heroine" or "icon" (product), but it also capitalizes on the artist's renown in diverse ways. Kahlo's widespread recognition among the 1990s art market, fashion industry, cultural tourist market (museums), "socially marginalized" communities, and "popular mainstream" culture, is therefore not a monolithic movement. The frequency and variety of uses suggest that the Kahlo commodity is not simply an object to be produced and exchanged. Inscribed in these transactions are complicated social and ideological as well as economic exchange values that can be understood only through critical analysis of the relationships among creative/political production and social/political reception. As long as the art canon marginalizes women artists by maintaining masculinist definitions of "artist" that are based on paradigmatic gender dichotomies, Kahlo's work must be put to work to expose and contradict the artist's purported psychobiographical motivations to paint as a means to oppose the canon itself. This opposition is to a masculinist discourse that lionizes male artists who enact celebrated masculine stereotypes, marginalizes women artists who enact paradigmatic feminine qualities, and debases women who "attempt" to enact masculine endeavors. The psychobiography of Kahlo relates to the gendered territories of the art canon in two different ways. First, her compositions are associated with "feminine" themes of motherhood, domesticity, and marriage, three paradigmatically female categories in which Kahlo does not comfortably fit. She was not a mother; she did not restrict her interests and activities to the home; and her marriage did not conform to bourgeois monogamous, heterosexual patterns. In this sense, the complexities of Kahlo's work are devoured, obliterated by popular interpretation. Second, her divergence from "valued" feminine categories is usurped in artist = oeuvre interpretation to produce a cautionary "case study" of the tortured tribulations of resisting patriarchal prescription. In this sense, Kahlo herself is portrayed as "devouring," dangerously attempting to operate outside of social prescription. Kahlo's historiography thus constitutes a remarkable demonstration of how female artists can at once be invited and denied full integration into the art-history canon through disavowing the social, political,

public relevance of their paintings as products of creative production that both re-flect and resist patriarchal prescription. In other words, the symbolic significance of Kahlo's work in the context of production and reception (current popularity) is eradicated, overshadowed by the tragic tale of a tormented woman who could not, or did not, fit a feminine paradigm of passive, domestic caretaker.

## Notes

1. In contrast, my examination of Kahlo's paintings is directed at casting aside powerful binary categories that are so ubiquitous as to seem natural. I have looked first to a particular composition, identifying ways in which it reflects and resists containment, and have considered the work of the artist to have dynamic social relevance that is negotiated differently in different contexts. My investigation has not been directed toward determining "correct" interpretations. Rather I am interested in the consequences of inscribing particular ideologies within distinct interpretive methodologies, and unconsciously selecting theoretical approaches according to ways they reverberate with ongoing political negotiations. The paradigmatic art historical product, repackaged and circulated through the popularization of the product "Kahlo's life = Kahlo's oeuvre," reproduces the image of Kahlo as a signifier for the artist's subjectivity. Conversely, I acknowledge that the image of Kahlo has become a floating signifier; and I demonstrate how it has been employed at the service of patriarchal prescription and argue for reconsidering it as a signifier for subverting patriarchal prescriptions. For instance, in the larger work of which this is an excerpt, I have demonstrated that Kahlo's role as Rivera's wife overshadows any critical examination of Kahlo as a painter who portrays women's public and private resistance to social prescription; how a focus on her health problems overshadows how her paintings may be used to resist the social, medical, and aesthetic oppression of women; how a focus on what the men of the Surrealist movement said about her and her work overshadows the way that that work contests the very masculinist core of surrealist definition; and how a focus on her personal motivations for wearing Tehuana dress overshadows how her self-representation in Tehuana clothing relates to a specific political debate. In essence, I implicitly have shown how Kahlo's art is taken out of ("evacuated from") social history as it is slotted into ("contained by") masculinist discourses, including those of art history, that perpetuate patriarchal prescription for gender dichotomies.
2. Kahlo's 1990 notoriety in other countries has particular cultural and social significance, analysis of which is beyond the scope of this essay.
3. See, for example, "Bomb Beribboned" (1938, 20).

# AFTERWORD
## The Afterlife of Icons and the Future of Iconology

*Patrick O'Connor*
*Dianna C. Niebylski*

So this anthology ends with an essay devoted to the afterlife of Frida Kahlo, who played with fetishizing her own image while she was alive but has become quite a different fetish figure for art historians, both non-feminist and feminist, and for a second wave of admirers who retell the story of her life to help give meaning to their own lives. Lindauer's essay is not the only one in this book to examine the afterlife of an icon: indeed, all of our essays on political figures describe how ideological positions inform the understanding of political icons after their death. And when we include cultural shifts over time in approaches to race and gender, we can see how changes on these positions also resignify icons like Carmen Miranda and Lupe Vélez. This should not come as a surprise: any sign that continues in circulation over time can change its meaning—the word "call" changes with the arrival of the telephone or the word's adoption by the stock market; the word "Madonna" changes with the arrival of a pop star. The original meaning must share space with the new meaning, as Mexicans who remember Gael García Bernal as a child actor of *telenovelas* retain that memory even when they talk with friends outside Mexico about his adult roles. Like words, some icons remain relatively stable over time, and some don't. So some philologists of internationally known figures may study relatively simple icons, while some will track faces with many meanings that will shift again and again over time.

Because icons have afterlives, iconology will always have a future. But as philologists of popular culture, many of our contributors naturally look to the past rather than to the future and seek to find an original meaning for their chosen figure. Surely no one would wish us to do otherwise, but we should also be wary of what constitutes an icon's "original" meaning. All the skepticism toward origins in the philosophical tradition from Nietzsche through Derrida (or, if one prefers, in Borges) should also apply to our icons; to privilege the original meaning of an icon over its subsequent meanings is an ideological (or even aesthetic) decision, not a natural one. But this is difficult for us. As a group we acknowledge but often viscerally resent the Warholian process, always potential in culture, by which mass reproduction and decontextualization empties out the face as meaningful sign. In our anthology, Spicer-Escalante invokes Baudrillard to show, with a certain amount of irritation, how the famous photograph of Che has circulated to the

point of emptiness. This radical decontextualization feels all too much in keeping with those definitions of postmodernism that emphasize the privileging of surface over depth and presentness over the past, and provokes those who decry a culture of frantic distraction conquering a world of slow thought. This dichotomy is an old modernist trope, but it is not entirely false. The iconologue responds by recontextualizing, returning lost histories for the benefit of those who look at the iconic face in the airlessness of the seemingly pure present.[1]

With its center of gravity firmly in the past, then, especially the era of the various mass political and cultural movements roughly from the Mexican to the Cuban Revolution—or from the arrival of cinema in Latin America to the arrival of television—, this anthology dedicates relatively little time to the twenty-first century, either its (our) own mass movements or the changes in technology by which images can now be circulated, fixed, or altered. There are at present, and no doubt there will be more, Latin American icons: how will the people who bear the famous faces of the future come to our attention beyond their local notoriety?

We should not necessarily expect the processes to be very different, either in culture or in politics. In film, for instance, the technology that turned watching movies from a mass to a domestic or individual experience is now complete in Latin America. And yet the larger technologies of reproduction and distribution, and the seats of cultural capital, have proven to be resilient. Television did not destroy Hollywood. The DVD eventually destroyed the VCR, but it did not destroy Hollywood either, which has shifted due to challenges first from television and then from the new media, while filmmakers outside Hollywood have absorbed the decline of US and European art-house cinemas showing foreign films. Nevertheless, the proliferation of film festivals and alternative platforms for displaying foreign films has changed the celebrity system surprisingly little since the 1970s. The Cannes and Havana film festivals may seem more and more like anachronisms (even as they served as models for Telluride and Toronto), but they and other old-media forms of iconization, necessary for certain kinds of international celebrity, are still at work today. People still read People and Gente at the beauty parlor and barbershop, even if now sometimes there are articles about people famous for their YouTube clips.

For our political icons of the last century, the path to international prominence was the capture of a nation-state (although the rhetoric of the Cuban Revolution was internationalist, it too needed to entrench itself in a nation and a nationalism). To follow the analogy with Hollywood sketched above, some present and future icons will also no doubt continue to come to our attention through the prior capture of a national audience. It is particularly unfortunate that some of the Latin American regions not covered by this anthology correspond to places that have had significant political change since the fraying of the neoliberalism that reigned at the end of the twentieth century. Perhaps it was too soon for academics to present analyses of the faces of the "pink tide" from Hugo Chávez to Evo Morales, or perhaps cultural historians are keeping these figures at arm's length for fear of seeming to write either hagiographies or character assassinations.[2] But we would venture to say that, once a national-populist leader is in place, the top-down diffusion and dissemination of his image will not differ noticeably from the national machinery, local and global, that circulated the faces of Eva and Che and in some ways even Pancho Villa in the twentieth century: any new *technology* of iconization

will be absorbed into the national project. What has changed, thanks to new technology, is the speed with which *non*-iconizing images of these same national figures can circulate, thanks to the availability and affordability of video technology and the concomitant explosion of interest in documentary film of the last decade.[3]

Yet if the old mode of making a cultural or political celebrity shares space with newer modes, those new modes can also create icons, and this has important theoretical implications. Many of the essays in this volume involve some variation of the narrative of dissemination and diffusion. In this narrative, a Latin American person grows in meaning or power within her or his world, on whatever scale. As the icon reaches an audience that either has no knowledge, or only stereotyped knowledge, of the original Latin American space from which the icon developed, its meaning changes. But what will happen when there are ways for images to circulate without necessarily winning over Hollywood or occupying the state capital?

Since the mid-1990s Nestor García Canclini has been arguing that the paths of global circulation more and more often take detours around the nation-state or the more concentrated zones of cultural capital. The path to iconicity may no longer require the trip to the national movie studio and then the deracinating trek to Hollywood, or the clandestine radio station fomenting a national rebellion from the archetypal landscape of the eternally exploited peasants. A Latin American icon will necessarily mean something different if it arises, expands, and gains followers without any longer following that regional-national-cosmopolitan route.

While we suspect that the faces that come to us from new media will "cite" the roles received from the technology of the past—celebrity Cuban blogger Yoani Sánchez will be compared to a war journalist or a samizdat publisher, for instance—the lack of a top-down cultural or political field for icons to negotiate on their way up and out will also change how their images are consumed. But perhaps merely the sorts of people who compose the field will change, and the power to be a tastemaker will merely move from celebrity magazines or national political journals to popular bloggers and media aggregators on the Net. If the next Pablo Neruda is uploading his podcasts onto YouTube, who would draw your attention to it?

If professors and researchers wish to make incursions into the new processes of iconization, we will have to change our relationship to the new media. But in the meanwhile, we continue to reflect on these older icons, and we tell the stories of how they sprang from very specific infrastructures, and how they moved others, and then us, and perhaps also you.

## Notes

1. We can only gesture here toward what we might call radical modernist ways to find the past, unexpectedly, in the future: Benjamin is often invoked for such projects; so too Borges's idea of destiny and Lezama's theory of the image.
2. As he was a passionate advocate for the partisan use of the academy in the eras of the *testimonio* and of *zapatismo*, John Beverley is also urging the Latin American academy to make a commitment to the nationalist projects of the pink tide (Beverley 2011).
3. To continue with the faces of the pink tide, examples of this swiftness would be *The Revolution Will Not Be Televised* (2003), about the attempted coup against Chávez, and *Cocalero* (2007), about the Bolivian coca union's support of Evo Morales; neither film participates in a purely hagiographic (or iconoclastic) rhetoric.

# Note on the Authors

**Janis Breckenridge** (University of Chicago) is associate professor of Spanish at Whitman College. She recently co-edited a collection of essays titled *Pushing the Boundaries of Latin American Testimony: Meta-morphoses and Migrations* (together with Louise Detwiler, Palgrave Macmillan, 2012). Recipient of the *Feministas Unidas* Essay Prize in 2007, Janis has published in *Letras femeninas*, *Monographic Review*, *Romance Languages Annual*, and several edited volumes. Her work addresses such diverse subjects as human rights and collective memory as represented in literature, film, and public space in post-dictatorial Argentina; Latin American cinema and fiction; testimonial literature; lesbian sexuality; photographic documentation of revolution; and the parodic treatment of travel literature. Her current research focuses on the graphic novel and committed comics. Janis wishes to thank Whitman College for the generous support of an Abshire Research Scholar Award to support publication of the present article.

**David William Foster** (University of Washington, 1964) is Regents' Professor of Spanish and Women and Gender Studies at Arizona State University Tempe and past chair of the Department of Languages and Literatures. His research interests focus on urban culture in Latin America, with emphasis on issues of gender construction and sexual identity. He has written extensively on Argentine narrative and theater, and he has held teaching appointments in Argentina, Brazil, Chile, and Uruguay. His most recent publications include *São Paulo: Perspectives on the City and Cultural Production* (2010) and *Urban Photography in Argentina: Nine Artists of the Post-Dictatorship Era* (2007). Major previous work includes *Violence in Argentine Literature: Cultural Responses to Tyranny* (University of Missouri Press, 1995); *Cultural Diversity in Latin American Literature* (University of New Mexico Press, 1994); *Contemporary Argentine Cinema* (University of Missouri Press, 1992); and *Gay and Lesbian Themes in Latin American Writing* (Austin: University of Texas Press, 1991). He is also the editor of *Latin American Writers on Gay and Lesbian Themes: A Bio-Critical Sourcebook* (Greenwood Press, 1994). *Sexual Textualities: Essays on Queer/ing Latin American Writing* was published by the University of Texas Press in 1997.

**Brian Gollnick** is associate professor of Spanish and Portuguese at the University of Iowa. He is the author of *Reinventing the Lacandón: Subaltern Representations in the Rain Forest of Chiapas* (2008) and articles on Mexican and Latin American literature and cultural theory.

**Robert McKee Irwin** (New York University) is chair of the Graduate Group in Cultural Studies and professor in the Department of Spanish and Portuguese at the University of California, Davis. He is author of *Mexican Masculinities* (2003) and *Bandits, Captives, Heroines, and Saints: Cultural Icons of Mexico's Northwest Frontier* (2007), which was awarded the Thomas L. Long Award for Best Critical Book in Western American Literary and Cultural

Studies by the Western Literature Association, and coauthor of *El cine mexicano se impone: Mercados internacionales y penetración cultural en la época dorada* (2012). He is also coeditor of *Hispanisms and Homosexualities* (1998), *The Famous 41: Sexuality and Social Control in Mexico, 1901* (2003), and *Diccionario de estudios culturales latinoamericanos* (2009; English edition 2012), and editor of Eduardo Castrejón's *Los cuarenta y uno* (2011).

**Margaret A. Lindauer** (Arizona State University) is associate professor and museum studies coordinator in the Department of Art History at Virginia Commonwealth University. She is the author of *Devouring Frida: The Art History and Popular Celebrity of Frida Kahlo* (Wesleyan University Press, 1999).

**Ana M. López** (Communication Studies, University of Iowa) is associate provost for faculty affairs and director of the Cuban and Caribbean Studies Institute at Tulane University. She is an associate professor in the Department of Communication and teaches film and cultural studies. Her research is focused on Latin American and Latino film and cultural studies. She is currently working on early sound cinema in Latin America and the radiophonic imagination. Her most recent publication is a collection of essays entitled *Hollywood, Nuestra América y los Latinos* (Havana, Cuba: Ediciones Unión, 2012).

**Bécquer Medak-Seguín** is a PhD student in the Department of Romance Studies at Cornell University whose ongoing research focuses on politics and subjectivity in twentieth-century Latin American art, literature, and film. His work has appeared or is forthcoming in *Hispania, Research in African Literatures, Cultural Critique, Cultural Politics, The Comparatist, The International Journal of Žižek Studies*, and *Letras Femeninas*, among other journals, and he has forthcoming chapters in several edited volumes. The co-edited article that appears in this volume could not have been possible without the generous help of an Abshire Research Scholar Award from Whitman College.

**Rielle Navitski** is a PhD candidate in the Department of Film and Media at the University of California, Berkeley. She has written on Latin American and silent cinema for *Screen, Cinema Journal*, and *The Moving Image*. Her dissertation project focuses on popular sensationalism in cinema and the popular press in Brazil and Mexico in the first three decades of the twentieth century, examining the role of spectacles of violence and technology in asserting local modernities.

**Dianna C. Niebylski** (Brandeis University) is professor of Latin American and Comparative Literature and past chair of the Department of Hispanic and Italian Studies at the University of Illinois at Chicago. Her most recent publications include her edition of *Sergio Chejfec: Trayectorias de una escritura. Ensayos críticos* (IILI, 2012), *Humoring Resistance: Laughter, Bodies and Excess in Latin American Women's Fictions* (SUNY, 2004), an annotated edition of *Rosario Ferré: Maldito amor y otros cuentos* (FCE, 2006), and numerous articles on contemporary Latin American literature and culture. Her current research and most recent publications explore the representation of poverty, globalization, and illicit trades in Latin American literature and film.

**Patrick O'Connor** (Yale University) is associate professor and chair of the Hispanic Studies Department at Oberlin College. He is the author of *Latin American Literature and the Narratives of the Perverse: Paper Dolls and Spider Women* (Palgrave, 2004). His current projects are tentatively titled *Cortázar's Afterlife*, on Cortázar's posthumously published texts and his reputation both in and out of Argentina, and *The Backstage of Postmodernity: Argentine Culture and the Neoliberal Bubble*, on the circulation during Menem's Argentina of Argentine stereotypes in global culture and on Argentine novelists' responses to globalization.

**Lizabeth Paravisini-Gebert** (New York University) is professor of Caribbean culture and literature in the Department of Hispanic Studies at Vassar College, where she holds the Randolph Distinguished Professor chair and directs the Program in Environmental Studies. She is the author of a number of books, among them *Phyllis Shand Allfrey: A Caribbean Life* (1996), *Jamaica Kincaid: A Critical Companion* (1999), *Creole Religions of the Caribbean* (2003, with Margarite Fernández Olmos), and most recently, *Literatures of the Caribbean* (2008). Her biography of Cuban patriot José Martí is forthcoming from Rutgers University Press. Her edited volumes include *Sacred Possessions: Vodou, Santería, Obeah, and the Caribbean* (1997) and *Displacements and Transformations in Caribbean Cultures* (2009). Her articles and literary translations have appeared in *Callaloo*, the *Journal of West Indian Literature*, the *Jean Rhys Review*, the *Journal of Caribbean Literature*, *Obsidian*, and the *Revista Mexicana del Caribe*, among others.

**Kristy Rawson** (University of Michigan). Her dissertation, "A Trans-American Dream: Lupe Vélez and the Performance of Transculturation," represents a comprehensive examination of Vélez's transnational screen and stage career. With Johannes von Moltke, Rawson co-edited the anthology *Siegfried Kracauer's American Writings: Essays on Film and Popular Culture* (University of California Press, 2012), which includes an introduction co-written by the editors.

**Ignacio M. Sánchez Prado** (University of Pittsburgh) is associate professor of Spanish and International and Area Studies at Washington University in Saint Louis. He is the author of *El canon y sus formas: La reinvención de Harold Bloom y sus lecturas hispanoamericanas* (2002) and *Naciones intelectuales: Las fundaciones de la modernidad literaria mexicana (1917–1959)* (2009), winner of the LASA Mexico 2010 Humanities Book Award. He has edited and co-edited seven scholarly collections, the most recent of which is *El lenguaje de las emociones: Afecto y cultura en América Latina* (with Mabel Moraña, 2012). He has published over thirty scholarly articles on Mexican literature, culture, and film, as well as on Latin American cultural theory. He is currently working on a book on film and neoliberalism in Mexico titled *Screening Neoliberalism: Transforming Mexican Cinema, 1988–2012*, to be published in 2014 by Vanderbilt University Press.

**Beatriz Sarlo** may well be Latin America's foremost public intellectual at this writing. Her publications in English include *Borges: A Writer on the Edge* (1993), *Scenes from Postmodern Life* (2001, tr. Jon Beasley-Murray), and *The Technical Imagination: Argentina's Modern Dreams* (2007, tr. Xavier Callahan). Her essays on culture, postmodernity, and globalization are the subject of constant allusion and polemic. In Spanish, many of these essays are included in her books, *Escenas de la vida posmoderna: Intelectuales, arte y videocultura en la Argentina* (1994), *El imperio de los sentimientos: Narraciones de circulación periódica en la Argentina, 1917–1927* (2000), *La pasión y la excepción* (2003)—in which her essay on Evita included in this volume first appeared—*Tiempo pasado: Cultura de la memoria y giro subjetivo* (2005), and *Ciudad vista: Mercancías y cultura urbana* (2009). Her most recent book, *La audacia y el cálculo* (2011), is an assessment of the presidency of Néstor Kirchner. From 1990 she has been the editor of the important Argentine journal *Punto de Vista*, which she helped found during the dictatorship in 1978. She has taught at the Universidad de Buenos Aires, Columbia University, University of California–Berkeley, University of Maryland, University of Minnesota, and University of Chicago. Her honors and awards include the Wilson Fellowship, a Guggenheim Fellowship, the post of Simon Bolivar Professor of Latin American Studies at the University of Cambridge, and Brazil's Ordem do Merito Cultural in 2009.

**J. P. Spicer-Escalante** (University of Illinois at Urbana–Champaign) is professor of Hispanic American Literature and Culture at Utah State University. He is the author of *Visiones*

*patológicas nacionales: Lucio Vicente López, Eugenio Cambaceres y Julián Martel ante ladistopía argentina finisecular* (2006), has edited critical editions of works by Argentine authors Eugenio Cambaceres (*Sin rumbo*, 2005) and Eduarda Mansilla (*Recuerdos de viaje*, 2006), and is the founding co-director and managing editor of *Decimonónica: Revista de Producción Cultural Hispánica Decimonónica* (2003–present). He co-edited *Au Naturel: (Re)Reading Hispanic Naturalism* (2010), a collection of essays on Hispanic American and Spanish Naturalism in literature and cinema. His scholarly work centers on travel writing, literary and cinematic naturalism, and the intersection of cultural modernity and economic modernization. His recent research focus has included work on Guevara's travels in Cuba during the Cuban Revolution (*Studies in Travel Writing*, December 2011), as well as the completion of the book project titled *Mapping Che: Travel, Social Consciousness, and the Search for the New Man* (University Press of Florida).

**Juan Villoro**, Mexican novelist and essayist and former Mexican cultural attaché to the German Democratic Republic, holds a degree in sociology from the Universidad Autónoma de Mexico. His novels include *El disparo de argón* (*The Shot of Argon*, 1991), *Los once de la tribu* (*The Eleven of the Tribe*, 1995), *El testigo* (*The Witness*, 2004), *Llamadas de Amsterdam* (*Calls from Amsterdam*, 2007) and the short story collection *Los culpables* (*The Guilty Ones*, 2008). He is a frequent collaborator in Latin American newspapers and journals and has written extensively on topics as diverse as rock music, Andy Warhol, and soccer. In recent years he has been a professor at UNAM (Universidad Nacional Autónoma de México) and a visiting professor at Yale, Princeton, and the Universitat Pompeu Fabra de Barcelona.

**Eva Woods Peiró** (SUNY–Stony Brook) is associate professor at Vassar College in Hispanic Studies and directs the Media Studies program. Her books include *White "Gypsies": Race and Stardom in Spanish Musical* (Minnesota UP, 2012) and a collection of essays entitled *Visualizing Spanish Modernity* (Berg, 2005), edited with Susan Larson (University of Kentucky). She is also involved in the collaborative book project *Cinema and the Mediation of Everyday Life: An Oral History of Cinema-Going in 1940s and 1950s Spain* (Berghanh, 2013) and its sequel, *Film Magazines, Fashion and Photography in 1940s and 50s Spain*. Her current monograph project, *Race, Technnology and Mobility in Spanish Visual Culture*, examines the intersection of discourses on race and technology in Spanish silent films. Her published journal and book articles focus on popular cinema in Spain before the 1960s.

# Bibliography

*El abuelo y yo*. 1992. TV program. Dir. Juan Carlos Muñoz. Televisa.

*Across the Universe*. 2007. Film. Dir. Julie Taymor. Revolution Studios, Gross Entertainment, Team Todd.

Adams, Jane Meredith. 1992. "In Death, Mexican Artist a Cult Figure." *Chicago Tribune*, November 8, sec. 1:23.

Adorno, Rolena. 2000. *Guaman Poma: Writing and Resistance in Colonial Perú*. 2nd edition, with new introduction by the author. Austin: University of Texas Press.

Aguilar Mora, Jorge. 1990. *Una muerte justa, sencilla, eterna: Cultura y guerra en la revolución mexicana*. Mexico City: Ediciones Era.

Allen, Henry. 1988. "That's Zsa Zsa, Daaahhling!" *The Washington Post*, October 27, B1.

Allende, Isabel. 1999. *Hija de la fortuna*. New York: Harper Collins.

Altman, Rick. 1980. "Cinema as Ventriloquism." *Yale French Studies* 60:67–79.

*Amando a Maradona*. 2006. DVD. Dir. Javier M. Vázquez. INCAA / Kelly Park Film Village.

*Amores perros*. 2000. DVD. Dir. Alejandro González Iñárritu. Altavista/Zeta.

*And Starring Pancho Villa as Himself*. 2003. DVD. Dir. Bruce Beresford. HBO.

Anderson, Jon Lee. 1997. *Che Guevara: A Revolutionary Life*. New York: Grove Press.

André, María Claudia. 2006. *Latina Icons: Iconos Femeninos Latinos e Hispanoamericanos*. Northridge, CA: Floricanto Press.

*Andrés no quiere dormir la siesta.*. 2009. DVD. Dir. Daniel Bustamante. El Ansia Producciones.

Anger, Kenneth. 1959. *Hollywood Babylone*. Paris: J. J. Pauvert.

———. 1965. *Hollywood Babylon*. Phoenix: Associated Professional Services. [unauthorized].

———. 1975. *Hollywood Babylon*. San Francisco: Straight Arrow Books.

———. 1984. *Hollywood Babylon II*. New York: Dutton.

*Anita*. 2009. Film. Dir. Marcos Carnevale. INCAA, Shazam S.A.

Apter, Emily and William Pietz, eds. 1993. *Fetishism as Cultural Discourse*. Ithaca: Cornell University Press.

Ara, Pedro. 1996. *Eva Perón: La verdadera historia contada por el médico que preservó su cuerpo*. Buenos Aires: Sudamericana.

Argos. 1925a. "La tiple 1926," *El Universal Ilustrado*, September 24, 43–47.

———. 1925b. *El Universal Ilustrado*, August 13, 10.

———. 1925c. "On dit . . . gossip de la semana," *El Universal Ilustrado*, September 10.

———. 1926. *El Universal Ilustrado*, September 9.

Arias, Arturo, ed. 2001. *The Rigoberta Menchú Controversy*. Minneapolis: The University of Minnesota Press.

Arredondo, Isabel. 2002. "'Tenía bríos y, aún vieja, los sigo teniendo': Entrevista a Matilde Landeta." *Mexican Studies / Estudios Mexicanos* 18 (1): 189–204.

Arrizon, Alicia. 1999. *Traversing the Stage: Latina Performance*. Bloomington: Indiana University Press.

*Así era Pancho Villa*. 1957. Film. Dir. Ismael Rodríguez. Hispanomexicana Films, S.A.

*Ask the Dust*. 2006. DVD. Dir. Robert Towne. Paramount.

*The Assumption of Lupe Vélez*. 1999. VHS. Dir. Rita González. Subcine, USA.

Azuela, Mariano. (1915) 1992. *Los de abajo*. Edited by Marta Portal. Madrid: Ediciones Cátedra.

*Babel*. 2006. DVD. Dir. Alejandro González Iñárritu. Paramount.

*The Bad One*. 1930. Film. Dir. George Fitzmaurice. United Artists.

Baddeley, Oriana. 1991. "Her Dress Hangs Here: De-frocking the Kahlo Cult." *Oxford Art Journal* 14 (1): 10–17.

Baker, Kenneth. 1989. "Sartre's Life Up to World War II." *San Francisco Chronicle*, Aug 6, 7.

*Bananas is my Business*. 1995. Film. Dir. Helena Solberg. Prod. David Meyer. Channel Four Films, Riofilme.

*Bandidas*. 2006. DVD. Dirs. Joachim Roenning and Esper Sandberg. Europa Corp / TF1.

Barnard, Tim. 1986. *Argentine Cinema*. Toronto: Nightwood Editions.

Barthes, Roland. (1957) 1972. *Mythologies*. Translated by Annette Lavers. New York: Farrar, Straus and Giroux.

———. (1967) 1983. *The Fashion System*. Translated by Richard Howard. New York: Farrar, Straus and Giroux.

———. 1977. *Image, Music, Text*. Translated by Stephen Heath. New York: Hill and Wang.

———. 1980. *Camera Lucida: Reflections on Photography*. Translated by Richard Howard. New York: Hill and Wang.

Bartra, Roger. 1999. *La sangre y la tinta: Ensayos sobre la condición postmexicana*. Mexico City: Océano.

Baudrillard, Jean. 1981. *For a Critique of the Political Economy of the Sign*. St. Louis: Telos Press.

———. 1994. *Simulacra and Simulation*. Ann Arbor: University of Michigan Press.

Beaume, Georges. 1952. "Dolores Del Rio: Reine du Mexique." *Cinemonde*, no. 932, June 13.

Beltrán, Mary. 2009. *Latina/o Stars in U.S. Eyes: The Making and Meanings of Film and TV Stardom*. Urbana: University of Illinois Press.

Benjamin, Walter. (1938) 1970. "The Work of Art in the Age of Mechanical Reproduction." In *Illuminations*, edited by Hannah Arendt, translated by Harry Zohn. New York: Schocken Books.

Berg, Charles Ramírez. 2002. *Latino Images in Film: Stereotypes, Subversion, and Resistance*. Austin: University of Texas Press.

Berger, John. 1977. *Ways of Seeing*. London: Penguin Books.

Berman, Sabina. 1994. *Entre Villa y una mujer desnuda*. Mexico City: Gaceta.

Bertazza, Juan Pablo. 2010. "Multi Norma." *Página 12/Radar*, March 14. *www.pagina12.com.ar/diario/suplementos/radar/9-5996-2010-03-14.html*.

Bérubé, Allan. 1991. *Coming Out Under Fire: The History of Gay Men and Women in World War Two*. New York: Penguin.

Beverley, John. 2011. *Latinamericanism after 9/11*. Durham: Duke University Press.

———. 2004. *Testimonio: On the Politics of Truth*. Minneapolis: University of Minnesota Press.

*Bird of Paradise*. 1932. Film. Dir. King Vidor. RKO.

"Bird of Paradise." (1932) 1983. *Variety Film Reviews* Vol. 4, September 13. New York: Garland.

Blackthorn, John. 2000. *I, Che Guevara: A Novel*. New York: William Morrow.

Blakewell, Elizabeth. 1992. "Frida Kahlo's Legacy: Awareness of the Body Politic." In *Pasion por Frida: Museo Estudio Diego Rivera and de Grazia Art and Cultural Foundation*, edited by Blanca Garduño and José Antonio Rodríguez, 189–92. Mexico, D.F.: Instituto Nacional de Bellas Artes.

*Blindness*. 2008. DVD. Dir. Fernando Meirelles. Rhombus.

Blommers, Thomas J. 2002. "Social and Cultural Circularity in *La historia oficial*." *CiberLetras* 6. *www.lehman.cuny.edu/ciberletras/v06/blommers.html*.

Bodeen, De Witt. 1967. "The Career of Dolores Del Rio." *Films in Review*, May.

"Bomb Beribboned." 1938. *Time*, November 14, 29.

Borges, Jorge Luis. 1974. "El otro duelo." In *El informe de Brodie: Obras completas*. Buenos Aires: Emecé.

——. 1974. "El simulacro." In *El hacedor: Obras completas*. Buenos Aires: Emecé.

——. 2007. *Discusión*. In *Obras completas 1: 1923–1949*, 205–338. Buenos Aires: Emecé.

——. 2007. *Evaristo Carriego*. In *Obras completas 1: 1923–1949*. Buenos Aires: Emecé.

Borsa, Joan. 1991. "Frida Kahlo: Marginalization and the Critical Female Subject." *Third Text* 13 (Spring): 21–40.

Bowser, Eileen. 1969. *Film Notes*. New York: Museum of Modern Art.

Brenner, Anita. (1943) 1971. *The Wind That Swept Mexico*. Austin: University of Texas Press.

Brodersen, Diego. 2010. "Memorias de los años de plomo." *Página 12*, February 4. *www.pagina12.com.ar/diario/suplementos/espectaculos/5-16841-2010-02-04.html*.

Brooks, Peter. 1995. *The Melodramatic Imagination: Balzac, Henry James, Melodrama, and the Mode of Excess*. New Haven: Yale University Press.

*Bugambilia*. 1944. Film. Dir. Emilio Fernández. Films Mundiales.

Burns, Jimmy. 1996. *The Hand of God: The Life of Diego Maradona*. London: Bloomsbury.

——. 2001. *The Hand of God: The Life of Diego Maradona, Soccer's Fallen Star*. London: Lyons.

Burns, Walter Noble. 1932. *The Robin Hood of El Dorado*. New York: Coward-McCann.

Burton, Julianne. 1990. *The Social Documentary in Latin America*. Pittsburgh: University of Pittsburgh Press.

Burucúa, Constanza. 2009. *Confronting the "Dirty War" in Argentine Cinema, 1983–1993: Memory and Gender in Historical Representations*. Woodbridge, UK: Tamesis.

*El callejón de los milagros*. 1995. DVD. Dir. Jorge Fons. Alameda Films / IMCINE.

*Cama adentro*. 2004. DVD. Dir. Jorge Gaggero. Aquafilms.

Campobello, Nellie. (1931) 1940. *Cartucho*. Mexico City: Ediapsa.

Candelario, Ginetta B. 2007. *Black Behind the Ears: Dominican Racial Identity from Museums to Beauty Shops*. Durham: Duke University Press.

Capote, Truman. 1987. *Answered Prayers: The Unfinished Novel*. New York: Random House.

Cardinal, Roger. 1992. "Martyr to Her Art." Review of *Frida Kahlo: The Paintings*, by Hayden Herrera and *Frida Kahlo: Torment and Triumph in Her Life and Art*, by Malka Drucker. *Times Literary Supplement*, August 14, 15.

Cardoso, Abel. 1978. *Carmen Miranda, a cantora do Brasil*. São Paulo: Simbolo.

Casey, Michael. 2009. *Che's Afterlife: The Legacy of an Image*. New York: Random House.

Castañeda, Jorge. G. 1998. *Compañero: The Life and Death of Che Guevara*. New York: Vintage.

Castillo, Ana, ed. 1997. *Goddess of the Americas: Writings on the Virgin of Guadalupe*. New York: Riverhead Trade Books.

Castillo, Edgardo Pérez. 2010. "La historia del 'no te metás.'" *Página 12/Rosario 12*, February 24. *www.pagina12.com.ar/diario/suplementos/rosario/12-22467-2010-02-24.html*.

Castillo, Pedro and Albert Camarillo. 1973. *Furia y muerte: Los bandidos chicanos*. Los Angeles: Aztlán.

Castro, Donald. 1999. "The Massification of the Tango: The Electronic Media, the Popular Theatre, and the Cabaret from Contursi to Perón, 1917–1955." *Studies in Latin American Popular Culture* 18:93–113.

Cauthorn, Robert S. 1993. "The Cult of Kahlo." *The Arizona Daily Star*, March 5, F12+.

Cepeda, María Elena. 2010. *Musical ImagiNation: U.S. Colombian Identity and the Latin Music Boom*. New York: New York University Press.

Chanan, Michael. 2001. "Alberto Korda. Ebullient Cuban photographer whose portrait of Che Guevara became an icon for a generation of protest." *The Guardian*, May 27. *www.guardian.co.uk/news/2001/may/28/guardianobituaries.cuba*.

Chávez Camacho, Armando. (1948) 1967. *Cajeme: Novela de indios*. Mexico City: Porrúa.

*Che!* 1969. Film. Dir. Richard Fleischer. Fox.

*Che (Part 1* and *Part 2).* 2008. DVD. Dir. Steven Soderbergh. IFC Films, Wild Bunch, Telecinco, and Laura Bickford / Telecinco Cinema / Morena Films.

*Che Guevara.* 2005. DVD. Dir. Josh Evans. Beechwood Cottage Film and Music, Guerrilla Works LLC.

*Che Guevara donde nunca más se lo imaginan.* 2004. DVD. Dir. Manuel Pérez. ICAIC / First Run Features.

"Che Guevara Photographer Dies." 2001. BBC News online. May 26. Accessed July 21, 2010. *news.bbc.co.uk/2/hi/americas/1352650.stm.*

*El Che: Investigating a Legend.* 1997. DVD. Dirs. Maurice Dugowson and Aníbal de Salvo. Canal Plus / White Star.

*Chevolution: The Man. The Myth. The Merchandise.* 2008. DVD. Dirs. Trisha Ziff and Luis López. Red Envelope Entertainment, 212Berlin Film and Faction Films.

*Cheyenne Autumn.* 1964. Film. Dir. John Ford. Warner Bros.

*The Children of Sanchez.* 1978. Film. Dir. Hal Bartlett. Bartlett/CONACINE.

*La ciénaga.* 2001. Film. Dir. Lucrecia Martel. 4K Films, Wanda Visión S.A., Code Red.

*Citizen Kane.* 1941. Film. Dir. Orson Welles. RKO.

*The City of Your Final Destination.* 2009. Film. Dir. James Ivory. Hyde Park International, Merchant Ivory Productions.

*Cleopatra.* 2006. Short Film. Dir. Peter Mays.

"El club Che Guevara se abre camino en el fútbol cordobés." 2010. Clarín.com, January 24. Accessed July 21, 2010. *edant.clarin.com/diario/2010/01/24/deportes/d-02126153.htm.*

*Cocalero.* 2007. Film. Dir. Alejandro Landes. Fall Lines Films.

Collier, Simon. 1986. *The Life, Music, and Times of Carlos Gardel.* Pittsburgh: Pittsburgh University Press.

Comolli, Jean-Louis. 1978. "Historical Fictions: A Body Too Much." Translated by Ben Brewster. *Screen* 19:2.

Conner, Floyd. 1993. *Lupe Velez and her Lovers.* New York: Barricade.

Cooper, Marc. 1994. "Roll Over, Che Guevara." In *Roll Over Che Guevara: Travels of a Radical Reporter,* 81–91. London: Verso.

*Copacabana.* 1947. Film. Dir. Alfred E. Green. Beacon Productions.

Córdova Casas, Sergio. 1993. "Lola Casanova: Al margen del mito y la leyenda." *Boletín de la Sociedad Sonorense de Historia* 68/69:12–15/15–19.

Cormack, Robin. 2007. *Icons.* Cambridge, MA: Harvard University Press.

*Cousins.* 1989. Film. Dir. Joel Schumacher. Paramount.

*El crimen del padre Amaro.* 2002. Film. Dir. Carlos Carrera. Alameda Films / IMCINE.

"El crimen del Padre Amaro." (N.d.) *Box Office Mojo. www.boxofficemojo.com/movies/?page=intl&id=elcrimendelpadreamaro.htm.*

Crowther, Bosley. 1949. "That Night in Rio." *New York Times,* March 10.

Cruz Tejada, Miguel. 2009. "Johnny Pacheco relata que su primer encuentro con Rubirosa es el más lindo de toda su vida." *El Nuevo Diario* (New York), March 25.

*Cuesta abajo.* 1934. Film. Dir. Louis J. Gasnier. Exito Productions.

*Cuestión de principios.* 2009. Film. Dir. Rodrigo Grande. Linea de Tres Producciones.

Dagostino, Mark. 2004. "Gael Garcia Bernal." *People,* October 11. *www.people.com/people/article/0,,709930,00.html.*

*Dark Holiday.* 1989. Film. Dir. Lou Antonio. Peter Nelson-Lou Antonio Productions, Finnegan/Pinchuk Productions, Orion Television.

Dávila, Arlene. 2001. *Latinos, Inc.: The Marketing and Managing of a People.* Berkeley: University of California Press.

Davis, Darién J. 1996. Review of *Bananas is My Business* (film), directed by Helena Soldberg. *American Historical Review* 101 (4): 1162–64.

De la Mora, Sergio. 2006. *Cinemachismo: Masculinities and Sexualities in Mexican Film*. Austin: University of Texas Press.

De la Vega Alfaro, Eduardo and Patricia Torres San Martín. 1999. *Adela Sequeyro*. Guadalajara: Universidad de Guadalajara / Universidad Veracruzana.

De Lauretis, Teresa. 1984. *Alice Doesn't: Feminism, Semiotics, Cinema*. Bloomington: University of Indiana Press.

———. 1991. *Technologies of Gender: Essays on Theory, Film, and Fiction*. Bloomington: Indiana University Press.

De los Reyes, Aurelio. 1988. "Nacimiento de un mito: Dolores del Rio." *Historia, leyendas y mitos de Mexico: Su expresión en el arte*. Mexico City: Universidad Autónoma de Mexico.

———. 1996. *Dolores Del Rio*. Mexico City: Servicios Codumex.

De Usabel, Gaizka S. 1982. *The High Noon of American Films in Latin America*. Ann Arbor, MI: UMI Research Press.

*Déficit*. 2007. Film. Dir. Gael García Bernal. Canana.

Del Castillo, Richard Griswold, Teresa McKenna, and Yvonne Yarbro Bejarano, eds. 1991. *Chicano Art: Resistance and Affirmation, 1965–1985*. Los Angeles: Wright Art Gallery, UCLA.

Del Sarto, Ana, Alicia Ríos, and Abril Trigo, eds. 2004. *The Latin American Cultural Studies Reader*. Durham: Duke University Press.

Deleuze, Gilles. 1986. *Cinema 1: The Movement-Image*. Translated by Barbara Habberjam and Hugh Tomlinson. Minneapolis: University of Minnesota Press.

———. 2004. *A Thousand Plateaus: Capitalism and Schizophrenia*. Translated by Brian Massumi. New York: Continuum.

Deleuze, Gilles, and Félix Guattari. (1980) 1987. *A Thousand Plateaus: Capitalism and Schizophrenia*. Translated and with a foreword by Brian Massumi. Minneapolis: University of Minnesota Press.

Derrida, Jacques. (1967) 1978. "Structure, Sign and Play in the Discourse of the Human Sciences." In *Writing and Difference*. Translated by Alan Bass. London: Routledge.

*Desperado*. 1995. Film. Dir. Robert Rodríguez. Los Hooligans / Columbia Pictures.

Di Núbila, Domingo. 1998. *La época de oro: Cine argentino I*. Buenos Aires: Ediciones del Jilguero.

*El día que me quieras*. 1935. DVD. Dir. John Reinhardt. Éxito Spanish Productions / Paramount.

*Diarios de motocicleta*. 2004. DVD. Dir. Walter Salles. Film Four.

D'Lugo, Marvin. 2008. "Early Cinematic Tangos: Audiovisual Culture and Transnational Film Aesthetics." *Studies in Hispanic Cinemas* 5 (1, 2): 9–23.

Doane, Mary Ann. 1985. "Ideology and the Practice of Sound Editing and Mixing." In *Film Sound: Theory and Practice*, edited by Elisabeth Weis and John Belton, 54–62. New York: Columbia University Press.

*Dogma*. 2004. DVD. Dir. Kevin Smith. View Askew / STK.

*Doña Perfecta*. 1950. Film. Dir. Alejandro Galindo. Cabrera Films.

Dorfman, Ariel. 2009. *Americanos: Los pasos de Murieta*. Buenos Aires: Emecé.

*Dot the I*. 2003. DVD. Dir. Michael Parkhill. Alquimia/Arcane/Summit.

*The Dove*. 1927. Film. Dir. Roland West. Norma Talmadge Film Corporation.

Drucker, Malka. 1991. *Frida Kahlo: Torment and Triumph of her Life and Art*. New York: Bantam.

Dueñas, H P. 1994. *Las divas en el teatro de revista mexicano*. México, D.F: Asociación Mexicana de Estudios Fonográficos.

During, Simon. (1993) 2007. *The Cultural Studies Reader*. London: Routledge.

Durovicová, Nataša. 1992. "Translating America: The Hollywood Multilinguals, 1929–1933." In *Sound Theory, Sound Practice*, edited by Rick Altman, 138–53. New York: Routledge.

Ellner, Rebecca. 1997. "Tropicalizing Latin Americanness: Hollywood, Ethnicity, and the Colonial Discourse." Master's thesis, Tulane University.

Eloy Martínez, Tomás. 1995. *Santa Evita*. New York: Vintage en Español.

———. 2002. "La tumba sin sosiego." *La Nación*, June 8.

Enkvist, Inger. 2008. *Iconos latinoamericanos: 9 mitos del populismo del siglo XX*. Madrid: Ciudadela.

*Entre Pancho Villa y una mujer desnuda*. 1996. DVD. Dirs. Sabina Berman and Isabelle Tardán. Televicine and Televisa.

*Espérame*. 1932. VHS. Dir. Louis Gasnier. Paramount.

*Evangeline*. 1929. Film. Dir. Edwin Carewe. United Artists.

Evdokimov, Paul. 1990. *The Art of the Icon: A Theology of Beauty*. Translated by Steven Bingham. Redondo Beach, CA: Oakwood Publications.

*Evita*. 1976. LP. Music and lyrics by Andrew Lloyd Webber and Tim Rice. MCA Records.

——. 1978. Performance. Music and lyrics by Andrew Lloyd Webber and Tim Rice. Dir. Harold Prince. Chor. Larry Fuller. Prince Edward Theatre, London. June 21.

——. 1996. Film. Dir. Alan Parker. Cinergi Pictures.

Facio, Sara. 1990. *Sara Facio, Retratos, 1960–1992*. Buenos Aires: La Azotea.

——. 1992. "The Streets of Buenos Aires." In *Desires and Disguises: Five Latin American Photographers*, edited and translated by Amanda Hopkinson, 53–64. London: Serpent's Tail.

Falicov, Tamara L. 2010. "Argentine Cinema and the Construction of National Popular Identity, 1930–1942." *Studies in Latin American Popular Culture* 17:61. www.utexas.edu/utpress/journals/jaslapc.html#17.

Fante, John. 1939. *Ask the Dust*. New York: Stackpole Sons.

Fein, Seth. 1994. "Hollywood, U.S. Mexican Relations, and the Devolution of the 'Golden Age' of Mexican Cinema." *Film-Historia* 4 (2): 103–36.

——. 1998. "Cold-War Hollywood in Postwar Mexico: Anticommunism and Transnational Feature-Film Production." In *Visible Nations*, edited by Chon Noriega. Minneapolis: University of Minnesota Press.

Fernández, Adela. 1986. *El Indio Fernández: Vida y mito*. Mexico City: Panorama.

Figueroa, Alfredo. 1996. Introduction to *Joaquín Murrieta, "El Patrio,"* by Manuel Rojas (1986), 1–9. Translated by I. G. Garza. Mexicali: La Cuna de Aztlán.

Filosi, Analía. 2010. "La actríz que nunca falta." *TVShow* (Uruguay), July 3. www.elpais.com.uy/suplemento/sabadoshow/La-actriz-que-nunca-falta/sshow_498741_100703.html.

Fiol-Matta, Licia. 2002. *A Queer Mother for the Nation: The State and Gabriela Mistral*. Durham: Duke University Press.

——. 2011. "The Thinking Voice: When Listening Trumps Celebrity." PMLA, 126 (4), October: 1092–101.

*Flaming Star*. 1960. Film. Dir. Don Siegel. Fox.

*Flor Silvestre*. 1943. Film. Dir. Emilio Fernández. Films Mundiales.

*Flying Down to Rio*. 1933. Film. Dir. Thorton Freeland. RKO.

Fojas, Camila. 2008. *Border Bandits: Hollywood on the Southern Frontier*. Austin: University of Texas Press.

Fontova, Humberto. 2007. *Exposing the Real Che Guevara and the Useful Idiots Who Idolize Him*. New York: Sentinel.

Foster, David William. 1990. *Gender and Society in Contemporary Brazilian Cinema*. Austin: University of Texas Press.

——. 1998. *Buenos Aires: Perspectives on the City and Cultural Production*. Gainesville: University Press of Florida.

*The Four Horsemen of the Apocalypse*. 1921. Film. Dir. Rex Ingram. Metro Pictures.

Fouz-Hernández, Santiago, and Alfredo Martínez-Expósito. 2007. *Live Flesh: The Male Body in Contemporary Spanish Cinema*. London: I. B. Tauris.

Franco, Jean. 1970. *The Modern Culture of Latin America: Society and the Artist*. London: Penguin.

——. 1973. *Spanish American Literature Since Independence*. New York: Harper and Row.

——. 1984. "Tree of Hope." Review of *Frida: A Biography of Frida Kahlo* by Hayden Herrera. *Latin American Literature and Arts* 32 (January–May): 54–56.

———. 1994. *An Introduction to Spanish American Literature*. Third Edition. Cambridge: Cambridge University Press.

Fregoso, Rosa Linda. 2003. *MeXicana Encounters: The Making of Social Identities on the Borderlands*. Berkeley: University of California Press.

*Frida*. 2002. DVD. Dir. Julie Taymor. Lion's Gate / Miramax / Handprint / Ventanarosa.

"Frida." *Box Office Mojo. www.boxofficemojo.com/movies/?page=intl&id=frida.htm.*

Frida Kahlo Homepage. *www.cascade.net/kahlo.html.* (site discontinued).

Fuentes, Carlos. 1982. *Orquídeas a la luz de la luna*. Barcelona: Seix Barral.

*The Fugitive*. 1947. Film. Dir. John Ford. Argosy.

Gabara, Esther. 2008. *Errant Modernism: The Ethos of Photography in Mexico and Brazil*. Durham: Duke University Press.

*Gaby: A True Story*. 1987. Film. Dir. Luis Mandoki. G. Brimmer Productions, TriStar Pictures.

Galaz, Fernando. n.d. "Lola Casanova" (transcription). INAH, Hermosillo, Sonora. "Artículos históricos sonorenses" Vol. 2, Ficha 8225: 305–6.

*The Gang's All Here*. 1943. Film. Dir. Busby Berkeley. Fox.

Garber, Marjorie B. 1992. *Vested Interests: Cross-Dressing and Cultural Anxiety*. New York: Routledge.

García, Fernando Diego, and Oscar Sola. 2000. *Che: Images of a Revolutionary*. Translated by Richard Whitecross and Troth Wells. London: Pluto Press.

García Canclini, Nestor. 2001. *Consumers and Citizens: Globalization and Multicultural Conflicts*. Translated by George Yúdice. Minneapolis: University of Minnesota Press.

———. 2002. *La globalización imaginada*. Madrid: Ed. Paidós.

———. 2005. *Hybrid Cultures: Strategies for Entering and Leaving Modernity*. Translated by Christopher Chiappari and Silvia López. Minnesota: University of Minnesota Press.

García Riera, Emilio. 1970. *Historia documental del cine mexicano*. 1st edition. Mexico City: Ediciones Era.

———. 1987. *México visto por el cine extranjero*. Guadalajara: Ediciones Era / Universidad de Guadalajara.

———. 1992. *Historia documental del cine mexicano 2*. Guadalajara: Universidad de Guadalajara.

Garduño, Blanca, and José Antonio Rodríguez, eds. 1991. *Pasion por Frida: Museo Estudio Diego Rivera and de Grazia Art and Cultural Foundation*. Mexico, D.F.: Instituto Nacional de Bellas Artes.

Gaspar de Alba, Alicia, ed. 2002. *Velvet Barrios: Popular Culture and Chicana/a Sexualities*. New York: Palgrave Macmillan.

*The Gateway of the Moon*. 1927. Film. Dir. Raoul Walsh. Fox.

*The Gaucho*. 1927. DVD. Dir. Richard Jones. United Artists, USA.

Gil-Montero, Martha. 1989. *Brazilian Bombshell: The Biography of Carmen Miranda*. New York: Donald I. Fine.

*Girl of the Rio*. 1932. Film. Dir. Herbet Brennon. RKO.

Gledhill, Christine. 1991. *Stardom: Industry of Desire*. New York: Routledge.

Gonzales, Rodolfo "Corky." (1967) 1997. "I Am Joaquín." In *The Latino Reader*, edited by H. Augenbrahm and M. Fernández Olmos, 266–79. Boston: Houghton Mifflin.

González, Jennifer A. 1993. "Rhetoric of the Object: Material Memory and the Artwork of Amalia Mesa-Bains." *Visual Anthropology Review* 9.1 (Spring): 82–91.

González de Mendoza, J. M. 1959. "Carlos Noriega Hope y *El Universal Ilustrado*." In *Carlos Noriega Hope, 1896–1934*, 33–48. Mexico, D.F.: Instituto Nacional de Bellas Artes.

Gover de Nasatsky, Miryam E. 2006. "La ficción como testimonio en el espacio textual de *La historia oficial*, guión cinematográfico correspondiente a Aída Bortnik y Luis Puenzo." *Alba de América: Revista literaria* 25 (47–48): 349–56.

Granado, Alberto. 2004. *Traveling with Che: The Making of a Revolutionary*. Translated by Lucía Álvarez de Toledo. New York: Newmarket Press.

Grimes, William. 2005. "A Jet-Set Don Juan, Right Up to the Final Exit." *The New York Times*, September 16.

Grosz, Elizabeth. 1991. "Lesbian Fetishism?" *Differences: A Journal of Feminist Cultural Studies* 3:39–54.

Grupo de los Siete. 1925. "Se debe acabar el Ba-ta-clán?" *Revista de Revistas*, September 13.

Gruzinksi, Serge. (1989) 1993. *The Conquest of Mexico: The Incorporation of Indian Societies into the Western World, 16th to 18th Centuries*. Translated by Eileen Corrigan. Cambridge: Cambridge University Press.

Guevara, Ernesto (Che). 1993. *Notas de viaje*. Havana: Casa Editora Abril.

Gugelberger, Georg M., ed. 1996. *The Real Thing: Testimonial Discourse and Latin America*. Durham: Duke University Press.

Guha, Ranajit. 1999. *Elementary Aspects of Peasant Insurgency in Colonial India*. Durham: Duke University Press.

Guillermoprieto, Alma. 2001. "The Harsh Angel." In *Looking for History: Dispatches from Latin America*, 72–86. New York: Vintage Books.

Guzmán, Martín Luis. (1928) 1991. *El águila y la serpiente*. Mexico City: Ediciones Porrúa.

Hariman, Robert, and John Lucas Lucaites. 2007. *No Caption Needed: Iconic Photographs, Public Culture, and Liberal Democracy*. Chicago: University of Chicago Press.

Hart, John Mason. 2000. "The Mexican Revolution, 1910–1920." In *The Oxford History of Mexico*, edited by Michael Meyer and William Beezley, 435–66. New York: Oxford University Press.

Hazera, Lydia. 1989. "Joaquín Murieta: The Making of a Popular Hero." *Studies in Latin American Popular Culture* 8:201–13.

Hernández, Fortunato. 1902. *Las razas indígenas de Sonora y la guerra del Yaqui*. Mexico City: Elizalde.

Hernández-Reguant, Ariana. 2002. "Copyrighting Che: Art and Authorship under Cuban Late Socialism." In *The Anthropology of Globalization: A Reader*, edited by Jonathan Xavier Inda and Renato Rosaldo, 254–76. Oxford: Blackwell Press.

Herrera, Hayden. 1983. *Frida: A Biography of Frida Kahlo*. New York: Harper and Row.

———. 1990. "Why Frida Kahlo Speaks to the '90s." *New York Times*, October 14, sec. 5:1+.

———. 1991. *Frida Kahlo: The Paintings*. New York: Harper Collins.

Herrera Sobek, María. 1992. "Joaquín Murieta: Mito, leyenda e historia." In *Entre la magia y la historia*, compiled by J. M. Valenzuela Arce, 137–49. Tijuana: Colegio de la Frontera Norte / CONACULTA.

Hershfield, Joanne. 2008. *Imagining La Chica Moderna: Women, Nation, and Visual Culture in Mexico, 1917–1936*. Durham: Duke University Press.

*High Flyers*. 1937. DVD. Dir. Edward F. Cline. RKO, USA.

*High Steppers*. 1926. Film. Dir. Edwin Carewe. First National.

*El hijo de la novia*. 2001. Film. Dir. Juan José Campanella. INCAA, JEMPSA, Patagonik, Pol-Ka, and Tornasal Films S.A.

Hippolyte, Nelson. 2003. "Review of *El hijo de la novia*." *Chasqui: Revista de Literatura Latinoamericana* 32 (1): 157–60.

*La historia oficial*. 1986. VHS. Dir. Luis Puenzo. Historias Cinematográficas Cinemanias.

Hofstadter, Dan. 1996. "Frida Kahlo." *New York Times Magazine*, November 24, 96–97.

Holmes, Stephanie. 2007. "Che: The Icon and the Ad." BBC News online. October 5. Accessed October 20, 2010. *news.bbc.co.uk/2/hi/americas/7028598.stm*.

*Honolulu Lu*. 1941. DVD. Dir. Charles Barton. Columbia, USA.

Hughes, Langston. 1965. "Commentary." *New Pittsburgh Courier*, July 24, 6 (28): 8.

Iberri, Alfonso. 1993. "El rapto de Lola Casanova." In *Sonora: Un siglo de literatura*, edited by G. Rocha, 275–77. Mexico City: CONACULTA.

"'Iglesia Maradoniana' celebra el cumpleaños de su máximo ídolo pagano Iglesia Maradoniana."
2013. SitiosArgentina.com.ar. Accessed January 8. *www.sitiosargentina.com.ar/notas/
notas_viejas/80.htm.*

*Imagen del Hombre Nuevo.* 2006. DVD. Dir. Chea Prince. Public Domain, Inc.

*In Caliente.* 1935. Film. Dir. Lloyd Bacon. Warner Bros.

Irwin, Robert McKee. 2007. *Bandits, Captives, Heroines and Saints: Cultural Icons of Mexico's
Northwest Frontier.* Minneapolis: University of Minnesota.

Isaacs, Bruce. 2008. *Toward a New Film Aesthetic.* London: Continuum.

Isla, Carlos. 2002. *Joaquín Murrieta.* Mexico City: Fontamara.

Jackson, Joseph Henry. (1854) 1977. Introduction to *The Life and Adventures of Joaquin Murieta.
Celebrated California Bandit,* by Yellow Bird [John Rollin Ridge].Oklahoma: University of
Oklahoma Press.

Jacobs, Lea. 1991. *The Wages of Sin.* Wisconsin: University of Wisconsin Press.

Jakubowicz, Eduardo, and Laura Radetich. 2006. *La historia argentina a través del cine: Las
"visiones del pasado" (1933–2003).* Buenos Aires: La Crujía Ediciones.

Jamandreu, Paco. 1981. *Memorias: El cuerpo contra el suelo.* 2nd edition. Buenos Aires: Corregidor.

*The Jazz Singer.* 1927. Film. Dir. Alan Crosland. Warner Bros.

Jenkins, Henry. 2007. *The Wow Climax.* New York: New York University Press.

*Joanna.* 1925. Film. Dir. Edwin Carewe. First National.

Johnson, Susan Lee. 2000. *Roaring Camp: The Social World of the California Gold Rush.* New York:
W.W. Norton.

Johnson, Timothy W. 1982. *"What Price Glory?" Magill's Survey of Cinema: Silent Films,* Vol. 3.
Englewood Cliffs, NJ: Salem Press.

Joseph, Gilbert M., Anne Rubinstein, and Eric Zolov. 2001. *Fragments of a Golden Age: The Politics
of Culture in Mexico Since 1940.* Durham: Duke University Press.

*Journey into Fear.* 1943. Film. Dir. Orson Welles. RKO.

Kalfon, Pierre. 1997. *Che, Ernesto Guevara, una leyenda de nuestro siglo.* Barcelona: Plaza y Janés.

Kantorowicz, E. H. 1957. *The King's Two Bodies: A Study in Mediaeval Political Theology.* Princeton:
Princeton University Press.

Katz, Friedrich. 1998. *The Life and Times of Pancho Villa.* Palo Alto: Stanford University Press.

Kettenmann, Andrea. 1993. *Frida Kahlo, 1907–1954: Pain and Passion.* Köln: Benedikt Taschen.

*Kill Bill, Vol. 1.* 2003. DVD. Dir. Quentin Tarantino. Miramax / A Bande Apart.

*The King.* 2005. DVD. Dir. James Marsh. Content Film / Film Four.

Klein, Melanie. 1987. *The Selected Melanie Klein.* Edited by Juliet Mitchell. New York:
The Free Press.

Knafo, Danielle. 1993. "The Mirror, the Mask, and the Masquerade in the Art and Life of
Frida Kahlo." *The Annual of Psychoanalysis* 21:277–99.

Knight, Alan. 1990. "Revolutionary Project, Recalcitrant People: Mexico, 1910–40." In *The
Revolutionary Process in Mexico: Essays on Political and Social Change, 1880–1940,* edited by
Jaime E. Rodríguez O., 227–64. Los Angeles: UCLA Latin American Center Publication.

*Kordavision.* 2005. DVD. Dir. Héctor Cruz Sandoval. Halo Group News and Entertainment.

Kunzle, David, ed. 1997. *Che Guevara: Icon, Myth, and Message.* Los Angeles: UCLA Fowler
Museum of Cultural History / Center for the Study of Political Graphics.

*The Lady from Shanghai.* 1947. Film. Dir. Orson Welles. Columbia.

*Lady of the Pavements.* 1929. DVD. Dir. D. W. Griffith. United Artists, USA.

Leal, Luis. (1904) 1999. Introduction to *Vida y aventuras del más célebre bandido sonorense,
Joaquín Murrieta,* attributed to Ireneo Paz, 1–95. Houston: Arte Público Press.

Lefort, Claude. 1990. *La invención democrática.* Buenos Aires: Nueva Visión.

Leñero, Vicente. 1973. "Compañero: Pieza en Dos Actos." In *México Teatro 1970,* 187–243.
Mexico City: Aguilar.

León Sarabia, Sonia. 2008. "A propósito de la labor en el teatro de revista de Roberto Soto." In *Cuatro obras de revista política para el "Teatro de Ahora"* (1932), edited by Alejandro Ortiz Bullé Goyri, 45–63. México, D.F.: Universidad Autónoma Metropolitana.

*Letters to Juliet.* 2010. DVD. Dir. Gary Winick. Summit/Applehead.

Levin, Tom. 1984. "The Acoustic Dimension: Notes on Cinema Sound." *Screen* 25 (3): 55–68.

Levy, Shawn. 2005. *The Last Playboy: The High Life of Porfirio Rubirosa.* New York: Harpers.

Lewis, Vek. 2009. "When Macho Bodies Fail. Spectacles of Corporeality and the Limits of the Homosocial/sexual in Mexican Cinema." In *Mysterious Skin: Male Bodies in Contemporary Cinema*, edited by Santiago Fouz-Hernández, 177–92. London: I. B. Tauris.

*The Life of General Villa.* 1914. Film. Dirs. Christy Cabanne and Raoul Walsh. Mutual Films.

*Lola Casanova.* 1949. Film. Dir. Matilde Landeta. Tacma.

"Lola Casanova, la reina de los seris." 1918. *El Universal Ilustrado*, February 15.

López, Ana M. 1991. "Are All Latins from Manhattan? Hollywood, Ethnography, and Cultural Colonialism." In *Unspeakable Images*, edited by Lester D. Friedman, 404–24. Urbana: University of Illinois.

López Urrutia, Carlos. 2001. "El Murrieta chileno (la historia de un fraude literario)." In *Vida de Joaquín Murieta*, by Pájaro Amarillo [John Rollin Ridge], 133–42. Mexico City: Umbral.

*Loves of Carmen.* 1927. Film. Dir. Raoul Walsh. Fox.

Lowe, Sarah M. 1991. *Frida Kahlo.* New York: Universe.

Lowell, Edith. 1970. "A Comparison of Mexican and Seri Indian Versions of the Legend of Lola Casanova." *Kiva* 35 (4): 144–58.

Loza, Steve. 2000. "Latin Caribbean Music." In *Garland Encyclopedia of World Music*, Vol. 3, ed. Ellen Koskoff: 790–801. London: Routledge.

*Las luces de Buenos Aires.* 1931. DVD. Dir. Adelqui Millar. Paramount.

*Lupe* (aka *The Life, Death, and Assumption of Lupe Vélez*). 1966. Film. Dir. José Rodríguez-Soltero. Film-Makers' Cooperative, USA.

*Lupe.* 1965. Film. Dir. Andy Warhol. Independent production.

*Madame DuBarry.* 1935. Film. Dir. William Dieterle. Warner Bros.

Madsen, Alex. 1995. *The Sewing Circle: Female Stars Who Loved Other Women.* New York: Carol Publishing.

Magaña Esquivel, Antonio. 1964. *Medio siglo de teatro mexicano.* Mexico, D.F.: INBA.

Mahfouz, Naguib. (1966) 1991. *Midaq Alley.* Anchor.

Mahieux, Viviane. 2010. "Cube Bonifant: The Little Marquise de Sade of the Mexican Crónica." *Review: Literature and Arts of the Americas* 43 (1): 19–37.

*La mala educación.* 2004. DVD. Dir. Pedro Almodóvar. Canal + / El Deseo / TVE.

Maradona, Diego Armando. 2000. *Yo soy el Diego (de la gente).* Buenos Aires: Planeta.

*Maradona by Kusturica.* 2008. DVD. Dir. Emir Kusturica. Pentagrama / Telecinco / Wild Bunch.

*María Candelaria.* 1943. Film. Dir. Emilio Fernández. Films Mundiales.

Maria y Campos, Armando de. 1996. *El teatro de género chico en la revolución méxicana.* Mexico, D.F.: Consejo Nacional para la Cultura y las Artes.

Marshall, P. David, ed. 2006. *The Celebrity Culture Reader.* New York: Routledge.

Martínez, Adolfo C. 2010. "Retrato familiar que también es espejo social." *La Nación*, February 4. *www.lanacion.com.ar/1229145-relato-familiar-que-tambien-es-espejo-social*.

Martínez Gandía, Rafael. 1930. *Dolores del Rio: La Triunfadora.* Madrid: Compañía Iberoamericana de Publicaciones, S.A.

Matamoro, Blas. 1982. *La ciudad del tango: Tango histórico y sociedad.* Buenos Aires: Editorial Galerna.

Melhuus, Marit, and Kristi Anne Stølen, eds. 1996. *Machos, Mistresses, Madonnas: Contesting the Power of Latin American Gender Imagery.* London: Verso.

*Melodía de arrabal.* 1933. DVD. Dir. Louis Gasnier. Paramount.

Menchú, Rigoberta. 2003. *Me llamo Rigoberta Menchú y así me nació la conciencia*. Edited by Elisabeth Burgos-Debray. Mexico, D.F.: Siglo XXI Editores.

Menéndez, Ana. 2003. *Loving Che: A Novel*. New York: Grove Press.

Mercer, John, and Martin Shingler. 2004. *Melodrama: Genre, Style, and Sensibility*. New York: Wallflower Press.

Mérida, Carlos. "Escenas de la vida nacional: Una mujer blanca reina de los seris: El rapto de Lola Casanova" 1920. *El Universal Ilustrado*, July 8.

Metz, Christian. 1975. *The Imaginary Signifier: Psychoanalysis and the Cinema*. Translated by Celia Britton, Annwyl Williams, Ben Brewster, and Alfred Guzzetti. Bloomington: Indiana University Press.

*Mi vida loca*. 1993. DVD. Dir. Allison Anders. Channel Four / Cineville / HBO / Showcase.

Miller, Nicola. 2003. "Contesting the Cleric: The Intellectual as Icon in Modern Spanish America." In *Contemporary Latin American Cultural Studies*, edited by S. Hart and R. Young, 62–75. London: Arnold.

Mimiaga, Ricardo. 1989. "Lola Casanova y los seris." In *Memoria del XIII simposio de historia y antropología de Sonora*, Vol. 2, 379–99. Hermosillo: Universidad de Sonora.

Minghetti, Claudio D. 2010. "Reflexiones de tiempos difíciles." *La Nación*, February 1. *www.lanacion.com.ar/1228077-reflexiones-de-tiempos-dificiles*.

Molina-Guzmán, Isabel. 2006. "Mediating *Frida*. Negotiating Discourses of Latina/o Authenticity in Global Media Representations of Ethnic Identity." *Critical Studies in Media Communication* 23 (3): 323–51.

———. 2007. "Salma Hayek's *Frida*: Transnational Latina Bodies in Popular Culture." In *From Bananas to Buttocks: The Latina Body in Popular Culture*, edited by Myra Mendible, 117–28. Austin: University of Texas Press.

———. 2010. *Dangerous Curves: Latina Bodies in the Media*. New York: New York University Press.

Molina-Guzmán, Isabel, and Angharad N. Valdivia. 2004. "Brain, Brow and Booty. Latina Iconicity in U.S. Popular Culture." *The Communication Review* 7:205–21.

Monsiváis, Carlos. 1982. *Celia Montalván (te brindas, voluptuosa e impudente)*. Mexico, D.F.: Martín Casillas Editores: Cultura/SEP.

———. 1983. "Dolores del Rio: Las responsibilidades del rostro." In *Mexico en el arte*, Vol 1. Translated by John Kraniauskas as "Dolores Del Rio: The Face as Institution." In *Mexican Postcards*. London: Verso.

———. 1988a. *Escenas de pudor y liviandad*. Mexico, D.F.: Ed. Grijalbo.

———. 1988b. "Notas sobre la cultura mexicana en el siglo XX." In *Historia general de México, 1377–1548*. Mexico City: El Colegio de México.

———. 1997. *Mexican Postcards*. Translated by Jon Kraniauskas. London: Verso.

Monsiváis, Carlos, and Carlos Bonfil. 1994. *A través del espejo: El cine mexicano y su público*. Mexico, D.F.: Eds. El Milagro / IMCINE.

Morla Vicuña, Carlos. 1867. *El bandido chileno Joaquín Murieta en California*. Santiago: Imprenta de la República.

*The Motorcycle Diaries*. 2004. DVD. Dir. Walter Salles. Film Four, South Fork Pictures, Tu Vas Voir Productions, BD Cine, Inca Films. S.A., Sahara Films, Senator Film Production, Sound For Film.

Mulvey, Laura, and Peter Wollen. 1982. *Frida Kahlo and Tina Modotti*. London: Whitechapel Gallery.

Muñoz, José Esteban. 1999. *Disidentifications: Queers of Color and the Performance of Politics*. Minneapolis: The University of Minnesota Press.

Muñoz, Rafael F. (1931) 1992. *Vámonos con Pancho Villa*. Buenos Aires: Ediciones Austral.

*Música en espera*. 2009. Film. Dir. Hernán A. Golfrid. BD Cine, Cine.Ar, Film Suez.

*Nana*. 1944. Film. Dirs. Celestino Gorostiza and Roberto Gavaldón. Azteca, MEX.

Navitski, Rielle. 2011. "The Tango on Broadway: Carlos Gardel's International Stardom and the Transition to Sound in Argentina." *Cinema Journal* 51 (1): 26–49.

Nericcio, William Anthony. 2007. *Tex{t}-Mex: Seductive Hallucinations of the "Mexican" in America*. Austin: University of Texas Press.

Neruda, Pablo. (1966) 1973. "Fulgor y muerte de Joaquín Murieta." In *Obras completas* 3: 129–42. Buenos Aires: Losada.

Newman, Kathleen. 1993. "National Cinema after Globalization: Fernando Solanas's *Sur* and the Exiled Nation." In *Mediating Two Worlds: Cinematic Encounters in the Americas*, edited by John King, Ana M. López, and Manuel Alvarado, 242–57. London: BFI.

Niebylski, Dianna C. 2005. "Caught in the Middle: Ambiguous Gender and Social Politics in Sabina Berman's play *Entre Villa y una mujer desnuda*." *Revista de Estudios Hispánicos* 39 (1): 153–77.

*No Other Woman*. 1928. Film. Dir. Leon Tellegen. Fox.

*No te mueras sin decirme adónde vas*. 1995. DVD. Dir. Eliseo Subielo. Vhero Films.

Novo, Salvador. (1946) 1967. *The New Mexican Grandeur*. Translated by Noel Lindsay. Mexico City: Ediciones Era.

*Nuevo Mensajero Paramount*. 1932. 15:1(January): 14.

———. 1934. 19:10 (October): 147.

———. 1935. 20:1 (April): 7.

O'Malley, Ilene. 1986. *The Myth of the Revolution: Hero Cults and the Institutionalization of the Mexican State, 1920–1940*. West Port, CT: Greenwood Press.

*One Man's War*. 1991. Film. Dir. Sergio Toledo. Channel Four Television, Skreba Films, TVS Films.

Oropesa, Salvador A. 2005. *The Contemporáneos Group: Rewriting Mexico in the Thirties and Forties*. Austin: University of Texas Press.

Ortiz Bullé Goyri, Alejandro. 2005. *Teatro y vanguardia en el México posrevolucionario (1920–1940)*. Mexico, D.F.: Universidad Autonoma Metropolitana.

*La otra*. 1945. Film. Dir. Roberto Gavaldón. Producciones Mercurio.

*Paco*. 2010. Film. Dir. Diego Rafecas. MATIZ Arte Digital, San Luis Cine, Zazen Producciones.

Palazón Mayoral, María Rosa. 1993. "Las verdaderas leyendas de Joaquín Murrieta." *Revista Casa de las Américas* 191:37–49.

*Pals First*. 1926. Film. Dir. Edwin Carewe. First National.

Paranagua, Paulo Antonio. 1985. *Cinema na America Latina: Longe de Deus e perto de Hollywood*. Porto Alegre: LandPM Editores Ltda.

———. 1996. "America Latina busca su imagen." In *Historia General del Cine* Vol. 10, edited by Carlos F. Heredero and Casimiro Torreiro. Madrid: Ediciones Cátedra.

Paredes, Américo. 1970. *With a Pistol in His Hand*. Austin: University of Texas Press.

Parish, James Robert. 1974. *The RKO Gals*. London: Ian Allen.

———. 1978. *The Hollywood Beauties*. New York: Arlington House.

Parle, Dennis. 1985. "Narrative Style and Technique in Nellie Campobello's *Cartucho*." *Kentucky Romance Quarterly* 32 (2): 201–11.

Parodi, Enriqueta de. (1944) 1985. "La dinastía de Coyote Iguana." In *Cuentos y leyendas*, 25–31. Hermosillo: Gobierno del Estado de Sonora.

Parra, Max. 2005. *Writing Pancho Villa's Revolution: Rebels in the Literary Imagination of Mexico*. Austin: University of Texas Press.

*El pasado*. 2007. DVD. Dir. Héctor Babenco. 20th Century Fox Argentina.

Paz, Ireneo (attrib.). (1904) 1919. *Vida y aventuras del más célebre bandido sonorense, Joaquín Murrieta*. Los Angeles: Libro Diario.

Peluso, Hamlet, and Eduardo Visconti. 1990. *Carlos Gardel y la prensa mundial*. Buenos Aires: Ediciones Corregidor.

Peña Acuña, Beatriz. 2010. "Latinos in U.S. Film Industry." *Journal of Alternative Perspectives in the Social Sciences* 2 (1): 399–414.

Peña Ovalle, Priscilla. 2006. "Shake Your Assets: Dance and the Performance of Latina Sexuality in Hollywood Film." PhD diss., Faculty of the Graduate School of University of Southern California.

"People." 1955. *Time*, December 12, 14.

Pereira Poza, Sergio. 2000. "Joaquín Murieta, la expresión dramática de la rebeldía latino-americana." In *Indigaciones sobre el fin de siglo*, edited by O. Pelletieri, 77–86. Buenos Aires: Galerna / UBA / Fundación Roberto Arlt.

Pérez, Laura E. 2007. *Chicana Art: The Politics of Spiritual and Aesthetic Altarities*. Objects/Histories: Critical Perspectives on Art, Material Culture, and Representation, edited by Nicholas Thomas. Durham: Duke University Press.

*Personal Che*. 2007. DVD. Dir. Douglas Duarte and Adriana Marino. Skyview Media.

Peza, Juan de Dios. 1902. "Una obra histórica de suma importancia." In *Las razas indígenas de Sonora y la guerra del Yaqui*, by Fortunato Hernández. Mexico City: J. de Elizade.

Pilcher, Jeffrey M. 2001. *Cantinflas and the Chaos of Mexican Modernity*. Wilmington, DE: Scholarly Resources.

Pile, Steven. 1996. *The Body and the City: Psychoanalysis, Space and Subjectivity*. London: Routledge.

Pinto, Alfonso. 1977. "Lupe Velez." *Films in Review* 28:513–24.

Plagens, Peter, Barbara Belejack, and John Taliaferro. 1992. "Frida on Our Minds." *Newsweek*, May 27, 54–55.

Pollock, Griselda. 1980. "Artists, Mythologies and Media." *Screen* 21:57–96.

Poniatowska, Elena. 1992. "Diego, I am Not Alone: Frida Kahlo." In *Frida Kahlo: The Camera Seduced*, edited by Carla Stellweg, 15–20. San Francisco: Chronicle Books.

———. 1993. "Dolores Del Rio." In *Todo Mexico*. Vol. 2. Mexico City: Editorial Diana.

Portal, Marta. 1996. Introduction to *Los de abajo*, by Mariano Azuela, 11–63. Madrid: Cátedra.

Pratt, Mary Louise. 1991. "Arts of the Contact Zone." *Profession* 91:33–41.

———. 1993. "Criticism in the Contact Zone." *Critical Theory, Cultural Politics, and Latin American Narrative*, edited by Steven M. Bell, Albert Le May, and Leonard Orr, 83–102. Notre Dame: University of Notre Dame Press.

———. 2004. "Mi cigarro, mi Singer, y la revolución mexicana: La danza ciudadana de Nellie Campobello." *Revista Iberoamericana* 206:253–73.

Prida Santacilia, Pablo. 1960. *Y se levanta el telón: Mi vida dentro del teatro*. Mexico, D.F.: Ediciones Botas.

Quiroga, José. 2000. *Tropics of Desire: Interventions from Queer Latino America*. New York: New York University Press.

Ramírez, Gabriel. 1986. *Lupe Vélez: La mexicana que escupía fuego*. Mexico, D.F.: Cineteca Nacional.

Ramírez Berg, Charles. 1992. *Cinema of Solitude: A Critical Study of Mexican Film, 1967–1983*. Austin: University of Texas Press.

———. 2002. *Latino Images in Film: Stereotypes, Subversion, and Resistance*. Austin: University of Texas Press.

*Ramona*. 1928. Film. Dir. Edwin Carewe. United Artists.

*Ramona: Birth of a Mis-ce-ge-Nation*. 1991. Film. Dir. David Avalos.

Ramsey, Cynthia. 1992. "*The Official Story*: Feminist Re-Visioning and Spectator Response." *Studies in Latin American Popular Culture* 11:157–69.

Rawson, Kristy. 2012. "A Trans-American Dream: Lupe Vélez and the Performance of Transculturation." PhD diss., University of Michigan.

*The Red Dancer of Moscow*. 1928. Film. Dir. Raoul Walsh. Fox.

*Redhead from Manhattan*. 1944. Film. Dir. Lew Landers. Columbia, USA.

*Resurrection.* 1927. Film. Dir. Edwin Carewe. United Artists.

*Revenge.* 1928. Film. Dir. Edwin Carewe. United Artists.

*The Revolution Will Not Be Televised.* 2003. Film. Dirs. Kim Bartley, Donnacha O'Briain. Bórd Scannán na hÉireann, Nederlandse Programma Stichting (NPS), CoBo Fonds.

Reyna de León, Carmela. 1943. *Dolores o la reina de los kunkaks.* Pitiquito: Imprenta Económica.

Richmond, Robin. 1994. *Frida Kahlo in Mexico.* San Francisco: Pomegranate Books.

Ridge, John Rollin [Yellow Bird, pseud.]. (1854) 1955. *The Life and Adventures of Joaquin Murieta.* Norman: University of Oklahoma Press.

Ríos Bustamante, Antonio José. 1991. *Latinos in Hollywood.* Encino: Floricanto Press.

Rivera, Guadalupe, and Marie-Pierre Colle. 1994. *Frida's Fiestas: Recipes and Reminiscences of Life with Frida Kahlo.* New York: Clarkson Potter Publishers.

Roberts, Andrew. 2008. *Postcards of Political Icons.* Oxford: Bodleian Library.

Roberts, Shari. 1993. "The Lady in the Tutti-Frutti Hat: Carmen Miranda, a Spectacle of Ethnicity." *Cinema Journal* 32 (3): 3–23.

*Robin Hood of Eldorado.* 1936. Film. Dir. William A. Wellman. MGM.

Rocha, Gregorio. 2006. "And Starring Pancho Villa as Himself." *The Moving Image* 6 (1): 142–45.

Rodriguez, Clara. 2004. *Heroes, Lovers, and Others: The Story of Latinos in Hollywood.* Washington, D.C.: Smithsonian Institute Press.

Rodriguez, Jeanette. 1994. *Our Lady of Guadalupe: Faith and Empowerment Among Mexican-American Women.* Austin: University of Texas Press.

Rojas, Manuel. 1986. *Joaquín Murrieta, el Patrio.* Mexicali: Gobierno del Estado de Baja California.

Rojas González, Francisco. (1947) 1984. *Lola Casanova.* Mexico City: FCE.

*Los rollos perdidos de Pancho Villa.* 2003. DVD. Dir. Gregorio Rocha. Universidad de Guadalajara, Banff Centre: Archivia Films.

Ross, Andrew. 1989. *No Respect: Intellectuals and Popular Culture.* New York: Routledge Press.

Rowe, William, and Vivian Schelling. 1991. *Memory and Modernity: Latin American Popular Culture.* London: Verso.

Rubenstein, Anne. 2007. "The War on 'Las Pelonas': Modern Women and their Enemies, Mexico City, 1924." In *Sex in Revolution: Gender Politics and Power in Modern Mexico*, edited by Jocelyn Olcott, Mary Kay Vaughan, Gabriela Cano, and Carlos Monsivais, 57–80. Durham: Duke University Press.

*Rudo y cursi.* 2008. DVD. Dir. Carlos Cuarón. Canana.

Ruiz Castañeda, María del Carmen, and Sergio Márquez Acevedo. 2000. *Diccionario de seudónimos, anagramas, iniciales y otros alias.* Mexico, D.F.: UNAM.

Sadler, Darlene, ed. 2009. *Latin American Melodrama: Passion, Pathos, Entertainment.* Urbana: University of Illinois Press.

"Salma Hayek." 1996. *People*, May 6. *www.people.com/people/archive/article/0,,20141211,00.html.*

Sandoval-Sánchez, Alberto. 2003. "Latinos and Cultural Exchange. De-Facing Mainstream Magazine Covers: The New Faces of Latino/a Transnational and Transcultural Celebrities." *Encrucijada/Crossroads: An Online Academic Journal* 1 (1): 13–24.

Saramago, José. 1997. *Blindness.* New York: Harcourt, Brace.

Sarlo, Beatriz. (1994) 2001. *Scenes from Postmodern Life.* Translated by Jon Beasley-Murray. Minneapolis: University of Minnesota Press.

Sasturain, Juan. 2010. *La patria transpirada: Argentina en los mundiales.* Buenos Aires: Sudamericana.

Savigliano, Marta E. 1995. *Tango and the Political Economy of Passion.* Boulder: Westview Press.

Schjeldahl, Peter. 1990. "Frida Kahlo." *Mirabella* 1 (November): 65–66.

Schmitt, Richard. 2002. "Large Propagators: Racism and the Domination of Women." In *Revealing Male Bodies*, edited by Nancy Truana, William Cowling, Maurice Hamington, Greg Johnson, and Terrance MacMullan, 38–54. Bloomington: Indiana University Press.

*The Science of Sleep*. 2006. Film. Dir. Michel Gondry. Partizan Films, Gaumont, France, 3 Cinéma.

Sebreli, Juan José. 1966. *Eva Perón: ¿Aventurera o militante?* Buenos Aires: Ed. Siglo XX.

———. 2008. *Comediantes y mártires: Ensayo contra los mitos*. Buenos Aires: Debate.

Sedgwick, Eve Kosofsky. 1990. *The Epistemology of the Closet*. Berkeley: University of California Press.

Sellin, Christine Petra. 1997. "Demythification: The Twentieth Century Fox *Che!*" In *Che Guevara: Icon, Myth, and Message*, edited by David Kunzle, 98–103. Los Angeles: UCLA Fowler Museum of Cultural History / Center for the Study of Political Graphics.

Shipman, David. 1970. "Dolores del Rio." In *The Great Movie Stars: The Golden Years*. New York: Crown.

Sigal, Silvia. 1999. "Las Plazas de Mayo." In *La Argentina en el siglo XX*, edited by Carlos Altamirano. Buenos Aires: Ariel.

Sluis, Ageeth. 2010. "Bataclanismo! Or, How Female Deco Bodies Transformed Post-revolutionary Mexico City." *Americas* 66 (4): 469–99.

Smith, Terry. 1993. *Making the Modern: Industry, Art, and Design in America*. Chicago: University of Chicago Press.

Sobarzo, Horacio. 1981. *Episodios históricos sonorenses y otras páginas*. Mexico City: Porrúa.

*Sol de otoño*. 1996. Film. Dir. Eduardo Mignogna. V.C.C.

Solanas, Fernando, and Octavio Getino. 1997. "Towards a Third Cinema: Notes and Experiences for the Development of a Cinema of Liberation in the Third World." In *New Latin American Cinema: Theory, Practices and Transcontinental Articulations*, edited by Michael Martin. Detroit: Wayne State University Press.

Solares, Ignacio. 1996. *Columbus*. Mexico City: Alfaguara.

Sommers, Joseph. 1968. *After the Storm: Landmarks of the Modern Mexican Novel*. Albuquerque: University of New Mexico Press.

Sontag, Susan. 1969. "Notes on Camp." In *Against Interpretation, and Other Essays*. New York: Dell.

Soutar, Jethro. 2008. *Gael García Bernal and the Latin American New Wave: The Story of a Cinematic Movement and its Leading Man*. London: Portico.

Spadoni, Robert. 2007. *Uncanny Bodies: The Coming of Sound and the Origins of the Horror Genre*. Berkeley: University of California Press.

Stacey, Jackie. 2006. "Feminine Fascinations: A Question of Identification?" In *The Celebrity Culture Reader*. Edited by P. David Marshall, 252–85. New York: Routledge.

*Stand and Deliver*. 1928. Film. Dir. Donald Crisp. DeMille Pictures.

Stellweg, Carla, ed. 1992. *Frida Kahlo: The Camera Seduced*. San Francisco: Chronicle Books.

Stoll, David. 1999. *Rigoberta Menchú and the Story of All Poor Guatemalans*. Boulder: Westview Press.

Streeby, Shelley. 2000. "Joaquín Murrieta and the American 1848." In *Post-Nationalist American Studies*, edited by J. C. Rowe, 166–99. Berkeley: University of California Press.

Strejilevich, Nora. 2006. *El arte de no olvidar: Literatura testimonial en Chile, Argentina y Uruguay, entre los 80 y los 90*. Buenos Aires: Catálogos.

Studlar, Gaylyn. 1996. *This Mad Masquerade: Stardom and Masculinity in the Jazz Age*. New York: Columbia University Press.

Sturtevant, Victoria. 2005. "Spitfire: Lupe Vélez and the Ambivalent Pleasure of Ethnic Masquerade." *The Velvet Light Trap* 55:19–32.

*Sunset Boulevard*. 1950. DVD. Dir. Billy Wilder. Paramount Pictures.

Symmes, Patrick. 2000. *Chasing Che: A Motorcycle Journey in Search of the Guevara Legend*. New York: Vintage Books.

Taibo, Paco Ignacio, I. 1984. *Siempre Dolores*. Barcelona: Planeta.

Taibo, Paco Ignacio, II. 1999. *Guevara, Also Known as Che*. Translated by Martin Michael Roberts. New York: St. Martin's Press.

Tal, Tzvi. 2000. "Viejos republicanos españoles y joven democratización latinoamericana: Imagen de exiliados en películas de Argentina y Chile: 'La historia oficial' y 'La frontera.'" *Espéculo: Revista de estudios literarios* 15, July 24. www.ucm.es/info/especulo/numer015/tzvi_tal.html.

¡*Tango!* 1933. Film. Dir. Luis Moglia Barth. Argentina Sono Film S.A.C.I.

*Tango Bar*. 1935. VHS. Dir. John Reinhardt. Éxito Spanish Productions / Paramount.

*El tango en Broadway*. 1934. VHS. Dir. Louis Gasnier. Éxito Spanish Productions / Paramount.

*Tangos: El exilio de Gardel*. 1985. DVD. Dir. Fernando Solanas. Tercine, Sarl / Cinesur S. A.

Taylor, Diana. 1997. *Disappearing Acts: Spectacles of Gender and Nationalism in Argentina's "Dirty War."* Durham: Duke University Press.

Taylor, Julie. 1979. *Eva Perón: The Myths of a Woman*. Chicago: University of Chicago Press.

Taylor, Low. 1989. "Image and Irony in *The Official Story*." *Literature/Film Quarterly* 17 (3): 207–9.

*Teresa*. 1989–1991. Telenovela. Dirs. Antonio Serrano and Jorge Sánchez-Fogarty. Televisa.

Thompson, Currie K. 1991. "Remaking Buenos Aires: Argentine Film from *Tango!* To *Kilómetro 111*." *Post Script: Essays in Film and the Humanities* 21:24–30.

Thornton, Bruce. 2003. *Searching for Joaquín*. San Francisco: Encounter Books.

*Timecode*. 2000. Film. Dir. Mike Figgis. Screen Gems, Red Mullet Productions.

Tomlinson, Emily. 2004. "Mapping the Land of 'I Don't Remember': For a Re-Evaluation of *La historia oficial*." *Bulletin of Hispanic Studies* 81 (2): 215–28.

Torres Saillant, Silvio. 2000. "The Tribulations of Blackness: Stages in Dominican Racial Identity." *Callaloo* 23 (3): 1086–111.

*The Trail of '98*. 1928. Film. Dir. Clarence Brown. MGM.

*Los tres berretines*. 1933. Film. Lumiton.

Tutino, John. 1986. *From Insurrection to Revolution in Mexico: The Social Bases of Agrarian Violence*. Princeton: Princeton University Press.

Unruh, Vicky. 2006. "Choreography with Words." In *Performing Women and Modern Literary Culture in Latin America*, 92–114. Austin: University of Texas Press.

Usigli, Rodolfo. 1976. *Mexico in the Theater*. Translated by Wilder P. Scott. Ann Arbor: University of Michigan Romance Monographs.

"Valdano, Jorge: Frases célebres." 2010. *Heroes y leyendas*. heroesyleyendas.wordpress.com/2010/05/18/jorge-valdano-y-sus-frases-celebres/#more-97.

Valdez, Luis. (1963) 2005. "The Shrunken Head of Pancho Villa." In *Luis Valdez: Mummified Deer and Other Plays*, 132–91. Houston: Arte Público Press.

Valdivia, Angharad. 2000. *A Latina in the Land of Hollywood: And Other Essays on Media Culture*. Tucson: University of Arizona Press.

Valenzuela Arce, José Manuel, comp. 1992. *Entre la magia y la historia*. Tijuana: Colegio de la Frontera Norte / CONACULTA.

*Vámonos con Pancho Villa*. 1936. Film. Dir. Fernando de Fuentes. Cinematográfica Latinoamericana.

Vasconcelos, José. 1977. *The Cosmic Race/La raza cósmica*. Translated by Didier T. Jaén. Baltimore: The Johns Hopkins University Press.

Vasey, Ruth. 1997. *The World According to Hollywood, 1918–1939*. Madison: University of Wisconsin Press.

Vázquez Montalbán, Manuel. 2005. *Fútbol: Una religión en busca de un Dios*. Barcelona: Debolsillo.

*Vendetta*. 1972. Dir. Eugenio Martín. Grenada Films, Scotia International.

Vickers, Hugo. 1985. *Cecil Beaton*. London: Weidenfeld and Nicholson.

Vila, Pablo. 1991. "Tango to Folk: Hegemony Construction and Popular Identities in Argentina." *Studies in Latin American Popular Culture* 10:107.

Virilio, Paul. 1994. *The Vision Machine*. Bloomington: Indiana University Press.

*Vital Signs*. 1990. Film. Dir. Marisa Silver. Fox.

Vogel, Michelle. 2012. *Lupe Vélez: The Life and Career of Hollywood's "Mexican Spitfire."* Jefferson, NC: McFarland.

*El vuelo del águila*. 1994. DVD. Dirs. Gonzalo Martínez and Jorge Fons. Televisa.

Wallis, Brian. 2006. "Che Lives!" In *Che Guevara: Revolutionary Icon*, edited by Trisha Ziff, 23–31. New York: Abrams Image.

Walsh, Rodolfo J. 1985. "Esa mujer." In *Obra literaria completa*. Mexico, D.F.: Siglo XXI Editores.

Weinbaum, Alys Eve, Lynn M. Thomas, Priti Ramamurthy, Uta G. Poiger, Madeleine Y. Dong, and Tani E. Barlow. 2008. "The Modern Girl as Heuristic Device: Collaboration, Connective Comparison, Multidirectional Citation." In *The Modern Girl Around the World: Consumption, Modernity, Globalization*, edited by The Modern Girl around the World Research Group, 1–24. Durham: Duke University Press.

*What Price Glory?* 1926. Film. Dir. Raoul Walsh. Fox.

*The Whole Town's Talking*. 1926. Film. Dir. Edward Laemmle. Universal.

Williams, Claire. 2007. "*Los diarios de motocicleta* as Pan-American Travelogue." In *Contemporary Latin American Cinema: Breaking Into the Global Market*, edited by Deborah Shaw, 11–28. Lanham, MD: Rowman and Littlefield.

Wolf, Vicente. 2010. *Frida Kahlo: Photographs of Myself and Others. From the Vicente Wolf Collection*. New York: Pointed Leaf Press.

*The Wolf Song*. 1929. Film. Dir. Victor Fleming. Paramount.

Woll, Allen. 1977. *The Latin Image in American Film*. Los Angeles: UCLA Latin American Center Publication.

———. 1978. *The Films of Dolores del Rio*. New York: Gordon Press.

*Wonder Bar*. 1934. Film. Dir. Lloyd Bacon. Warner Bros.

Wood, Raymund. 1974. "Ireneo Paz and 'Vida y aventuras de . . . Joaquín Murrieta.'" *American Notes and Queries* 12 (5): 77–79.

*Y tu mamá también*. 2001. Film. Dir. Alfonso Cuarón. Anhelo Producciones, Besame Mucho Pictures, Producciones Anhelo.

Zamora, Martha. 1991. *Frida Kahlo: The Brush of Anguish*. San Francisco: Chronicle Books.

Zibawi, Mahmoud. 1993. *The Icon: Its Meaning and History*. Preface by Olivier Clément. Collegeville, MN: The Liturgical Press.

Ziff, Trisha, ed. 2006. *Che Guevara: Revolutionary Icon*. New York: Abrams Image.

# Index

Page numbers in **bold** refer to illustrations.